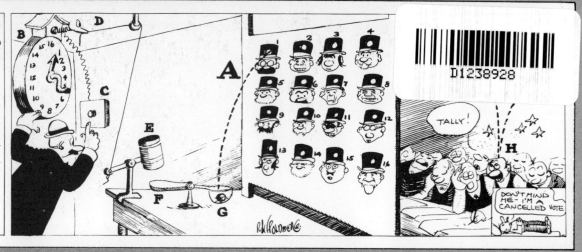

RUBE GOLDBERG

HARPER & ROW,
PUBLISHERS
NEW YORK
EVANSTON
SAN FRANCISCO
LONDON

Peter C. Marzio

RUBE GOLDBERG

HIS LIFE AND WORK

FIRST EDITION

Designed by Lydia Link

Library of Congress Cataloging in Publication Data

Marzio, Peter C
 Rube Goldberg: his life and work.

 Bibliography: p.
 1. Goldberg, Reuben Lucius, 1883–1970.
NC1429.G46M3 1973 741'.092'4[B] 73–4108
ISBN 0–06–012830–5

For Barbara

Contents

Acknowledgments

I knew Rube Goldberg during the final year of his life. I addressed him as "Mr. Goldberg" then, but now I call him Rube. Despite my feelings of warmth and admiration, I have worked to write this biography as objective history. It is an attempt to combine the events of his personal life and his cartoons, to show the interrelationship between life and laughter.

In pursuing this goal I have received the untiring cooperation of innumerable people. Rube's wife Irma has aided my search for the details of Rube's life in every conceivable way: supplying long-forgotten cartoons from her magic closet, opening Rube's unpublished manuscripts and memoirs for my scrutiny, giving me endless hours of interviews, and pointing me toward many friends who also consented to reminisce before a tape recorder. Without her constant assistance, this book would have been much less accurate.

Others in Rube's family have also given generously of their time. Mr. Walter Goldberg, Rube's younger brother, supplied photographs, news clippings, family documents, and countless anecdotes. Mrs. Garrett Goldberg, Rube's sister-in-law, volunteered numerous personal impressions about Rube's father Max. Rube's older son, Mr. Tom George, and his wife Laverne were most helpful in re-creating the course of Rube's changing attitudes toward modern art. Rube's younger son, Mr. George George, and his wife Judy supplied answers to my endless questions. Their willingness to discuss Rube's career in its successes and its failures proved essential for a balanced presentation.

Although most members of Rube's generation have died, three extraordinary men remain amazingly alert. Mr. George Wagner, who admitted to age ninety-two when I interviewed him, remembered Rube's adolescent years with clarity and enthusiasm. Mr. Edgar "Scoop" Gleeson knew Rube as a fledgling newspaper cartoonist for the San Francisco *Chronicle,* and he corresponded with Rube for more than sixty years. Mr. John Wheeler of New York City recounted anecdotes from Rube's early years on the New York *Evening Mail.* All three men cooperated beyond the reasonable expectations of any author.

Members of the National Cartoonist Society, particularly Mr. Milt Caniff (*Steve Canyon*) and Mr. Robert Dunn (*Little Iodine*)—both consenting to long interviews—helped in many ways. So did members of the Society of Illustrators and the Dutch Treat Club (both in New York City) and the Bohemian Club of San Francisco.

The King Features Syndicate provided answers to all my questions regarding Rube's career. Mr. John H. Wright, Mr. John Willicombe, and the late Mr. Milton

Kaplan of King Features were especially helpful.

Dr. Alan Fern of the Prints and Photographs Division at the Library of Congress shared some of his keen insights about the relationship of art and technology in the twentieth century. His willingness to discuss his ideas was a welcome change from the tight-lipped demeanor of too many scholars.

I am also indebted to several institutions for the richness of their collections and the cooperation of their staffs: the Bancroft Library of the University of California at Berkeley, the Harry S. Truman Library, the New York Public Library, the Library of Congress, and the Johns Hopkins Library. The Smithsonian Institution, where I have worked the past several years, permitted me to use many of the materials gathered for one of its temporary exhibitions, "Do It the Hard Way: Rube Goldberg and Modern Times."

Mrs. Anne C. Golovin, associate curator at the Smithsonian Institution, shared all of her research on Rube with me. Dr. Daniel J. Boorstin, director of The National Museum of History and Technology, provided innumerable insights, and Mr. Todd Mann of Vassar College read the entire manuscript, making helpful suggestions. Mr. John Reedy of the *Reader's Digest* provided a comprehensive file on Rube's life.

Mrs. James Durnan, Miss Genevieve Gremillion, and Miss Patricia Jensen handled the typing—each showing remarkable accuracy and care.

To Hugh Van Dusen of Harper & Row, who first suggested this book, I am indebted both for his interest and for his careful editing. Miss Cynthia Merman shared the editing chores and attended to the multitudinous details involved in an illustrated book of this kind.

And what can any author say about a wife who participates in the creation of a book from the first outline to the final page-proof? My wife Barbara has ordered my time and edited my words; she has researched and encouraged and prodded and guided my work at every turn. She has been a virtual collaborator.

P. C. M.

Washington, D.C., 1971

Introduction

"You have to have courage to be a creator," wrote Rube Goldberg in 1965. "It's all in the doing, and it shouldn't be talked about too much." While these words are discouraging to any biographer, Rube himself was too tempting a subject for silence. He was a leading American cartoonist from 1910 to 1930. As one of the most original humorists in American history, Rube won the admiration of millions. By the time of his thirty-second birthday he was being hailed as a "genius," at forty-five he was the "master," and at sixty he had earned the title of "Dean." Rube was a torrent of creativity, a wellspring of laughter.

Rube's productivity has become a legend. In seventy-two years he published nearly 50,000 cartoons. Yet, unlike many creative geniuses, he had only a few idiosyncrasies. He was inveterately fond of cigars, for example, smoking at least five a day for sixty-five years—a rounded total of 118,700 cigars at an estimated cost of $47,480. "My father was an addict," remembered Rube in 1964. "My two sons are addicts. And my grandson . . . smokes an occasional cigar. Guess it is in the blood."

Like so many details of life, Rube had a grand philosophy about cigars.

A cigar is a test of love. A lot of wives don't like their husbands to smoke cigars. They send them down into the basement or out to the woodshed when the men want to light up. You know what happened to a friend of mine many years ago? His wife sent him out to the woodshed once too often and he never came back. He turned up several years later in Australia where he had settled down with another woman—one that he really loved.

Every Christmas and birthday Rube replenished his humidor by steering his friends and relatives away from "senseless gifts" such as neckties, mufflers, money clips, and fountain pens and encouraging them, instead, to give him "*good* cigars in any quantity . . . that might fit their immediate bankroll." These brown cylinders constituted his private "incense-and-myrrh," as he referred to them, and he often wondered whether Joseph had handed out "stogies" in Bethlehem before the Wise Men arrived with their more publicized gifts.

A cigar, for Rube, was a "symbol of expansive satisfaction," and its therapeutic effects—the "easing of tensions, the warming of friendships, the feeling of luxurious contentment"—more than outweighed its contribution to pollution. A cigar required staunch independence, a rugged individualism which risked friendships, families, and social goodwill—all for a few short minutes of personal pleasure.

It is more than a coincidence that many of the male characters in his cartoons are sucking, puffing,

or munching on a Havana torch, for Rube's cartoons are extensions of himself. The cigars are fixed facial features, as organic as a nose and more important than a brain. The cigar was a shield for the character's psyche: It marked an attitude of oblivion toward the perils of everyday life, a defense of comfort against blaring radios and reckless automobile drivers. It is no wonder that Rube's lifetime hero was Winston Churchill, who as a statesman had earned some fame but as a cigar smoker had achieved immortality. The thought of Churchill blowing thick clouds of obnoxious smoke straight into the faces of kings and dictators made Rube glow with delight. Democracy, in Rube's system of values, included not only the freedom of speech, the freedom of worship, and the right to vote but, most importantly, the freedom of odor. Weren't smoke-filled rooms the symbols of political democracy? Wasn't this the age of minorities? Fellow Americans, exhorted Rube, "let us continue to fight for equal rights with cigarettes, broccoli, cabbage, cologne, and perspiration. We dedicated cigar smokers must feel it our duty to keep puffing away regardless of the squawks around us and enjoy the illusion of elegance and contentment. Got a match?"

This kind of personal reflection, projected to encompass a general social issue, characterized most of Rube's work. His greatest talent was to grab the obvious elements of everyday life and to make them tell us about ourselves. So while he has won enduring fame as a comic of American technology (even the genius of RCA, the late David Sarnoff, called him the "father of invention"), his real subject was man in America.

The story of Rube Goldberg (Figs. 1 and 2) is the story of success, hard work, relaxation, love, a little despair, and a lot of fun. He reveled in living and in thinking, for ideas were his stock-in-trade. When he

latched on to technology, he struck a vein of humor which only a few earlier comic prospectors had tried to tap. Throughout the nineteenth century, European visitors in America marveled at the innumerable labor-saving inventions. The English novelist Anthony Trollope wrote in 1862, "The great glory of the Americans is in their wondrous contrivances—in their patent remedies for the usually troublous operations of life." Since America was born at the start of the industrial revolution, it has always been what the late historian Charles Beard called a "technological civilization." The shortage of manual labor and the absence of ancient guilds made machines—and even automation itself—essential elements in American life. Although the national census reports have shown that most Americans lived in rural areas until 1920, their work habits and life-styles were increasingly dictated by industrialization. Pioneers, the most rural of all Americans, used machine-made firearms and steamboats and railroads and telegraphs. The "technological civilization" permitted the settlers to span and settle the entire continent very quickly. For Americans, complex machinery has been ever present and ever growing, but few Americans until the arrival of Rube Goldberg saw it as a subject for comedy.

The United States Patent Office records for the nineteenth and twentieth centuries often read like a series of books dedicated to outdoing Rube himself. Every conceivable idea—including automatic hat-tippers, lip-straighteners, and beds which convert into bureaus—is there. The European travelers have testified repeatedly that mechanical innovation appeared as a natural state of mind, and that it was motivated, in the words of one Frenchman, by the Americans' "passion for physical well being."

Here is the heart of Rube's humor. Despite our

"wondrous" gadgets, our desire for comfort, and our talented mechanics, life is still a pain in the neck or a vacuum cleaner that won't turn off. Time and again Rube reminds us that laughter results not just from a pie in the face but from an uncontrollable car which was invented to *serve* our needs. He was a humorist of, by, and for the twentieth century. And so it is the purpose of this book to capture the unique qualities of his wit, to explore the paths of his numerous careers, and to relive, as best one can, the elation which millions of daily readers felt as they scurried through their newspapers searching for the latest Goldberg joke.

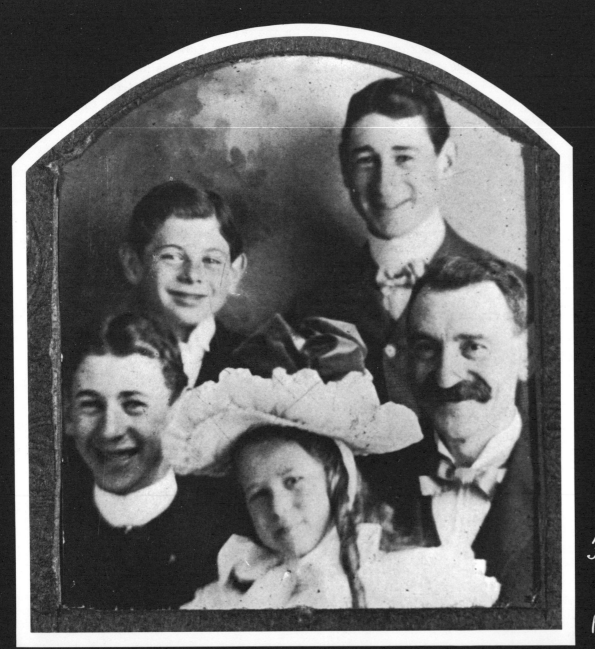

Front: Rube, Lillian, Max.

Back: Walter, Garry

1902

1
The Reign of Max

It takes some doing to come across an American adult who has never heard the name Rube Goldberg. To say that the name is a household word or that the man has become a legend would be semantic banter. In fact, the very life of Rube Goldberg had a tender, sensitive quality which eluded the American public. For too long, too many have conceived of Goldberg as a wild mechanic who worked on crazy contraptions in a sterile laboratory or greasy garage. Actually, he was a quiet, hardworking, gentle man with a simple instinct for goodness. His brilliant satire was a positive genre, aiming to cleanse and refresh rather than discourage or destroy. Millions of Americans saw his daily cartoons and washed away any meanness or hatred they had accumulated in their daily battle for survival. Rube was the nation's confessor, its spiritual physician, sworn to honesty and to laughter. Reacting to Rube's cartoons, his readers stood on common ground, free from social pretense and stripped of fads.

Raised in San Francisco for the first twenty-four years of his life, Rube was surrounded by a raw, bustling American community striving for wealth, order, and respectability. He saw people of every class and color, working to get ahead, seeking the good life which America could offer. In 1883, the year Rube was born, San Francisco was run by land and mining speculators, shipping magnates, and saloon keepers. It was a rough-and-tumble city with unpainted wooden buildings perched high on hills with unparalleled views of the entrance to the Pacific Ocean. It had Chinese and Italians, and Scots and Jews, clinging to their national idiosyncrasies but claiming a common American heritage. Unlike New York, San Francisco was tightly knit and sociable; it had not yet learned the dark art of impersonality. A young boy walking the streets had few fears, but he was sure to encounter city drunks, hobos, and long-winded politicians, all searching for a tender heart. The new mechanical wonders, San Francisco's famed cable cars, occasionally challenged the harmless, picturesque loafers, left over from the gold-rush days, as the city's number one claim to uniqueness. The meeting of old and new stimulated Rube to cartoon a series of stormy encounters between man and machine. But even without mechanical props, the town characters were a great attraction to a young boy with a visceral sense of humor. One strolling resident, the self-anointed Emperor Norton, crept around town in royal garb, acknowledging the mock homage of all who saw him. Professor Hardass haunted the saloons, soliciting anyone to kick him in the posterior for the price of a drink. And the Golden Gate's two notorious pugilists, Cockey O'Brien and A. Wing,

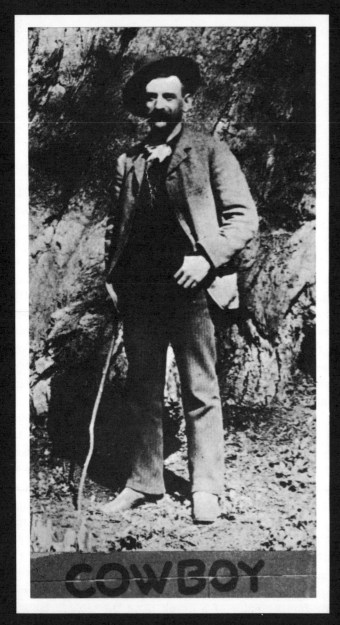

COWBOY

Max, 1896

Hannah, 1879

were sure to caress the canvas at any time—for the right price.

It was a city of new money folded neatly in diamond-studded money clips, a place, as Rube remembered, where one could see "the pot-bellied forms of affluent plumbers lying luxuriously in barber chairs," and tired, bedraggled horses drawing rickety Chinese laundry wagons. The rich San Franciscans of Nob Hill could clothe themselves as well as their New York cousins, but they had one problem. They were all dressed up with no place to go. Tuxedoed gentlemen often made their way to all-night poker games, and fashionable women met in one another's parlors to gossip. Rube was a product of San Francisco's Gilded Age, as one native termed the 1870–1890 era—an era when people who had earned their money were learning how to enjoy it.

Rube's home was a microcosm of all that was San Francisco. His father, Max Goldberg, was a San Francisco landmark. Born in Prussia in 1851, Max was a Jew who spoke German. He made his way to California sometime before the Civil War and caught on to America's love for buying and selling real estate. At various times in his life he owned cattle ranches in Arizona, oil lands in California, and wooded hills near the Rockies. In San Francisco he became deeply involved in politics. As a Republican ward boss of the Thirty-eighth Assembly District, gubernatorial campaign manager, city police commissioner, banker, and fire chief, he knew the Golden Gate politicians intimately.

In 1897 Max's political life was directed toward Asa R. Wells, candidate for mayor of San Francisco. Wells was a ponderous, statesmanlike individual who distinguished himself throughout the campaign by keeping quiet and hiding in a downtown hotel room. Max campaigned for Wells with impassioned speeches extolling the stalwart qualities of the invisible candidate. (According to rumor, Wells was a terrible public speaker cursed with an acid personality.) Things looked promising for Max until Wells bolted from his confinement one afternoon and made his way to Golden Gate Park, where returning Spanish-American War veterans were being honored by ten thousand Californians. For some mysterious reason the Honorable Wells climbed to the rostrum and proceeded to warn his audience of the prevalence of venereal disease among soldiers returning from abroad. The Democrats seized on Wells' faux pas and defeated him soundly.

Max was also a part-time political comrade of Abe Ruef, the corrupt dictator of San Francisco's political arena, and the real power behind Eugene Schmitz, the inept Republican mayor during the 1906 earthquake. Ruef ruled the city by an elaborate system of graft and public robbery. The red-light districts, the notorious Barbary Coast saloons and dance halls, and the general lawlessness of the city owed their survival to San Francisco's answer to Tammany Hall. Amazingly, Ruef remained unmolested until 1907, when he was finally brought before a grand jury, charged with bribery, and eventually sentenced to San Quentin for fourteen years.

Fortunately, Max was low enough on the political ladder to escape the long shadow of guilt cast by Ruef's indictments, but he was close enough to the center of power to give Rube an insider's impression of the American democratic process at work. As late as 1961, for example, Rube wrote to his lifelong California friend Edgar "Scoop" Gleeson how nice it would be to "mull over the state of the world in contrast to the 'good old days' when Abe Ruef glorified the diseased ladies on Jackson Street."

On countless Friday nights leading citizens met at

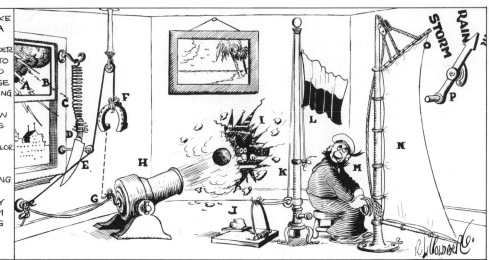

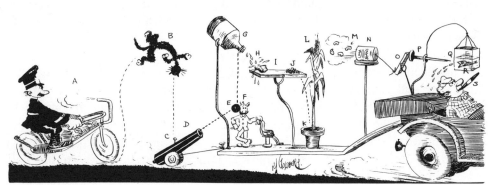

1. Professor Butts' Scientific Barometer, 1931
2. Simple Way to Light a Cigar in an Automobile Traveling Fifty Miles an Hour, 1915

the Goldberg home for a rousing game of poker. Big bellies, booming voices, luxurious moustaches, black, smelly cigars, and empty heads formed a comical fraternity, with chips, cards, and coins changing hands at a bewildering rate. Rube tried to remain inconspicuous, but observing the pompous politicians inevitably brought audible giggles. To Rube's innocent eyes San Francisco's leaders were the strangest physical specimens that Mother Nature could possibly assemble.

"To this day," Rube wrote in 1931, "politics to me seems so shackled by personal involvements. There is little room left for real dedication." He never forgot Max's social gatherings, for in later life his cartoons of politicians and other windbags simply recreated these childhood visions (Fig. 3). Whenever he cartooned a friendly game of poker, he could not help recalling Max's Friday night meetings (Fig. 4). And after he evolved his famed invention cartoons, he felt compelled to contribute a new-styled voting machine, complete with sleepy politicians (Fig. 5). Two of his longest-running features, *It's all wrong, . . . , it's all wrong* and *Father was right,* were direct outgrowths of Rube's early experiences. *It's all wrong* (Fig. 6) often focused on political corruption or other forms of social injustice, while *Father was right* expressed Rube's unremitting love for Max (Fig. 7).

Although Max Goldberg had little formal schooling, he enjoyed reading world history, law, and Shakespeare. He memorized lengthy passages from *Hamlet, King Lear,* and *The Merchant of Venice* and quoted them continuously to his less educated comrades. When giving the English master a rest, Max would speak with a true Western accent, using phrases like "looka here" and "I reckon," and to complete the picture, he wore a wide-brimmed Stetson hat which never seemed to leave his head.

In 1878 he married the pretty Hannah Cohen from the small town of Gilroy in the central part of California. They had seven children, four girls and three boys, with Rube appearing third in the series. The oldest girl died at the age of eight, and two other girls died in their infancy. Garry was sixteen months older than Rube, Walter was eight years his junior, and Lillian was the youngest.

Hannah Goldberg was a frail woman with a weak heart and crippling rheumatism. Nurses and doctors always seemed to be coming and going from Rube's childhood home, and an atmosphere of expectancy filled every room. She was confined to her bed for months at a time, and then, as if by a miracle, she would recover. The "aroma of sickness," as Rube described it, would leave the house, being replaced with a "tone of affectionate gaiety." Max would strum a long-neglected banjo, Garry played the violin, and Rube did his best at the piano. Max sang early folk songs about illicit love and hangings and rugged pioneers. One rough-house number began:

> Her mouth was like a cellar door.
> Her face was like a ham.

And during these happy times the Goldbergs hired a horse and carriage at Johnson's Livery Stable for a dollar and a half and drove gaily through Golden Gate Park. They ate special coffee cake made with sugar and cinnamon and drank Max's homemade wine with seltzer. But the merriment was always short-lived, halted by Hannah's recurrent illness. When she was forty-five, Hannah died, leaving three young boys and a daughter to Max's care.

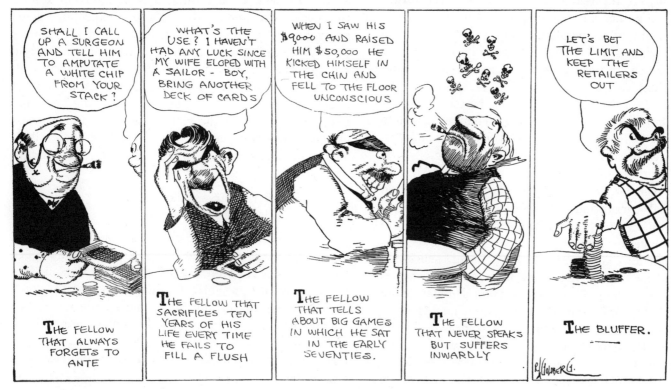

3. Campaign speeches are useful, at that, 1924

4. A Poker Gallery, 1910

While his wife was alive, the robust Max was renowned throughout San Francisco as a martinet and an autocrat. He ran a strict house, subjecting all members to a stern, fierce discipline. After Hannah's death Max tightened his vicelike grip. He would call the children from their play by placing two fingers in his mouth and whistling loudly. They responded instantly, fearing the worst if they dallied along the way.

Each of the Goldberg children had special chores, and the one Rube hated most was sawing wood. Through some political chicanery, Max received logs and lumber left over from city building projects. This wood came in odd sizes, so Rube and Garry and Max had to saw it into small pieces for the kitchen stove and the parlor fireplace. "Down into the cellar we'd go," remembered Rube,

to take turns at the end of one of those two-handled saws. . . . My father never seemed to tire as he kept pushing his end back and forth. Garry managed to keep up with the rhythmic torture. But I tired very quickly. I got blisters long before the other two cellar woodsmen. I'd wait for somebody to ring the front door bell so I could rush upstairs and answer it.

Strenuous physical exercise never endeared itself to Rube.

Somehow Max felt he could do a decent job of raising the boys, but a girl was a different matter. Lillian, for example, had blond hair that reached to her waist, and each morning Max arose early to help her braid it. With a dripping wet comb he wound her hair so tightly that the part at the back of her head looked like a fresh scar. She begged and cried for him to be gentler, but the surrogate mother felt his responsibility so keenly that he could not do his duty any other way.

As Rube noted, "He had to hurt my sister to show he loved her."

During the 1890s Max became president of a private company called the San Francisco Collateral Loan Bank. Located on Kearny and Sacramento streets, the bank advertised its main service as "discounting City warrants." In fact, Max and his partners advanced salaries to city employees who were low on funds. These short-term loans earned Max a comfortable salary and, more importantly, gave him direct contact with the city fathers. His temporary jobs as city fire chief and police commissioner resulted from his banking contacts. The bank also served as a clearinghouse for selling government lands, and Max purchased generous chunks for himself—land which, after his death, yielded high returns to the Goldberg children.

When Rube was thirteen, Max was "appointed" one of the directors of the Yosemite Valley. National parks were not yet in existence, for land seemed abundant and free, and Teddy Roosevelt—an early conservationist—was still five years from the presidency. The Yosemite Valley was a state game reserve, a virgin territory unspoiled by the debris of the modern-day, tin-can campers. On his first trip to the Valley, Max took Rube and Garry as traveling buddies. It was a "thrilling experience," Rube wrote. "The train went only to Mariposa where we took a real stage coach drawn by four fiery horses. I felt like a pioneer, only the Indians were missing." Rube described this trip time and time again after he moved to New York. A city dweller to the core, a confirmed New Yorker, Rube equated the grandeur of Yosemite with Paradise—a tiny indication of the peace and beauty and innocence of divine creation. Yosemite gave Rube a sense of the beginning of time, before men and machinery had

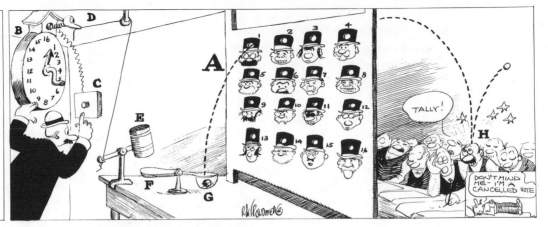

5. Use our simple voting machine
6. It's all wrong, Euclid, it's all wrong, 1915

bungled God's masterpiece. Later, Rube's greatest cartoons dealt with the impact of technology on the world, a concept strongly developed from his early vision at Yosemite (Figs. 8 and 9).

With a name like Rube Goldberg, one might expect a family tree full of rabbis, tailors, and delicatessen proprietors. The fact is that Rube was a very casual Jew. Max Goldberg himself inspired this attitude, for most of the San Francisco politicians were Scottish Presbyterians and Irish Catholics, and he blended easily. The Goldbergs placed candles on the dining-room table on Fridays nights and observed the two High Holy Days, the New Year and the Day of Atonement. Max, however, was far from a model Jew, seldom going to the temple on Saturdays and rarely impressing anyone with his religious performance. As Rube observed, "He had a talent for mimicry which led me to suspect that his devotion had histrionic overtones." As a result, Rube was never at peace in a temple; the archaic rituals and the strange words only jangled his funny bone. To Rube, men were the comical victims of elaborate, obscure ceremonies, whether performed at the high altar or at the political poker table.

The absence of any traditional religious baggage made Rube a free spirit, an objective observer of the world, willing to analyze facts as he found them. He was free to create his own intellectual scheme complete with intricate iconography and wise sayings. He avoided the destructive inbreeding that narrows any strict religious group, and he stepped into the world of men destined to be a creative leader and a devastating critic. It was a young Rube Goldberg who knew that his work had to be his religion, for its intensity and sincerity made it sacred to him. Rube was, indeed, a humanist who believed in God. His cartoons would make a lively Bible—timeless, true, and funny.

The warring impressions of his colorful childhood had a curious effect on Rube. The loud political bravado, the regular Friday night poker, and the continual chanting from the dens of finance caused him to turn inward, to carve out a quiet personal world as a new-styled pioneer of humor.

Rube was a shy, hesitant boy who seems to have generated a continual stream of comical ideas. His youthful reticence was a reaction to Max's flamboyance and to his older brother's supreme self-confidence, for Garry was a clever, outgoing lad with a grand wit. Those few surviving people who knew them both agree that Garry's perception and sense of timing certainly made him Rube's equal. Garry could amaze the household with his magic act and his polished monologues with cliché witticisms garnered from mail-order jokebooks. He even won neighborhood fame as an accomplished ventriloquist. Garry simply awed Rube, who later confessed, "At that time when the others were doing funny stunts I used to think of lots funnier ones that I might have done—a minute or two too late to do them even if I'd had the courage." At times, of course, Rube did stand up and get some laughs. His younger brother, Walter, the quietest of the Goldberg boys, remembered him as being "bright" and "intelligent" and with a special knack for mimicry. "Rube could do anything he put his mind to do," Walter noted. "He seemed to find everything easy, even school." The mimicry Walter remembered suggests that even in his early teens Rube was fascinated with people. He observed them in their daily activities, watching them bang their heads against life. Rube may have felt awkward in the world of stand-up comedians, but he was developing a natural sense of humor. All he needed was the right act.

Like most precocious children of anxious middle-class

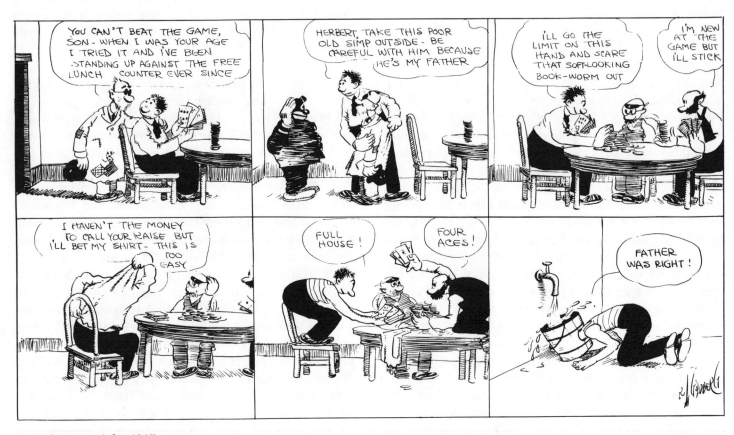

7. Father was right, 1915

parents, Rube was inundated by an avalanche of illustrated books. According to a family legend, when Rube was four years old, he received a copy of Bill Nye's humorous *History of the United States* filled with illustrations by Frederick Burr Opper, one of America's premier comic artists. Rube was so attracted to the pictures that he traced them onto transparent tissue paper which his mother used for dress patterns. Four years later Rube's love for line drawings had developed into an obsession. He traced from books, newspapers, calendars; even Goldberg drawings from cigar can wrappers still survive. He developed an intimacy with the works of the great illustrators: Charles Dana Gibson (originator of the "Gibson Girls"), Homer Davenport, T. S. Sullivant, Eugene ("Zim") Zimmerman, and Walter Appleton Clark. When he was nine, Rube occasionally helped Garry with his magazine delivery route and thus had the chance to see the work of his drafting idols in the *Saturday Evening Post, Collier's*, the old *Life, Puck*, and *Judge*. "I would literally smell the ink on the pages," wrote Rube in one of his abortive autobiographies. The "pungent aroma gave me a greater thrill than inhaling the fragrance of the most exquisite perfume." Nobody encouraged him, as Rube remembered. "No one in my family showed any interest in the creative arts. Somehow it was in my bones to delve into the intricacies of techniques and dream that someday I would be able to develop a style or a line that would help me put down on paper the exaggerations I felt going on in my little world."

Rube paid for professional drawing lessons during three periods in his life: (1) as an eleven-year-old artist anxious to learn the "secrets of composition," (2) as a college sophomore enrolled to become a mining engineer, and (3) as a twenty-four-year-old New Yorker recently transplanted from San Francisco. The first stint was the longest and made the most impression. The teacher's name was Charles Beall, a San Francisco sign painter with high ideals and empty pockets. Beall worked for the brother of Rube's best friend, George Wagner, and he taught art classes on Friday nights to boost his income and his ego. Rube and George joined these weekly sessions, paying fifty cents upon entering "the studio." Beall must have been a teacher blessed with an innate sense of balance between freedom and discipline. Aesthetically, he was a traditionalist who directed his students to draw straight lines, circles, and angles before attempting elementary pictures. "Control" was essential for any artist, and Beall drummed an appreciation for discipline into Rube's mind. But unlike most pedagogues who stick to a single system of instruction, Beall knew when to forgo tradition. Rube, for example, was cursed with a serious defect from birth: He was left-handed. Max sought to cure the malady by ridiculing him every time he dropped a dish or shattered one of his mother's fragile bisque ornaments. For years Rube practiced being right-handed until he finally became ambidextrous enough to drop dishes from both hands. As an enthusiastic golfer during his adult life, Rube even owned two sets of clubs—one for normal people and the other for southpaws. He must have taken to drawing easily, for the flexible Beall never mentioned the handicap and didn't seem to care whether Rube used his hands or his feet.

Rube worked with a vicious persistence and, according to George Wagner, deeply impressed his frustrated teacher. Rube tried all artistic mediums from india ink to oil color, and after one year of Beall's tutelage he won his first art prize in a competition at the John Swett Grammar School, the scene of his early education. The "Old Violinist" is a pen-and-ink copy of a black-and-white lithograph showing a friendly

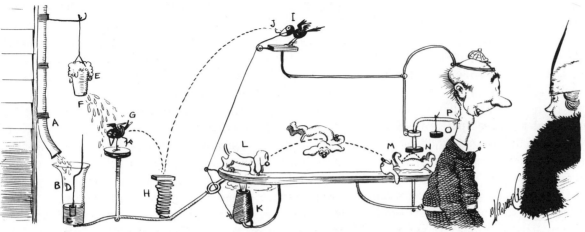

WATER FROM DRAIN-PIPE (A) DROPS INTO FLASK (B) — CORK (C) RISES WITH WATER CARRYING NEEDLE (D) WITH IT — NEEDLE PUNCTURES PAPER TUMBLER (E) CONTAINING BEER (F) — BEER SPRINKLES OVER BLUEBIRD (G) AND HE BECOMES INTOXICATED AND FALLS ON SPRING (H), WHICH BOUNCES HIM TO PLATFORM (I) — HE PULLS STRING (J) THINKING IT IS A WORM — STRING FIRES OFF CANNON (K) WHICH FRIGHTENS PEACE-HOUND (L), CAUSING HIM TO JUMP IN AIR, LANDING ON BACK IN POSITION (M) — HIS HEAVY BREATHING RAISES DISC (N), WHICH IS BROUGHT BACK INTO ITS ORIGINAL POSITION BY WEIGHT (O), — THE CONTINUAL BREATHING OF THE DOG MOVES SCRATCHER (P) UP AND DOWN OVER MOSQUITO BITE, CAUSING NO EMBARRASSMENT WHILE TALKING TO A LADY.

PROFESSOR BUTTS TRIES TO FIX A LEAK IN THE BOILER AND WHEN HE IS RESCUED FROM DROWNING HE COUGHS UP AN IDEA FOR AN OUTBOARD MOTOR THAT REQUIRES NO FUEL. AS YOU REACH FOR ANCHOR, BUTTON (A) SNAPS LOOSE AND HITS SPIGOT (B) CAUSING BEER TO RUN INTO PAIL (C). WEIGHT PULLS CORD (D) FIRING SHOT GUN (E). REPORT FRIGHTENS SEA GULL (F) WHICH FLIES AWAY AND CAUSES ICE (G) TO LOWER IN FRONT OF FALSE TEETH (H). AS TEETH CHATTER FROM COLD THEY BITE CORD (I) IN HALF ALLOWING POINTED TOOL (J) TO DROP AND RIP BAG OF CORN (K). CORN FALLS INTO NET (L). WEIGHT CAUSES IT TO SNAP LATCH OPENING FLOOR OF CAGE (M) AND DROPPING DUCK INTO SHAFTS (N). AS DUCK (O) TRIES TO REACH CORN IT SWIMS AND CAUSES CANOE TO MOVE AHEAD. IF THE FALSE TEETH KEEP ON CHATTERING YOU CAN LET THEM CHEW YOUR GUM TO GIVE YOUR OWN JAWS A REST.

8. Our Modest Mosquito-Bite Scratcher, 1917

9. Professor Butts' Fuelless Outboard Motor

gentleman with rather strange figure proportions. The perspective is something less than perfect as the left shoulder and arm fade into obscurity. To Rube's credit, he devoted his efforts to the old man's personality, making a valid try to reveal warmth and kindness. In later life Rube's cartoons were marked by the same imbalance: Character, humanity, and personality always outweighed technical refinement.

Rube and George Wagner studied with the sign painter every Friday night for three years. When he entered Lowell High School, Rube had learned the fundamentals of drawing well enough to consider himself an "Artist" (Rube favored a capital "A"). He published a bewildering assortment of drawings in the high school paper, as if serving an unwitting four-year apprenticeship for his life's work. "Every time the school paper came from the press," Rube reminisced in 1968, "I felt sorry that everybody couldn't be as talented as I was." Somehow Rube found time to study as well, and although he defined high school as a "big blur," he was graduated in December of 1900, half a year ahead of his class. Though he seemed to thrive in school, Rube detested the whole idea of study for its own sake. Even kindergarten was a nuisance, a "maze of colored pictures, jungle beasts staring . . . from large books, a horse-faced teacher, and . . . frightened children," wrote Rube as a college sophomore. Later he cartooned his sentiments, laying bare the pretensions of frustrated teachers and the general uselessness of academia. *It's all wrong, Euclid, it's all wrong*, which appeared on February 15, 1915, indicated Rube's convictions (Fig. 6).

Rube's precociousness was beginning to show, and he owed it all to a man who painted billboards advertising the enticing aroma of San Francisco sourdough bread. Rube didn't know it, of course, but he was traveling a path blazed by several famous American artists. Benjamin West, Charles Willson Peale, and Gilbert Stuart all first learned their craft from anonymous sign painters whose work enhanced the entrances to taverns. Such inauspicious teachers of deep conviction and practiced competence have given the world many brilliant students, and Rube was Charles Beall's contribution.

YE JOLLY (?) SOPHOMORE

10. Ye Jolly (?) Sophomore, 1903

2
The Fan Kid

Pa Goldberg failed to rejoice in Rube's art work. He searched San Francisco for a means to dissuade his son from pursuing a useless profession. In later years Rube joked about his father's fear by re-creating a conversation between Max and his political comrade Colonel Daniel M. Burns, Republican boss of California.

"Dan," muttered Pa, "my son Rube—you know, the little chap who's always seemed all right—well, Rube says he's going to be an artist, and I just can't get him away from the idea."

"Hum, that is serious," consoled Colonel Burns. "What do you suppose caused it? The family has always been—er—ah . . ." Burns hesitated, a bit embarrassed. "That is, there's nothing hereditary about it, is there? In other words, the family history is such that it furnishes no explanation of why your son Rube should be a little—er—er—let us say, a little flighty?"

"That's the remarkable part of it," answered Max Goldberg proudly. "Our family record is as clean as a whistle. We've never had a single solitary artist in it —not one."

In true patriarchal manner, Max and Burns made plans for Rube's college career, setting their sights on West Point or Annapolis. They were sure that either institution would convince Rube that art was a waste of time. Max even arranged for tentative appointments to the academies, but Rube resisted and declared for a career in art. So with typical Goldberg logic he enrolled as a student of mining engineering in the University of California at Berkeley.

Max had learned that John Hays Hammond, noted mining expert, was working for the Guggenheims at a total income of $1,000,000 a year. Newspapers headlined Hammond's good fortune and every father in America wanted his son to study the subterranean craft. When Max approached Rube, he was ready for a negative reply, but—as always—Max was one step ahead. "Why, my boy," Max consoled after Rube's mouth dropped to the floor, "don't you know that all the great artists, such as Da Vinci and Homer Davenport and Fred Opper and Rembrandt and Tad Dorgan, spent years studying mining engineering before they ever lifted a brush?" Rube couldn't argue against those references, so off to Berkeley.

Since he lived at home until he was twenty-four years old, the differences between high school and college were slight for Rube. He commuted from San Francisco to Berkeley every school day for three and a half years. The eighteen-mile trip started with a cable-car ride to the ferry, which lighted on the shores of Oakland, and a short train trip to the campus completed the journey. Rube would change at the gym into

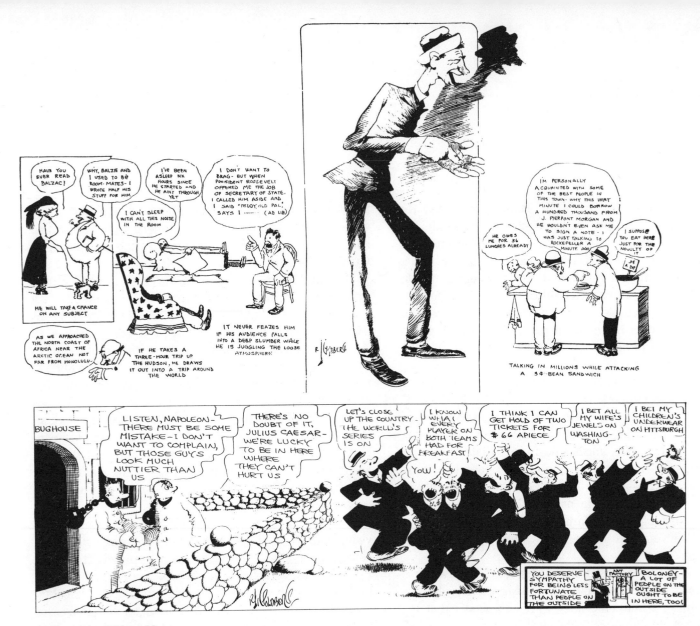

11. Lunatics I Have Met

12. Insanity is chiefly a matter of opinion, 1917

proper campus dress, attend classes, and return home in the evening. The round trip took almost three and a half hours—a strenuous daily regimen. Coming in at midterm, he worked to make up five months of physics, chemistry, and trigonometry; and while he insisted he could never fathom the difference between a sine and a cosine, he passed the final examinations to enter the sophomore class—ten months of work in half the time.

Rube enjoyed the Berkeley campus because it encouraged him to draw. As an illustrator for the *Pelican*, an early college comic periodical, and with the college yearbook (Fig. 10), Rube added his own touch of humor to Beall's steadfast rules. He continued his pursuit of art in a sophomore drawing class which read William Morris Hunt's *Talks on Art*. Although Rube grew to distrust aesthetic theories, he painstakingly underlined and annotated this tome, for Hunt was hailed as one of the great teachers in America (1880s), renowned for his emphasis on life as the basis of art. He even traveled with his students in a special "art wagon" to study and to paint from nature.

Two passages in Hunt's *Talks* caught Rube Goldberg's deep attention. As if telling a cartoonist how to spend his life, Hunt insisted, "No exaggeration can be stronger than Nature, for nothing is so strange as the truth." Rube repeated these sentiments all his life, as in 1940, when he declared that "humor comes from everyday situations because nothing is as funny as real life." Again, Hunt touched a responsive chord with a second commandment: "Lay aside your intelligence and draw things as they look to you." By this he meant that while the perfect human body has an ideal form, most real bodies fail in one area of proportion or another. Artists must forget the Greek rules and learn to see people as they are. Needless to say, Rube went out of his way to prove that Phidias and

other ancients were wrong. By the time he reached full stride as a cartoonist, he answered the Greek ideal with a weird assortment of characters designed to drive any classicist to despair. Rube's people have round, lumpy heads and bulbous eyes; their legs are too long or too short, their mouths too big, and their brains too small. They have every shape of moustache and whisker the world has ever seen, with pointy tips or ragged edges or tangled strands of hair. This ridiculous parade did not spring full-blown from the dark cavities of Goldberg's mind. Each character lived and breathed and at one time or another crossed Rube's eye and he quickly jotted down the likeness on a matchbook or an envelope or a calling card. Now, he may have exaggerated a lump or two, and he may have made people a little more ridiculous than they really were, but Rube used real physical features to concoct his humor, just as Phidias created the perfect human form from the body parts of all humanity. Rube's people are the antithesis of Greek statues, yet both aim at depicting humanity.

While attending the College of Mining Engineering, Rube worked at several odd jobs which simply reinforced his faith in the strangeness of the human race. One part-time duty came through a friendship with Arthur Hare (called "Bunny" by his friends), son of George Hare, under-sheriff of Marin County. Once a month Rube and Bunny earned six dollars each for escorting patients to mental institutions at Napa and Stockton. Many were handcuffed or straitjacketed, but most seemed perfectly normal. Rube talked with them at length, and after numerous trips he slowly arrived at a theory of relative insanity. He believed that every human being was slightly daffy, for all harbored a fair share of irrational, uncontrollable passions and desires. By sheer luck, most people avoided being put on the inside of asylum walls—either they were crafty

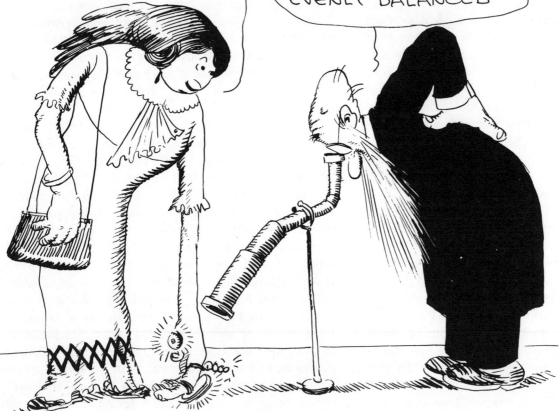

THE DANGER OF THE
DINNER-RING MANIA.

13. Detail: And still we pity
the savages who wear rings
in noses, 1911

enough to avoid detection or they were slightly less imbalanced than those who enforced the law. So long as one's particular insanities did not hurt others, he could remain free to indulge his appetites.

For fourteen years Rube drew a series of cartoons entitled *Lunatics I Have Met*. He started the cartoons in 1908, six years after his work as an assistant to Under-Sheriff Hare. He simply applied his thoughts about the inmates of Napa to the people he met every day. Like his series *It's all wrong, . . . , it's all wrong*, which came directly from his childhood memories, the *Lunatic* cartoons drew on a general notion derived from earlier experiences (Fig. 11).

Rube was not the first artist to stare at insanity. Francisco Goya and Vincent Van Gogh had seen the horrors too, but they drew deep, dark, foreboding pictures delineating the hopelessness and the ugliness of the human condition. As if to frighten their audiences, both artists personified insanity with mangled bodies and staring eyes and raw violence. But Rube penetrated the emotional instability of the inmates until he found their humanity, and the closer he looked, the more certain he became that "insanity" was a matter of degree. He punctuated this idea with *Insanity is chiefly a matter of opinion*, drawn in 1917, a summary of *Lunatics I Have Met* (Fig. 12).

As part of his engineering education Rube was expected to get some practical experience. After his sophomore year, therefore, he took a summer job at Oneida Gold Mine in Amador County, California. The night of his arrival was less than encouraging and everyone seemed mean and impersonal. Rube found his way to the bunkhouse, where the innocence of the funny little boy from Vallejo Street slowly eroded. First-generation Poles and Italians who spoke a rough, coarse English looked like swarthy-skinned monsters to Rube. "They slept in layers like giant hero sandwiches," he wrote to Max. "My virgin nostrils will never be the same on account of the odor of sweat, tobacco, cheap wine and halitosis."

In the morning he received a denim shirt and loose levis, reminiscent of the Napa inmates'. When he reported to the mine shaft, he climbed into a deep iron bucket that held sixteen men. Using a ladder to reach the bottom, Rube was the first man in, securing a position which would ensure his safety—he thought. But his "companions" piled in after him, and Rube found hobbed boots pressing into his tender skull. "All aboard?" The bucket plummeted two thousand feet down into the bowels of the earth. As Rube remembered, "I was never so alone in my life."

Each miner carried a candlestick, the base consisting of an iron spike with a loop to hold the candle and a pointed end to stick in a timber while working. Rube was a "mucker," the lowest-ranking miner, who shoveled loose quartz into heavy iron cars. He also carried dynamite for the blasting experts, a job that filled his heart with terror.

His first blast was memorable:

After planting the dynamite I heard an ominous sputtering and felt strong hands pulling me along the tunnel for about a hundred yards. Voom!

I waited for the world to fall on me. This was the end. My hands were pretty well lacerated from shovelling but otherwise I was all in one piece. I said a quick prayer and then there was complete silence. The kerosene lamps flickered and my own candle had gone out. I called to someone in a shaky voice. There was no answer. I was alone. I don't know how much time elapsed. It was an eternity. Finally I was rescued by a foreman who told me the miners had been hauled to the surface for lunch. I had no appetite when I was whizzed upward into the world of the living. I was too busy looking at the blue sky.

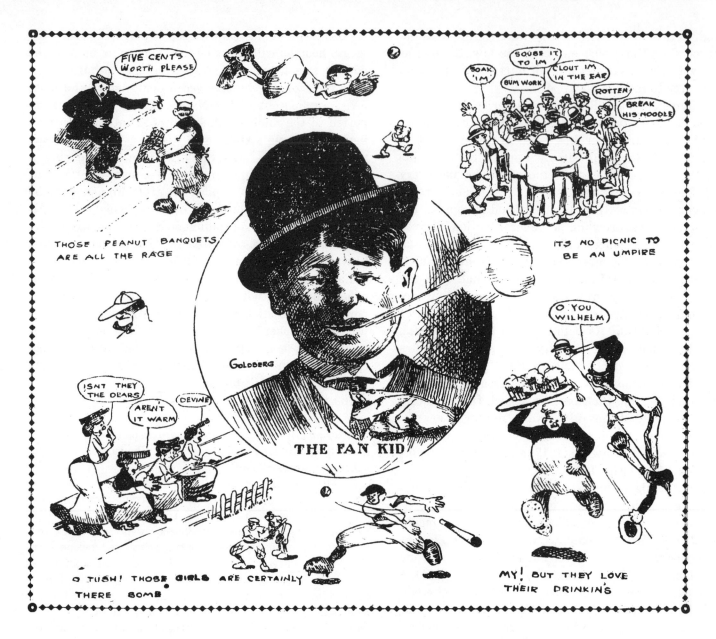

14. The Fan Kid, 1904

Five hours after this frightening baptism, Rube found himself standing in a makeshift shower surrounded by naked giants. Their muscles bulged like the "billows of a turbulent sea," Rube wrote that night, "while my meagre bones looked like a pitiful pile of splinters that had been scraped off the timbers that supported the dripping shaft." His blistered hands were puffed with pain, but he could see only humor and irony. Among the many things he learned at the Oneida Gold Mine, he would never forget "what a big job it is to gouge enough quartz out of mother nature's insides to produce the gold for one wedding ring." He assured Max that when he slipped a gold band on the finger of his future wife he would realize the full measure of his marriage vows. One of Rube's earliest cartoons was called *The Danger of the Dinner-Ring Mania* (Fig. 13).

Rube was graduated from the Berkeley campus in the spring of 1904. He questioned the significance of his formal education, but he was proud of his accomplishments: a four-year diploma in three and a half years, a portfolio of first-rate cartoons and caricatures, and a new sense of confidence. In college Rube began to feel that he could stand alone without using Max or his friends as a crutch. Later in life he found that his college education had given his cartoons a generalizing power that most other cartoonists failed to perceive. Berkeley became a very special place for Rube; as he grew older, his fondness deepened. In 1964 he donated a large number of his cartoons and personal papers to the archives of the campus library.

Rube Goldberg, mining engineer and occasional cartoonist, hated mining—Oneida told him all he wanted to know. Anxious to salvage something from his three-and-one-half-year stint at college, Rube went to work for Thomas P. Woodward, San Francisco's city engineer and a close friend of Max Goldberg. For the lucrative monthly salary of $100, Rube mapped sewer pipes and water mains—a job, he said, that was "as interesting as it sounds." The aroma associated with his projects did not offend him, for mining at Oneida had filled his senses with every stench known to modern man; but while working each day at City Hall he saw "shady characters hiding behind Doric columns plotting . . . the ruin of the innocent people of San Francisco." City politics pained him and simply reinforced his unfavorable childhood impressions of civic leaders. In addition to the dishonesty of San Francisco's officials, he was depressed by the lethargy of city employees. Next to his desk sat a man who had worked for San Francisco for forty years at $150 a month. The dust had settled on his shoulders, and his life seemed all but extinguished. For Rube, this torpor was worse than death, and with typical vision he projected his own future: "There I am at eighty; if I work and vote the party ticket at every election I'll get a $50 bonus in salary sometime within the next forty years—good night."

Six months into his new job Rube decided to quit. "I can't stand it any longer, Pa," he pleaded to his outraged father. "I've got to try cartooning." Rube's boss, Mr. Woodward, thought he'd gone goofy. "All I can say is that you're making a big mistake," he advised. "If you stick along here you'll be getting $150 a month some day. It's an old adage that you should never throw away your dirty linen until you have clean." At that point Rube was off adages for life.

It took courage to repudiate Max and the city's number one sewer expert, but Rube was coming into his own. For twenty-one years he had watched his elders plodding their way through the misery and the troubles of life. Somehow, even Max seemed to drift aimlessly, coerced by politicians and speculators who aimed to use him to their own advantage. Practical men like

Max were prone to compromise, to intellectual inactivity, and to vacillating loyalties. Surely, intellectuals such as the university professors might serve as an antidote—but not in Rube's opinion. They spent their lives trying to answer unsolvable problems without lifting humanity above the graft and corruption of everyday life. "Wisdom" and political tomfoolery failed equally in Rube's mind. He had to try another course. So he headed for the offices of the San Francisco *Chronicle* where the city editor, Ernest Simpson, hired him on the hunch that the *Pelican* cartoons could be transformed into general statements about life in the Golden Gate City.

The fledgling eight-dollar-a-week cartoonist reported to the head of the *Chronicle*'s art department, Harry Mayo Bunker, a nervous man whose pet dislike was "aspiring young artists." As Rube reported to Max, he was "as affable as a man with the willies after a bad night." The veteran artists gave Rube the silent treatment and made him feel as comfortable as a man "sitting on a tack in the electric chair." Conditioned by the Oneida experience, Rube persevered, confessing later that he was afraid to leave and afraid to stay. A remote corner of the art room complete with a lone, dust-covered table welcomed him, so he set right to work apprehensively penciling a cartoon of a rabid baseball rooter. He labeled it *The Fan Kid*, a title which seemed positively devilish to a new cartoonist, and after inking it in, smuggled it to the city desk. Simpson looked it over dispassionately, approved it, and ordered a three-column spread (Fig. 14). The success was a shock. Rube waited until one o'clock the next morning when the first edition appeared. There it was on the sports page. It seemed like a dream, and he had to tell Max. Buying five extra copies he bolted to Max's bedroom. "Pa, Pa, wake up; I've got good news for you,"

Rube exclaimed. "Look at this! The *Chronicle* published my cartoon. I've got a job with them. What did I tell you?"

Max rubbed his eyes, bounced out of bed, and grabbed the paper. "Well, what do you know about that! You put it over, boy, you've sure put it over big. I knew all the time you were going to do it." Then Max closed his eyes and buried his head in sleep.

Rube was wide awake. He imagined a city at his feet, overwhelmed by the genius and humor of the creator of *The Fan Kid*. How could anyone sleep with the *Chronicle* sitting by his door, carrying the sensation of the modern world?

The next morning, after breakfast with the family, Rube and Max took a long walk. Max had one last bit of advice for Rube: "My boy, the thing I want to tell you is to discount this great honor. . . . You are now a professional cartoonist but keep your wits about you. The worst disease in the world is a swelled head. You mustn't think you're better than everybody else in the world." Rube's reply was a classic: "I promise, Pa. I'll treat people the same as I always have. They'll never know."

Proud and sure, the new Opper—flushed with success—pranced into the *Chronicle* office with "no thought of snubbing Bunker or any of the rest of the cartoonists." He was the first to arrive, so he did not receive loud cheers or heavy slaps on the back. As the others straggled in they ignored Rube, obviously overwhelmed by his meteoric rise. Then Bunker entered. He glanced at Rube and spoke a friendly word to the office cat! He seemed as "genial as an insolvent undertaker with a galloping dandruff, painter's colic, housemaid's knee, and barber's itch," remembered Rube.

"Good morning, Michelangelo," he shot at Rube. "Do you realize you've been dead for over three hundred

years? If you want to make a hit with me, stay out of sight."

These words suggested to Rube that he had not endeared himself to either Harry Bunker or the rest of the *Chronicle* artists. Retreating to the corner desk, the birthplace of *The Fan Kid*, he produced another cartoon and took it to Simpson, who accepted it without a friendly word. The following day was disappointing —his first rejection—but after some encouragement from Max, Rube produced *Which?* for the August 16 edition.

Then the euphoria faded. For seven consecutive days Simpson irreverently threw Rube's drawings into the wastebasket, and the more he worked, the higher the garbage heap climbed. To justify his weekly eight dollars Rube swept floors and filed photographs in the morgue. The other artists humiliated him by firing juicy watermelon pits at his finished drawings, forcing him to redraw them three or four times. And all Rube could remember was his father's warning: "Don't get a fat head." Fat chance.

Writing for the *Saturday Evening Post* twenty-two years later, Rube altered the story of his early career. The seven-day limbo became a three-month hell in the *Post* version, suggesting the lasting pain of that insufferable time. Slowly Rube softened the tough hide of the *Chronicle* staffers. He won a close friendship with Waldemar Young, a sporting editor who later knew fame as a Hollywood scenario writer for Rudolph Valentino. Wally Young was a descendant of Brigham Young and, according to one newsman, was an editor "who approached his vowels and his vegetables with equal relish." Young convinced Simpson that Rube should get a better break. His penance for inexperience was becoming excessive. So after a seven-day blackout, Rube was assigned to cover a prep school football game across the bay in Berkeley. As one might expect, things did not go smoothly.

Before going on his assignment Rube spent an hour studying old photographs of athletes in action. He practiced drawing them in different poses, giving each gladiator his due. Then he sharpened all his pencils, ruled his drawing paper, and got everything ready so that he could meet his deadline upon returning to the office. After sketching the event furiously all afternoon, he returned to find his desk top nailed shut and his carefully arranged apparatus gone.

Rube exploded. He darted to the machine shop, grabbed a hammer and a handful of nails, and nailed down every desk top in the room, including Harry Bunker's. Then he locked away all the unfinished art work of the other illustrators and resolved that his days as the office simp were over.

Returning later from dinner, he found the other artists swearing while whacking furiously at their desks. Rube went to his corner, removed the nails, and finished his drawing. Three hours later he took it to Simpson, who—to Rube's amazement—accepted it! Even more amazing, Simpson told him that the *Chronicle* had decided to run more sports cartoons. For the next nine months Rube appeared in a three-column spread three days a week.

Back in the art room the atmosphere had changed too. Bunker called Rube to his desk and said, "That's the best stunt you've ever done around this office— nailing up these desks. If I'm not mistaken, you're going to get along much better as an artist from now on."

Little did the *Chronicle* realize what had happened. Rube was accepted as one of the regulars just as the publisher, Colonel de Young, had decided to enliven his paper with cartoons and photographs. Pictures were

supposed to broaden the appeal of a newspaper, and several tycoons, like William Randolph Hearst, believed that pictures increased sales. Hearst hired artists and cartoonists from the illustrated magazines like *Puck*, and *Judge*, and the old *Life*—the very ones that had inspired Rube. In battling Joseph Pulitzer for national prominence, he copied the idea of a daily comic strip (1890s) and instituted a color comic section for the Sunday edition of the New York *Journal*. By 1900 the newspapers of Hearst and Pulitzer had yanked comics and pictures from magazines and made them daily features. De Young was getting in step with the big boys, and Rube was ready with his Higgins ink and thick Bristol board. Max Goldberg's boy had started his career in the beginning of the new age of picture journalism, and he grew with it until "Rube Goldberg" became a national synonym for "humor."

3
At Home in the Ring

Most early cartoonists began on the sports page, so Rube was typical—keeping company with Bud Fisher (of *Mutt and Jeff*) and Frederick Burr Opper, one of the most productive and brilliant cartoonists in America. His *Happy Hooligan, And her name was Maud,* and *Alphonse and Gaston* rank Opper at the top with the comic strip greats. Occasionally he produced all three strips for a single issue of Hearst's *Journal*! At other times he worked with Rudolph Dirks as co-author of the *Katzenjammer Kids*.

As Stephen Becker has observed in *Comic Art in America*, the material for sporting cartoons came from current events. The characters were loud, violent, and colorful, and there were no continuous story lines or dialogue to worry about. Something new and fresh every day. A cartoonist was free to seek humor in a particular event or to develop the personalities of hundreds of characters a year; if he found several he enjoyed, he could let them reappear in a regular comic strip.

Bud Fisher, for example, worked with Rube on the *Chronicle*. While cartooning the preparations for the Jeffries-Johnson heavyweight battle, he hit upon a character named Jeff (for Jeffries). Then, on November 15, 1907, he launched the first successful daily comic strip, *Mutt and Jeff*.

Rube did not win the instant fame of Bud Fisher, but late in February of 1905 he unknowingly began his first continuity strip. Chief Editor Simpson was excited over a bout which had been arranged between Jimmy Brett, a California lightweight who had just missed being world champion, and Jabez White, champion lightweight of England. Having learned, via rumor, that White was an old man and that the fight had been fixed in Brett's behalf, Simpson aimed to expose the fraud, and he chose Rube as the *Chronicle* detective. "I want you to run a series of cartoons roasting this bunch of highbinders to a frazzle," he instructed Rube. "We'll call the series 'James and Jabez and Easyville,' and don't be afraid to take any crack at them you want to. We'll show these smart alecks they have the wrong dope if they think the old town's asleep."

Rube drew eight *Easyville* cartoons endowing White with every physical maladjustment known to old age (Fig. 15). Depicted as a wobbling patriarch with flowing whiskers, flat feet, hollow chest, and curvature of the spine, White—apparently—didn't have a chance. But even Rube wasn't too sure. Although he was following orders, he later admitted that he was not able to detect any signs of old age when he visited White's training quarters.

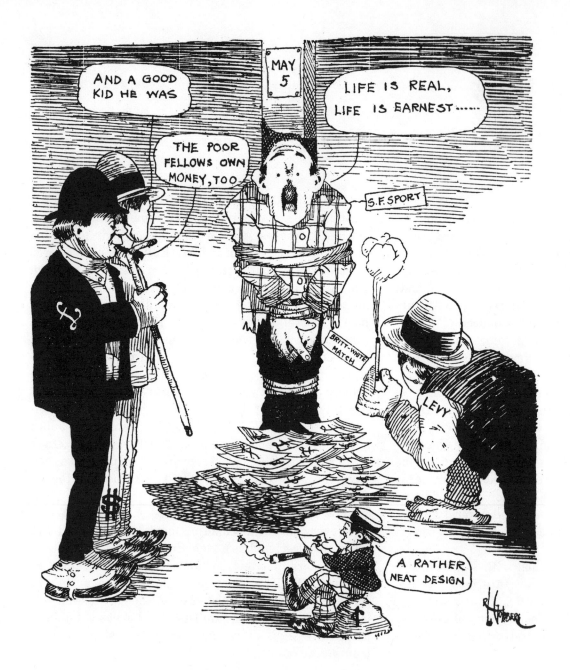

15. Easyville, 1904

White lost the scrap, but only by a last-minute knockout in the twentieth round. Simpson, of course, ignored the "details" and took all of the glory by saying that "the fight would have been an awful bust if the *Chronicle* hadn't exposed what was on tap." As for Rube, he resolved that he'd never again serve as another man's sleuth.

Easyville, in a modest way, presented Rube with a host of problems known to all veteran cartoonists. The characters, Jim and Jabez, needed distinct personalities. Their dialogue, their environment, and their thoughts had to be treated with consistency. Rube wanted to be funny, yet his mission was clear: "Fry 'em." While none of the eight cartoons is a masterpiece, they show Rube on his way to fame. They lack the depth and cohesion of his later works, and—as Rube observed in 1921—they had the style of goulash, with parts of Opper, Tad (Thomas A. Dorgan), and Homer Davenport all swished together. They looked as natural as a dog meowing or an elephant flying. But *Easyville* meant more than style and continuity because it crystallized a problem of greater meaning understood by few observers.

When Rube won his greatest fame in the 1920s, he was hailed as a philosopher-humorist who generalized about life in America. By that time he had a storehouse of everyday characters, each representing different aspects of human nature: wild inventors, gullible boobs, daffy women, simple children. He seldom used famous personalities like movie stars or prizefighters to spike his humor. He created and manipulated each character to illustrate a general point about man and the way he lives. The "Jabez and Jim" *Easyville* series puzzled Rube because it scraped against the natural grain of his humor. He felt compelled to use the stock pugilistic language of other sporting cartoonists, and his drawings of the principal characters were stereotypes straight out of ring magazines. Some of the touches are typically in the Goldberg tradition: little figures peeping around fences muttering punch lines, or fight fans in the background serving as a generalizing force. The particulars always dominate, however, with the precision of a master muckraker gunning down his prey.

Rube regretted this *Easyville* series because his attacks were too personal. In fact, the whole *Chronicle* experience was less than satisfying in retrospect. Its front page was a scandal sheet. The notorious Mafia-inspired murders which led to the daily discovery of pieces of bodies made for juicy headlines and shocking halftones. At times it was hard to distinguish the editorials from the news reports, particularly when the Russo-Japanese War of 1904–1905 threatened West Coast shipping. It was an exciting paper, however, filled with patriotism and romantic literature and serene travel sections to serve as antidotes for the domestic bloodbaths and marriage scandals. To Rube's credit, he avoided the mainstream of this turbulent journalism, but many of the cartoons suffered from inexperience and a willingness to submit to contemporary bias. Rube's ethnic and racial stereotypes from this period are offensive by today's standards, with vulgarisms like "coon," "chink," "dago," and "drunken Scots" sprinkled liberally throughout the 1904–1905 productions. These epithets, typical for the era, were important not for their offensiveness today but as signs that Rube was learning his craft, unwilling to drop traditions completely and to build his own world. That phase would come soon enough.

With all these clichés, Rube was still one of the most original cartoonists in America the minute he began. *The Fan Kid* was of the general genre which Rube

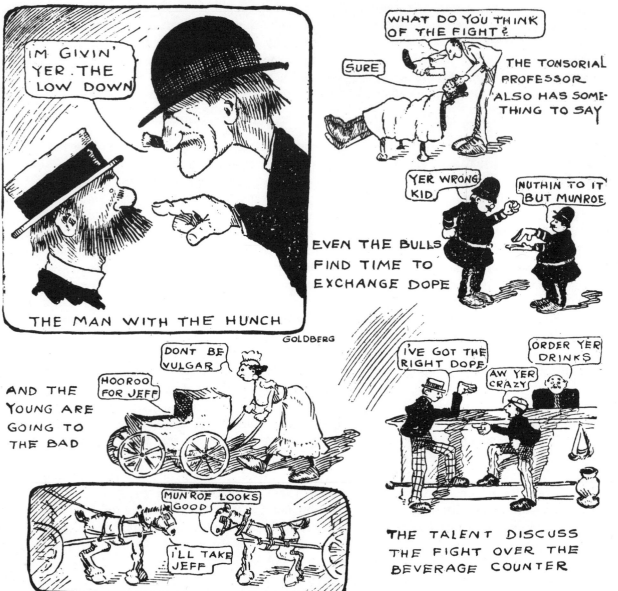

16. Everybody has picked the winner, 1904

would later develop, for it showed the impact of professional sports on the average man. The diehard cheering, the amateur predicting, the know-it-all analyzing are all there. Eventually he would broaden his inquiry to show how entertainment, politics, travel, and, of course, technology affect us. *The Fan Kid*, therefore, was a true beginning.

Other cartoons from the *Chronicle* era followed a stuttering course between the general and the specific. When James J. Jeffries emerged from retirement in 1904 to fight for the heavyweight crown against Jack Munroe, Rube followed his own mind. *Everybody has picked the winner* (Fig. 16), published on August 26, 1904, the day of the battle, has the broad context of *The Fan Kid*. His post-fight cartoon, *There's only one giant now* (Fig. 17), has a balance and control lacking in most of his early cartoons.

After eight months on the *Chronicle*, Rube was ready to move. *Easyville* had bored him; besides, Tad Dorgan, the sporting cartoonist for the San Francisco *Bulletin*, had just skipped town to join the picture brigade of William Randolph Hearst in New York. Rube wanted Tad's old job. The *Bulletin* was reporting sports in cartoon form more often than the *Chronicle*, and Rube saw a chance to reach a greater audience. He pestered the *Bulletin*'s art editor relentlessly, finally winning a place which paid ten dollars a week—two dollars less than the *Chronicle*.

The sports editor was Hy Baggerly, a man whom Rube grew to respect and love. Under Baggerly's gruff leadership Rube's work attained a new maturity and subtlety which continued to grow throughout the 1920s. While Rube admired illustrators like Charles Dana Gibson who gave visual form to the written word, he preferred to express his own ideas. It puzzled him to learn that illustrators were ranked so-cially and professionally above cartoonists. Illustrators are mere copyists, Rube would say; cartoonists are the creators. In one unpublished short story from the 1920s Rube's hero jibes, "He's an illustrator, I'm just a genius."

Baggerly encouraged Rube to see a cartoon as a visual metaphor, the expression of a single thought. Cartoons were symbols for ideas, blending familiarity, contrast, and repetition with perfect timing. Style was the key to success, and Baggerly saw Rube trying to manipulate all the pieces, slowly discarding the clichés of the *Chronicle* era. Later, as the author of Lesson No. 19 in the *Famous Artists' Cartoon Course* (c. 1949), Rube looked back to the Baggerly days and repeated the advice given him at that time:

You are never really aware of the exact time your own style begins to develop. You are so consumed with a desire to draw, and so busy picking up pointers from the work of other men, that you are actually unaware of your own development until it really becomes a fact. In time your work will actually be you and nobody else. Personality is all-important in any creative art. If you have personality, it will show in your drawing.

Baggerly was just what Rube needed. Baggerly saw what others may have felt but failed to express. He was convinced that Rube was as much a writer as a cartoonist, and he once quipped to Rube that his captions were so long that he should forget the cartoons and turn to short stories.

While working for the *Bulletin*, Rube haunted Pop McCarey's Fight Pavilion at Alameda and Main in San Francisco. The Pavilion was a sawdust-floored barn which packed in huge crowds to see "has-beens," "will-bes," and "hopefuls." A month or so of this and Rube was ready for bigger things, so Baggerly sent him to Reno, Nevada, to cover the heavyweight championship

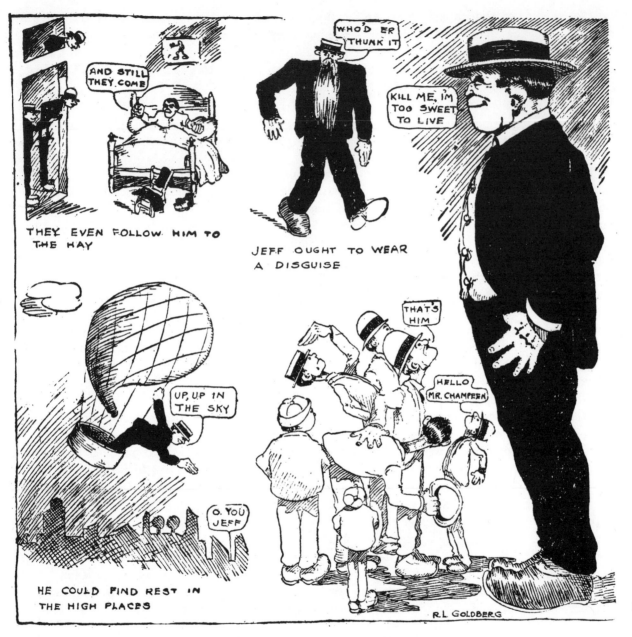

17. There's only one giant now, 1904

battle between Marvin Hart and Jack Root. The reigning champion, Jim Jeffries, had retired but had agreed to referee the fight and award the crown to the winner. Rube was teamed with Bill McGeehan, the *Bulletin*'s sportswriter, and together they covered the pre-fight scene. One day Bill and Rube stopped at a bar to have a drink before filing a story at the telegraph office. McGeehan, as Rube later noted, "became so potted with inferior grog that he was unable to write a line." Baggerly, upon learning of Bill's "misfortune," wired Rube to send a story with his cartoons. Rube answered, "I don't know how to write." Hy responded, "Just write anything that comes to your mind. Anybody can write." From that day on Rube averaged three columns a week for two decades.

Years later, in reminiscing essays and at banquet tables, Rube repeated this story so many times that neither he nor McGeehan could tell fact from fiction. But an ironic follow-up failed to enter the Goldberg folklore. The following day, as McGeehan's eyes began to regain their focus, a telegram arrived with instructions for Rube and his sober buddy to look out for a feature writer, Pauline Jacobson, who was on her way from San Francisco to Reno. Hordes of fight fans were pouring into the primitive town, and the one train connecting with Reno was hopelessly off schedule. Since nobody could predict when Pauline Jacobson would arrive, Rube and Bill periodically tramped over to the depot to look for their colleague. To relieve the monotony of these tiresome journeys they made frequent stops at a saloon conveniently situated between the hotel and the train station. After ten round trips (at two whiskeys per trip) the legendary Miss Jacobson rattled into town. Somehow, Rube and Bill escorted her to the hotel and then headed for the telegraph office to file their stories. But on the way they stopped for one last snort. A semi-steady McGeehan and a wobbly Goldberg felt their way to the office, plopped into the chairs by the typewriters, groped for the keys, and blazed away. Rube typed for five minutes, tore out his story, and handed it to the telegraph operator, who, according to Rube, examined it intently, turned it upside down, and exclaimed, "I can't decide if it's Arabic or Chinese." "Let me see it," gurgled McGeehan. "Hmmmm, it's either Rhodesian or Cambodian, I guess." As McGeehan lifted his eyes from the jumble, he found Rube fast asleep.

The next day Rube remembered, all too clearly, what had happened, and he expected to get canned. The dreaded telegram arrived about noon. As he tore it open, one line said it all:

TODAY'S STORY BEST YOU EVER WROTE.

BAGGERLY

Knowing that Baggerly was not the sarcastic type, Rube darted to the telegraph office. As the grinning telegraph operator asked, "How you feeling this morning?" Rube exclaimed: "To hell with how I'm feeling. What I want to know is whether I filed any copy for my paper last night." "Sure you did," said the operator. "Bill McGeehan wrote it for you."

As the *Bulletin*'s premier sports cartoonist, Rube came into close contact with the great boxers and daring fight promoters of the early twentieth century. Joe Gans, Jim Jeffries, Tom Sharkey, Benny Leonard, Jim Corbett, Joe Choynski, and Jack Johnson are faintly remembered now, but in the early days of Rube's career they were national heroes. Having been raised in a home of rigid discipline and educated at college for four years, Rube felt slightly out of place in this new, violent atmosphere of fractured bones and cauliflower ears. Often he would accompany cartoonists

John (Igoe) Dorgan, Bill Stevens, and Ralph Yardley to Woodward's Gardens on Valencia Street to watch five or six bouts and then retire to a local tavern to discuss the results. As an "outsider" Rube never became totally absorbed by the boxing world. He was excited by the colorful characters who populated the arenas, but his best cartoons show a relaxed detachment. Rube himself never went in for exercise or vigorous sports. His wood-sawing and mining ordeals would last a lifetime. He preferred to sit, to watch, and to laugh at the physical exertion of others. He liked boxing, he said, because of its "finality":

In big business the president of a company can be sailing in the Mediterranean surrounded by champagne and bikinis while business thrives or founders. A losing government candidate can alibi himself on television. And a painter can bask in the doubtful adulation of his immediate sycophants. Even a loser in war can claim a psychological victory and convince the winning nation that it should be responsible for a loser's rehabilitation.

But in boxing if you go down for the count of ten you cannot be carried back to your corner and say, "I won." Boxing is a game (regardless of occasional fixes) where there is an immediate result. Besides, the picturesqueness of the fighters, their language, their habits, and the hangers-on are continual sources of earthy humor.

More than any other sports star Rube enjoyed watching the heavyweight champion, Jack Johnson, flaunt all social shibboleths and defiantly savor his unconventional life-style. Johnson's white wife, his careless spending of easy money, and his relaxed manner impressed Rube deeply. Rube met Johnson in 1910 shortly after he started working for the *Evening Mail* in New York. The black champion was training for his title bout with Jim Jeffries, who had been lured from a five-year retirement by a winner's purse of $100,000. When

Rube walked in for his first interview with Johnson, he found the "big fellow lying on a training table getting shaved. His head looked like a lopsided canteloupe and his gold teeth gleamed through the lather." After a few polite greetings, Johnson got up and "ordered some champagne. Then he took out his bull fiddle and grinned as he scraped away not caring much what notes he struck." The meeting ended when Johnson changed his clothes to prepare for his daily regimen. Rube stayed on. "I watched him work out with three sparring partners and never saw anything so smooth and clever. He knocked out one and left the other two puffing so hard they had to quit. It was the greatest exhibition I ever saw."

Sixty years after this meeting with Johnson, Rube observed that the champ had been born too soon:

Jack Johnson was the symbol of a mood that illustrates the great change that has taken place in the American consciousness. There was resentment over the land that a black man had pre-empted the heavyweight championship and had proven himself superior to all other contenders. While Jack Johnson was not what you would call a puritanical paragon, he was a jovial fellow who enjoyed the seamy side of life, the variations of which are accepted as normal today.

Johnson, of course, beat Jeffries to a pulp in their fight at Reno and went on to a life of persecution and dissipation until he finally died in one of his fast automobiles. I tell this little story only to illustrate the transition from the resentment of the public to one black champion to the present admiration and applause that greets the hundreds of black champions that dominate the field of sport today.

Boxing was a haven for social misfits, the very people who in Rube's opinion give life its verve. Despite his solid middle-class upbringing, Rube seemed to thrive with eccentrics and crackpots, who somehow seemed to be purer specimens of humanity. Often they were

stripped of pretension and filled with strange ideas and stimulating dreams which normal people were incapable of perceiving. None of them fascinated Rube more than Tex Rickard.

Rickard was one of the most successful fight promoters in America. His imagination and daring were backed by cash and a keen ability to carry out any plan. One of his wildest schemes was his promotion for the Joe Gans and Battling Nelson fight in Goldfield, Nevada. For this "Battle of the Century" Tex whipped up public enthusiasm by depositing 1,500 twenty-dollar gold pieces in the Bank of Goldfield, crediting them to a joint account in the names of Gans and Nelson. Scheduled for Labor Day, 1906, the fight became a national news story. At that time Nevada was a speculator's paradise. Mines with names like Mizpah, Jumbo, Florence, Combination, and Red Top yielded pounds of gold and silver daily. Towns such as Tonopah, Rhyolite, and Goldfield sprouted instantly, and millionaires appeared just as fast. Rickard, the genius promoter, used all this color and romance to earn the gate receipts for this single bout, which totaled $78,000.

Days before the fight took place, thousands of people piled into Goldfield. At Rickard's invitation, Rube also appeared, but the ballyhoo in the press had led him to expect some grand metropolis sitting on foundations of gold. He was mistaken. His friend Harry Coleman, a news photographer, described Goldfield as

a scattered group of dirty canvas tents, sagging one-story, unpainted ramshackle shelters and lean-to's. Most of these were built of worn and weathered lumber, others with rusty sheet metal, scraps of tin and old tar paper, or empty bottles laid crosswise in walls of adobe. . . . The sprawling settlement was scarcely visible, even from a short distance.

Rickard operated the bank, the gambling tables, and the main saloon, which was manned by two dozen bar-tenders. "Women and deuces alike were wild," remarked Coleman, with 95 percent of the female population working for Rickard.

Rube couldn't believe it. Right there in the middle of nowhere was a man's paradise, an oasis of good times and recklessness, where liquor and women and sports seemed to thrive. It was like the dime novels he had read as a boy. The masculine atmosphere, the close-knit sense of community, and the total devotion to enjoyment all became elements of Rube's changing life. The tall talk of men whose wives are out of sight, the black cigars, and the hardy humor became synonymous with relaxation and escape. Single, free, and growing, Rube loved it all.

For Rube, Goldfield symbolized the slightly insane character of the human race. At a tremendous cost of energy and time and emotion, men were willing to inhabit and even enjoy living in the desert just to watch two sluggers punch each other to pieces for 1,500 gold coins. Had he read it in a novel, Rube would have dismissed it as an absurd fantasy. But the episode at Goldfield was so real that he began to think that maybe Max's friends and the Oneida gold miners and the newspapermen he had worked with weren't simply rejects from the mainstream of life but typical *homo sapiens* doing what came naturally. The nonsense of life began to smack at Rube repeatedly until the final blow—heard around the world—struck in 1906.

The San Francisco earthquake began at 5:13 A.M. on April 18. It was a dismal combination of natural events, human ignorance, and fear that made the disaster so traumatic, for it scarred the ground and the souls of the people who lived through it. When the earth shook and pulled itself apart that day, it destroyed the principal gas mains used to illuminate the city; it cut off rail and telegraphic communication, and, most tragi-

cally, it split the water pipes under the streets, thus making it almost impossible to extinguish even a campfire.

Most of the suffering came from the subsequent fire. Without water the flames roared unchecked for 74 hours, consuming 28,000 buildings in an area of 4.7 square miles. According to one estimate the fire burned at a cost of a million dollars every ten minutes. As Mayor Schmitz was slow to act, an *ad hoc* assembly of citizens, enforcing vigilante justice, roamed the city under the command of General Frederick Funston from the army garrison at the Presidio. With the fire department paralyzed, Funston ordered gangs of inexperienced dynamite teams to blow up all buildings surrounding the fire in a desperate effort to keep it contained. They bungled the job repeatedly, and the flames simply leaped across Funston's too narrow fire line and continued unimpeded.

The Goldberg home escaped the devastation, so Rube had a safe base of operations for his work. The *Chronicle* Building was consumed by 2:20 P.M., with many of Rube's original sketches and finished cartoons feeding the flames. Heroism and cowardice and thievery and charity abounded, for it was a time of extremes when people were driven to becoming caricatures of their own personalities. The young reporter for the *Daily News*, Ed "Scoop" Gleeson (one of Rube's close friends) wrote the most succinct, tender stories of his career. At one point he despaired temporarily because he could not describe the terror he saw: "It would have been like trying to reduce Hell to a single paragraph." But he caught the facts and reported them in human terms.

At 8:40 there were one hundred dead and dying at the Pavilion, and more arriving each minute. All of the city hospitals threw open their doors, and within a short time their wards and halls rang with the agonizing cries of scores of crushed and burned victims of the awful catastrophe. At the Protestant Orphan Asylum on Haight Street, fearful damage was done, and three little children were badly injured. Insane patients were taken from the Emergency Hospital to Mechanics Pavilion. Many of them were hurt. Some broke loose and ran among the dying, adding horror to the scene. . . .

Similar reports were repeated for days by an army of journalists. Doom and horror and death filled nearly every inch of every newspaper. Rube appeared in print on May 9, twenty-one days after the debacle began, and his view of things brought back a smile to the weary, soot-covered face of San Francisco.

San Francisco was humming with life the evening before the holocaust. The world's greatest baritone, Enrico Caruso, had given a rousing performance of *Carmen* at the Mission Street Opera House. Across town, sports promoter Jimmy Coffroth was sponsoring a colossal masked roller-skating carnival with a thousand-dollar prize for the winner. Never an opera fan ("Italian should be eaten and not heard"), Rube almost certainly opted for the skating as his evening's entertainment. After the contest Rube probably went to a saloon with Coffroth and others, then off to bed until 5:13 A.M. Afterward, as Rube walked the streets, he saw bands of Funston's men running about haphazardly trying to contain the fire. Every few blocks he was drafted into service to help clear the streets of debris or load dynamite onto wagons. It seemed like an intensified replay of the Oneida melee. When his hands were freed from manual labor, he sketched continuously, making an incredible attempt to find jokes in near-death (Fig. 18).

As supplies of food and clothing and blankets poured in from the rest of the world, Rube checked the dona-

tions carefully. He insisted that the cheese sandwiches were so old and hard that they, not Mother Nature, had caused most of the deaths. Later he even wrote a story insisting that he alone was responsible for the fire. As city engineer in charge of water mains he had designed things so that most of the "water would run around instead of through the pipes," making it impossible to extinguish the flames. The water that did make its way to the hydrants got dizzy running through Rube's spaghetti-like maze and, as anyone knows, dizzy water is incapable of performing any useful function.

Rube's ability to find humor in tragedy was a sign of his genius. By teaching his neighbors to laugh in the face of disaster, Rube gave them the strength to survive, to rebuild, and to dream. The earthquake taught him that any situation can be comical, and very often the jokes weren't hard to find even in dire times. During the recovery period Rube chronicled the new enthusiasm and vigor of his fellow citizens. In watching them rebound with their expansive optimism, he arrived at a basic philosophy that carried him successfully through seventy years of the disaster-prone twentieth century. According to Rube, the human race has an immense capacity for survival. But this talent is neither rational nor conscious; in times of disaster we always seem to struggle, to muddle, and to bungle through.

18. What Most Sporting Men Are Doing..., 1906

4
I'm the Guy

A year later San Francisco was still winnowing its way through the charred remains, working to save and restore the best of its turbulent Gothic past. The young but already renowned Rube Goldberg was engaged in some unsettling soul-searching of his own. He had risen quickly and he feared that he had exhausted all the Golden Gate could offer. His salary was about to peak at $50 a week, and although he had been working at the *Bulletin* for one year, his heart looked to the East. His idols, Frederick Opper and Tad Dorgan, were earning almost twenty times as much as he; they were reaching millions of people, they were national celebrities. But Opper and Tad had worked in the minor leagues of journalism for nearly nine years before receiving a call from the cartoonists' Messiah, the notorious multimillionaire newspaper publisher, William Randolph Hearst. Rube was impatient. His ambition, his new self-assurance, his energy, and his unbounded confidence prodded him to gamble his guaranteed local reputation for a chance to instigate a national laugh.

The quaintness of Rube's birthplace had turned into a tiresome cliché. In less than two years he had become San Francisco's leading humorist, credited with increasing the circulation of the *Bulletin* by 25 percent. He had a secret recipe for instant laughter. His cartoons leaned away from the shackles of localism and specificity, yet he always felt the need to touch base with the particular issues and problems of San Francisco (Fig. 19). He wanted to generalize about mankind, to characterize man in *any* city doing anything at all.

Rube justified his ambition by roasting the newspaper publishers for their parsimony:

Newspaper artists of that period were entirely unfamiliar with the art of making money. Every time an artist went to the cashier's office for his weekly pay envelope the publisher felt like a philanthropist. Whenever the iron ball started rolling in one of those weird attacks of economy with which newspaper offices are seized periodically, it invariably hit the art department first. Not for the world would the retrenchment hounds fire Stupid, the dumb copy boy, who smoked cigarettes in the office and slept on the job, but they seemed to take civic pride in tying the can to downtrodden disciples of the pen-and-ink cult.

San Francisco cartoonists, despite their talent and fame (which seemed to manifest itself full-blown in New York City), "commanded little respect," in Rube's opinion. Sports cartoonists ranked lowest of the low, and most readers assumed that anyone who drew a picture of Jack Johnson really wanted to caricature Teddy Roosevelt or William Howard Taft. Political

19. A Lime Light and a Few
 Side Lights on the National
 Game, 1904

cartoons were admired, but comic strips and sports cartoons and illustrations of everyday idiosyncrasies were regarded as strange products of ambiguous origin and a questionable future.

"I was completely sold on the idea that the big city was the one place where a fellow in my line had a chance to make good in a real way," remembered Rube twenty years later. As if he were trying to prove William Dean Howells' observation that "our wit, like our weather, formed the habit of coming first from the farther West," Rube reacted to every knock at his office door, expecting Hearst himself to appear. Despite his smooth face and hairless chin, Rube felt that if "I waited a day longer before going to New York my long white whiskers would get tangled up in my wheel chair and my progress on the road to fame would be hopelessly retarded." He also quipped that he was tired of dealing with salesmen "selling ointment to keep artists from getting corns on their elbows."

Determined and self-confident, Rube finally kissed an apprehensive Max farewell. Despite pleas to remain, Rube ignored his favorite cartoon caption (*Father was right*). It was a poignant separation. Max had pressed a diamond ring into Rube's unsuspecting hand, instructing his favorite son that diamonds could be redeemed for cash anywhere at any time. Max's ring not only ensured against starvation but could buy a ticket home. Clutching the ring, as well as a gold watch and a diamond-studded penknife which several fight promoters had given him, Rube boarded the train at Oakland. With the tears of his leaving, he became more and more convinced of his decision: He put his money on New York.

Rube was an urban animal who, as a child, had caught only a glimpse of the wilderness. Now his train took him through acres of corn and wheat and desert and bluegrass, giving him but another fleeting look at nature. He wasn't impressed. But New York—New York was "ringside," as Rube called it. It packed 4,349,971 more people than San Francisco in almost seven times the area. It had hundreds of tightly sealed, ethnic neighborhoods with little neighborliness. It was show business and big business and industry and sales and manufacturing and shipping. It sat in the ocean but knew not the sea. Its subways streaked by, jammed with anxious workers, but it was riddled with slums and unemployment. New York was a city looking for work and so was Rube, who arrived in October 1907.

Harry Mayo Bunker, Rube's nemesis from the *Chronicle*, had settled in New York a year earlier. Despite the friction of their early meetings they had become friends, and Bunker was anxious to help. He met Rube at Grand Central Station and put him up at his own place. Bunker's studio in the old Lincoln Arcade Building was a haven for celebrities, who congregated for nightly poker games. Tad and Henry Raleigh, the magazine illustrator, were inveterate card sharks and "regulars" there. "The games," as Rube remembered them in 1928, were "as quiet as a riveters' picnic. The idea of the players seemed to be that the one who could shout the loudest and smash the most furniture stood the best chance of winning. Tad seemed to win the noise award and he excelled in destroying tables and chairs." Sometimes the games went on until 4:00 A.M. Never liking the pastime, Rube held his head in pain and thought "how tame the San Francisco earthquake had been." Even Max's card-playing ventures seemed simple and straight in comparison.

In such company Rube lost the "gee whiz" aspect

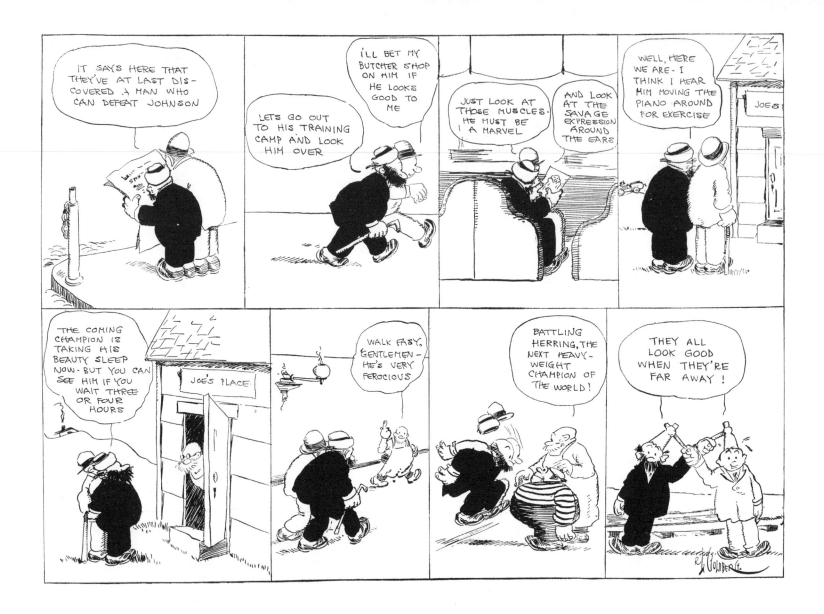

20. They all look good when they're far away, 1912

of his San Francisco character. Bunker and his colleagues were hard-core professionals grinding out daily columns and pictures for the New York papers. Rube's schoolboy innocence and natural wonder dissolved before the gruff, unspoken camaraderie of newspaper veterans—men who seemed to produce high-quality work automatically. Here they were in Bunker's apartment at dawn, unabashed by the prospect of facing empty Bristol boards and virgin typing paper later in the day. Their confidence and apparent facility amazed and inspired Rube; he envied their enthusiasm, their cool, and vowed to join their league.

Bunker cautioned Rube to be patient in his job hunting; the sight of a young artist being summarily ejected from a news office was common in New York. Rube pounded the pavement and rapped on editors' doors for twelve days—five days more than his initial blackout with the *Chronicle*. Everyone seemed disinterested. Irving Lewis, the executive editor of the now defunct *Morning Telegraph*, showed the aspiring San Francisco nimrod plenty of cold shoulder. Lewis displayed a revolver on the top of his desk, the sight alone enough to make Rube quiver. But Lewis himself delivered a generous blast of ridicule:

"Now just supposing there was an opening here, which there isn't—but supposing there was—what could you do for the *Morning Telegraph?*"

"I thought I might be able to improve the paper," answered the cautious San Franciscan. Lewis sputtered in disbelief. Blurting incoherent phrases about Rube's brashness and stupidity, he marched him to the morgue to show him early masterpieces by the *Morning Telegraph*'s cartooning staff. Rube left disappointed but convinced that he could do better. The *Sun, Globe, Evening Telegram,* and *Evening World* gave him the

same discourtesy; Rube was learning the meaning of equality.

To break the cycle of defeat he decided to play his trump. Hy Baggerly had given him a letter of recommendation to George Hughes, city editor of the New York *Evening Mail*, but pride had restrained him from using it. As Rube wrote many years later:

Influence is like carpet or wallpaper or a dog's tail. It's good to have it there but it's also good not to call too much attention to it. . . . *Getting someone else to intercede for you is like putting a rock in front of an unlocked door.* You stumble over the weaknesses of your benefactor's standing with the higher-up he is going to help you meet. I will not go out of my way to put any rocks in front of . . . open doors. . . . I may stumble or trip on my own nerve, but I'll walk in and if I'm thrown out I'll have nobody to blame but [myself].

Now he was anxious and hungry. His bankroll of $300 was "slipping fast," and his diamond ring and stickpin took on the appearance of dollar signs. But even a high hand didn't help, for although Hughes was cordial, he informed Baggerly's persistent young friend that the *Mail* owned Homer Davenport and that it didn't need an unknown. Hughes did not foresee that within a short time the famous Davenport would proclaim Rube Goldberg New York's greatest cartoonist.

Throughout his life, failure never defeated Goldberg; it simply encouraged another course. Instead of continuing his interviews with hard-boiled editors, Rube made his way into sports departments on the hope that leather-skinned athletic editors would recognize his talents. Illogical as it was, his reasoning worked. Rube returned to the *Evening Mail*, connived his way past a recalcitrant office boy, and presented himself to Fred Wenck, a well-known sportswriter and

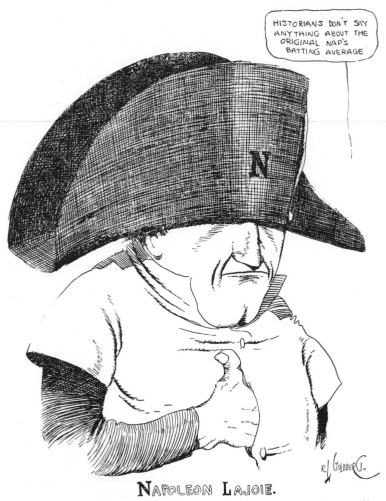

NAPOLEON LAJOIE.

Although Napoleon Lajoie has not yet been exiled to Helena, Mont., he is still young and has a chance. That he lived before in the shape of the little French emperor is certain. The first Napoleon swept everything before him with his trusty sword. The present Napoleon puts everything on the bum with his trusty bat. Lajoie is having a regular Napoleon hat made by a Cleveland hatter, so there will be no mistake as to his identity. When Waterloo is mentioned to him he turns up his coat collar and makes a noise like a defeated general. Nap's one ambition is to have his portrait hanging in the Paris salon. He says not a single American saloon is without his picture. Why win fame abroad? Echo, why not?

21. Reincarnation, 1908

22. Liberty Undaunted, 1909

former Olympic swimmer. Wenck resembled a wedge of granite with rosy cheeks, and his salutation resounded like a terrestrial disturbance.

"You Goldberg? I'm Wenck. Well, whatinell do you want?"

"A job. I'm a cartoonist. I've got some samples with me."

"And you've also got just two minutes to show 'em." Wenck mellowed. He spent a good deal more than two minutes looking over Rube's drawings, and the following day the *Evening Mail* had a new sports cartoonist at $50 per week. Rube, twenty-four years old and brimming with energy, was in New York to stay.

His first cartoon for the *Mail* was not a masterpiece, but Rube soon found his style. He decided very early in his New York career to develop general titles which could apply to numerous cartoons. These labels would give a thin continuity to his single-thought creations and help the readers to remember his works.

His earliest cartoon series for the *Evening Mail* oscillated between a folksy view of common events and a slightly strained spoof of highbrow beliefs. *They all look good when they're far away* began early in 1908 and continued intermittently until the late 1920s (Fig. 20). Resting on the simple truth that appearances and circumstances change with distance, this twenty-year hit alternated in the beginning with individual sporting or social cartoons and an unsuccessful series entitled *Reincarnation* (Fig. 21). In razzing the idea that human beings never really die but simply get recycled from one civilization to another, Rube soon found the one rule which guided his professional life: Abstract ideas are taboo for a popular cartoonist. While readers wrote letters commending *They all look good when they're far away*, hardly anyone mentioned *Reincarnation*, so Rube soon dropped that idea.

After *Reincarnation* Rube worked at the level of real life, common experiences—always aiming to make his readers feel that they, too, had been caught in similar circumstances.

His early works often lacked the subtleties and nuances of later cartoons, but from the start they exhibited a mastery of one-line humor. In a cartoon dated February 28, 1908, a little man, lacing the corset of a buxom dame, exclaims, "She was built ven meat was cheap."

While most of his cartoons exemplified a mass appeal (Fig. 22), Rube's first great hit, *Foolish Questions*, proved the epitome of democratic humor. Rube explained the inspiration for *Foolish Questions* on numerous occasions. Each time his story was slightly different, but on several points he remained consistent. His layout for the *Mail* was a seven-column, T-shaped spread with the space in the three center columns wider than at the ends. The central cartoon was the main attraction, with four smaller, complementary pictures around it. Rube felt that this early work lacked focus; visually and intellectually it seemed confusing. He continually sought new, imaginative ways to make the most of the 128 square inches of newsprint usually allocated for his work, but until he came up with *Foolish Questions* he was never satisfied. According to legend, the famous columnist Franklin P. Adams (F. P. A.), inspired *Foolish Question No. 1.*

"Did it ever occur to you what funny questions people ask?" observed Adams one afternoon. "You meet a fellow who's been out of town and say to him 'Hello, you back again?' On an August day, with the thermometer at 100 even, a man is pushing a lawn mower around the front yard

23. Foolish Questions, No. 2
1908

and oozing like a sponge, when some nut comes along and asks 'Cutting the grass?' "

Rube got the picture, and *Foolish Question No. 1* appeared on October 23, 1908. No. 2 followed the next day (Fig. 23), and by mid-November a *Foolish Question* occupied one-third of his daily space (Figs. 24–28).

It was obvious to all that Rube had tapped a comic's bonanza:

"Is that a folding bed?"
"No, this is a new box for my harmonica."

"Is this a heavyweight bout?"
"No, they're a couple of dwarfs dancing a fox trot on the south-east corner of a postage stamp."

"Oo, look, is that a snake?"
"No, that's a lost shoelace wandering around looking for a home in a new shoe."

"Oh, is your house right on the water?"
"No, Henry, that isn't water—we're going to have pancakes for breakfast and the grocer left a large order of maple syrup in front of the house this morning."

Rube established himself so quickly with *Foolish Questions* that most of the well-known cartoonists accepted him as an equal. Homer Davenport, editorial cartoonist on the *Evening Mail,* reported on January 15, 1909, that many New Yorkers were keeping scrapbooks of Rube's works. "Mr. Goldberg is a very happy boy," wrote Davenport:

His head works well, and his ability to portray his weird conceptions is very striking. . . . I sometimes wonder if a person with any real knowledge of the anatomy of a horse . . . could draw as funny a horse as does Goldberg. Hardly less funny than his horses are the noses he sets on the faces of people he draws. But funniest of all are the questions and answers of these bald-headed and hump-backed and knock-kneed people. What a simple creation is a paradox, and what a world of reality is there in Goldberg's *Foolish Question* series.

An instant smash, foolish questions were on everybody's lips; they even infiltrated the prewar vaudeville routines. New Yorkers laughed at themselves and sent Rube hundreds of humorous suggestions. The *Evening Mail* fanned the enthusiasm with billboard signs and promotion brochures proudly announcing that *Foolish Questions* were concocted by "New York's Funniest Cartoonist." Day after day the *Mail* observed:

EVERYONE ASKS THEM
EVERYONE ANSWERS THEM

They are so common that one seldom realizes how absurd they are. Goldberg makes them seem more so by his humorous answers.

A CURE FOR THE BLUES
A LAUGH IN EVERYONE

Between November 1908 and February 1910 the indefatigable Rube drew 450 *Foolish Questions.* He even managed to publish a book, *Foolish Questions,* in 1909. This startling success was due in part to the hoopla of the *Evening Mail*'s promotion office, but mostly it stemmed from the nature of Rube's humor. For *Foolish Questions* was a pure form of recognition comedy. Anyone who refused to laugh simply indicated his own stupidity. Yet the qualities that gave *Foolish Questions* an instant charm also threatened a quick decline. Once a joke of common faults is popularized, it quickly loses its laughs. By 1910 Rube felt the enthusiasm wane. He relegated *Foolish Questions* to an occasional side panel

24. Foolish Questions, No. 40,976
1918

and juggled several ideas before hitting a successful gag.

While *Foolish Questions* was a citywide hit, Rube made his debut on the vaudeville stage. When he first came to New York, he frequented the shows on the old Hammerstein Roof, a favorite haunt of writers, reporters, and professional athletes. On several occasions he was asked to step from the audience and ad lib a *Foolish Question* routine, obviously to the delight of all, for early in 1910 he made the first of numerous appearances at the Colonial Theater. Initially, these public appearances seemed like an inhuman torture; all Rube imagined was his brother Garry reeling off wisecracks and holding San Francisco audiences spellbound. Garry's performances seemed effortless and smooth, but Rube was about to learn the knack. By 1911 he found himself traveling as far north as Boston and south to Atlanta—a rigorous series of one-nighters, sandwiched between days of drawing. It's not clear just when he slept, but he seemed to thrive. Billed as a "monologue artist and a fortune teller," Rube would crack jokes, draw pictures, and play audience guessing games. One time, while doing a week at the Colonial, he shared a dressing room with a trained monkey, and another time he roomed next to an unknown Italian dancer with the unlikely name of Rudolph Valentino.

Rube stayed on the circuit until 1915, when his success in cartooning precluded other activities. He enjoyed the episode, however, for it gave him confidence and a broad spectrum of unforgettable experiences. His cartoon from December 18, 1911, *The versatile cartoonist Goldberg breaks into vaudeville*, showed the humorous trauma of his backstage existence (Fig. 29).

And it was vaudeville which gave Rube the replacement for *Foolish Questions*. Whenever he was stumped for an idea, he made an extra effort to meet all kinds of people. Their physical characteristics or peculiar speech patterns inspired him and provided models for future cartooning successes. One night on the Hammerstein Roof, Rube saw a vaudeville show which repeated the line "I'm the guy that put the salt in the ocean." That was it.

The adaptation was easy. In the beginning of his career Rube had borrowed from Tad a strange dwarf-like figure who popped up in unusual places—golf cups, kitchen drawers, laundry baskets—always making some wisecrack to emphasize the central theme of the cartoon. Readers enjoyed this little man because of his unpredictable appearances and his pungent phrases. He became Rube's newest hero, and *I'm the guy* was born. Rube's idea was simple. He saw that life was filled with everyday mysteries which could not be explained by the most brilliant scientist:

Why does Switzer cheese have holes?
Why do grapes have seeds, dogs have tails,
trees have leaves, bulls have horns?

Only Rube's dwarf knew the answers (Figs. 30 and 31). Like *Foolish Questions*, the number of suitable situations seemed infinite, but after several months Rube made a frightening discovery: He had exhausted Nature's stock of common wonders! Helped by a reader's suggestion, "I'm the guy who put the Hobo in Hoboken," Rube transformed the series into a play on words. In either case most New Yorkers agreed that Rube Goldberg was the guy who put the fun in the funnies.

"I'm the guy" is not a typical expression in current conversation, yet it is not extinct. Its occasional usage is a holdover from those years when "I'm the guy" was

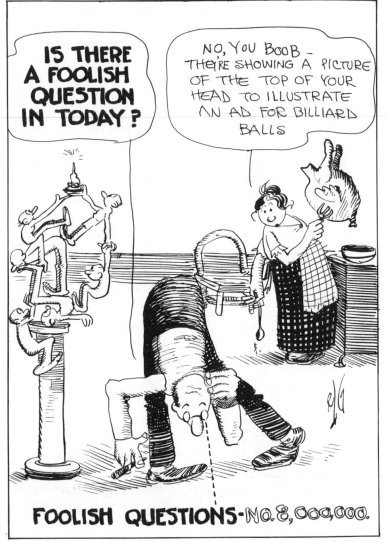

FOOLISH QUESTIONS-NO. 84,001

25. Foolish Questions, No. 8,000,000
 1914
26. Foolish Questions, No. 84,001

27. Foolish Questions, No. 1,407
 1911
28. Foolish Questions, No. 19
 1908

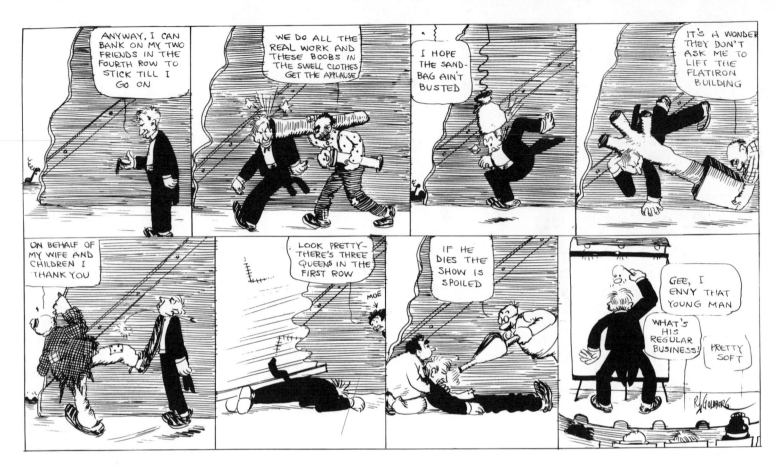

29. The versatile cartoonist Goldberg breaks into vaudeville, 1911

a full-blown fad. "I'm the guy" buttons appeared everywhere. Bumper stickers were still unborn, but comedians used "I'm the guy" jokes in their vaudeville acts and cigarette advertisers found it a handy lure for their wares. Even Rube capitalized on the phrase: it was the title of his first song hit. Bert Grant wrote the music to Rube's familiar words:

I'm the guy that put the salt in the ocean,
 I'm the guy that put the bones in fish.
I'm the guy that's five five high,
 I'll always live, I'll never die—
I'm the guy that put the wishbone in the wish.

I'm the guy that put the skin on bananas,
 I'm the guy that put the leaves on trees.
What's that, who am I?
 Why don't you know, I'm the guy—
I'm the guy that put the holes in Switzer cheese.

Rube's music publishers promoted the song by hiring a publicity expert with the Goldbergian name of Jo Jo. Like so many, Jo Jo was a "well-known" New York character who has remained too much of a mystery. At his worst he appeared an inscrutable, self-effacing, independent soul who savored life's sweet juices. Jo Jo met Rube at several social functions and found him an ideal commodity for mass sales. Super-salesman Jo Jo had a sentimental pitch, for the tonal qualities of his voice—in Rube's words—"put across one of those touching ballads on misspent lives and never failed to start the waterworks going among his auditors in the Bowery and Coney Island resorts." Jo Jo ran a regular plugging tour. He advertised Broadway shows, new cars, or toothpaste; it didn't matter. Jo Jo encouraged Rube by insisting, "It's a nut song, pure and simple, but it's a little over the head of some people

—you know—deep stuff. Now if you go along and let me introduce you as the fellow who wrote it, most people will get it in a minute."

Rube agreed to travel the Jo Jo circuit as Exhibit A of "I'm the Guy." Jo Jo would sing the song to half-cooked customers of Coney Island dives, then introduce the composer. Somehow Rube's presence convinced most listeners that instead of crying, as they did with most of Jo Jo's songs, they should laugh. Jo Jo was right. "It's just a question of knowing the tricks of the trade," he confided to Rube. "I knew everything would be all right if you trailed along."

The song scored for more than a year, and more and more people were talking about Rube Goldberg. It was certainly not the funniest doggerel concocted by a would-be poet, but people liked it. The newly invented phonograph made "I'm the guy" a repeatable gag echoing across America. Jo Jo's publicity worked wonders even though "I'm the Guy" appeared nine years before the first commercial radio broadcast. Jo Jo seemed to emit his own invisible waves which carried Rube a step closer to national notoriety.

Jo Jo was a transitional figure of the pre-mass communication days who combined the ploys and success of P. T. Barnum with the obscurity and facelessness of a network television program judge. Jo Jo was a mysterious, ephemeral being, dedicated to ballyhoo and boosterism. Facts or substance meant nothing, only notoriety and popularity, for Rube Goldberg's "I'm the Guy" deserved attention. Rube understood that if many people were going to enjoy his works, they needed advertisers and publicity agents to tell them that he, Rube Goldberg, existed. Yet these dealers in popular images were oblivious to the substance of his ideas. Rube did not distrust promoters completely, for

30. I'm the guy, 1911

31. I'm the guy, 1912

their tenacity and their imaginative brand of public service marked them as modern citizens aware of current problems. They employed a hard-shell practicality unknown to the Berkeley Professors, and they had a much broader impact on people's lives. Rube admired the flexibility and ingenuity of people like Jo Jo. Their daring, their independence, and their brashness drove them to success.

By the late 1920s the business of advertising and publicity had become institutionalized. The lone publicity agent became as rare as a Yankee peddler in Georgia, and Rube regretted this new impersonal phase. Jo Jo, and Jo Jo alone, had put the first pieces of Gold in Goldberg, but now, with Rube at the top of his career, syndicates and invisible corporate phrasemakers specialized in catapulting unknown cartoonists to fame. "I'm the guy" became a phrase connoting an older individualism and pride. Even Jo Jo succumbed. In 1928, seventeen years after *I'm the guy* appeared, Rube attended a performance of Mae West's *Diamond Lil* and recognized Jo Jo in the role of an old-fashioned singing waiter. Jo Jo was so true to life, wrote Rube shortly afterward, "that I closed my eyes and imagined I was again listening to Jo Jo do his stuff before one of those strange audiences. He was simply performing a revival of an extinct phase of New York life." But Jo Jo had become anonymous, a charade of a distant past which was slipping into oblivion.

The strange Jo Jo played a significant role in expanding the life of Rube Goldberg. He symbolized for Rube the inevitable force of impersonality characterizing modern times. Democracy, as Rube saw it, was working to erase vital personal distinctions, to homogenize everything to a point of uniformity. The modern era strove to eliminate accents, color, and idiosyncrasies from everyone's personality. Life without spice was the new recipe for social nourishment, but Rube refused to join the feast.

To him the essence of individualism was the response to challenge. He feared that growing wealth and flabby wills would make Americans too weak to meet the unexpected and the perilous. *I'm the guy* had started some serious thinking. Even John D. Rockefeller, Jr., the oil magnate and multimillionaire, responded. He called on Rube and asked him to address the Bible class which Rockefeller taught. Rube agreed, but the next few days were upsetting. He didn't know what to talk about. Prizefighting, Broadway dives, and Jo Jo seemed altogether inappropriate. As Rube wrote, "I had worked myself up to believing that anything I said was going to be as joyous as a notice from the Internal Revenue Collector."

The hour approached, and Rube was still without a topic. He started by drawing pictures for the class. These went over well, but then the paper ran out and a mild panic set in.

What further entertainment could I give them. I could not recite. I had neglected to learn juggling in my early youth. I wore the wrong sort of a hat to give a good imitation of Napoleon. Before I realized it I was seated at the piano playing and singing "I'm the Guy."

Remembering this successful tactic, Rube noted, "The singing waiter had tossed a note into the songs of the ancient prophets."

I'm the guy and the vaudeville experiences gave Rube a public confidence which he had exhibited only on rare occasions. When he first arrived in New York, for example, several friends advised him to change his

32. There's a little philosophy in back of anything
 that looks foolish, 1916

name. "Goldberg" was a fine name for a tailor but as a name for an artist it portended failure, they said. Rube balked at such an absurdity. He was Rube Goldberg from the San Francisco *Bulletin*. He was the son of Max Goldberg. Goldberg was his blood, his character, his work. He could not transform his name into a snappy-sounding label for a nonperson: "I'm the guy," Rube Goldberg.

Rube's quest for the pungency of life was symbolized in *I'm the guy*. Self-reliance. Personal accomplishment. Success. Victory. They're all part of it. Someone had to put the Hobo in Hoboken, the bard in bombardment, the con in conference, and the pain in paint.

"Guy" is a popular slang word from the nineteenth century, usually meaning a male person. Sporting enthusiasts used it incessantly, and Rube picked it up from the San Francisco newspapers. But Rube enriched its meaning and helped remove its tone of ridicule. He liked the way "guy" sounded, and noted that it forced a smile as it rolled off the tongue. A "guy" in Rube's vocabulary was a doer from the ranks of average citizens, someone who maintained his individualism by stamping his personality on something whole and identifiable. "Guys," not masses of faceless humans, gave life its flavor and its fun. *I'm the guy* was Rube's first attempt to laugh at and to affirm the value of individualism.

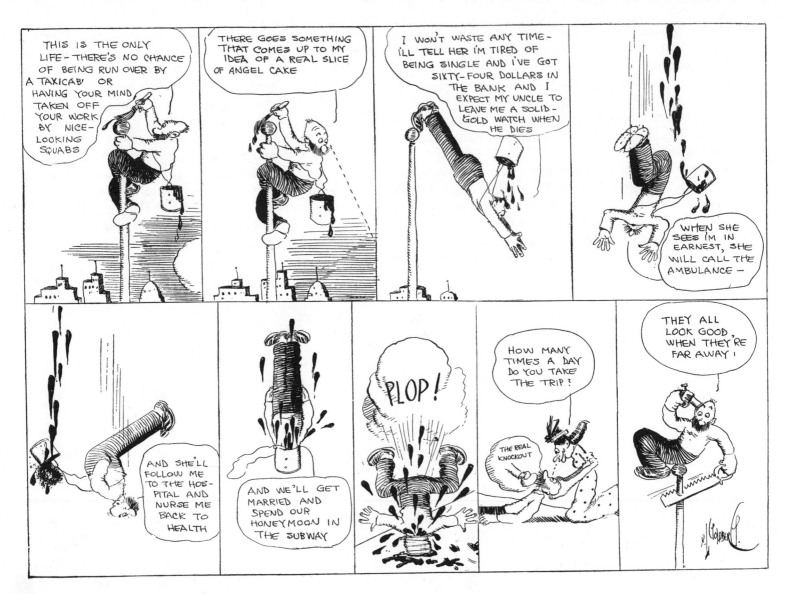

33. They all look good when they're far away, 1911

5
There's a Little Philosophy in Back of Anything That Looks Foolish

During Rube's most creative years, from 1909 to 1928, he produced two types of humor. One clarified the experiences of everyday life, and the other dramatized the confusion and irrationality of the human condition. (Fig. 32). While *I'm the guy* focused on individuals and credited them with their rightful accomplishments, most of his works revolved about a philosophical acceptance of the world's imperfections. Yet Rube shrugged off anyone who called him a philosopher. To him philosophers were renowned for their inability to tie their own shoelaces or to empty the garbage without dropping half of it on a newly waxed kitchen floor. He distrusted artists and writers who spent their lives deciphering the meaning of life, questioning the inevitability of death, or searching for the formula of absolute beauty. He saw no reason for pondering unanswerable questions or for brooding over human tragedy. He believed that tragedy as an art form dealt with death and with the path to death; it emphasized man's continual attempts to divinize himself, and to escape temporal pain; it always ended with cries of defeat. Rube couldn't help asking himself, "So why bother?" and he couldn't help feeling that life was to be lived and to be loved. In laughing at his own limitations, man could rise above tragedy and his inescapable fate. In the introduction to *Chasing the Blues*, a collection of his newspaper cartoons published in 1912, Rube summarized his philosophy of humor by emphasizing its earthy powers:

I must burden you with a terrible confession. This book is not a work of art! I admit that truth prevails rather from circumstance than choice. I have long since realized that my artistic deficiencies remove me from the sphere of Rembrandt and Michelangelo.

My ever-present realization of the material virtues of kidney stew and gorgonzola cheese has permanently destroyed whatever of the ethereal that may have been born within me.

With this awful fact staring me in the face I have set for myself the not-unpleasant task of drowning my tears in a sea of foolishness.

If, as you glance through these pages, a smile flits across your face, a base-hit will be registered on my subconscious scoreboard of satisfaction.

A touch of art may nourish the soul, but a good laugh always aids the digestion.

This philosophy ruled Rube's humor throughout his life. Near the end of his cartooning career, for example, he wrote (but never published) a short novel entitled "There's No Mustard on Mars." At one point the Russian heroine, Sonia, queries her American fiancé, Harvey Jones:

34. They always come back for more, 1910

"Harvey, dear, I don't understand you Americans, no matter how hard I try."

Harvey asked, "What is it you don't understand about us?"

"This meeting, for instance. We all cried and laughed at the same time. How is that possible?"

"When things get too bad there's nothing left to do but laugh. So we laugh."

Sonia was puzzled. "But that sounds a little stupid, darling."

"That's right, dear, I guess we Americans are stupid. Aren't you Russians stupid, too?"

"I'm afraid we are. We don't laugh enough, maybe."

"That's it. You take your stupidity more seriously than we Americans take ours."

Rube's cartoons dramatized general truths as manifested in seemingly trivial events. He attempted to catch man's continual search for perfection in a flawed world. Many of the cartoons end with a comic suicide, but his nameless heroes even bungled their continual attempts at killing themselves (Figs. 33). Though some do pull the trigger or lower the ax, Rube reassures us in one series that *They always come back for more* (Fig. 34). It is just such a flirtation with death that has often been an important ingredient of comedy. As in the movies of Charlie Chaplin, Laurel and Hardy, or the Three Stooges, Rube's cartoon hero, too, sometimes straddles the grave. He falls from rooftops, electrocutes himself, steps before speeding cars, yet always succeeds in fumbling his way to safety. The comic hero, by his very nature, cannot die. It is this hopeful, yet often unenlightening, conclusion that plays havoc with many comic creations. The great writers from Aristophanes to Anthony Burgess have been unable to overcome the simple truth: Comedy has no natural stopping point but simply dribbles to an innocuous conclusion. Rube's humorous articles often suffered from the innocuous conclusion, but his best cartoons were classics—well-rounded and full, complete and self-sufficient. They have a beginning and an end, free from ragged edges, and his technique was deceptively simple.

All of Rube's great cartoons have general titles which smack of a homespun, Ben Franklin, "I-told-you-so" philosophy. *They all look good when they're far away, They always come back for more, There's nothing in a name, Hospitality is a beautiful thing, if you only treat it kindly,* and *After all, a woman is only a woman* are aphorisms with thousands of applications. Rube used them continuously, applying them to numerous cartoons which depicted every kind of mess his heroes could find. In each case the cartoon simply affirmed the aphorism with a laugh. By fulfilling a common-sense prophecy, Rube's cartoons acquired a timelessness little known in the world of journalism or of comedy. As his friend Grantland Rice wrote, each cartoon "was based on the kind of universal experience that almost every one of us stumbles into at one time or another. Rube had a knack of looking underneath the surface and discovering things that only seemed obvious after he had pointed them out with his fun-stirring pen."

Rube's captions were the keys to his drawings. When the San Francisco *Call* began to carry some of his cartoons in 1923, it foolishly tried to drop Rube's titles and to insert a catchall heading, "Rube Goldberg's Ramblings." So on February 5 Rube penned a friendly but insistent protest to Edgar Gleeson:

Dear Scoop:

I have seen several of my deformed brain-children in the *Call* under the general caption "Rube Goldberg's Ramblings."

35. Crossing the English Channel, Boobs Abroad, 1913
36. Boobs Abroad, Naples, Italy, 1913

This is a good general title and I appreciate the headline position. But I think the title that goes with each picture is a real part of the cartoon and helps the dumbbells figure out what it is all about.

Only a few of Rube's contemporaries outlived him. The multitalented Harry Hershfield and the tenacious and brilliant Edgar "Scoop" Gleeson both agree that Rube's ability to generalize separated him from Tad or Opper or Davenport. Gleeson, who worked for sixty years as a San Francisco newspaper editor, put it this way:

If Tad drew a picture of a boy stealing an apple from a local fruit dealer and then came across with a punch line about honesty, that's because he actually witnessed the whole episode. Tad's humor came from his ability to define the natural or existing things in life which happen to be funny. But Rube went to college, he was one of the few humorists who did. In his science studies he learned about the difference between particular facts and broad ideas. He could see the general point in any single event. He could philosophize and still be funny.

In most cases Rube's philosophy grew out of his real-life experiences. For example, when *Mail* owner Henry L. Stoddard invited his employees to the wedding of his daughter, Rube decided to buy a new suit complete with striped trousers and a cutaway coat. He wanted to be the darling of the event, but the tailor foiled his plan. The outfit did not arrive at Rube's apartment till the last minute, and as Grantland Rice witnessed, "Rube came to the wedding in a state of perspiring exhaustion. He had run all the way." This was bad enough, but two of the prestigious guests, financeer George Perkins and former President Theodore Roosevelt, were dressed in casual clothes, "even more informal than those in which we slouched around the office," remembered Rice. This type of ironic twist became a trademark of Rube's comedy.

Like it or not, Rube was becoming a philosopher-humorist. The signs were unmistakable. Heroes gave way to average men, athletic predictions were replaced by observations about the daily game of survival, and compassion for durable truths triumphed over evanescent sparks of success. "The funniest of human traits to me is vanity," wrote Rube years later. "If there is as much as one person in the entire world who is 100 per cent free of this common malady, he has a good job waiting for him as the premier freak of all time. Yet the great majority of us think we are the single exception to the rule, which makes vanity just that much funnier, for any such delusion is in itself a form of it." Rube's graphic exaggerations were nothing less than spoofs on vanity, probes into the heart of man's ego.

In order to broaden and deepen his humor, Rube made his first trip to Europe in midsummer of 1913. *I'm the guy* was beginning to subside, for, like *Foolish Questions*, the life expectancy of Rube's features ranged from a year and a half to three years. Persuading the paper that he needed a new inspiration, he got the *Evening Mail* to agree to pay his expenses, and it promptly notified the public that Rube's mission was "to find whether or not there is a laugh left in Europe after all that unhappy continent has passed through lately." A daily deadline was the *Mail*'s only requirement. Whether on a boat or a train or locked in a hotel room, Rube religiously produced one finished drawing each day, two weeks in advance. His cartoons were headed *Boobs Abroad*, a takeoff on Mark Twain's earlier masterpiece, *Innocents Abroad*. The first appeared on July 14, 1913, and, predictably enough, Rube spoofed everything in sight by assuming

37. Between Vienna and the hock shop, Boobs Abroad, 1913

the posture of a simpleminded American devoid of sophistication and high culture. The good-byes at the dock, the passenger's confusion with nautical terms, and the inconveniences and discomforts of life aboard ship (cramped sleeping berth, the tourists' small talk, the inevitable seasickness) made the ocean liner a comic's paradise. (Fig. 35).

Once Rube arrived, he stayed for more than a month. He quickly decided that Europeans and Americans were basically alike. As human beings they were identical. They differed only in appearance—their clothes, their homes, their food. Since civilization itself was nothing more than appearances, Rube—as a humorist —found his jokes in the specific cultural trappings of the Old World nations.

In England he cartooned the unusual clothing styles (quipping on July 21, 1913, that "every time you look at an English suit . . . you feel like cabling a kiss home to your tailor"), characterized the British coffee as ink, snickered at the English accent, and concluded that the Beefeater at the Tower of London had stepped out of a history book. In Paris he spoofed the gendarmes with their gold-braided uniforms and swaying epaulets. Their fancy uniforms transformed them from average guys with screaming children and nagging wives into powerful beings who manipulated the destiny of drunks and tourists and imaginary maidens in distress. Rube loved them. The punch line of one cartoon read, "The only people in Paris who look as though they don't know how to fight are the soldiers."

In Germany he continued his fun with uniforms. At one hotel he saw a man he thought was the Kaiser accompanied by the entire general staff, but—after some embarrassment—it turned out to be a crowd of bellboys carrying ice water. Everywhere he went, the costumes of officials were exaggerated symbols of an ancient authority testifying to Europe's reverence of The Past. And a reverence for historical artifacts infiltrated all European society, insisted Rube; after he saw a toothpick in a glass case with a label reading "Toothpick Used by Napoleon After a Dinner in Honor of His Victory at Austerlitz," he became even more convinced that Europeans were supersalesmen entrenched in historic euphemisms and hyperboles.

Coincidentally, *Innocents Abroad* also focused on this peculiar brand of salesmanship. While touring Paris, Twain's roguish guide, A. Billfinger, pointed to a jagged bullet hole in a tree. The bullet had been meant for the Russian Czar who had visited France in the 1830s, and the tree became a favorite touring stop. Twain compared the European attitude with the American:

In America that interesting tree would be chopped down or forgotten within the next five years, but it will be treasured here. The guides will point it out to visitors for the next eight hundred years, and when it decays and falls down they will put up another there and go on with the same old story just the same.

Both Goldberg and Twain ridiculed Europe's daily charade of instant history. At one point in his journey Rube was so tired of tipping his tour guide that when he entered Rome he drew a cartoon depicting a simple American tourist confronted by an assortment of ancient statuary—all with outstretched hands. Another cartoon insists that Rube tipped so often that he even slipped a few coins to miscellaneous hotel guests as they wandered about the lobby. Still more surprising was their nonchalant acceptance of his offering.

Wherever this inveterate comic looked, he managed to find pretension, trickery, and idiosyncrasies. His 20/20 vision detected every flaw, every trace of spuriousness which the proud countries of western Europe tried to hide. His visit to Mount Vesuvius, for example,

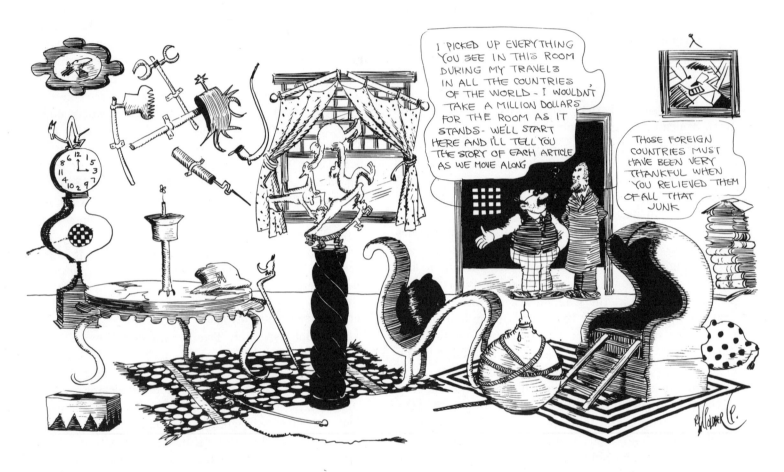

38. Some men think that anything that looks foolish
 is an antique, 1914

left some lingering doubts (Fig. 36). Traveling north he found that proud and gaudy Italy, the land of the Caesars, was filled with wine, trinkets, and poverty. But water, which was so cheap and plentiful in America, had vanished from Italian life. "Wine is so cheap you feel like a burglar every time you buy a bottle," wrote Rube from Rome. Why, some Italians even performed a daily ritual of dumping a bucket of the purple fluid over their heads while gurgling an eternal wish: "Some day I hope to be wealthy enough to wash my face with water." The virile Italian men, too, struck Rube as curious creatures addicted to prancing about town wearing their wives' jewelry: "The women can't go out to tea till their husbands get through with their earrings."

During his stay in Switzerland he failed to see one Alpine yodeler, a Saint Bernard dog with a keg tied to its neck, or a piece of real Swiss cheese. Were these fakes too? Paris, with its expensive nightclubs, was even more confounding. One cartoon, dated July 26, 1913, was titled *Every Frenchman you see at Maxim's is an American*. He balked at the prices, satirized the French barber who kept sticking his beard in Rube's eyes, and depicted the plight of the American who could not speak French but finally discovered that his hosts spoke perfect English after he showed them a roll of dollar bills. The English, in comparison to the inscrutable French, seemed more honest, but they were just a little daffy. "Take an Englishman away from his tea," quipped Rube, "and he's not an Englishman." On August 9, 1913, Rube discovered Holland, and a pun was unavoidable: "After spending a few days in Holland you know what it means to be in Dutch."

While he found numerous tourist stops nothing more than way stations for legalized robbery, he also poked fun at the tourists themselves. One lady in Rome kept telling the guide she had seen all the sights in the American magazines; another developed the habit of speaking French in Italy and Italian in France so no one could really discover that she didn't know either. Mark Twain, forty-four years earlier, had found similar companionship. One know-it-all explained the luminescent beauty of the Rock of Gibraltar at sunset: "I consider that them effects is on account of the superior regragability, as you may say, of the sun's diramic combination with the lymphatic forces of the perihelion of Jubitor."

Rube had purchased several souvenirs, but most of the names on his gift list had not been scratched. So while in Vienna on August 26, 1913, he published a warning for all would-be recipients (Fig. 37). He also spoofed the gullibility of the American collector in a cartoon entitled *Some men think that anything that looks foolish is an antique* (Fig. 38).

En route to Paris, Rube changed trains in Genoa. Asked for his passport, he confidently reached into an empty breast pocket and one hour later found himself in jail. It took two days for American officials to convince the skeptical Italians that he had honestly lost his papers (Fig. 39). The police issued him a temporary visa, and Rube decided to go home, arriving in New York in late August.

The following July he left again for Europe, this time to cover several boxing matches and to rest. After knocking about England, Belgium, and Germany he reached Paris—four days after World War I began.

Anti-German feelings were rampant. Paris was in a mild panic, but Rube tried to stay at ease. "I was going back to the Polo Grounds and the One-Step Halls and the Automat in a few days," he noted, "and the pillars of my tranquility could not be so easily shaken." Despite an innate dislike of Germany, he pitied the Germans

39. Boobs Abroad, Genoa, Italy, 1913

who were caught in Paris. The walls, he remembered a year later,

were plastered with notices instructing all Germans and Austrians to leave town within 24 hours. Heavy set gentlemen, with wrinkles in their necks, were busy explaining . . . in a rich Limburger dialect that they were Scotch tourists doing a bit of golfing in and around Paris. One man with Heidelberg dueling scars scattered all over his face pinned a Peruvian flag in his buttonhole and indicated he was deaf and dumb. The next day his power of speech returned to him suddenly when he crossed the border into Germany.

Was this a time for laughter? Perhaps not, but Rube swore he saw the "execution of a Pretzel in the Bois de Boulogne" and overheard this patriotic conversation:

Lady: This Frankfurter is the only thing I have in the house.
Starving Frenchman: Let me die, let me die.

Fearing for his own life he was anxious to leave, but his "heroic friends" at the *Mail* encouraged him to stay. It was unprecedented for a cartoonist to win the opportunity of seeing "history at close range," they said. And so, Rube was in Paris—a premature Bill Mauldin—and totally ignorant of French. To add to the confusion, he couldn't find the war! In one cartoon, he expressed a sincere conviction that *The closer you are to the front the less news you receive.* When he did catch a tidbit of raw information, it didn't seem to make any sense. European geography was a jumble for Rube; all the places had unpronounceable names (Fig. 40). If one man sneezed, "Ha-skive," another was sure to respond, "Have they retaken that fort again?" But the problem seemed to be a common one. Mark Twain, on his first visit to France, stopped in

Dijon—that place "which is so easy to spell and so impossible to pronounce." And back home, the *Evening Mail* ran a regular column entitled "How to Pronounce To-Day's War Names":

Aisne	Ain
Veally	Vah-yee
Champagne	Skom-pan
Woevre	Wev
Chambrettes	Shom-bret
Lys	Lease
Ypres	Eeep
Voormezecle	Voor-mez-ell

In one spoof, Rube summarized his own impressions:

Baron whosis sent a note to the Servian legislature or house of Congress, or Committee on Arrangements, or Board of Directors and told them in a few words he was peeved at the way the Servians neglected to include Hungarian dishes in their daily routine of food. The note was returned in a short time to the Baron saying that the Committee was very sorry to inform him that it was busy playing pool. So the Baron said, "I declare war. You're it."

To a democratic humorist, royal blood was a European affectation which led to incompetent leadership and needless wars. Rube felt no pain at jarring the nobility from their seats of complacency, but he did sympathize with the middle class, which usually paid the price for upper-class incompetence.

The war taught Rube a host of lessons about history and the role of individuals in the mainstream of historical forces. As he observed the mobilization of Paris, the run on the banks, and the changeover to a wartime economy, he was overwhelmed by his helplessness, his inability to do anything but swim willy-nilly in the confusion of everyday events.

40. You're foolish if you even try to say them, 1914

I'm the guy suddenly seemed a million miles away. Rube began to question the power of the individual to do anything, or even to know anything, about his own earthly destiny. Here he was in Europe being buffeted about by invisible curfews, inept army recruits, and obtuse customs officials. Where was justice? Rube couldn't even keep his clothes clean. On the seventh day of the war, he tried to get his trousers pressed but aggravation reigned:

I pressed the button marked "valet" and waited. I pressed the button marked "waiter" and waited. I pressed the button marked "porter" and waited. I pressed every other button in the room and waited. But nothing happened. Everything was pressed but my trousers.

In a more philosophical vein, he caught the essence of his dilemma:

I was seeing history. I did not know whether to be happy or sad. When you read history you can eat and ride on boats and send out laundry and bow to people and call for ice water. But I was seeing history, and I could not take out time for recess. I just had to keep on seeing it. It had me licked in all directions.

The longer he stayed in France, the more impressed he became with the irrationality of the human race. Most of the Americans who were awaiting passage home were terrified by the outbreak of war. The hostilities in Austria cut short their tours and threatened their safety. Americans at the Grand Hotel in Paris organized committees. There were committees for everything, joked Rube. "Member #365 of Committee #687 said President Wilson was sending over $200,000 to relieve our sufferings—the inability to have our trousers pressed, the lack of picture shows, the absence of bartenders, the high rate of taxicabs and other handicaps."

He also noted with his humorous perceptiveness that "if a man had gone through the American colony saying he had arranged to slip us through a hole in the Bois de Boulogne so we could come out on the other side of the world in the middle of the Pacific Ocean there would have been a mad scramble for tickets." He was overwhelmed with the confusion of the momentous present, and despite his on-the-scene advantages he was no more able to "see history at close range" than at long range. "What's it all about?" became a familiar question for Rube at this time, and it remained the fundamental query of much of his work for the rest of his life.

His ultimate extrication from Europe reinforced his faith in the incomprehensibility of the present. Each day when he visited the customs station he was told that he needed some kind of official paper. Never at a loss to improvise, Rube discovered an old dentist bill in the elastic pocket of his leather suitcase. It was stamped PAID in several places, and scroll-like symbols encircled the cancellation stamps. Rube decided to give it a try. He mumbled a few incoherent phrases to a newly installed official, tipped his straw hat, and stepped aboard a boat for America.

The trip was perilous. German U-boats haunted the desolate seas, but Rube reached home and prepared to launch a new and broader barrage of cartoons on his fellow Americans. As soon as he arrived in New York, he began to assemble an account of his travels. Unfortunately, his vow to keep a diary had been broken long before the war began. As Mark Twain observed in *Innocents Abroad*:

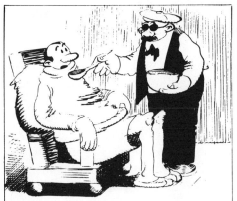

A RUNNER NAMED MERCURY MARATHON HATCH VERY CAREFULLY TRAINED FOR A CHAMPIONSHIP MATCH,

WHILE ON CAKE, CHEESE AND SAUSAGE TRAINED PERCIVAL LONG, FOR HE ATE THE WORST FOOD AND DID EVERYTHING WRONG:

BUT HATCH COULDN'T WEATHER THE MURDEROUS PACE, HE WAS THREE-QUARTERS DEAD WHEN HE FINISHED THE RACE,

WHILE LONG WON THE RACE WITH THE GREATEST OF EASE, AND HE RAN FROM THE TRACK FOR MORE SAUSAGE AND CHEESE!

THE IMPORTANT THING IN ATHLETICS IS TO TRAIN WITH THE GREATEST OF CARE

BOLONEY!

NURMI EATS APPLE BETWEEN RACES

41. Life's Little Jokes

At certain periods it becomes the dearest ambition of a man to keep a faithful record of his performances in a book; and he slashes at his work with an enthusiasm that imposes on him the notion that keeping a journal is the veriest pastime in the world and the pleasantest. But if he only lives twenty-one days he will find out that only those rare natures that are made up of pluck, endurance, devotion to duty for duty's sake, and invincible determination, may hope to venture upon so tremendous an enterprise as the keeping of a journal and not maintain a shameful defeat.

The lack of a diary did not stop Rube from publishing a paperback copy of his experiences several months after his return. *Seeing History at Close Range*, thirty-two pages long, contained a host of tired jokes culled from the newspaper cartoons and embalmed for a library shelf. It was a pale shadow of Rube's genius, lacking in substance and bordering on foolishness; it showed a weakness that plagued all his early books. At one point, however, he gave a poignant description of his reaction to the mobilization of Paris:

I have no particular interest in France, excepting, that I feel grateful for its artistic atmosphere, rare wines, cheap carriages and red lips. But a great big lump rose right up into the middle of my throat when I saw those men, fresh from heartbreaking farewells to their wives and children and sweethearts riding right square into almost certain destruction with the calm resignation and divine confidence of those inspired by some power more than mortal.

I cheered and sang and even shed a tear or two. Perhaps I would have felt the same way had I been in Berlin to see the German soldiers take leave of their loved ones.

I saw something that showed me there is still a nobility among men and it has nothing to do with a vest.

The helplessness Rube describes was captured in a series of cartoons entitled *Life's Little Jokes* (Fig. 41). The war, more than any other event up to that time,

stimulated his sense of the unexpected and awakened his interest in the unpredictability of life—the unforeseen events that make the poor rich and drive millionaires into slums. This was a classic form of comic inversion, one of the oldest styles of humor, but it evolved from Rube's own experiences and it punctuated his theory about the confusion of the present.

Life's Little Jokes usually came in four panels and it employed poetry as much as drawing to make its point. The rhyme in *Life's Little Jokes, No. 19*, for example, made the drawings all but irrelevant:

> Livingston Mush was
> A popular guy.
> He made many dates and
> He kept on the fly.
>
> Each day he got letters, the
> Story now goes,
> Inviting him out to fine
> Dinners and shows!
>
> Now Herbert McDuff was the
> Lonesomest gink.
> His room was so still he
> Could hear himself think.
>
> His phone it grew rusty
> And lonely on the wall
> For nobody ever gave
> Herbert a call.
>
> But Livingston didn't
> Enlist with the bunch,
> And now he's not even
> Invited to lunch
>
> While Herbert McDuff, clad
> In Uncle Sam's brown
> Is being invited
> All over the town.

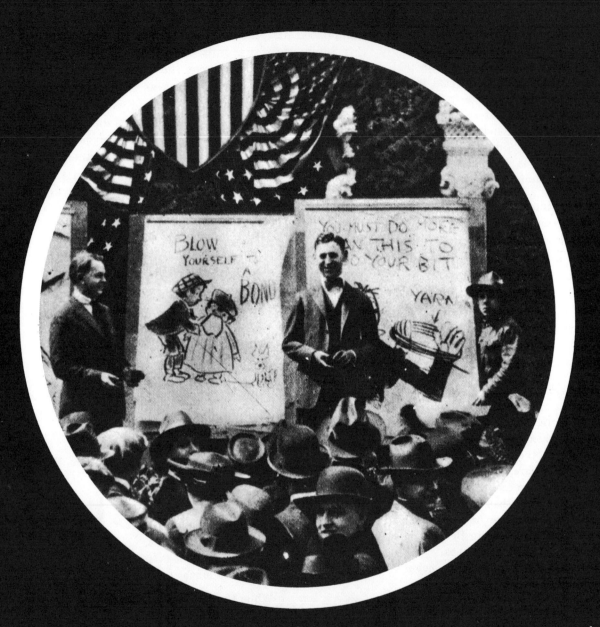

Cartooning for Liberty Bonds with Clare A. Briggs in New York City, 1918

The idea of cartooning comic reversals occurred to Rube in February of 1908, and he attempted several formats under the general series title *You can't always tell by the label*. But most of these pieces were visually confusing and much too complex, lacking the crisp simplicity and the clear progression of *Life's Little Jokes*.

Running along with *Life's Little Jokes* was another wartime series, *Fifty-Fifty* (Fig. 91), which instead of emphasizing real-life reversals played on a timeless faith in predictability. It proved that all men, regardless of wealth, are always dissatisfied and continually longing for a better life:

FIFTY-FIFTY: May 28, 1918

Poor Man, sitting behind a sickly flower pot: "I wish I could afford to own enough ground to raise my own vegetables."

Rich Man, standing in a large garden: "It cost me $18.60 to raise this radish and now I find out it's an onion."

Rube enjoyed juggling the contradictions of *Life's Little Jokes* and *Fifty-Fifty*, for they gave him a chance to look at life from several sides. They also tested the depth of his comic talents. Nobody but a visceral humorist could find the jokes in what appear to be minor tragedies. Both *Life's Little Jokes* and *Fifty-Fifty* rest on real-life situations that usually evoke anger or despair in those who are victimized. Rube shows the nonsense of particular human episodes by giving us both sides—success and failure, victory and defeat, love and rejection. He juxtaposes the extremes and lets us see the more fundamental problems which usually elude us.

Upon returning from his second trip abroad, he found both his time and his cartoons in great demand.

The vaudeville circuit clamored for his show, so he made what proved to be his final eastern tour. In Atlanta, meanwhile, his friend Frank Stanton scribbled a poetic tribute:

A Toast to R. Goldberg

I

Down in the Lowgrounds where Life has somber hues
Call off the undertaker!—Take Goldberg for the blues!
Fellows in the Hopeless Land say: "What's the latest news?"
And a laughing chorus answers: *"Take Goldberg* for the blues!"

II

And we take him, and we make him companion of our way;
We gallop on his race horse to the country of "Hoo-ray!"

Far in the mists behind us looms Tribulation Town;
We laugh our troubles down, boys, we laugh our troubles down!
To the Gloom Brigades—slow-marching—, Life thrills the cheering news:
"Take Goldberg for the blues, boys, take Goldberg for the blues!"

By 1915 Rube was forced to choose between the stage and the studio. Drawing by day and acting by night so wore him down that he canceled a spring tour. But war clouds began to appear and he found himself performing his vaudeville act free in fund-raising campaigns for the American Red Cross. He also worked with Homer Davenport, Tad Dorgan, and others selling Liberty bonds. His cartoons, however, were not perfect specimens of patriotism. *It's all wrong, Orson, it's all wrong* (Fig. 42), *Look at this and stop worrying about our standing army* (Fig. 43), *International Justice?* (Fig. 44), and *The Dumbness of It All* (Fig. 45) cast

42. It's all wrong, Orson, it's all wrong, 1916

a curious shadow over world affairs of the war decade.

Rube visited Europe for a third time in 1918 to cover the treaty conferences. Once again he maintained the guise of an American boob who longed for the "gladsome sight of the Statue of Liberty." He enjoyed his adventures in Europe, to be sure. Before he died he made at least twenty-two more visits, but he seemed to value these experiences because they heightened his appreciation of America. Never a blind patriot, in *It's all wrong, Orson, it's all wrong* he presented anything but an affirmation of American democracy. Yet the language barriers and the cautious friendships always kept him on tenterhooks while in Europe and he never gained an intimacy with any of the European cultures. Though he loved to cartoon humanity, he could never be a citizen of the world.

43. Look at this and stop worrying about our standing army, 1915

6

Learning to Drink White Rose Tea

From 1907 to 1922 Rube worked on the New York *Evening Mail* at such a frenetic pace that his friends feared for his health. When a major boxing event was scheduled in Philadelphia, he'd hop on a late afternoon train from New York, sketch the bout, have a drink or two with the newsmen, and then return to the *Mail* offices where he would draw until midmorning to meet his deadline. This routine was hectic enough, but the elevators in the *Mail* Building were always shut down by the time of his arrival, so he would have to drag his tired bones up twelve flights of stairs just to reach his drawing board. Wasn't technology grand?

Each cartoon had to be sketched, lined, inked, and then—more often than not—junked in the nearest wastebasket, giving way to a new version. It was not unusual for Rube to *complete* ten or eleven versions of a cartoon before making a final decision. This philosopher of imperfectibility and earthly mediocrity was a perfectionist with a passion for clarity and detail. He probed for the lowest common denominator in any joke. The simplest wording arranged to *sound* like everyday speech became a hard-won trademark of his humor. The competing New York *Journal*, with its own pages of brilliant cartoons, soon noticed Rube, and Hearst dispatched his right-hand man, Arthur Brisbane, to hire the fledgling genius. When Brisbane

offered Rube a regular place on the *Journal* at $50 a week, Rube nearly swallowed his cigar.

"Why," asked Rube, "can't the wealthy *Journal* pay me more than the *Evening Mail?*"

"Take it or leave it," snapped Brisbane, "but it's your last opportunity to work for Hearst."

Naturally Rube declined, and by 1915 he had proved that he didn't need William Randolph Hearst—a fact which few successful cartoonists could boast at that time.

From a young cartoonist in 1907 Rube had grown to become the heart of the *Evening Mail*. His colleagues called him the "star feature"—a "sensation in the great metropolis as a new type of cartoonist," insisted one writer. His cartoons appeared every day, including Sunday, and they were sold at a modest scale to the other newspapers by the McClure Newspaper Syndicate. Frank Parker Stockbridge, managing editor of the *Evening Mail* in 1915, billed Rube as America's most popular cartoonist. "His only possible rivals were Bud Fisher and George McManus," Stockbridge insisted in 1931, and "in my judgment, his work at that time was far superior in subtlety and imagination quality to either *Mutt and Jeff* or *Bringing Up Father*. I regarded Goldberg then . . . as having the keenest and most brilliant mind of any of the comic artists."

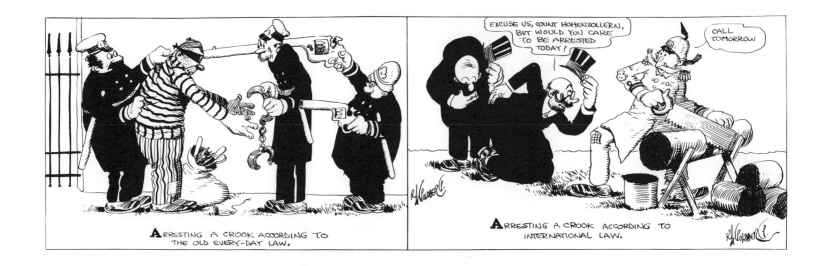

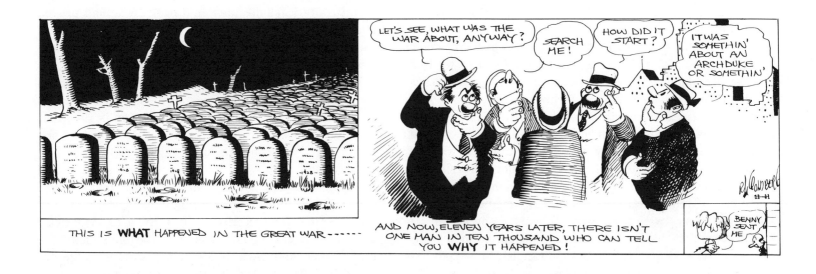

44. International Justice?
45. The Dumbness of It All, 1929

Rube's salary of $50 per week had risen dramatically; by 1915 he was getting $25,000 a year. He also earned $8,000 a year doing odd jobs and another $2,000 from rental properties in San Francisco, one of which, unbeknown to him, was a flophouse, complete with pimps and prostitutes! Yet all this was only a hint of his future bonanza. Toward the end of 1915 he received a second phone call from Arthur Brisbane—almost four years after the initial encounter. This time Brisbane was friendly and warm, and although Rube was tempted to quote an earlier warning ("it's your last opportunity to work for Hearst"), he refrained. "Rube Goldberg" was something the insatiable Hearst had to own, so he ordered Brisbane to open the coffers and offer Rube the unbelievable salary of $50,000 a year, guaranteed! Only Fisher and McManus collected more. For one of the few times in his life Rube was dazed into silence. While his paychecks from the *Mail* kept him clothed and gave him some gas money, the thought of doubling his salary was no less than wonderful. Hearst, of course, paid the highest newspaper salaries in the world, and many of Rube's colleagues had followed the golden path to San Simeon. Returning to the *Mail* from Brisbane's office, Rube, too, planned to join the Hearst brigade. Soberly he entered Frank Stockbridge's office to give his notice:

"Boss," stammered Rube, "I hate to leave you, but I don't see how I can stay on the *Mail* any longer. My contract expires at the end of the year, and I have a big offer from Hearst."

"Don't be foolish," replied Stockbridge. "You say that you hate to leave us, yet you talk about quitting as if it were a certainty. Would you rather stay here?"

"Why, of course, I would much rather stay with the *Mail*," beamed Goldberg, "but I don't see how I can turn down $50,000 a year."

"Who said anything about turning it down?" Stockbridge fired back. "Give me some time to work it out."

Like other newspapermen who bravely challenged the Hearst millions, Stockbridge was determined to find a way to keep his "star feature." The New York *Journal* was a sponge which, as Stockbridge saw things, soaked up the best journalistic talent in America. The *Evening Mail* had to hold on to Rube if it wanted to stay in competition.

Dr. Edwin L. Rumely, a farming-implement tycoon from Laporte, Indiana, had just purchased the *Mail* in 1915. This change of ownership had been one reason for Brisbane's second offer—it seemed like a good time to win Rube. Stockbridge talked Rumely into meeting Hearst's offer and aided by the imagination and energy of Virgil V. McNitt, devised a new syndicate for distributing Rube to every town and city across the land.

Virgil V. McNitt owned the Central Press Association, which operated from Cleveland, Ohio. He had been an editor for the Cleveland *Press*, had a sound knowledge of the history of printing (especially printing as a fine art), and wrote in a clear, direct prose. McNitt was a sensitive but hardheaded go-getter who would catapult Rube straight into the Random House dictionary.

Stockbridge's plan was simple: "We want to start the Evening Mail Syndicate," he told McNitt, "with you as manager. Your brother can run your Central Press out in Cleveland . . . and we will pay you a salary and percentage." It sounded good. Before coming east, McNitt traveled to Chicago, where Victor Lawson's *Daily News* was the first to subscribe. Others joined quickly. "Even before Rube's new contract went into effect," Stockbridge reminisced years later, "McNitt had sold him for more than the guarantee."

46. Phoney Films, No. 8, 1911

Today news syndicates are common, but McNitt's idea to sell a cartoonist nationally was bold in 1916, and Rube was fortunate to be the beneficiary; in fact, this was the biggest break he would ever get. McNitt had to convince local editors that their illustrations did not have to be strictly original, drawn by their own cartoonists, and revolving about local topics. Part of his solution was technological. He worked out a system whereby he could produce an unlimited quantity of matrices from a photoengraving of an original drawing, then mail the matrix to his subscribers. This matrix was simply a mold of the cartoon taken in a thick sheet of moistened paper. When fully molded it resembled a piece of dried cardboard into which the cartoon had been stamped. When the matrix arrived at a newspaper office it was filled with molten lead, thereby forming a cast, known as a stereotype, which became the printing plate. There was nothing to redraw; all was just as Rube had created it.

But technology wasn't enough to overcome a sacred prejudice, so McNitt attempted to *sell* Rube as a generalist whose jokes applied to local issues. And as proof of Rube's ability McNitt cited his salary. The $50,000 soon became national gossip.

In these pre-radio days McNitt spread the word with clever phrases in brochures, in advertising broadsides, and in newspaper blurbs. In one ad he simply asked: "How many youngsters of thirty-three do you know who draw salaries of more than $50,000 a year?" And why does Rube earn this yearly fortune? McNitt hammered home his answers: "Rube is intensely human." "Rube is genuinely humorous." "Rube's cartoons reflect the frailties, the vanities and foibles of the entire race." "Goldberg, in a good-natured way, gets human nature's number."

McNitt's promotion was printed on leaflets and dropped from airplanes. Pasted on fences and published in magazines, Rube's name seemed to be everywhere. Time and time again McNitt emphasized that Rube's humor was for all newspaper readers; it dealt with everyday problems, it deflated human pomposity, it surveyed the kinks and twists of human nature, and it could lift the spirits of anyone. In McNitt's words, Rube Goldberg "is the guy who made laughing a national daily habit." This was not an empty boast, for by the middle of 1916 Rube's cartoons made their way into three million homes a day. In less than one year the star feature had become a one-man show.

The publicity about his salary made Rube vulnerable to every insurance agent, investment specialist, and bond salesman in America. Long-lost acquaintances vowed eternal friendship, inventors asked for financial backing, and—most surprising of all—Rube noticed that the old waiters who used to sleep so peacefully were "constantly at my elbow and never give me less than nine plates of butter with my meal." Even magazines began soliciting him for articles to explain how he earned $50,000 a year. "I am afraid that if I tell the truth," Rube gibed, "I will have too much competition, and I will cease having my picture printed in full-page advertisements." The whole business became annoying, but Rube survived. "Brace up, old man," he told himself. "Maybe some day you'll be lucky enough to go broke."

Rube's salary was possible only because of the development of the news syndicate. McNitt's service was national, with subscribers in Boston and San Francisco, Minneapolis, Cleveland, Pittsburgh, Chicago, New Orleans, and many other cities. Each paper published the same cartoon on the same day, for the cartoons were created in New York almost three weeks in advance and mailed first-class in time for simultaneous

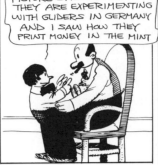

47. The New Education, 1930

48. I never thought of that, 1916

publication. Rube's drawings had a single national impact because of McNitt's syndicate, similar to television programming.

Newspapers, however, did not pay uniform fees for Rube's cartoons. According to McNitt, the charge was "based on the total circulation of all the English language newspapers of the town in which the paper that buys the picture is published." New York papers paid more for a daily syndicate feature than any paper in any other city. To succeed, a syndicate had to land subscriptions, not only in New York, but in Boston, Philadelphia, and Chicago. To make it big, newspapers in Saint Louis, Baltimore, Pittsburgh, and Kansas City had to be won as well. McNitt's checks were canceled in all these cities, and Rube's bank account continued to grow.

McNitt was a frustrated Scotsman who had made numerous trips abroad looking for his family tartan. Rube joked about this continual search for respectability in Scottish ancestry, simply asking, "So what?" McNitt ignored this irreverence and they got along well until contract time.

Each year Rube naturally fought for higher and higher sums. (From 1916 to 1928 his guaranteed salary grew steadily from $50,000 to $125,000!) Rube disclaimed any innate financial savvy, but he held all the cards. Since numerous publishers were bidding for his work, the selling price had to rise. With typical understanding and kindness, however, he brought Max into his yearly act:

Dear Pa:

It's that time again. They're talking about reducing my salary and I need you here to make sure the reverse happens. Enclosed is a train ticket, please come.

Your son,
Rube

Once a year for ten years, the senior Goldberg could be seen emerging from Grand Central Station and entering a chauffeur-driven Lancia: San Francisco Max was in town. Rube would take him to McNitt's office; they would "argue" salary for a while, then McNitt would submit and sign the new contract, and Rube would invite everyone to a grand party. Max, of course, was always the guest of honor. One of these celebrations coincided with Max's seventy-fifth birthday. The printed invitation read:

You're invited to a party
And there's no amusement tax. It's in honor of a guy
Who's known around the world as Max. For his humor and
 his wisdom
Not a soul with him compares. But his greatest claim to glory
Is the stetson that he wears:
. .
He's a lucky young gazabo
And he's got a million friends.
It's an evening you'll remember
For its sentiment and mirth,
For it's given by the children
To the finest dad on Earth.

Success with the *Evening Mail* was only one part of the making of Rube Goldberg. McNitt was far from satisfied. In 1913, when Rube visited Paris, the Pathé Exchange movie corporation had tantalized him with a generous contract to experiment with motion pictures. He had seen the first commercially successful animated film, Winsor McCay's *Gertie the Dinosaur*, four years before his first trip abroad; and as early as 1911 he had tried drawing some "flip cards" which gave the illusion of animation. As the tempo at the *Mail* quickened, however, he relegated his motion-picture plans to the back of his mind.

Many of his cartoons between 1912 and 1930 docu-

Irma and Rube, courting, 1916

ment his enduring fascination with the magic of celluloid. An early work entitled *All the world's a moving picture show* appeared in 1912 and depicted the plight of a poor boob who had painstakingly saved $631.40 to open a stationery store, only to discover that every available building in town had been rented to serve as a motion-picture theater. He also drew numerous cartoons for *Photoplay* magazine, spoofing the public images of the Hollywood gods. *Phoney Films* (Fig. 46), which he ran as a side panel for ten years, also dramatized the prevaricating qualities of the newest entertainment medium. And by the early 1920s when the movies began to assume regular plots with mass killings and suicides as regular ingredients, Rube questioned the recipes. Why, he wondered, did the movies contain as much death and struggle and destruction as life itself? In one cartoon he observed, "It is surprising there are any more actors left after looking at the films." When one of his characters went so far as to squawk, "I want my money back—one of the actors was alive at the end of the film," the theater manager could only respond, "There must be some mistake in the photography." Rube was also baffled by the hero worship engendered by motion pictures. He drew at least three cartoons in the 1920s entitled *The lives of movie stars furnish 99% of our conversation.* And in a slightly acid cartoon he offered a "hint" to the movie magazines: "We're tired of reading about the private lives of movie stars. Why not give a little attention to people in other walks of life? They're just as human and more interesting." As usual, Rube was forty years ahead of popular sentiment.

Talkies arrived in the mid-twenties along with flappers, raccoon coats, and empty whiskey bottles. If liquor was banned, then film became the national intoxicant, and the movie industry grew—in Rube's opinion—"to be the most important thing in American life." But like any fad it had its drawbacks, so on January 4, 1930, Rube took "to the man on the street."

Abbot Dillwhistle says—Since the talkies arrived my wife hasn't been home in time to cook me a single meal. I think the picture theatres should equip every seat with a kitchenette.

John Schnozzle says—I listen to riveting all day and when I get home my wife rushes me off to the talkies. When we get home again she turns on the radio. Things may be uncertain in this life, but there's one thing that will always be with me—my headache.

Philo Badweather says—For months I've been trying to tell my wife to darn my socks, but the only talk she'll listen to is the kind that comes from the screen.

Bertram Wrangle says—My children do all their homework in the talkies. The only study in which they've gotten 100% is necking.

Newsreels didn't do too badly in the Rube Goldberg rating system. Their eclectic character, their emphasis on *good* as well as bad news, made them palatable. And there was always the chance that they would make schools obsolete. *The New Education* appeared on June 7, 1930 (Fig. 47). Fittingly enough, it was "newsreels" that brought Rube into the Hollywood limelight. Throughout 1914 and on into 1915, he tested a multitude of ideas for a cartoon animation which would spoof the ultraseriousness of the daily newspapers. This mock newsreel was concocted in his "fun laboratory" high in the tower of the *Evening Mail* Building. Surrounded by cameras and projectors and other picture-producing machinery, and aided by a corps of technical and drafting assistants, Rube fought to

breathe life into his family of funny people. He even applied for several patents for improving animated film.

When the first installment of *The Boob Weekly* appeared on May 7, 1916, Virgil McNitt made sure that people lined up, money in hand, hours before the feature began. Pasting America with ads, he played on the popular notion that an animated film was still something of a miracle—yes, the figures appear to move! "The weird creatures of Goldberg's fancy, weird yet so very true to life, MOVE, WALK, and have BEING, and STRUT and FRET their parts like living men and women." And if you think Rube is funny in the newspaper, wait until you see his films, promised McNitt. "Little Oscar will burst his little sides yelling at Goldberg, and it is safe to say that Momma and Papa will have their little laugh, also."

The Strand Theater in New York, America's largest motion-picture palace, paid the Pathé distributors $1,500 a week for the seven-and-a-half-minute Goldberg special. According to the advance publicity, this was the highest price ever paid for a moving-picture rental —almost two hundred times the going rate. No one could explain why it cost more to make a man laugh in 1916 than it did to make him cry, but most reviewers agreed that Rube was worth it.

The Boob Weekly was a gentle satire on the news but, like so much of Rube's work, it proved to be prophecy. The first episode, for example, covered an airplane attack on the moon, and Rube made it clear that these important shots were "taken by our camera man at the risk of everybody's life but his own." It also showed the dedication of a statue erected to the first man who installed garbage cans in Oshkosh. Fittingly enough, the christening was performed with a bottle of polluted water from the San Francisco Bay!

Nor did politicians escape. One orator, standing all alone in a Goldberg-designed park, lifted his head and began: "Don't crowd, gentlemen—I'll speak loud enough for you all to hear me." Subsequent films sported titles such as *The Fatal Pie, From Kitchen Mechanic to Movie Star,* and *Leap Year.* Subtitled "All the news that nobody wants to hear," Rube's movies of airplanes and statues and politicians were seen by thousands in 1916–1917, a time when war and high idealism weighed heavily on people's minds. And like everything else Rube tried during that decade, the cartoons were an instant success. On May 9, 10, and 11 he found himself attending a round of New York parties complete with movie personalities and circus midgets. They had come to New York for a week-long exposition and trade show at Madison Square Garden sponsored by Fox, Paramount, and other Hollywood studios.

May 12, 1916, was "Rube Goldberg Night," and Rube held center stage for fifteen minutes with a humorous demonstration of cartoon wizardry. It was part of his old vaudeville act: He would draw a picture, then turn it upside down and it would change from a duck to a turnip, or from a flower to a new fashion in women's hats. As he was waiting to go on he found himself standing in a crowd. A young girl bolted up to him and asked excitedly, "Where is he?" "Where is who?" responded Rube. "Where is Goldberg?" said the girl. Being the star of the show and not being recognized would embarrass most people, but Rube rose to the occasion. He looked closely all around the mammoth arena, pointed finally to a fat man high in the stands, and directed the gushing girl to him for an autograph.

One measure of the success of *The Boob Weekly* was Rube's paycheck. By the end of April 1917, the series netted him $75,000, which—when added to his $50,000

a year from the *Evening Mail*—gave him a higher salary than that of the presidents of most of America's large corporations. But it was exhausting work with long hours. It took 200 single-frame cartoons to make just one minute of film. A seven-and-one-half-minute reel required 1,500 drawings. That meant 78,000 drawings a year. Even an indefatigable cartoonist with an army of assistants couldn't maintain the pace. At one point, late in 1916, Rube fell behind in his work at the *Evening Mail* and he began submitting the best of the single frames from his animated films. These were occasionally up to par but they lacked the depth and the precision that distinguished his usual work. By 1917 he was exhausted, so he called it quits. Since then, no one has succeeded in putting together a weekly animated spoof of the news.

But the experiment had a long-term benefit of higher value than money. Late in 1915 Rube organized a preview of his films at Delmonico's Restaurant in New York. It was a charity affair, and after his presentation he was introduced to Irma Seeman, a young beauty from Bayonne, New Jersey. Her father, S. W. Seeman, owned the White Rose Tea and Grocery empire and, like Rube, was not exactly strapped for cash. Irma, who was only twenty-one and recently graduated from the prestigious Ethical Culture School, had seen Rube during his vaudeville days when he had played the Colonial Theater. She remembered him as a humorous actor who drew pictures and juggled pieces of chalk while telling a comical story. Rube, thirty-two, a lean handsome man with custom-made clothes and lightning-fast cars was without doubt one of the most attractive and most eligible bachelors in America. The difference in their ages made Rube the commanding figure— suave, sure, and gentle. Irma gave him a confidence and an ease of manner which he had never known.

Theirs was admiration at first sight, which quickly became a durable love.

Rube's first chore in winning Irma was to convince her father that cartoonists weren't worthless artists who left nothing for posterity except a "batch of unpaid butcher bills." Mr. Seeman did not read the *Evening Mail*, so he was not familiar with Rube's cartoons. He made it plain that he had never heard of Rube Goldberg, and Rube retorted—in all honesty—that he had never heard of White Rose tea. Within a month Seeman learned to laugh at Rube's creations, and Rube found himself drinking tea.

With his usual sympathy Rube understood Mr. Seeman's plight:

I had no factory working for me, no store, no staff of bookkeepers, no inventories to take, no sinking funds; in fact, none of the usual business props. All I worked with was a bottle of india ink and a few ideas.

But Rube won his case by having Virgil McNitt send several ads about his salary to Mr. Seeman, and suddenly Rube's cartoons took on the economic importance of a can of tomatoes.

Luring Irma was not as easy, so Rube turned to his most potent weapon—his cartoons. Sprinkled throughout his yearly production from mid-1915 to October 1916 were Rube "specials," designed to win the heart of Irma Seeman. In these courting pieces Rube's love of self-effacement is clear. The creator of *I'm the guy*, the advocate of a stern individualism, was modest and charitable; Irma, the symbol of radiance, and Rube, the everyday dodo, composed the regular recipe. Rube's best jokes during the decades of fame and opulence were about himself. His self-debunking symbolized not only his love for Irma but his sense of confidence as a top-notch cartoonist (Fig. 48).

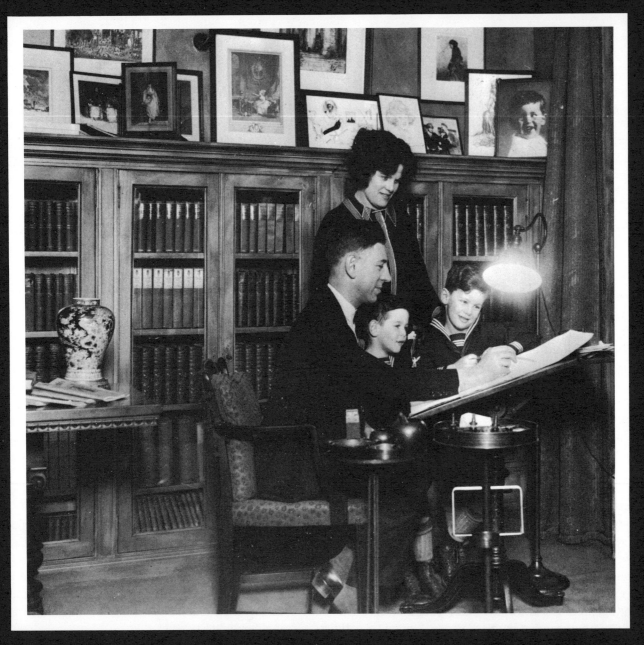

The family in Rube's library, early 1920's

The dream couple became engaged on July 18, 1916, and married three months later on October 17. While their wedding ceremony was performed with an unaccustomed regularity, Irma nearly canceled everything a few hours earlier—when she discovered that her groom had spent the night in jail! Rube had been charged with disorderly conduct and earned himself the morning headlines. The episode has become a Goldberg legend.

On the final evening of his bachelorhood Rube and several friends made the rounds of numerous taverns and at one point stopped at the Winter Garden to hear the singing of John Charles Thomas. After several songs, Rube—for some unexplained reason—began to laugh and chant "John Charles Thomas, ha-ha-ha-ha, John Charles Thomas, ha-ha-ha-ha, John . . ." Customers seated behind him complained, and finally someone was poked in the face. Most of the facts are muddled, but one is clear: When the police arrived, they quickly arrested Rube and plunked him in jail for the night. Fortunately he was released in time to attend his own wedding, but even a sheepish grin could not soothe the feathers of the Bayonne peacock. That required a two-week honeymoon in Jamaica and a leisurely tour of New Orleans.

When they returned, Rube threw himself into his work with a typical enthusiasm, but several changes became noticeable: Family situation jokes, which had appeared only on rare occasions, made regular showings, and the ugly female frumps with their sagging breasts and blubbery mouths gave way to flappers with bobbed hair, flat chests, and sensible thoughts. They nevertheless began to equal men in Rube's work, and that pure world of masculinity softened—as if, for the first time, he came to understand the role of women in society.

Rube's domestication was complete when Irma gave birth to two sons: Tom in 1918 and George in 1920. Both events were trumpeted in Rube's cartoons: the highest symbol of pride which he could express.

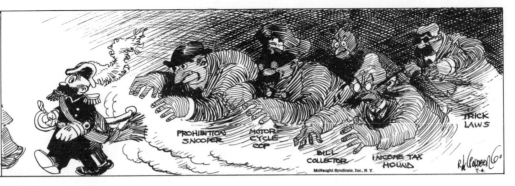

49. Independence Day, 1917

50. Children are not so dumb

51. Christmas Greetings from All Our Little Boobs, 1923

7

A Comedy of Manners: The 1920s

The 1920s were a halcyon decade for Goldberg's America, with revolutionary electrical appliances, daring fashions, jangly music, and a polite lawlessness—all seething with vitality. Rube's existence was a wholesome blend of strenuous work, high pay, nationwide fame, and deep family unity. Irma, young and radiant, anchored his life with love and compassion; she was his one close companion, his one honest critic, and—curiously enough—his *only* confidante. Although Rube had thousands of friends from around the world, he always tried to keep his distance. He built a newspaper-thin wall between himself and the outside world by religiously avoiding regular luncheon routines or studiously looking for new routes to work. Strangeness, newness, and surprise fueled his funnybone, but only Irma caught a glimpse of the creative process. She alone shared his intimate thoughts or helped him to develop a new idea or told him when to give up an unworkable notion. This semidetachment gave him, he felt, an unparalleled view of man, a view available only to an "intimate outsider."

But this period was not just the Age of Rube Goldberg; it was also the age of Will Rogers and Charlie Chaplin. Rube believed that Chaplin was the "greatest entertainer in the world," and he first met the movie genius one evening while purchasing some precious gems at Cartier's. Although Chaplin had scheduled a date with Mary Pickford, he detoured for a drink at Rube's home and stayed long enough to give the sleepy Goldberg children a half-hour review of his talents. "The boys rubbed their eyes and looked around," remembered Rube:

They didn't know Chaplin from Adam. But he immediately took in the situation and started to identify himself. He walked around the room with that small shuffling gait, took a stick to which a balloon had once been attached and manipulated it in the manner of his famous cane and went through the vivid facial changes that were his mark of genius. The boys shouted with laughter and even applauded when he had finished. They wanted more. . . . Chaplin danced around the room in a priceless imitation of a French minuet as a final acknowledgment of the boys' applause.

Rube remembered that Chaplin was deeply concerned at that time with the influence of childhood on adult life. "Whatever we do today," Chaplin philosophized, "comes out of earlier experiences." Rube grasped this generalization and used it later to explain the course of his career. This meeting was important in Rube's life because it triggered an understanding of the basic distinction between his own humor and Chaplin's. While both comics played the theme of a good soul in an evil world, Rube's heroes passively endured what-

ever befell them. More like Chaplin's short-term rival, Harry Langdon, Rube's characters are grown men who react to adversity with the trusting innocence of a child. They are nonviolent, nonevil, and they try to love everything and everybody, including their avowed enemies. They live in a world where even inanimate, nonhuman things spoil their hopes and their plans. Chaplin's style was different. Whether in *Modern Times* or *The Kid* or *The Gold Rush* or *City Lights*, Chaplin tried to *think* his way through trouble. He does suffer, but never passively. His humor is often a battle of wits slapsticking for survival. Both comics took potshots at shyster lawyers and stupid sheriffs, enjoying the ultimate laugh of catching the world with its pants down; yet Chaplin's aim was deadly. In his 1936 production of *Modern Times*, for example, the rapid assembly lines, the huge impersonal machinery, and the mindless workers come closer to depicting tragedy than humor. Even Chaplin's Goldberg-type contraption, the Billows automatic feeding machine, is a severe indictment of automation. Oddly, a number of Rube's contemporaries claimed that *Modern Times* was inspired by Rube's inventions, but Chaplin himself insisted that the idea came to him after a visit to a Ford assembly plant.

Chaplin acted on the premise, wrote movie producer Frank Capra, that "all is ridiculous! Virtue, authority, sweet love, wealth—all ridiculous." This theory certainly described Chaplin, but it was too severe for Goldberg. Rube always gives society a second chance, and if it fumbles the second effort he gives it a third and a fourth and a fifth. Perpetual redemption! Rube believed in the continuity of human experience. He saw life as a regenerative process fueled by man's conviction that this time things will be better. But somehow those eternal laws of human bungling always interfere, utopia slips out of sight, and laughter lives.

While Chaplin dominated the comedy of celluloid, Will Rogers ruled laughter from the lectern and the newspaper column. Rube knew Rogers, too; they had roomed together in 1920 while covering the Republican National Convention in Chicago for the McNaught Syndicate. At night, after the histrionics of the political windbags, Rogers would keep a group of admirers in a constant uproar with his lighthearted anecdotes. "Joy seemed to ooze from every one of his pores," reported Rube. "He was never in better form." This was quite a compliment because Rube often criticized Rogers for "staying on too long being fascinated by his own words."

At midnight they would both retire. Since there was one bed and a cot, Rube would insist that Rogers (who was four years older) take the bed, but he always refused. Instead he would undress in a painful silence and plop into the canvas contraption with, as Rube described, "a gesture of abject misery." Rube felt responsible, for here he was sleeping with the "man who had the whole country in hysteria, the homespun American who apparently cared nothing about the social amenities and habiliments," but instead of laughing, Rogers seemed depressed beyond recognition. So Rube tried to cheer him up:

"Weren't those delegates the funniest-looking bunch of guys you ever saw!"

No answer. Rube tried again: "Does anybody really believe those speeches they made this afternoon?"

No answer.

"Hey, Will, are you awake?"

Still nothing.

Rube dozed off and awoke at dawn. There was Rogers,

flat on his back staring wild-eyed at the ceiling. Later in the morning he got up, dressed, and left without a single word.

At lunch, V. V. McNitt, the syndicate manager who had made Rube a national celebrity, explained that Rogers was miserable because several of his sentences had been cut out of his copy a few days earlier. Rube learned firsthand that Rogers was not always light-hearted, that he had prolonged moods of silent depression which could be triggered by the "little pangs of imaginary wrongs." Rube became convinced that neither Rogers nor any other popular idol showed his true self to his adoring public.

Rogers and Goldberg worked several other political conventions together, and finally—after some prodding from Rube—Rogers became a regular on the McNaught payroll. Quite a catch! Like Goldberg, who astounded his fans with his versatility, Rogers worked with every medium. He began in vaudeville twirling a lariat while adding occasional comments about national and international affairs, and soon his humorous monologues became a symbol for all that was funny in oral humor. He played in several Broadway productions, silent moving pictures, and talkies. He traveled on a national lecture circuit, following the tracks of Mark Twain and Artemus Ward. Then radio programs, books, and regularly syndicated news columns. At the height of his career he was earning $20,000 per week and reaching about 40,000,000 readers. He was the nation's jester, outranking even Rube in both salary and audience appeal.

Despite Rogers' cowboy image, he was a philosopher who used ideas as the basis of comedy. When criticized for the poor grammar in his news columns, he responded, "Shucks, I didn't know they was buyin' gram-mar now. I'm just so dumb I had a notion it was thoughts and ideas." His contemporaries agreed: "It seems to be his mission," wrote the *World's Work* in 1930, "to tell us the hard, blunt truths about ourselves—truths about our politics, our civic standards, and our social habits. They are the sort of truths we do not always like to hear, but we will take them with a contagious chuckle."

Shortly before his tragic death in an airplane crash in 1935, Rogers wrote in a Goldberg vein, "Two hundred years from now history will record: 'America, a nation that flourished from 1900 to 1942, conceived many odd inventions for getting somewhere, but could think of nothing to do when they got there.'" This message—as we will see—also lay at the root of Rube's humor, but there was an essential difference in their creative contributions. Rogers came out of the tradition of Josh Billings and Mark Twain, and he played on the incongruity of a local country boy thrust into the modern world of complex machines and deep learning. Like a number of popular predecessors, he pitted his local idiosyncrasies against the world, using his pretended naïveté as a foil to expose the weakness of the high and the mighty. He worked the various media brilliantly, always adjusting to their peculiar strengths, creating for himself the largest audience the world had ever seen. While Rube, too, eventually addressed himself to radio, television, Broadway, and Hollywood, he lacked the ease which gave Rogers his charm.

Rube was at his best when he worked on the printed page within his own unique format. His humor was a blend of cartooning and writing, a highly individualistic style, a hybrid that seemed to defy imitation. Neither the captions nor the drawings could stand alone, but together they became a new kind of news-

paper humor which lost its character when translated into other media.

This uniqueness isolated Goldberg from both Chaplin and Rogers; indeed, it separated him from all of America's humorists, forcing him to work alone, with Irma serving as his only censor. But the loneliness of being an original humorist did not make him a recluse. The five-story town house on Seventy-fifth Street near Riverside Drive which he bought in 1920 was a whirligig of social and family activity. His yearly earnings had reached $185,000 by then, causing him to contract the "galloping disease of ownership." He dubbed the house his "giant receptacle of joy" because the $42,000 purchase price proved to be one of his smaller expenses. Rube had grown to hate cramped apartments, so with the help of their friend, architect LeRoy "Sport" Ward, Rube and Irma removed part of the second floor and installed a winding staircase with a wrought iron balustrade. Then marble fireplaces, modern plumbing, English-basement-type entranceways, stone columns, and statues—they went all the way, tripling their initial investment.

With construction periodically curtailed by strikes and labor disputes, the Goldberg family made daily visitations to view the painful progress. Finally, on December 1, they moved into a partially completed dream, but for months afterward, Rube joked, "We'd wake up in the morning to see men in overalls walking past our beds carrying tools and lunch boxes." Since the ornamental iron doors hadn't arrived when they moved in, the Goldbergs were forced to put up with cold winds howling through the house. At one point Rube had to nail the Christmas tree to the floor to keep it from being blown down! Irma also felt the ill effects, for she was soon hospitalized with a severe throat in-fection and a 105 degree temperature. All was miserable; so miserable that Rube vowed he would sell that "wreck of flaunting opulence." But when Irma recovered and when the new doors were hung, his hatred for plaster and mortar gave way to pride. Rube Goldberg had arrived.

He loved the house, with one exception. Above the elaborate marble fireplace were two plaster ladies, each sporting three sets of breasts. These were sacred, mythological figures, but the twelve breasts troubled Rube, especially after he caught the boys studiously counting the wondrous protrusions. So after consultation with "Sport" Ward he called in a stonemason to chisel off all but two of the breasts from each of the lovely ladies. His reasons were more practical than prudish. As he later explained, "I did not want my sons to grow up under the misapprehension that a lady has more than two beautiful exterior lung muscles. I did not want the boys to be disappointed later in life."

The grand mansion called for a new life-style. Chambermaids, cooks, nurses, chauffeurs, and butlers were on hand. Rube and Irma had five servants, a custom-made Minerva touring car, private tailors and shoemakers, European vacations, catered banquets at their home—all the trimmings to give their life a verve which few enjoy. On one trip to France they even met the aging Isadora Duncan, who, despite a few extra layers of fat, performed in their honor. According to one witness, "Her age and weight faded before her grace."

Occasionally Rube would question his own extravagance, particularly after visits to the lavish Long Island estate of John Golden. Golden, a millionaire who had won fame as a theatrical producer, was one of Rube's many friends noted for being parsimonious. Like a

latter-day American President with symbolic economizing in mind, John Golden kept every light in his home turned off except for the one he was using. Whenever he left a room he would flick the switch to "off," feel his way through a pitch-black hallway to his new destination, then, "snap": One light, and only one, would appear. This wasn't Rube's way. As he wrote in 1928: "I never think twice before spending a dime for something that will sate my craving for some of the better things in life."

The two boys gave the house a felicitous atmosphere for fun and informality. Their toys filled every room. Tropical fish in tanks with gurgling water enhanced hallways and bathrooms. A second-floor miniature golf course made of expensive lampshades, vases, carpets, and shoes threatened the moves of any unwary visitor. For one thin dime anyone could play! The boys even hand-printed a house newspaper entitled the FLASH-BEZITZ and delivered it to the kitchen staff. As the readership expanded, however, the boys' schoolwork began to suffer. Instead of dismantling the project, or insisting that Tom and George spend more time on their school lessons, Rube purchased a mimeograph machine to reduce the printing time! Naturally, this psychology backfired because the machine increased the number of pages per issue as well as the circulation and the boys' grades dipped even lower. The project survived for more than a year, and although Irma and Rube pretended annoyance, they secretly enjoyed the whole affair. As Rube joked, "The boys were attending a progressive school which ignored the old-fashioned concepts of spelling and punctuation to give the pupils more freedom of expression. Hence the articles and the advertisements in the FLASH-BEZITZ were anything but perfect examples of accepted jour-

nalism." The articles were a clear reflection of the Goldberg dinnertime conversation. (See pages 96–97.)

Rube's love for Tom and George was demonstrated, not by lavish gifts and mimeograph machines, but by a willingness to give them unending chunks of his valuable time. The children of too many of his friends had gone awry because of their parents' refusal to give themselves unselfishly to camping trips and baseball games. In fact, in March of 1933 Rube published his philosophy of fatherhood in a crisp article for the *Saturday Evening Post* entitled "Thankless Children":

Fathers with vests unbuttoned to give bulging stomachs a chance to achieve their full measure of globular perfection complain bitterly about the matter-of-fact way in which their off-spring have accepted their benign bounty. The members of the younger generation have traveled from the cradle to the speak-easy without pausing by the wayside to acknowledge the supreme sacrifices made by papa and mama. Children have blandly accepted all their parents had to give and then left them standing on the street corner of old age, waiting for a perfect stranger to give them a lift to the grave.

Boloney, answered Rube. He berated fathers who spent their evenings listening to the "Poetry of Canned Salmon hour on the radio" and worrying about Sam Mulligan's chances for Street-Cleaning Commissioner. Rube made sure, for example, that family outings made up a large part of his domestic routine. Once each year the entire clan would camp early in the morning on the corner of Seventy-fifth Street and Riverside Drive to watch New York's Memorial Day parade. Few sights were funnier to Rube than a patriotic assembly of overweight and gray war

THE-TENTH-EDITION-MARCH _ 1932 _ _ _ _ _

TRAFFIC !!!!!

The Flash-Bezitz is confronted with a great problem, that problem is traffic.

Far out in the wilderness one finds traffic lights by the dozen, but where they are needed most, they are as scarce as chicken's teeth! Then there is the parking hog who parks in the space of two cars and the only thing that could get in the space that he leaves is an Austin's grandchild. We think that they ought to have Robots instead of traffic cops because they at least would not be as dumb as policemen when traffic becomes conjested and then bawli people out for nothing. There is a place which is out a little ways from New York where two main roads cross one another and there is not one traffic light there! Not far away there is a dead end road with a traffic light! - - - - -

While a cop is giving a man a ticket for passing a red light which was so far up in the air that you would have to get a telescope to see it, another man goes by at about a hundred and ten miles a hour and the cop disregards him. Things like these are what the Flash-Bezitz is striving to correct and we think that while the Mayor is trying on his new beret he should think twice about the poor motorist and traffic! Any suggestions sent to the Flash-Bezitz will be apprciated

THE LOWDOWN!!

The staff this month got very good report cards, much to their fathers delight! Mom is going to give us each a new school bag because we got such good report cards considering what we had gotten the months before! – – – – –

There is an automobile tire coming out that has no spokes and is inflated with 12 pounds pressure! It is very much thicker than our present day tires.

Easter will be here soon and all of the people will put on their new clothes (if they have any left!) Pop got a new hat very much to our surprise, and he is going to show it to New York on Easter!

Down in Bermuda, where Gracie Brown, (one of our subscribers) is, the water is so scarce that a line is painted around the bathtubs showing how much water you can use, when you take a bath! There is a line for men and a line for women (the women get a little bit more water than the men!)

The income tax pest is upon our country! We have already heard of six suicide and 1132 people fainting on account of it! Well the Flash Bezitz sure wishs you the best of luck with yours! – – – – –

Staff - Tom Goldberg - Editor in Chief - George Goldberg Business manager - And Al Carxol printer – – – – – of this paper. – – – – – –

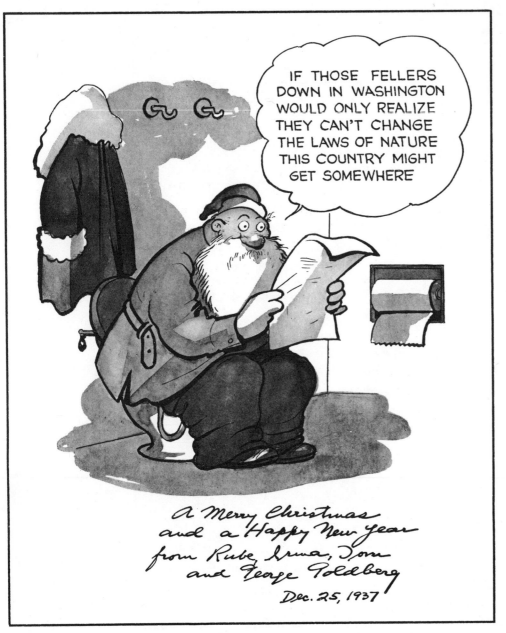

52. Rube Goldberg Christmas Card,
1937

veterans reliving the imaginary victories of their youth. Dressed in moth-eaten, ill-fitting, anciently styled uniforms, the veterans struck Rube as comic heroes similar to the extravagantly attired French gendarmes or the gaudy Italian police. He could not take ceremony seriously. His mind just naturally probed past the flags and medals until it sensed warm flesh. *Independence Day—July 4, 1917* (Fig. 49) was as patriotic as Rube could be.

The Memorial Day parade was led by a few surviving Civil War veterans who stole the show. Some rode in ancient automobiles, but most marched. They wore their original Union uniforms, and heavy martial music nudged them into a sprightly stride. Many, in their eighties, had rheumatism in their joints, but this was their day.

Ever alert to a joke, Rube saw that "their outward show of stamina was not quite matched by the inner workings of their urinary tracts." Those heroes from the past would shift their weight from one foot to another whenever the parade stopped to let in new marchers. Rube had to help:

I went up to one veteran who seemed to be the most agitated and said, "Pardon me, but if you would like to take a leak I have a convenient John of my own right down the street." He whispered a few hasty words to some of his unhappy companions and in no time at all I had nine Civil War veterans following me to my house.

They thanked Rube profusely, relieved themselves, and "fell into line with a new burst of energy." The following year and for six years after that Rube had an impressive line of Civil War veterans marching toward his toilet. On one occasion, Rube reported, "there was such a crowd that the whole parade took our street for the regular line of march. It took a squadron of police to untangle the mess."

The incident contained the basic elements of Rube's humor. Instead of responding to the martial music and letting his mind soar to thoughts of victory and glory, Rube saw only bladders and toilets. He reminds us that despite our flashy outward appearances and our desire to rise above the detail of everyday life, we are, nevertheless, earthlings tied to a fixed rhythm and hounded by lackluster necessities. The Civil War veterans were running after an ideal and stumbled over reality. They were no different from all men who, as the French philosopher Henri Bergson wrote, are "childlike dreamers for whom life delights to lie in wait."

Nonpatriotic holidays were also greeted with a rambunctious love of laughter and a frenzied determination to make the *house* a depot for enjoyment. From mid-November until early January the Goldbergs entertained continuously. Quiet gatherings for a drink and some talk usually started just before Thanksgiving, but by Christmas the pace was frantic. Rube would draw and think by day so he could drink and laugh at night. He thrived in these times of social gaiety, being stimulated by the baubles, the lights, and the holy symbols of heaven (Figs. 50 and 51).

On Christmas day, 1929, for example, he treated his readers to his newest invention, the *Unbreakable Parent*. The cartoon depicted a weary father, clad in thick armor, bravely repelling the onslaught of his children. As if to put their Christmas gifts to the test, the little brats are shown aiming their cannons, army tanks, baseball bats, and bows and arrows at dear old dad. All the missiles failed to pierce Rube's foolproof

A few words from a friendly doctor within your wife's hearing will help tide you over the holiday season

A sudden attack of deafness is always a great help around Christmas

It's a simple thing to pick a fight with her around the 20th of December and make up after New Year's

You have to spoil a suit of clothes, but this will pay in the long run

As a last resort try hypnotism

53. ... Overcome the High Cost of Christmas ..., 1924

shield, thus vindicating a shaky faith in technological solutions to social maladies.

The *Unbreakable Parent* was not an isolated inspiration but only one of a long line of cartoons documenting Rube's holiday skepticism. For his personal friends he designed an extraordinary series of Christmas cards depicting Santa Claus as a down-and-out hobo anxious to earn a quick buck (Fig. 52). Santa's sloppy attire and total lack of genuine ebullience remind us that even the universal dispenser of goodwill is an ordinary guy bewildered by the world he is supposed to serve.

Rube admitted that he did not invent the Christmas card but he alone knew who did: T. Frothingham Eggplant, a bewhiskered Englishman with a wrinkled, pointed head. According to Rube, the invention was an unfortunate case of serendipity:

One night many hundreds of years ago T. Frothingham Eggplant invited his friend, Pierre Saltseller, to his house for a sociable game of stud poker. Eggplant lost several hundred pounds and some odd shillings and told Pierre he would send him a check the very next day. As Pierre left the house the ace of spades fell out of his sleeve!

The next day, which happened to be Christmas, Pierre received a letter from Eggplant. But instead of finding a check enclosed, he found the ace of spades.

Thus the custom of sending a card at Christmas came into existence and went sliding down through the ages leaving in its wake a trail of mixed sentiments and tired letter carriers.

Rube also maintained this querulous position in his daily cartoons. Holiday shopping drove him nearly mad (Figs. 53 and 54), and his all-too-true comment, "the worst part of Christmas presents is that you have to use them," put him in the big league of Christmas debunkers—a league headed by H. L. Mencken and Robert Benchley. *The Old Rag Doll* (Fig. 55) was yet another brand of protest which was too tender for laughter.

While Christmas was pleasant in the house on Seventy-fifth Street, New Year's Eve was greeted with a planned exhilaration. Between 1925 and 1930, Rube and Irma invited five hundred guests each year to a party that stunned New Yorkers out of their blasé acceptance of the stupendous. Rube and Irma were unaccustomed to extravagance on such a mass scale, so it was a bold decision to open the bank account and mail the invitations, but—once their minds were set —they aimed to throw a party which was both "intimate and original."

When Rube started to earn his handsome salary (c. 1915), he found himself being invited to a boring string of stiff parties. He had always disliked over-refinement. One of his earliest cartoons observed that "ballroom conversation is the closest thing in the world to nothing" (Fig. 56). He loathed stuffed shirts. And he detested polite buffets: "you know, those parties where the host provides everything except the table." Rube even devised several mechanical tools for mixing drinks (Fig. 57), but each cartoon smacked more of irritation than of ingenuity. His cartoon *Notice that only one of these people is smiling* (Fig. 58) is an accurate symbol of Rube's general social preference.

Of all the social paragons whom Rube met, he envied only one: his affluent boyhood idol, Charles Dana Gibson. Despite Gibson's wealth and his meticulously decorated New York town house, Rube always felt relaxed whenever he and Irma visited there. "The atmosphere," wrote Rube, "was at the same time elegant and unpretentious." Regardless of how formal the occasions, Irene Gibson, one of the famous Langhorne

54. [Preparing for Christmas Shopping]

sisters and the original Gibson Girl, welcomed guests with a genuine warmth. "She knew the exact line that kept elegance from becoming boredom," observed Rube. Her very presence obliterated tension and self-consciousness.

Rube and Irma took Charles and Irene Gibson as their models of social conduct. The Goldbergs entertained continuously, slowly learning how to handle obstreperous butlers and wisecracking nurses. The New Year's Eve blast was their grand salute to New York society.

The preparations were a quartermaster's dream. Rube purchased gigantic sheets of white paper and sent them to all his artist friends. Each drew an original, and Rube hung them throughout the house as backdrops to the live celebration. According to all reports, every one was a masterpiece. Charles Dana Gibson produced one of his renowned Gibson Girls and Howard Chandler Christy drew a flamboyant nude. Other participants included Milt Gross, Arthur William Brown, John LaGatta, Peter Arno, George McManus, Billy DeBeck, Winsor McCay, and James Montgomery Flagg. The result: a panorama of newspaper and magazine art created by the masters themselves. Even Rube contributed. As if anticipating a future career, he constructed a cardboard statue of Joshua Pluto, inventor of the comfort station. According to Rube's plans, Mr. Pluto would spend most of the night in a window recess behind a curtain. At the appropriate time the curtain would be drawn and Mayor Jimmy Walker would dedicate this tour de force.

Meanwhile, Irma worked feverishly. She had two floors of furniture checked into storage, handled the catering problems, and hired strolling minstrels. Several hours before the guests arrived, all the pieces started to converge. The flowers came, then the food: ham, turkey, beef, sturgeon, caviar, smoked oysters, rare fruits, madrilene, cheeses, and elegant pastries. The liquor had been delivered throughout the day in small bottles to avoid drawing the attention of the frustrated officials charged with the impossible task of enforcing the Volstead Act.

The guests were scheduled to arrive at nine, but Rube was apprehensive. "I was in a daze," he wrote a short time later, "like a man suddenly dropped through a skylight into a factory that made highly colored baubles for Christmas trees." He wanted this soiree to be a hit, and shortly before nine his nerves erupted. "Suppose they don't come! Suppose nobody shows up!" But the mobs were prompt. A montage of faces streamed past the door—Hollywood stars, popular journalists, famous artists, big-name politicians. Each time Rube went to shake somebody's hand, someone else would place a coat over his arm. Within a short time he had collected a sizable pile without really meeting anybody.

Cupie Black, a former captain of the Yale football team, was made the official bouncer. He wore a one-piece, skintight, pink body-stocking over his football equipment, and—according to Rube—he was supposed to represent either a funny cupid or the "Spirit of the New Year." Cupie Black did his best to discourage the gate-crashers. At one point Rube overheard him shouting, "Get out of here, you bum. Your name ain't on the list. My job is to get rid of the ringers. Out, bum!"

A chorus of protest responded, however: "Let him in. Don't you know who he is?"

"Sure," yelled Black. "He says he's a violinist. We're lousy with violinists."

55. A Christmas Story Entitled "The Old Rag Doll," 1916

George Gershwin joined Rube to see who was trying to make his way past Cupie. A spasm of laughter doubled up Gershwin, for the "crasher" was none other than his good friend Jascha Heifetz. From that point on, the doors swung wide. The Algonquin group, led by Alexander Woollcott, Marc Connelly, and Heywood Broun crashed the party. Even the great Houdini was there performing his famous needle trick. Rube described the performance:

He unwrapped a paper of needles, placed them on his tongue and swallowed them all. A large crowd stood around gaping down his throat to make sure that the needles were not hidden in his bridge-work. Then with a flourish he swallowed a tangled piece of thread. When they were all satisfied that he had actually swallowed both needles and thread he pulled the thread out from between his compressed lips with all the needles strung on it at regular intervals.

In different areas of the house, recording stars were singing the songs they had made famous. Comedians, including the Marx brothers, were going through their polished routines. Broadway and vaudeville stars, such as Billy Gaxton and his wife, Madeline, were present, as well. Musicians played continuously.

At midnight Cupie Black donned a pair of wings and became the cherubic impersonation of the New Year—1927. Rube unveiled Joshua Pluto, and Mayor Walker tossed off a verbal gem:

Fellow citizens: We are foregathered here to pay tribute to the memory of one of our most illustrious citizens, a benefactor of inestimable distinction, a man who at great personal sacrifice, in the face of insurmountable obstacles, gave comfort and relief to our people. Hardly a man, woman, or child in our fair city has not partaken of the benefits of his unselfish benefactions—his sympathetic understanding of the unexpected calls of nature to which the human body

is prone—regardless of race, color or religion—Democratic or Republican—all have enjoyed uninterrupted privacy within the temples of purification which he has established. I will say unequivocally and without guile that his invention is even more of a blessing to human freedom than the secret ballot.

The guests applauded every cliché and demanded the mayor sing his original song, "Will you love me in December as you do in May?" Walker performed magnificently. The house resounded. For one evening, at least, the heart of New York seemed to beat on Seventy-fifth Street.

The festivities ended around 4:00 A.M. A number of guests were too drunk to move so they slept throughout the house, even on the children's beds (Tom and George had been shipped out for the evening). The next day while surveying the second floor, which looked like the lost and found department of the subway, Rube gave the whole affair a lot of thought. Why did he do it?

He really wasn't sure, but some motives were detectable. For one thing, Christmas was fun but a little too mechanical, even for a great inventor. It was a "monotonous chain of give-and-take," wrote Rube in 1929, a polite and sociable game with strict rules and hard-and-fast deadlines. The New Year's Eve blowout represented Rube's self-fulfilling desire to give and receive nothing, just for the fun of it—that is, "nothing but the satisfaction of a temporary break from the shackles of righteous balance."

Rube's philosophy of wealth and enjoyment separated him from many of his friends who paraded New York's "Great White Way." He never made his money into a god; it always remained a faithful servant. A millionaire who craved nothing more than to become a billion-

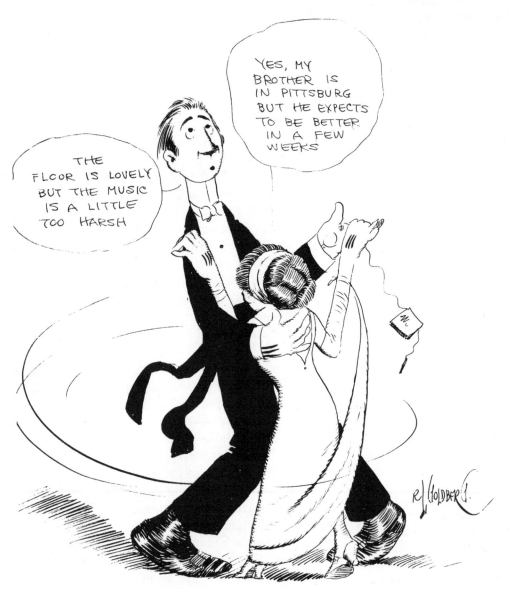

56. Detail: May I have the next dance? 1904

aire was a very poor man in Rube's mind. As he wrote in 1959, "If you have been fortunate enough to latch on to some of the better things in life, as we were, try throwing a few of them away. You don't know how superior it makes you feel."

The party made Rube feel that he still had life by the throat: I'm the guy who put the part in party. Rube was in control, for not even money could make him bend. This rather serious, almost philosophical, approach to fun explains one personal psychological problem which Rube never quite understood. He explained the symptoms vividly the day after his first party:

Although completely surrounded by the cream of New York professional life, all drinking and eating and dancing, . . . I did not quite feel like part of it all. A strange loneliness took possession of me and I weaved about seeing that nobody present suffered from the slightest neglect. The gay sounds and noises made sustained conversation impossible— just bits of sentences that in themselves conveyed no actual meaning, a sense of gloom which I did my best to hide. I never could explain why this happened to me. Always at the height of some good fortune like signing a new contract or receiving a reward. I had perfected a technique of hiding my real feelings when a depressed mood stole stealthily into my consciousness. I made myself smile more broadly and assumed an especially kindly attitude towards those around me. I never knew why this happened to me. I must have given way to my feelings for a moment because Lou Davis, the wholesale-butcher-song-writer nudged me and said, "Cheer up. Say, Rube, why are you giving this party?"

I said, "Search me." And then my mood passed as mysteriously as it had come.

Much of this trance was due to Rube's profound ability to size up people and human situations. As if by means of some inner radar system, this student of life could scan a person's psyche and pronounce his character with a frightful precision. That power made him a great humorist but it also showed him the predetermined tragedies of life. He made his living by wearing the ancient mask of comedy, but he could have easily turned it around and focused on the inevitability of death and the absurdity of life. At the times of his greatest triumphs the mask of tragedy seemed close at hand, for the true rewards always fell short of his expectations. But he held his ground and kept his smile. The depressions quickly passed, and the jokes kept coming.

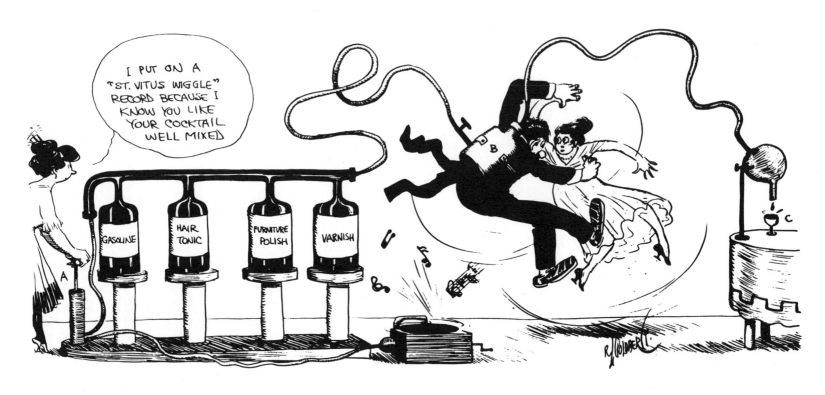

57. No home should be without one..., 1915

58. Notice that only one of these people is smiling, 1926

59. Somebody said, "Comparisons are odious," 1925

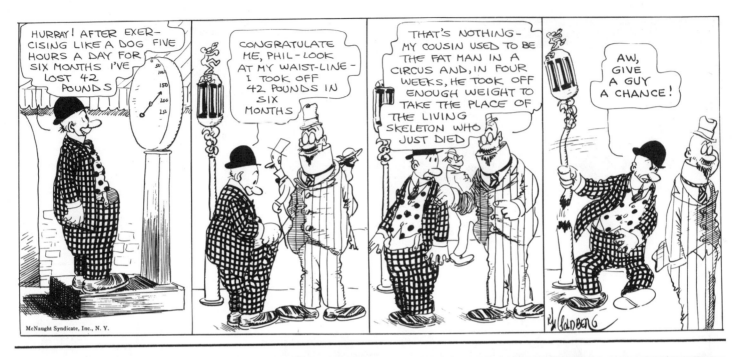

60. Aw give a guy a chance, 1923

61. Steve

8
The Fall Guy

In November 1924, sportswriter Hugh Fullerton advanced the theory that cartoonists look like and, often live like, the characters they draw. "Unconsciously," wrote Fullerton, "they inject their own peculiarities into their drawings. Study George McManus and you will observe a certain likeness to Mr. Jiggs. . . . Bud Fisher looks like Mutt." Rube, of course, did not mirror the physical distortions of his characters, but he tended to think of himself as a real-life fall guy—a clumsy, impractical but well-meaning boob who did, in fact, live his cartoons. He was Boob McNutt or Steve or the fall guy in *It's all wrong, . . . , it's all wrong, Father was right, Life's Little Jokes,* and *That's life.*

One of his classic fall guy incidents occurred in 1921 when he and Irma decided to rent a summer home in the plush surroundings of Great Neck, Long Island. Many of the well-known cartoonists, songwriters, novelists, actors, and painters occupied this "impressive galaxy of genius," including Rube's old buddy, Tad, who entertained wrestlers and fighters in a "slap-happy banter." Ed Wynn lived a few doors from Tad and, according to rumor, could be heard screaming his own weird puns in the middle of the night. Producer John Golden, actor Thomas Meighan, and novelist Joseph Conrad also resided in palatial estates with high-fenced yards.

Shortly after Rube had settled in, he was visited by two of Great Neck's most prestigious inhabitants, F. Scott Fitzgerald and Ring Lardner. The two writers had been introduced recently by one of Rube's good friends, Frank Crowninshield, editor of *Vanity Fair.* Lardner was a successful sportswriter who had followed Rube's lead by investigating the social import of boxing and baseball. His weekly syndicated column became a national institution, and his short stories, poems, and satirical observations won the praise of the brightest critics. Fitzgerald, of course, was the debt-ridden genius whose *yearly* income at that time did not even equal one of Rube's two-week paychecks. Both Fitzgerald and Lardner were dedicated drinkers who loved to play practical jokes. Their work habits also coincided. They wrote incessantly during concentrated periods, sometimes for three or four days with very little sleep. Then they would take a few days off to engage in convivial recreation until their store of inspiration had been sufficiently replenished. Rube, on the other hand, was more prosaic. He kept regular hours, day after day, "relaxing evenings like a shoe clerk," as he put it.

The day the two friends appeared they spotted their prey putting the finishing touches on a cartoon. Rube had planned to get a haircut and then take Irma to

62. Boob McNutt, 1932

dinner. Lardner and Fitzgerald asked him to join them for a bite to eat, and he agreed only after they promised to get him back "right after lunch."

The conversation and the booze sent his mind soaring:

The first hour of the luncheon was among the most enjoyable I had ever spent. We talked baseball, art, golf, and writing. We ate in the open air surrounded by lilacs and wisteria. A man named Duval or something kept bringing in glasses and taking them away. When he brought them in they were full and when he took them away they were empty. As this continued the wisteria grew more hazy and the lilacs took on a slightly alcoholic aroma.

In a short time Rube was hopelessly drunk, and while he gave up the idea of finishing his cartoon, his need for a haircut assumed a greater importance. As Rube wrote, "All I knew was that I wanted to get my noggin sheared."

"Well, why didn't you say so before!" his companions exclaimed. "We'll go with you."

It was almost closing time when the inebriates reached the barbershop in the village, so Lardner and Fitzgerald convinced the proprietor that *they* would cut Rube's hair and subsequently lock up the shop. Goldberg plunked himself down in the chair and fell asleep. An hour later he awoke gasping for air, a shaving brush stuffed halfway down his throat. He looked in the mirror and saw "two eyes staring at me out of what looked like a doorknob dipped in whipped cream. My two illustrious friends had clipped my skull closer than a convict's." Rube had gotten his haircut with a vengeance!

The next day he sought retaliation, but the "two flowers of genius" had slipped back into isolation. Nine years later Lardner atoned by publishing a biographical spoof in *Collier's* entitled "Reuben, the Young Artist, or There's Gold in Them Teeth." Lardner's thesis was simply that, despite Rube's meandering career from art to engineering to cartooning, he was a natural-born humorist who could not help succeeding.

Rube played the role of a fall guy beautifully. By the time he had met Lardner and Fitzgerald he knew his part by heart. His painful experiences on the *Chronicle*, his discouragement after arriving in New York in 1907, and his first two journeys to Europe were memorable examples. But perhaps the most famous occurred shortly after World War I.

In 1918 a company of actors from New York's Friars Club, to which Rube belonged, made a two-week tour of the large cities to raise money for a new clubhouse. George M. Cohan was the abbot of the Friars at that time, and he wrote an old-fashioned minstrel show for this tour. Rube and a fellow cartoonist, Bud Fisher, were part of the cast, which was made up of some of the best theatrical men in New York, including Willie Collier, De Wolf Hopper, Julius Tannen, Frank Tenney, Sam Harris, and Irving Berlin. After their nightly performances the troupe would meet in the dining car of their special train. One night, as George Cohan was sitting with Rube, a porter brought in a few decks of cards. Cohan picked up a deck, shuffled it, and challenged Rube to draw a high card against him. The bet was for fifty cents. After ten consecutive plays Cohan had won five dollars for an unbroken turn of wins. "Ten dollars or nothing, Rube," Cohan chanted, and when he drew the high card for his twelfth straight win they doubled up again. The small crowd which began to gather simply gasped at Cohan's success. Five more rounds and Rube owed $2,560. Nineteen straight.

At this point, according to Rube's account, Irving Berlin whispered to the unlucky cartoonist, "Don't be

63. Boob McNutt, 1933

an idiot. You can't stand the gaff. This fellow's a millionaire, and you'll lose every cent you have."

Rube brushed Berlin aside and asked Cohan, "How much is this for?"

"Five thousand, one hundred and twenty dollars." Rube pulled a jack and Cohan a king.

Again.

Cohan drew a four. The crowd held its breath. But Rube drew a three! $20,480.

Twice more and Cohan had $81,920.

"I can't stay up all night giving you a chance to get even," Cohan snorted. "One more draw and that's the last. What do you want to make it for?"

"Double or quits," quaked Rube.

Rube drew the $163,840 card first: a five of spades!

"That looks like an easy one to beat," said Cohan, drawing a card from the middle of the deck. The crowd closed in and Cohan exposed the three of clubs.

Even!

Cohan grinned and rose from his chair. "Good-night, fellows. The next time you want to see Rube and me do our act you'll have to pay admission."

After he left, the other Friars stood in disbelief. Had they been duped? "On the level now, Rube," asked Berlin, "was that game just a lot of bunk?"

"Absolutely," Rube responded. "George whispered to me when Jim Corbett and Sam Harris came over that all bets were off and we'd just have a little fun with you fellows."

"Well then, all I've got to say is that if either one of you could act as well in the minstrel show as you can in a phony card game the thing would be a risk. But at that I think you're a liar."

Berlin was right, as Rube confessed. He had hated cards since his childhood.

It was at this time that Rube developed the protective word to curb his penchant for fall-guyism. During his college days he had observed that Americans loved to use slang phrases to let the hot air out of anyone who seemed artificial, pretentious, or conniving. "We do a great deal of expressing ourselves, in terms of slang," wrote Rube in the 1920s, "and it seems to please our imagination most when we can devise some odd-sounding word or phrase that applies to the ancient art of sham." Rube, of course, gave us a classic expression: "Boloney" (Fig. 59). He used it in his cartoons to contrast the falsehoods and the truths in our daily lives. In most cases "Boloney" appeared in a little box (called a "filler") at the lower right corner of his daily cartoons. "Boloney" was born in Cleveland, where Rube had been covering the 1920 World Series between the Indians and the Brooklyn Dodgers. Morris Gest, a theatrical producer, was touring the play *Aphrodite*, and he invited all the newsmen to a performance. Rube attended and, like the other journalists, was dazzled by the elaborate staging. Then the inspiration:

When the big scene of the play came, embellished with all the flourish Morris Gest always gave his shows, most of the audience sat enraptured with the magnificence of the display. Apparently everybody in the theater but one was deeply moved. . . . A business man from Philadelphia was the single exception. With a wave of disgust, he walked toward the entrance, remarking as he started to leave, "That's just a lot of boloney."

Rube broke up with laughter: "Such a descriptive phrase for such an event! Contrasting so sharply with the solemnity of the moment, it struck me as one of the funniest lines I had ever heard."

"Boloney" did not appear in Rube's cartoons until

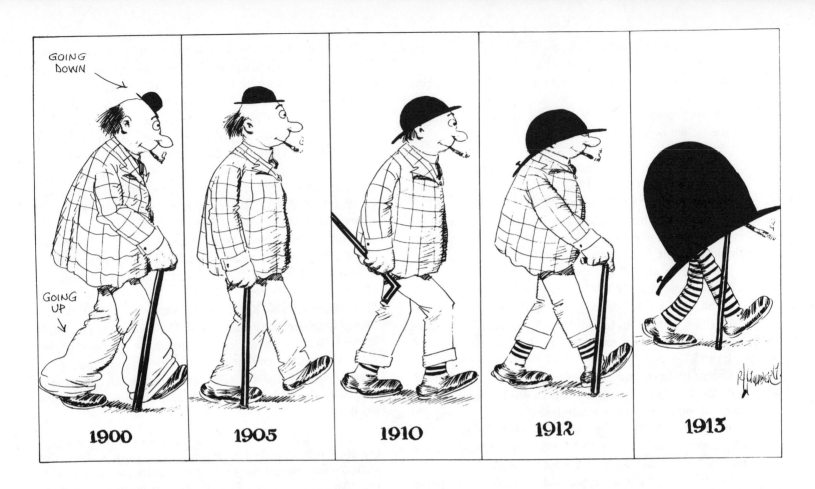

64. Style of Men's Hats and Pants, 1912

six months later. When it did, Rube used it as he had heard it used: a foil against pretension and fakery. He even had a rather clear philosophy:

> Boloney sausage is a funny sort of thing . . . in the sense that most people like it and hate to admit they do. . . . Why had it never been used . . . in cartooning? The only explanation I could find was that the word didn't mean a thing when spelled correctly—Bologna. Everybody under the sun called it boloney—a marvelous moniker in itself—and nobody would know what you were talking about if you pronounced it the right way.

"Boloney" became a nationwide response to hoodwinking and fall-guyism and it's used widely. Of course, Rube gave us its most eloquent phrasing: "No matter how thin you slice it, it's still boloney."

But the anecdotal character of Rube's life was not confined to either literature or show business. Politics and family relations also played a part. Rube inherited from his father a casual but steady allegiance to the Republican party. He strayed from the path only once, in 1932, when he voted for Franklin Roosevelt. Having been raised in a Republican hotbed of political corruption, Rube was not exactly shocked by the graft and bribery of New York's Tammany Hall in the 1920s. Even the general air of socially acceptable lawlessness and the public tolerance of gangster politicians did not annoy him. Mayor Jimmy Walker, who was first elected in 1925 and then again in 1929, was the idol of the city. The former songwriter had jumped from Tin Pan Alley to politics without missing a beat or changing his tune. He was a playboy who seemed to spend more time on ocean liners than in City Hall, a full-time pleasure-seeker addicted to nightclubs, racetracks, and women.

Rube and the mayor often appeared at the same social functions because Irma's brother, Billy Seeman, was one of Jimmy Walker's closest friends. Billy was a constant source of gossip for Broadway columnists. Being a "confirmed" bachelor with a flair for publicity, he was the absolute opposite of Rube. He and the mayor would disappear for days at a time and give marathon parties at Billy's apartment in Greenwich Village above the Pepper Pot. Billy often kept his closets full of theatrical costumes, so whenever visitors called they never knew whether their host was going to be dressed in full Indian battle regalia or in the costume of Emmet Kelly—complete with makeup, putty nose, and white lips. Billy convinced Rube that men could be unpredictable, colorful, and independent. As Rube noted, "Billy might turn up in a rodeo on one of Tom Mix's horses, or in the circus at Madison Square Garden on a performing elephant. You might find him playing the violin in the orchestra at the Copa Cabana or dressed up as a Bavarian waiter serving beer in a Yorkville rathskeller." When he was a senior at Cornell, Billy drove a busload of chorus girls from the Ziegfeld *Follies* through the campus. He missed being expelled by the thickness of a White Rose tea leaf.

When Billy was commissioned as a second lieutenant during World War I, Pop Seeman, Irma, and Kitty, Irma's sister, planned a grand celebration with dinner and the theater. The family was assembled at 7 P.M., but the guest of honor was missing. A phone call from Billy described the over-hasty cab ride from the training field to the railroad station. When the taxi stopped suddenly, Billy's head had gone through the glass partition that separated him from the front seat. Treated for the damage at the nearest hospital, Billy assured Rube he was all right. He would meet the Goldbergs and the Seemans at the theater.

After a quiet but enjoyable dinner Rube and his

65. You generally pick out the wrong one, anyway,
 so why not this? 1917

entourage went to the play. Just as the curtain was rising for the first act, Billy arrived. Dressed in a meticulously tailored olive-gray uniform, he appeared, remembered Rube, as "a perfect specimen of American youth ready to make the supreme sacrifice for his country. The bandage on his head was as neat and well-tailored as his uniform. An even white band going completely around his head and another white band extending at right angles under his chin. A model for a James Montgomery Flagg war poster."

The most startling experience of the evening, however, occurred during the intermission when the theater manager appeared and made an impassioned plea in behalf of Liberty Bonds. Unfortunately the audience refused to part with a dime. The manager seemed to have exhausted all his persuasive phrases, but he gave one last try: "I am asking you older people to open your purses and help in a desperate cause— to buy bonds, to make an investment that will bring interest while our young men go abroad to risk their lives. I guess I have to bring home to you what I am trying to convey—a living example of the horrors of war." He then turned to Billy and asked him to stand. Billy, bandages and all, rose briskly and smiled radiantly. The effect was "electric," in Rube's word. "Young ladies rushed from one person to another writing down orders for Liberty Bonds." It was the theater's most patriotic demonstration, and Billy was the star of the show.

This type of zany thing happened to Billy time and time again. When he married the actress Phyllis Haver, the wedding was held in Rube's house on Seventy-fifth Street. During the ceremony Paul Whiteman and his band stationed themselves outside the front door. They planned to surprise Billy by bursting into music when the bride and groom appeared. Unluckily, the affair indoors was spoiled when a decorator sent by the florist decided to test Rube's liquor. As the crasher finally was ousted, Whiteman hit a downbeat and played "Here Comes the Bride," but only the limp body of the inebriate appeared. Billy and Phyllis were still inside!

The fall guy took on numerous forms in Rube's cartoons. Usually he was a nameless sufferer who accepted a kick in the pants as readily as did San Francisco's town loafers (Fig. 60). But sometimes, like Steve, he had a special knack for eliciting pity and laughter simultaneously (Fig. 61).

Rube captured the essence of fall-guyism with his Sunday color comic hero, Boob McNutt. Boob was the lovable loser, the eternal scapegoat, who attracted trouble every Sunday for twenty years. Born in 1915, he did not come into his own until June 9, 1918, after Rube and the Evening Mail Syndicate signed a contract with William Randolph Hearst's Star Company. The *Mail* received $22,100 per year and turned over 75 percent of the take to Rube. When the *Mail* was absorbed by the New York *Telegram* (1924), Virgil McNitt's McNaught Syndicate renegotiated a five-year agreement with Star to produce a Sunday color page and six dailies, all featuring Boob McNutt. For this increased production the Hearst company upped its yearly payment to $78,000. These lucrative arrangements lasted until September 30, 1934, when Boob retired, obviously exhausted from counting his money.

The Boob McNutt Sunday page, which appeared in Great Britain as well as in the United States, was crammed with romance and suspense and technological gadgets of every description. There were Mike and Ike, Boob's buddies, twin bunglers unparalleled even

66. The income tax has started a lot of weary thinking, 1913

in the crazy world of comic art. Evil scientists and weird animals stalked the Boob brigade at every turn, but somehow—as in Rube's daily works—the heroes tripped their way to safety.

Boob was a bachelor who courted the beautiful Pearl. They were always on the brink of marriage, as Rube himself explained, "with something constantly happening at the crucial moment to defer the ceremony, due to some stupid blunder by the hero." When they finally tied the knot—a move brought about by Boob's fan mail—Rube feared that the end of the strip was near. "Please note," he wrote in the *Saturday Evening Post* (1928), "that the word 'finis' is written to most love stories when the hero and heroine join in wedlock." But Boob lived another seven years, stumbling along from one misadventure to the next (Fig. 62).

Few cartoonists pack as much into a single page as Rube attempted. During the mid-1920s his Sunday offering included twelve panels of dense activity—each panel as crowded as many of his daily cartoons. At the top right corner he often included a Boob McNutt cutout or a word puzzle or a guessing game (Fig. 63). While these works lack the novel slant of Rube's single-thought creations, the name Boob McNutt became synonymous with the hapless fall guy. When Paul V. McNutt, administrator of the Federal Security Agency, was discouraged from running for the presidency in 1940, he remarked, "Boob McNutt ruined my chances of ever being President. People just won't take a chance on a fellow named McNutt because he might turn out to be a boob."

Stephen Becker, in his pioneering history of comic art in America, put it this way: "McNutt, McNitt, McNaught. It could only happen to Rube Goldberg!"

67. Woman's place is in the home, but that is no reason she should
 not vote, 1918

9
Life's Little Pleasures

Rube's self-effacing fall guy image helped him to keep his humor on the broadest plane of popular acceptance. Most newspaper readers, even in the roaring twenties, did not sail to Europe, or dine with Jimmy Walker, or own custom suits and hand-finished touring cars. And Rube was well aware that social prominence could estrange him from the base of his success: the everyday lives of everyday people. Never an elitist cartooning for the few, he worked to remain a democratic philosopher appealing to the widest spectrum of newspaper readers.

Usually his daily cartoons depicted the average guy doing his best to abide by custom. But custom, as Rube saw it, was continually changing. No sooner does a person get used to a new pair of shoes or adjust to a new diet than everything changes. It was just this comedy of manners which tickled Rube, who understood the pain and embarrassment most people feel while trying to stay up to date. Whenever a new clothing style (Figs. 64 and 65), or tax amendment (Fig. 66), or liquor law appeared, Rube simply watched people trying to adapt. Newness, or, more precisely, the social confusion which inevitably follows in its wake, became a dominating subject of his work.

Virtually all of Rube's cartoons, for example, show people in costumes that do not fit. Their shoes turn up or bend out; their pants are baggy, their hats crumpled. Rube's characters are forever out of fashion. Their wrinkled ties and stained trousers led him to quip, "Adam and Eve had the best of it when it came to clothes."

Clothes, and man's continual struggle with clothes, fascinated Rube. Somehow, in trying to clothe himself in a distinctive manner, man seemed to call greater attention to his nakedness. As the drama critic Walter Kerr has noted, "Clothing is something patched together to conceal a truth: not the truth of sexuality but the truth of vulnerability. But it can never be more than a temporary defense, and the ultimate image it is straining toward is that of the naked man in a rain barrel." Clothing which is ripped or dirty convinces us that the wearer is indeed human, and Rube's humans are among the most human specimens ever to congregate on a single drawing board.

In Rube's opinion, women were the keepers of clothing styles; for some of them, clothing was more essential than food. Rube's eye-catching girls of the twenties were modeled after Irma—lean, graceful, and of course stylish—but most of his caricatures were far from ideal. Unlike the Thurber cartoons, which depicted women as domineering monsters, Rube's ladies represented every conceivable type. A

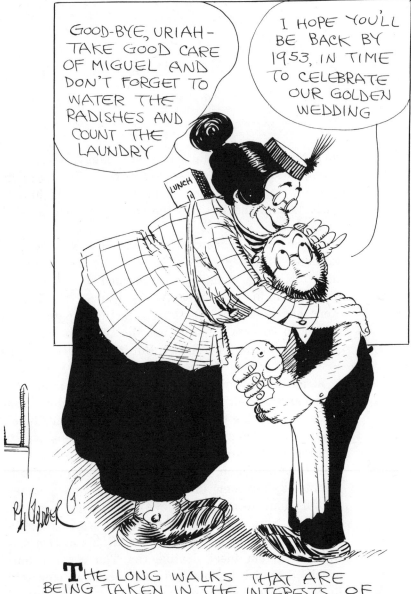

THE LONG WALKS THAT ARE BEING TAKEN IN THE INTERESTS OF SUFFRAGE MAKE IT LONESOME AROUND THE HOUSE.

68. The suffragettes are getting ready for the walk to Washington, 1913

humorous cross section could be found every Tuesday at the *Weekly Meetings of the Tuesday Ladies' Club,* a series Rube began sometime around 1914 and ran until 1935. It was based on Rube's sincere belief that women are one-way sound machines: champion talkers but totally inadequate listeners. Most of the meetings were culturally oriented, characterized by hot air and a constant chatter of non sequiturs.

George Meredith, the English writer, observed in his *Essay on Comedy* (1877) that all nations with a sound tradition of comedy give a special place to women: "Where women are on the road to an equal footing with men, in attainments and in liberty, comedy flourishes." Although Meredith was incorrect when he made sexual equality a precondition for comedy, Rube certainly illustrated the quality of humor inherent in the battle of the sexes. His sympathetic treatment of the suffragettes is a clear example (Figs. 67 and 68).

Women, of course, were not his sole concern. The subjects of style and modernity seemed inexhaustible. Long before the news media became a common item for public debate, Rube made a few of his own observations. His generic title for all newspapers was "The Daily Groan." He was impressed by the plethora of bad news and the never-ending search for the latest scandal. The original purpose of a great many cartoons was to offset tragedy with a laugh, to keep people on a healthy emotional diet.

It was during World War I that Rube made a few obvious but important comments which many "experts" are only today coming to understand. First, he insisted that it was impossible for newspapers to remain neutral on current issues (Fig. 69). Second, in their drive to sell the most newspapers, publishers failed to distinguish between the important and the trivial —everything, regardless of its absurdity, was peddled

as the newest NEWS (Fig. 70). Third, news stories of celebrities sold newspapers. And if a picture or two accompanied the reporter's copy, so much the better (Fig. 71). And finally, America's passion for the newest, latest, most up-to-date news had created a torrent of words which could not be read by the fastest reader (Fig. 72).

Rube also maintained his personal crusade against politicians. When he covered the Republican presidential convention in 1920 with Will Rogers, he accompanied William Jennings Bryan, who was on a retainer with the McNaught Syndicate. During his campaign of 1896 the former hero of the Populist party ate five full meals a day, took half-hour catnaps between endless whistle-stops, and when awake never stopped his tongue from moving. The habits of 1896 carried over to 1920. According to Rube, Bryan, the youngest man ever to run as a powerful contender for the presidency, was

always asleep and had to be awakened to write his daily story for the papers. We would tap him on his sleepy shoulder and before he was quite awake he would start orating about the "great American heritage," "the flag," and "our founding fathers." Oratory to him was like an automatic belch.

To Rube, Bryan was a living caricature of all politicians and speechmakers. Somehow politicians thrived on clichés and choked on gut issues. In 1920, for example, they preferred to spend great quantities of wind on the merits or faults of the newly proposed League of Nations: Should America join or should she revel in a new era of isolation? "Who cares?" asked Rube on July 14, 1920, because "The League of Nations isn't so close to the voter as it is to the orators." Another campaign issue was the Red Scare which Attorney General Palmer had concocted. Rube viewed

69. It's less dangerous to fight than to remain neutral, 1915

70. I'm cured, 1914

71. When a rich man sneezes, they set it to music, 1916

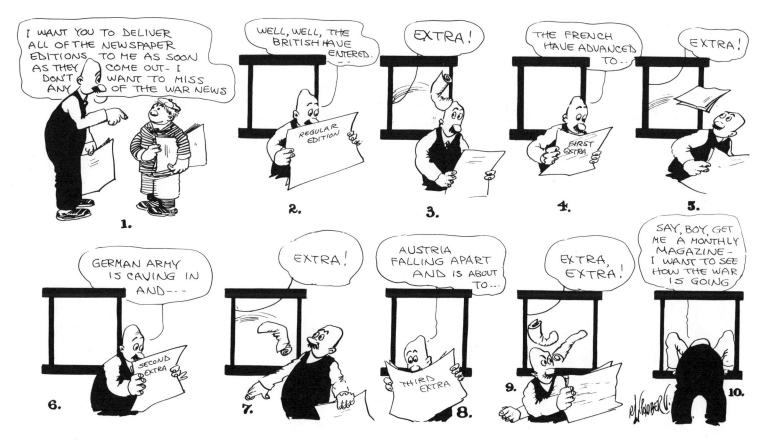

72. You don't get time to read an extra before another comes out, 1918

Soon the wheeled affair appeared and was rolled down the hall accompanied by a Ku Klux parade.

My wife and I had not been home from the hospital more than five minutes when the letter man arrived with the bill.

73. Ku Klux Parade, from *Is There a Doctor in the House?* 1929

74. The letter man arrived with the bill, from *Is There a Doctor in the House?* 1929

this early version of McCarthyism philosophically: "Every investigation is something like a doughnut," he wrote; "there's no end to it."

Instead of substantive issues and illnesses, Rube aimed his humor at a greater political disease: public speaking. In a cartoon entitled *Breaking Even,* he provided responses for men who attend political banquets but never "get a chance to address the chronic 'after dinner speaker' ":

(A) I have written an original poem for this occasion entitled, "In cheese there is strength": "O Honored guest/ You are a pest,/ You're baggy at the knees,/ Although you're wrong you are in strong—/ Here's to a piece of cheese."

(B) Unprepared as I am after practicing on this speech for six months . . .

(C) Gentlemen, this is the proudest moment of my life— when I realize that every man at this table owes everybody else money, I am deeply touched.

(D) Mr. Toastmaster, Fellow members of the Hinge-designers Protective Association, Waiters, Friends, Enemies, Everybody, Nobody and Honored guest . . .

(E) As I look around me and see agony written on your smiling faces, I am reminded of the story of the undertaker and the baked apple.

(F) I know there are many brilliant speakers to follow so I will only take up 3 or 4 hours of your precious time to point out the advantages of that noble institution, the celluloid collar.

But while many of Rube's cartoons embodied his fall guy image, his best-known chronicle of the unfortunate anybody is a little book written in 1928: *Is There a Doctor in the House?* It was based on two real-life misadventures, both ending with Rube as a victim of medical vagaries and stupidity. The first incident occurred late in 1927 when Irma made one of her frequent trips to the hospital. Though basically a healthy individual, one part of her anatomy or another always needed adjustment. Like a finely tuned, high-powered machine, she required regular and sensitive attention. On this particular trip her appendix needed repair, so Rube, innocent family man that he was, faithfully performed his duties:

Sunday night I took my wife to the hospital and met the two nurses who were to sit around for the next three weeks reading the latest novels and tabloids at eight dollars apiece a day. . . . After a sleepless night, I reached the hospital at nine and was told I could not enter the sick-room. They were wrapping the patient for mailing to the operating room. . . .

Soon a wheeled affair appeared and was rolled down the hall accompanied by a Ku Klux parade. They all marched in perfect order, their heads encased in spotless white flour sacks. My wife was queen of the carnival and rode aloft in the wheeled chariot [Fig. 73].

The next few hours were pure agony. Rube had his chauffeur drive him around town, then back to the hospital. The fourth floor, he insisted, "was as silent as a tomb." Had the knife slipped? Did the doctor know his stuff? Would everything be OK? Rube was befuddled and knotted by frustration.

By six o'clock that evening Irma had revived but was not the personification of social grace. "When I entered the sick-room," noted Rube, "sure enough my wife was out of the ether. But she was also out of sympathy with any views I had to express regarding the latest achievement in the art of surgery." After a forlorn look from Irma, Rube departed for a second night of restlessness.

When he called the nurse the following morning, she told him not to buy flowers but to bring a radio, a soft pillow, a dozen grapefruit, some Castoria, and a

75. This is only a psychological cartoon, so that lets us out

folding card table. "For several days," joked Rube, "when people saw me walking along the street they thought I was a pack-mule that had strayed from the desert." Being a romantic person, he was itching to bring candy and perfume and flowers. Finally when he got the go-ahead, he ran straight to the florist for a box of roses. But when he triumphantly carried them into the hospital room, he found that Irma's friends were a step ahead of him. "The room was filled with candy hats loaded with gardenias. Vases longer than golf bags were bursting with American beauties, and carnations oozed out of fancy urns and bowls. My two dollars' worth of flowers looked like the parsley you push off the plate after the chops are served."

And there was more anguish to endure. Every time Rube tried to enter Irma's room, he would find a crowd of women "talking about their own operations," which were similar to Irma's but always worse. Each had been attended by the greatest specialist in the world. Each had the best nurses, the most flowers, and the cheeriest room. The crowning blow came five minutes after Irma returned home: The letter man arrived with the bill (Fig. 74).

Rube caught the whole ordeal in a superb essay entitled "I, Rube Goldberg, Hereby Plead for Ether for Husbands, Too" (first published in *Cosmopolitan*, December 1928).

"Well, doc," asked Rube after the operation, "is she all right now?"

"Your wife really had a remarkable condition," answered the whiskery genius. "The magoozlum valves were all crowded around the appendix, causing adhesions which affected the screeves duct and completely shut off the woff. This pressed up against the immik gland and twisted the gadget around forty-five degrees, filling the goofle with carbon and causing a slight infec-

tion of the yonkle. It was a clear case of ovis poli."

The good doctor even provided a diagram of Irma's insides.

"What is that round thing with the mark on it that makes it look like the number six ball?" asked Rube after careful scrutiny.

"Oh, don't bother about that," the doctor answered, "I took that out."

"And what is that oblong thing with the bay window in it?"

"I took that out, too."

"And how about the barn over there and that bunker here, and that hedge there and all those artichokes lined up in the corner?"

"I thought I might as well take those out, too, as long as I was at it."

Rube concluded that the doctor hadn't missed a thing. He was a "cutting fool," Rube observed, "and there was I with a hollow wife on my hands. On stormy nights the wind would whistle through her with a sad, sad moan and the children would think she was haunted."

There is no record of Rube's having read Molière, but his insights into modern medicine men suggest at least a passing sympathy with the French master. After one of Molière's doctors gives an obscure, unintelligible explanation about a disease, a colleague observes, "The arguments you have used are so erudite and elegant that it is impossible for the patient not to be hypochondriacally melancholic, or, even if he were not, he must surely become so because of the elegance of the things you have said and the accuracy of your reasoning." Both Molière and Goldberg depicted doctors as automatons who try to regulate life like a business routine. Their doctors are the quintessence of pedantry, the supreme example of scientific paragons pretending

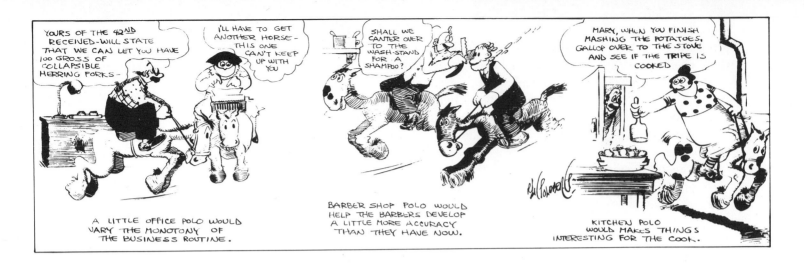

76. International polo will have us doing everything on horseback
77. Rube Goldberg's Boobs : Babe Ruth's homeruns bring back the days
 of the old air raids, 1920

to outdo nature. One of Molière's characters, Sgana-relle, for example, answers an observation that the heart is on the left and the liver on the right by confidently noting, "Yes, it was so formerly, but we have altered all that; now, we practise medicine in quite a new way." Again, Doctor Deaforus in *Malade Imaginaire* insists that "you are only bound to treat people according to form," and Doctor Bahes, in *L'Amour Médecin*, proclaims that "it is better to die through following the rules than to recover through violating them."

Rube, too, worked to expose the nonsense connected with professional etiquette. His main criticisms were twofold: (1) Doctors take themselves too seriously and (2) they often lack common sense. Even when Rube reached the eighth decade of his life, he did not soften his crusade against professional pomposity. In 1966, for example, he was admitted to a hospital to have a large sliver of bone removed from his right knee—the result of a fracture he had incurred while "training for the knee-crawling-collar-button-finding-event in the coming Mexican Olympics." A coterie of specialists ("the best in the world!") peered somberly at his X-rays for hours. They had conferences and meetings, and through it all not one of them cracked a smile. The third night they decided that "tomorrow we will operate," but the following day they decided against it. According to Rube, there "was a strike of knife-sharpeners, so all their learning and all their meetings went blahooy."

But while Molière's humor casts a serious doubt about the state of knowledge on the new and sometimes spurious profession, Rube's jokes had a different cast. He did not ridicule the facts or the achievements of medicine, for even Molière would be tongue-tied before the modern wonders of surgery and drugs. No, Rube

poked fun at physicians' pride and their inability to explain their work with simple words to average people. Their very skills seemed to put them out of touch with everyday life.

Rube's respect for the knowledge which is crammed into a doctor's head was strained severely after he suffered from an incorrect diagnosis. Early in the spring of 1928, he and Irma and the boys rented a vacation house in Connecticut. Late one evening he awoke with severe chest pains and a strangling sensation in his throat. Being a bright guy, he knew that if he stopped breathing, he would lose "interest in talking movies and stock profits and good-looking girls and pitch shots to the green." So he asked Irma to summon the doctor. After a routine examination Rube learned that everything was working correctly except his heart! A slight attack, or something like it, had occurred!

The following day the Goldbergs headed for New York. Rube was so frightened that sweat oozed from every pore. Going to his car he clung to a white picket fence surrounding the property and was observed to have taken one step every five minutes. Once in New York, he visited a slew of specialists, each of whom convinced him that his heart was healthy and that he had nothing to fear. Needing reassurance, he even sought out a psychoanalyst in a desperate attempt to learn the "truth."

For most of his life Rube regarded psychology as a kind of mental alchemy—a complete fraud created by simpleminded intellectuals (Fig. 75). His cartoon *This is only a psychological cartoon, so that lets us out* clearly depicted his feelings. To Rube's surprise the doctor made a few poignant observations. He insisted that Rube was a hypersensitive person who let himself become too annoyed with the peculiarities of others. "If there is something wrong with other people," the

78. Detail: A Smile in Brooklyn, 1919

analyst noted, "it is their own cause for worry, not yours. Don't let little things bother you. Don't look for weaknesses in other people. Ignore them. If you think you are better than other people, don't try to prove it all the time. They'll find it out."

The perceptive "shrink" (as Rube called him) had cut to the core of the forty-six-year-old humorist's personality. For twenty-four years Reuben Lucius Goldberg had earned a handsome income by doing just what the doctor said he shouldn't do: analyzing others, looking for their peculiarities, and struggling to be the number one comic in America. Rube did not take the analysis too seriously, but he did tuck it in the back of his mind for future reference.

As Rube was leaving the analyst's office, he asked him what all this psychological mumbo jumbo had to do with his chest pains. "Very simple," the doctor answered. "You are in a highly nervous state and you are swallowing air into your stomach. Don't swallow any more air." "That's a hot one," thought Rube; "how does one know when he is swallowing air?" Later, a heart specialist confirmed the psychoanalyst's diagnosis and prescribed a regimen of exercise to be followed four times a week. Typically his new schedule led to an endless stream of fall guy laughs which Rube revealed in another article: "What You Need Is Exercise."

To appreciate the joke of Rube's being ordered to a gymnasium we must remember that until 1933 his cartoons usually appeared on the daily sports page, and, as we have seen, his earliest cartoons attempted to explore the social impact of professional athletics. While his San Francisco editors worked to keep him on the sporting event itself, his first love was with the fans and their spouses. Once in New York, his natural talent to generalize developed into a masterful com-

mentary on "professionals at play." The rising sport of international polo, for example, was bound to "have us doing everything on horseback" (Fig. 76), predicted Rube.

As for baseball, the Sultan of Swat was making his play for national renown. On August 6, 1920, Rube insisted that "Babe Ruth's homeruns bring back the days of the old air raids" (Fig. 77). Baseball exerted a special magic. When the Brooklyn team won the pennant in 1919, Goldberg actually witnessed a few happy faces on Bedford Avenue. This detail (Fig. 78) from one cartoon proves baseball's humorous effects.

Through it all boxing remained his favorite sport. Jack Dempsey and Gene Tunney were Rube's good friends until his death. Dempsey, of course, was king of the ring in the 1920s: a young Hercules who hammered opponents mercilessly as he soared to national fame. Even the polite, intellectual sectors of the middle class began to cheer him on, causing what Rube called a "growing refinement of prize fighting." When Dempsey appeared in *Vanity Fair* posed as Rodin's *Thinker*, Rube exploded and demanded equal time. So in the September 1923 issue there appeared a stern warning to all "nice, refined gentlemen with brains that can fathom the deepest intricacies of a problem in bridge, and tongues that can unravel the names of the great Serbian painters, Hungarian playwrights, and Russian composers." Boxing, said Rube, might adapt to changing social conditions but it could never be put in a class with "violin recitals, debating societies, nut sundaes . . . embroidery and Mah Jongg." There were certain unchangeable, sanctified facts about the sport, and Rube defined them with the precision of a logician: "Fighting is fundamentally a lowbrow game. It is based on the hypothesis that one man must arrange matters with his fists so that another man can't stand

79. The Movable Tee—for Pests Who Take an Hour to Drive

up any more. The fight fans are unhappiest when there is no blood. The blackeye is the symbol of action. The crowd jeers when nobody gets hurt." As if to prove his point, Rube often drew cartoons which were nothing more than a series of portraits depicting the most contorted chunk of a boxer's anatomy, his head. These grotesque caricatures have a diabolical quality. Although they dramatize the ugly and the battered, we laugh at them because they are drawn in fun. The captions reassure us that Rube is a close and sympathetic friend. "So many things have already become high and righteous and mighty and properly organized," wrote Rube in 1923, "that restaurant proprietors will soon have to furnish a table of contents with every plate of hash served in their establishments. . . . Don't let the boy with the cauliflower ear know he is a great artist with a message to deliver to humanity. Don't let him know he is a half-brother to Apollo. He is one of the few natural products we have left."

But Rube's love for the bloody knockout was generated from the sideline. He himself never trod upon the canvas. Golf was the only sport he practiced, and even that he regarded as a joke (Fig. 79). "The golfer who is not a liar is not a golfer," he observed. Occasionally he would drop a score into the high 80s, but more often than not he carded a 95 or above. Golf really wasn't exercise, Rube quipped one time. "The only energy I expend in the game is walking from the first tee to a sand trap where I generally remain for the rest of the day." Being ambidextrous, he owned two sets of clubs and, depending on his mood, would address the ball from either side. He continually ridiculed the golfing perfectionists who kept changing the rules, the equipment, and even the courses. His good friend Grantland Rice, editor of the *American Golfer*, loved Rube's humor and invited him to jot down a few of his own pet peeves. His philosophy of the game is apparent from this section of the article, which appeared in the July 12, 1924, issue:

I have been trying to play golf for the last seven years and have been reading about the game for twice as long. I get no comfort out of the continuous flow of golf reform literature that bellows and splashes against the shores of duffer island. Those who are suggesting new improvements are tackling the game from the wrong end.

When I read that the new rules prohibit the use of corrugated club ends it has as much effect on me as if I had just heard that the Gaekwar of Barada had issued a decree calling for purple tassels on all elephant saddles on Mondays and Fridays. The only good my back-spin mashie ever did me was to use it as an onion grater when we were fortunate enough to have caviar sandwiches on picnics.

Some people think the new metal shafts are a great improvement over the wooden ones. I have tried both and I would do just as well with rhubarb or asparagus. Every time they bring out a new ball called "The Purple Flash" or "The Comet's Tail" or "The Galloping Dandruff" I laugh so loud I wake up my caddie. I made the best drive of my whole golfing career with a meat ball I had picked up by mistake from a passing lunch wagon.

Another thing that seems to take up a lot of time and energy among those who are sincerely but unwisely seeking new antidotes for the duffer's poisonous mistakes is wearing apparel. I have actually gone out on the links carrying eighteen sweaters—one for every hole. Each one of the sweaters, according to the ad, was built to give the player a particular advantage in playing certain shots. Some were fashioned to keep the neck rigid, others were made to keep the elbows dry when playing chip shots out of the ocean and still others were designed with special cartridge belts for carrying spare pencils with which to write down extra large scores. The sweaters were all different, but my shots all remained the same.

I even went and purchased a pair of those terrible-looking

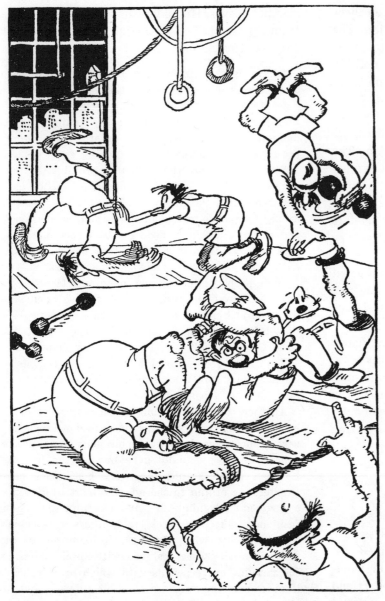

They were throwing their legs over their heads and tying themselves into sailors' knots.

80. Tying Themselves into Sailor Knots,
from *Is There a Doctor in the House?*
1929

English knickers that are baggy enough to hold a radio set, and stop somewhere between the knee and the ankle. They don't look like short pants and they don't look like long pants. They are a first cousin to balloon tires but don't give you near the mileage. I played one round in the pair that I bought and my caddie said to me just before he left, "Gee, your old man must be a pretty big guy, if you can wear his pants cut down and they're still too big for you." I gave the pants to my wife's sister who was having a garden party at her place in the country. She used them for Chinese lanterns.

As I said before, the reformers are trying to reform the game from the wrong end. The thing that needs changing is not the golf ball or the golf club or the golf trousers. It is the golf course. I am surprised that nobody has ever thought of suggesting the left-handed golf course. The left-handed golf course is bound to come if the game is to survive. It is an absolute necessity—for me at least.

I forgot to mention that I am left-handed—and there must be thousands of other unfortunates in this country like myself. I have been advised to switch to right-handed. But why should I? I have been eating soup for forty years with my left hand and I am not boasting when I say that my shirt front is as clean as the average man's. In the ordinary course of things it is no handicap to be left-handed. No woman ever refused to bow to me when I tipped my hat with my left hand—that is, no woman who knew me. I don't remember ever making a waiter sore by handing him a tip with my left hand.

When I take a practice swing at home people look in through the window and say, "Good morning, Mister Sarazen." But when I go out on the golf course and take the same identical swing the ball doesn't seem to go anywhere. So I know it must be the fault of the course. Logic is logic.

Here are a few of the handicaps I suffer when I play on the regulation course:

When the average player shoots he stands facing the other people on the tee. Being left-handed I must stand with my back to the crowd. Besides wondering whether or not they are giving me the raspberry, I must try to be a gentleman and say each time I step up to the ball, "Excuse my back." And you know that any talk during a shot throws a man off his stance—even if it be his own voice that is doing the talking.

In standard golf courses most of the out-of-bounds limits are on the left side of the fairway. A sliced shot always puts me out of bounds. So I naturally stand well around to the right on every tee to play safe, so my drive will slice back into the fairway. Then for some reason or other I don't slice at all. My shot goes straight and I hit the president of the club who is playing three fairways to the right. This puts me in continual bad standing, besides giving all the club members the extra trouble of finding a new president.

Another thing. When I make a beautiful shot right on the green next to the pin I invariably find that I have played for the wrong green. My left-handed vision has given me a cock-eyed idea of the course.

My greatest handicap is the traps where I must admit I spend a good part of my week-ends. It takes an experienced miner to go down into a hole with nothing but the blue sky as his only area of vision and still keep his sense of direction. After the seventh shot, my left-handed leanings force me around in an angle of ninety degrees without realizing that I have turned at all. Then elated with the wonderful "out" I have finally negotiated, I rise to the surface only to find that I have shot right back through the foursome behind me and lost about sixty yards. I once had a series of these mishaps and spent an hour and a half on one hole continually losing ground. There was an insane asylum across the road from the course and it took my friends quite a while to convince an attendant who happened to see me that I was not an escaped inmate.

There are many other disadvantages that we left-handers must suffer, including the fact that they're building suburban homes closer and closer to the golf courses. The left-hander, when he dubs a shot, always lands in somebody's back yard and this isn't very pleasant when they're cooking cod fish.

81. Bicycle Craze, by Frederick Opper, 1896

I think I have made my case clear. What golf really needs is the left-handed course where left-handers can be segregated like smallpox patients. It will be a simple matter to lay out one of these courses. All the golf architect needs to do is take a plan of any well-known course and build it backwards. He may run into a few snags in the locker room. It will be quite a feat of engineering to get Paul, the attendant, to mix cocktails standing on his head and it may be a little difficult to get the water to run uphill in the shower baths. But trifling difficulties have never stopped the march of progress. Did snags and prejudices stop Lysander J. Lentil when he started to construct the first portable sink, now socially known as the finger-bowl?

Rube's respect for professional athletics and his humorous disdain for amateur practitioners and know-it-all philosophers made his own exercise program a bitter remedy, even for chest pains. But he gave it a try. He joined a gentlemen's gym where everything was "orderly and quiet." There wasn't a cauliflower ear in the house, and everyone wore neat white attire. The first part of his program called for his writing a check for $250. Then he slipped into a T-shirt and shorts and joined a muscle-bound instructor with a "high tenor voice." Rube felt conspicuous: "I had never lifted a dumb-bell in my life excepting once years ago when I took a girl out into the country and had to carry her across a stream." He saw some fat business executives tossing heavy medicine balls at one another while others were "throwing their legs over their heads and tying themselves into sailor's knots" (Fig. 80). Rube wrote later, "But when I started tossing the leather projectile back and forth I realized what a tough job Atlas has had standing around all these years holding up the world." Every time the ball crunched into his chest he felt it was "stuffed with broken battleships that were junked by the Treaty of Versailles." After the perilous game of catch he was shoved into a high-pressure shower, roasted in a steam box, and catapulted into the dressing room. Somehow he made his way home, sank into bed, and slept for fifteen hours. "The following day it took me three quarters of an hour to shave. I barely had enough strength to open my egg."

He stuck with the triweekly torture for nearly a month and then threw in the towel:

I was simply dead tired. After my workout I could rest in any position. I relaxed in the subway with four umbrellas sticking in my eye and a Bronx politician at my side taking home a bundle of herring. I fell over a toy aeroplane when I entered the house and I simply lay there until some of the guests started to throw cigarette butts in my mouth thinking I was a decorative ash tray.

Although Rube still worried about the state of his health, he finally rejected the exercise therapy. In this light it is not difficult to understand why his cartoon characters are extraordinary specimens of uncoordination. They always seem to trip or slip, spending half of their lives flat on their noses, for Rube endowed most of his creations with his own lack of athletic prowess. Balance and physical dexterity were the enemies of his graphic slapstick. By having his characters fumble and sprawl, he dramatized his own limitations. But Rube's failure at physical feats had a deeper influence. It made him more dependent on, and hence more sensitive to, the technological handmaidens of the twentieth century. His crazy inventions reflected his own lack of physical grace, and his criticism of the inventions of others reflects his failure to tame those very contraptions which promised the easy life.

143

82. Our lives are all more or less run by machinery, 1912

10
The Gadget Strewn Path of Civilization

While analyzing the human race, Rube became convinced that most Americans were being overwhelmed by an annoying surfeit of new sounds, new names, new facts, and complicated information imperfectly apprehended. There seemed to be an abundance of social frustration and a quickened pace of life forced by the continual growth of automation. So from 1909 to 1935 Rube drew at least one cartoon a week which reduced the complex technological wonders of the twentieth century to basic human terms. These cartoons are among his most perceptive works, for by employing everyday common sense he revealed the social impact of American technology in disarmingly humorous terms and helped to expose one of the grand ironies of the modern age.

To appreciate Rube's technology cartoons, we must recall that when he was born, the horse and the boat were the principal forms of transportation. There were no automobiles, no superhighways, no airplanes, no radios or television sets, and only a few commercial telephones. In 1883 bicycles were the newest means for personal transportation, and early cartoonists like Frederick Opper captured their popularity. His *Bicycle Craze* (Fig. 81), published in the New York *Herald* in 1896, anticipated the spirit of Rube's later works. Electrical lighting and flush toilets and Kodak cameras

were also just beginning to win public enthusiasm, but movies and air conditioners were mere pipe dreams.

Rube lived in the midst of the greatest technological revolution that man had ever seen. It was a stupendous age. Electricity and atomic energy were captured and tamed during his eighty-seven years. He lived to see men step on the moon, juggle human hearts from the dead to the living, and send moving pictures through thin air. It was an age of social invention, a time when new machines were being standardized, mass-produced, and marketed for everyone. Inventors prayed for success and entry into the American household. This democratic attitude was as new as the inventions themselves, for in times past men had invented things primarily to solve their own particular problems, or to make *themselves* more comfortable, or to protect themselves against predators. But Rube saw inventors who worked with the single idea of selling something new to everyone. Many succeeded. And perhaps unintentionally they transformed the world.

Rube perceived this change long before most people had learned to drive a car. His cartoons dramatized both the social pain and the enjoyment felt by his generation as it learned to live with automation. The changeover from muscle power to self-propelled machinery appeared in every room of the house. A life-

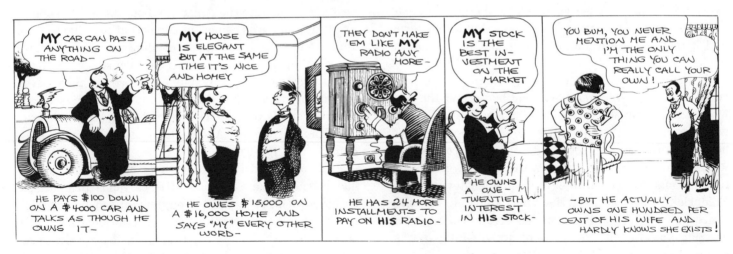

83. Another Triumph for Science, 1929

84. The Pride of Ownership, 1929

style that had remained unchanged for centuries now disintegrated at an unnatural pace as a mysteriously brash, rambunctious newcomer, complete with wires, tubes, filaments, and knobs dazzled and charmed its way to the top.

By the start of the twentieth century the average city dweller could illuminate his home with electricity; unlike the richest European monarch of the Renaissance, he could control night and day. This new power came from Thomas Edison, the merchant-inventor who worked in his Menlo Park invention factory seeking a cheap, reliable filament for his newborn light bulb. Earlier, Alexander Graham Bell had demonstrated his talking telegraph at the Philadelphia World's Fair of 1876, and after that he devoted his life to making the telephone a tool which the average man could afford. By the mid-1880s major newspapers and businesses were tied together by Bell's lines, and by 1900 America was tangled in a web of instantaneous communication.

Meanwhile George Eastman was transforming photography from a mysterious craft of flash powder, glass plates, zinc oxide, and cumbersome machinery to a simple black box called the Brownie No. 1. "You just push the button; we'll do the rest," promised Eastman. The age of family snapshots, travel pictures, and amateur photographers began.

By the time Rube celebrated his twenty-first birthday this stream of sensible and exotic gadgets was beginning to seep into middle-class America. By 1929 the average guy owned a host of machines which promised continuous entertainment, supreme control over nature, endless hours of freedom—a preposterously carefree existence. But the critical time for a perceptive humorist was the first three decades of the twentieth century—that period when the fundamental shift from hand to machine transformed the home. It was, in Rube's eyes, the great Age of Incongruity, a rare moment in history when a totally new, mechanized style of living sat alongside an older and slower life pattern. Here was an uneasy coexistence, a time when gasoline-powered vehicles shared the road with horses, when some people took the plunge and ordered a telephone but refused to give up their gas lighting, when others began to fly before most had ridden in an automobile. The incongruities were pervasive; they appeared everywhere and affected everyone.

Rube reveled in the incongruous, democratic machine age. He bought custom cars and Kodak cameras. He owned every electrical gadget he could get his hands on, and—as we have seen—he savored the movies. Three months before he died he summarized his continual marveling at modern machinery:

When your memory goes back to the days when the telephone was a strange, ugly contraption which hung in the hall and into which you dropped a nickel to hear a buzzing sound that seldom came out in the form of words (it was customary for honest people to drop slugs into the slot to avoid paying for something that perhaps would never become practical); when you can recall a time when it was a miracle to press a button and see a bulb light up in the front parlor; when in your mind there is still a picture of yourself attending a matinee at the Grove Street Theatre for a dime and seeing a little man lift a long pole to light up the gas jets in an elaborate chandelier hanging in the proscenium; when your eyes beheld a camel actually moving its head on the motion picture screen; when there were only four automobiles in the United States in 1896; then you wonder at the indifference with which everyone accepts the miracles of modern civilization—men landing on the moon and refrigerators that make instant ice cubes. Today every stunning achievement becomes just another happening in the headlong course of "advancement" that leads us to God knows where.

IF YOU ARE AN
ACROBAT, YOU MAY
POSSIBLY GET THROUGH
ONE OF THOSE MODERN
REVOLVING DOORS WITHOUT
BEING MORTALLY WOUNDED.

85. Detail: Oh yes, civilization
has made life really worthwhile,
1911

The miraculous gifts of Edison and Bell and Eastman promised the easy life, but Rube was quick to see a Pandora's box brimming with evil and ignorance and frustration. The wondrous gadgets didn't always work. Too new and mysterious to fix at home, they portended repair bills. The inventions often disturbed other people who didn't need them, and invasion of privacy became an issue. Many customers were suddenly faced with loan payments and indebtedness because of the costly contraptions. But most of all, Rube realized that their complexity and unreliability brought out the worst in human nature: anger, covetousness, and despair.

Although many of Rube's cartoons—for example, *Our lives are all more or less run by machinery* (Fig. 82), *Another Triumph for Science* (Fig. 83), and *The Pride of Ownership* (Fig. 84)—state general truths about mechanization, he refrained from writing, or even drawing, a coherent philosophy about The Machine. He distrusted social philosophers such as B. F. Skinner, Marshall McLuhan, and Amitai Etzioni because of their pretentious belief that somehow they know more about us than we do ourselves. He did record, however, the everyday human reactions toward modern technology. Much of what he had to say about automated affluence might seem trite to people of the 1970s who know too well the uneasiness occasioned by powered lawn mowers and color television sets, to say nothing of their unpredictability. But in 1900, inventors, entrepreneurs, and scientists were christening the new century as the technological utopia, as an era which promised to eliminate sweat and toil, and to replace them with leisure and ease. Rube envisioned the gap between the promise and reality and it was alarmingly wide.

To understand Rube's singular position, it is essential to remember that throughout most of man's history machinery was generally viewed as an unquestioned good. Even the nineteenth-century Marxists, who denounced automation as a devilish curse, a link in the chains that imprisoned the lower classes, quickly succumbed to the salubrious hum of the dynamo once they assumed the seat of political power. For centuries, profound thinkers like Augustine in his *City of God* and Francis Bacon in the incomplete *New Atlantis* had defined utopia in terms of sophisticated technologies which relieved men from their harsh labors. It's difficult to keep from smiling when Augustine promises "endless happiness" in a world where "exuberant invention" is a habit of the mind. His ecstasy is not infectious to a reader who must make ten more monthly payments on a dilapidated automobile. "What wonderful—one might say stupefying—advances has human industry made in the arts of weaving and building, of agriculture and navigation!" enthuses the Bishop:

With what endless variety and designs in pottery, painting, and sculpture produced, and with what skill executed! What wonderful spectacles are exhibited in the theatres, which those who have not seen them cannot credit! How skillful the contrivances for catching, killing, or taming wild beasts! And for the injury of men, also, how many kinds of poisons, weapons, engines of destruction, have been invented, while for the preservation or restoration of health the appliances and remedies are infinite! To provoke appetite and please the palate, what a variety of seasonings have been concocted! To express and gain entrance for thoughts, what a multitude and variety of signs there are, among which speaking and writing hold the first place! what ornaments has eloquence at command to delight the mind! what wealth of song is there to captivate the ear! how many musical instruments and strains of harmony have been devised! What skill has been attained in measures and numbers! with what sagacity have the movements and connections of the stars been discovered!

86. Detail: Oh yes, civilization has made life really worthwhile, 1911

87. An elevator trip will soon be an overnight jump, 1929

It is unfair to condemn this naïveté simply because Augustine never had the misfortune to electrocute himself while scrubbing his teeth. If only he could return to earth and spend a day in New York City during a blackout.

More than a thousand years later Francis Bacon simply added a high degree of imagination to Augustine's optimism. The *New Atlantis* is complete with miracle gadgets to cure any sickness; innumerable machines for making "papers, linen, silks, tissues; dainty works of feathers of wonderful lustre and . . . many more"; a variety of sources of artificial heat and light which imitates the sun; enginehouses, "where are prepared engines and instruments for all sorts of motions"; airplanes which "imitate . . . flights of birds"; robots; etc.

For both Augustine and Bacon the "good life" is aided and symbolized by machines. Their dreams were probably the eternal wishes of the less eloquent masses, for man has continually sought an escape from drudgery.

While the ancient philosophers and modern prognosticators revered the promises of technology, Rube was struggling through the newly invented revolving door (Fig. 85) or trying to catch forty winks in a Pullman car (Fig. 86). Both contraptions led him to exclaim, "Oh yes, civilization has made life really worthwhile." Even elevators were upsetting. When they first appeared in the 1860s, they saved Americans from the agony of climbing six flights of stairs to the cheapest rooms at the top of a cold-water tenement. But elevators encouraged builders to make skyscrapers, and in 1929 Rube issued a weary protest about the amount of time he seemed to be spending in those traveling boxes. *An elevator trip will soon be an overnight jump* (Fig. 87) appeared on February 2. In-

cidentally, the elevator reversed rent priorities, making the top floor the most expensive in a building. Had Rube been poor, he could have saved himself from riding hundreds of miles on the new vertical highways.

Many of Rube's satires are painfully true today. *Did you ever try to read one of those little medical thermometers?* (Fig. 88). Or what about modern packaging, which evolved during World War I? "Everything you pick up is wrapped in germproof paper," Rube observed, "so now it is impossible to tell what is what" (Fig. 89).

Of all the inventions Rube spoofed, four received his constant attention: the telephone, the camera, the radio, and the automobile. They were among the most revolutionary and the most mysterious—but they were also the most pervasive. They had an irresistible lure. Like the song of the sirens tempting Odysseus to flirt with death, the click of a camera, the ringing of the phone, the roar of a car, and the blaring of a radio combined to form the anthem of modern confusion.

As Rube watched Irma ring up her friends and spend a few hours shooting the breeze through Mr. Bell's lines, he concluded that the telephone had opened an inexhaustible verbal gusher. The telephone "has superseded the dog as man's best friend," he wrote in 1921. "Why, telephone bells are part of your soul." The telephone challenges us to break the peace and quiet of our homes, said Rube forty years later. "The numbers on the dial beckon like those on a roulette wheel, to come and gamble away your peace of mind, your well-laid plans for a normal day, your time and even your money." This passion for dialing was so intense, he calculated, that not less than 395,555 people lose their minds every year waiting to get into telephone booths.

By its very nature the telephone brought out the

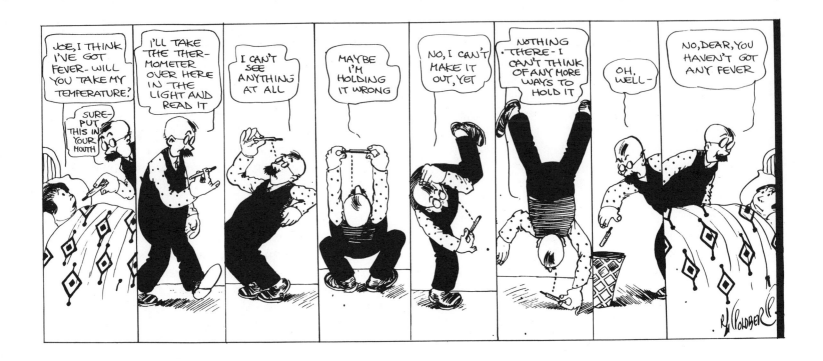

88. Did you ever try to read one of those little medical
 thermometers? 1920

seamy side of the human psyche. In *Telephonies* (Figs. 90 and 91), a series of cartoons begun in 1912, Rube portrayed the telephone as a custom-made prop for the good-natured but inveterate liar. But the telephone was not the only time-consumer. The camera fad began in the last decade of the nineteenth century and remains a permanent feature of American life (Figs. 92, 93, and 94). Rube was, however, ahead of his time when on December 5, 1916, he drew *It costs too much to live and you can't afford to die* (Fig. 95), because only in the late 1950s did moneylenders (i.e., banks) begin to install cameras to protect their funds.

In 1920, KDKA in Pittsburgh made the first commercial radio broadcast. Less than two years later, 378 commercial broadcasting licenses had been issued. Americans loved the radio and listened to it faithfully, for, unlike television, radio receivers were inexpensive from the beginning. The Crosby Pup cost $9.75 in 1925; everyone could participate in the golden age of broadcasting (Fig. 96).

As Rube listened, he cartooned radio broadcasts—a constant stream of weather reports, time tones, news, stock prices, and advertisements. Why, the radio performed so many services that most people kept it blaring night and day. They didn't want to miss out on anything. Our national predilection for excess led Rube to draw *Radio is destroying the art of Conversation,* and when a few brave souls tried to converse, he warned, *You can't compete with the radio* (Fig. 97). All the homes he entered seemed to have either a radio or a phonograph in every room. There was no escape. The hosts would always ask him to sit in front of one noise box or another in order to get the "full tone." For these people Rube concocted a Dantesque *Breaking Even: How to Get Square with the Man Who Always Starts His Talking Machine as Soon as You Get in the House* (Fig. 98). And this cartoon predates stereophonic buffs by forty years. It wasn't long before modern man could prove his existence by pointing to his swollen ears. *Who said peace on earth?* (Fig. 99), asked Rube in 1924.

But in Rube's mind, telephones and cameras and radios were harmless toys when compared to the most democratic and the most revolutionary invention to prosper in his own lifetime: the automobile. Henry Ford produced his first successful car in 1904, the year Rube began his cartooning career, and Ford's greatest achievement, the Model T, rolled out of the factory as Rube was making his way to New York City.

At first Rube saw the automobile as a curiosity, and he enjoyed cartooning some of the choice episodes in that stormy love affair between a man and his runabout. *Foolish Questions No. 2,468,579* suggested the wonder and good-natured bewilderment created by the new self-starter in 1914 (Fig. 100). The two empty-headed boobs staring at the crankless car could be anybody reacting to anything new. Even sophisticated car users often react when first entering a luxury auto: "Are these push-button windows?"

The Model T, with its automatic ignition, was a national mania. The total number sold in 1909 was more than doubled in 1911 and by 1917 it had reached 750,000. Gas became more essential than food for many motorists, but the escalated wartime prices made it all but prohibitive. For those who tried to save money by purchasing a "compact car," Rube sent up a caution signal. *You'll soon be able to use your dog house for a garage* (Fig. 101) anticipated by almost fifty years the Volkswagen fad of the 1960s.

Mr. Ford dedicated himself to democratizing the automobile. His inexpensive, reliable Model T served

89. Everything you pick up is wrapped in germproof paper

90, 91. Telephonies, c. 1912

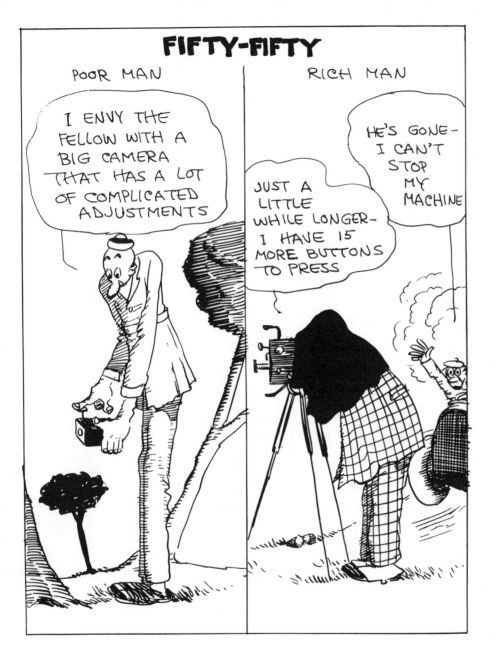

92. Fifty-Fifty, 1917

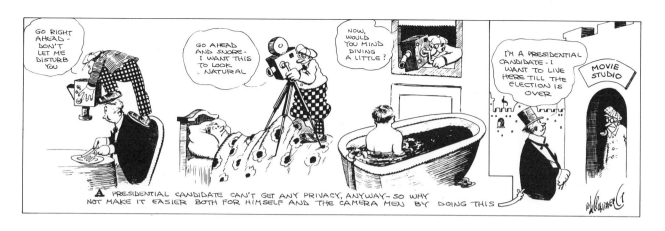

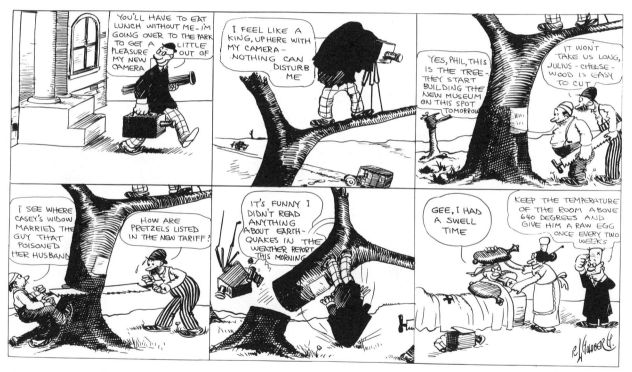

93. A candidate should live in a movie studio, 1928

94. The summer camera nut always mails you these, 1917

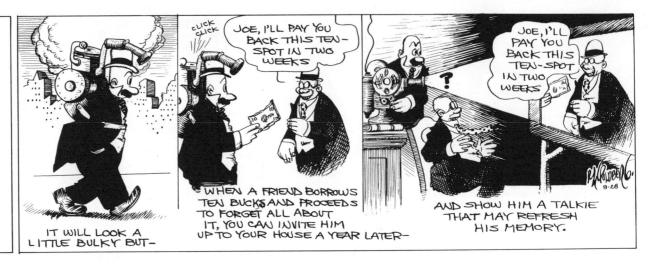

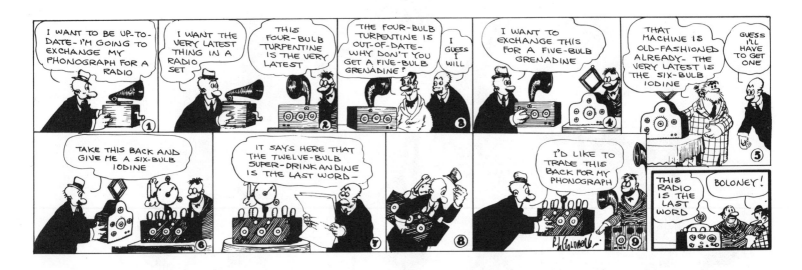

95. It costs too much to live and you can't afford to die, 1916

96. A radio is out of date before you get it home, 1925

97. You can't compete
with the radio, 1929

98. Breaking Even : How to Get Square with the Man Who Always Starts
His Talking Machine as Soon as You Get in the House

99. Who said peace on earth? 1924

more drivers than any other motorized vehicle. When it was finally retired in 1927, it had sold well over the 15 million mark. Henry Ford did not believe in change for its own sake, so the T did not alter radically in appearance during its entire twenty-year lifespan. Ford never used flashy colors or plush upholstery or big motors; and while the low price generated tremendous sales, it also made the T a mundane car which quickly fell out of step with modern designs. Since Ford's competitors could not match either his price or his mechanical reliability, they sold their cars by emphasizing color and styling and speed. In rejecting the "static" model, they established today's policy of planned yearly changes, always stressing newness and difference.

Rube Goldberg believed that the future lay with Ford's competitors and insisted that Americans always preferred the newest or the most complex. Chevrolet, under the perceptive direction of Alfred P. Sloan, made the annual model change a regular policy and surpassed Ford sales in 1924. But long before this Rube had seen the formula for success. On October 22, 1914, he observed that *Father Time will have to move faster to keep up with the new automobile models* (Fig. 102). And if Father Time was perplexed by the rate of change, the consumer faced even greater confusion. The welter of hyperbolic claims and the carnival-styled bantering of high-pressure salesmen defied cool reason. So Rube prescribed *The Most Sensible Way to Select Your New Make of Automobile* (Fig. 103).

In addition to institutionalizing the clamor for newness with his annual model policy, Alfred Sloan also developed the "family" of General Motors cars. He believed that GM could succeed if it offered models in a broad span of prices arranged so that the jump between any price group was not too great. A consumer, Sloan correctly reasoned, would spend a little more to own a Pontiac providing it did not exceed by more than a few dollars the highest-priced Chevrolet. GM cars were reorganized into graduated categories, and soon there was a "ladder of consumption" with Chevrolet on the bottom rung and Cadillac at the top. Sloan invited consumers to climb as high as their salaries and love of automotive prestige would carry them. He even offered them a little boost with his GMAC finance company. As in other instances, Rube Goldberg anticipated the auto industry's course of activity. *Joe, sweep out padded cell 763* (June 9, 1916) might well have served as a blueprint for the GM corporate structure (Fig. 104).

Salesmen and auto executives were not the only grist used in Goldberg's humor mill. The consumer, too, was an ingredient for laughter. Insisting that "there's a limit to convenience even in automobiles," Rube cartooned a one-sided conversation between a salesman and a potential buyer, who, like most of us, was hunting for the ultimate bargain (January 27, 1917):

Buyer: I'd like to buy an automobile that will suit my needs.
Salesman: Sure, what kind would you like?
Buyer: I want a machine that I can use for a limousine in winter and a runabout in summer and—I want it small enough to use for a delivery truck when the folks are not using it and—I'd like to have as much power as a 12-cylinder car but not to use any more gasoline than a 2-cylinder machine. You know what I mean—about $10,000 worth for $5,000.
Salesman: You don't need an automobile, you need a doctor.

It is necessary to remember that most of these cartoons appeared before 1925. By close observation Rube had singled out the unique and often the most per-

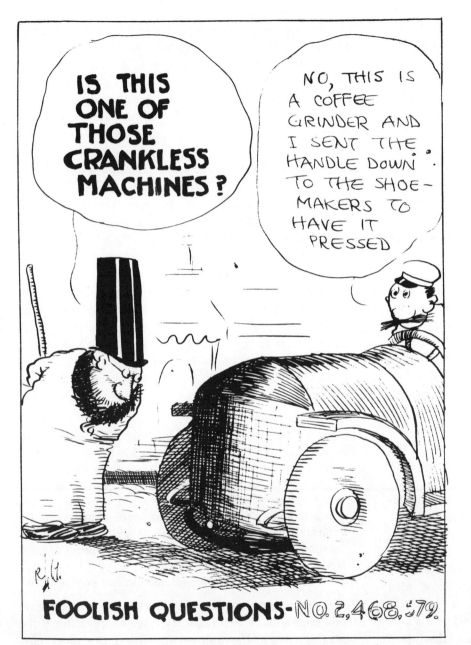

100. Foolish Questions, No. 2,468,579
1914

101. You'll soon be able to use your dog house for a garage

102. Father Time will have to move faster to keep up with the new automobile models, 1914

103. The Most Sensible Way to Select Your New Make of Automobile, 1916

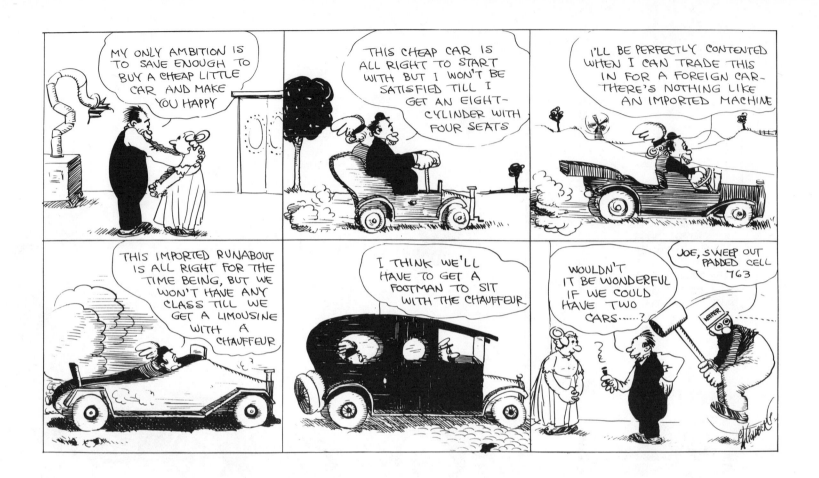

104. Joe, sweep out padded cell 763
 1916

105. The Unfortunate Pedestrian,
by Frederick Burr Opper,
1898

106. Now you can cross the street without worrying, 1925

plexing sociotechnological problems, and he dramatized them in prophetic cartoons. His attention to detail gives each panel unusual depth; even if we do not like the main joke, we can laugh at the lamp bases, the hood ornaments, the windmills, or the facial expressions.

But Rube Goldberg was not the first cartoonist to deal with life in a mechanized age. His childhood idol, Frederick Burr Opper, filled the pages of *Puck, Judge,* and the New York *Herald* with prophecy. Opper foresaw high-powered telescopes, flying machines, electric toothbrushes, and swift automobiles, all before 1895. His *Unfortunate Pedestrian,* which appeared in a New York *Herald* rotogravure in 1898, was an early portrayal of the motorcar menace. Opper saw technology jolt man out of his ancient living patterns into a new, uncertain world of smoke and speed and noise. But much of Opper's material isn't funny. In fact, Opper himself was not the epitome of joviality. His glass eye always captivated people who met him for the first time. One young cartoonist, after meeting Opper, asked an editor how he could tell which eye was artificial. "It's the one with the kind look," responded the editor.

Unlike Rube, who worked until he found the joke, Opper often cartooned social conditions as they existed without giving them that certain twist that makes the reader laugh. The *Unfortunate Pedestrian* (Fig. 105) is true—but that's all. Rube's counterpart, *Now you can cross the street without worrying* (Fig. 106), telescopes the whole ordeal into one pregnant image. The joke in *Now you can cross the street without worrying* rests on real-life tragedy; pedestrians *do* get run over. And like any great humorist, Rube does not crusade for tighter safety regulations but devises a machine to help people live with the rules already on the books. While both cartoons are based on the same information, Rube's conception is compact and pungent; it exemplifies the essence of wit. Again, the ultimate tragedy has not only been avoided but, by its very incongruity, turned into a joke (Fig. 107).

The ultimate combination for laughter is based on the familiar tragedy: woman vs. the automobile, with the husband doomed to be referee. On Tuesday, June 4, 1918, the *Weekly Meeting of the Tuesday Ladies' Club* assembled on a wooded lot to watch one of the members attempt to tame a Ford. With the frightened husband in the front seat on the passenger side, the wife, behind the steering wheel, is receiving a blast of instructions. She belts off the open road and crashes through a dense forest, splintering trees and scattering every squirrel and beaver. The husband's chatter is sensibly chaotic: "Take your foot off the clutch—You've got your brake on—Not so much gas—Put her in third speed—Hey, don't touch the spark—No, leave the self-starter alone—How much insurance do you carry? More gas." The wave of destruction and the husband's frustration are funny enough, but Rube also gave the wife, her marshmallow face stuck high in the air, a chance to speak: "Isn't the sky beautiful?"

Most humorists would stop here, but Rube carries the joke to a higher pitch. Like Aeschylus or Euripides, he includes a chorus which gives the episode broad social comment. The Ladies' Club, Rube's chorus, has been observing the driving fiasco, and their gossipy non sequiturs are priceless:

Lady 1: I think it will be much cheaper for her in the hospital if she takes a room by the year.
Lady 2: I'm not saying anything—But her husband knew what he was doing when he gave her a chance to break her neck.

107. Goldberg throws a gasoline fit, 1909

Lady 3: Poor thing. She never even had enough brains to learn how to run a gas stove.

Lady 4: I'll start now to think of a good excuse in case she asks me out for a ride.

Women were, in fact, such reckless drivers that it wasn't long before the "stronger sex" adopted the habit. In an exclusive interview with one New Yorker Rube exposed the new mania. "Why so sad, old man?" asked Rube. "I have met with a terrible misfortune," he responded. "I'm ruined for life. This afternoon I ran over a man without killing him instantly. Woe is me."

Taxicab drivers surely led the run-'em-down and kill-'em club, so Rube invented some *Lifesaving Apparatus for People Who Ride in Taxicabs* (Fig. 108). But even these ingenious gadgets failed to save many innocent people. Writing for *Collier's* November 3, 1928, Rube declared,

. . . The old-fashioned method of dying is obsolete. The great fear of having to be pushed around in a wheel chair in our old age has been entirely eliminated by the blessings of latter-day enlightenment. All we need to do to avoid the perils of senility is to take a jaunt in a speedy car or board the latest airplane. We surprise the legatees by dying young and leaving everything to the Society for the Perpetuation of Whiskers on Billy Goats.

By the middle of the roaring twenties it seemed that everyone in America owned a car. Twenty million were on the road, and people who couldn't afford a car surely longed for one. But as more and more cars appeared, Rube began to take the whole matter a little more seriously. He warned that a car, like any modern gadget, is a mixed blessing, at once a magic carpet and a millstone. *But it doesn't mean anything* (Fig. 109) expressed his growing pessimism. The final panel of this cartoon was Rube's prediction for the future of American automotive life. He published it on September 13, 1923, and thereafter found great difficulty in laughing at the social impact of a threatening national phenomenon.

Viewing the growing automobile chaos in 1949, for example, he predicted that the world would end twenty years later. The fatal blow was not dealt by the atomic bomb or bacteriological warfare, as other doomsayers had predicted, but—ironically enough—by the automobile, America's symbol of life and movement. Written by the last survivor on earth (c. January 1970), the article, entitled "The Great Jam," explains the steps to destruction. By 1960 all public parks had been gouged from the earth and replaced with great caverns to serve as commuter parking lots. Multilevel garages, designed like huge decks of cards, soared fifty stories high, with every inch spoken for long before completion. Apartment landlords rented parking spaces on the roofs of their buildings and installed special elevators to whisk each car to its designated perch. Improvised parking facilities became so widespread, Rube noted, that "passengers looking down from commercial airplanes could not tell where the streets end and the roofs begin. All were filled with cars."

To keep the economy rolling, the automobile factories sped up production at a frightening rate, and city traffic ground to a halt. Enterprising drivers headed for open roads, but soon even these looked like "sluggish snakes of chrome and aluminum moving at a pace so painfully slow it soon diminished to a dead stop." Yellowstone Park and the Grand Canyon became blanketed with "a crazy quilt of cars jammed bumper to bumper, fender to fender and windshield-wiper to windshield-wiper."

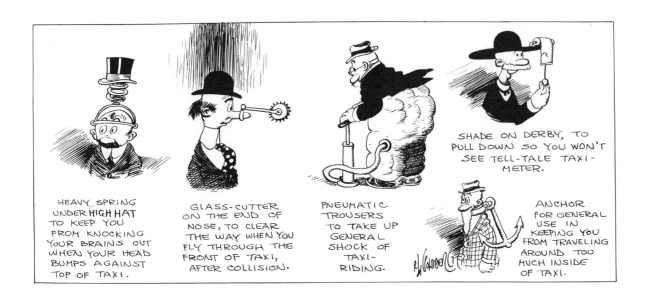

108. Lifesaving Apparatus
for People who Ride in
Taxicabs, 1923

109. But it doesn't mean
anything, 1923

By 1965 the inevitable was near. Refusing to face the truth, Americans hoped for a wizard to appear and solve their fatal parking problems. Finally, in 1969, every car from coast to coast, over mountains and across the desert, became locked—bumper to bumper. New models coming off the assembly lines piled up in a confused mass, crushing workers and adding to the general melee. Motorists trapped in cars simply starved, while in the cities cars became so tightly packed against shops and homes and hotels that no one could get out and no one could get in.

Imprisoned grocers had to eat their own stocks and when they finished they simply lay down and died. Stranded jewelers tried to exist on tie clips and engagement rings. But they choked to death. . . . Tremendous crowds were left isolated in moving picture palaces. They managed to exist for a time without food as they were so absorbed in the love-making on the screen. . . . Few people passed away in their own homes. They all rushed foolishly to their cars. But once in the mechanical maelstrom, they were finished.

By September 9 all was quiet. Not a horn sounded, not a gear crunched, not a breath stirred. "The mechanical Frankenstein, the automobile, destroyed the most mechanically-minded nation in the world."

Written in 1949, the article reads as an up-to-date description of the automobile mess afflicting the second half of the twentieth century. But it seemed too fantastic in 1949 and was rejected by five magazine editors.

Behind all of Rube's cartoons is the belief that men never really change. Telephones and radios may bring new powers and new problems, but the basic human needs and social relationships remain. Rube's phrase "the gadget strewn path of civilization" implies that machinery is simply a temporary thing which fails to penetrate the human mind. While extending his powers of energy conversion, communication, and mobility, man fails to transform radically either his character or the meaning of life.

But if man refuses to change, the world around him certainly changes. Life, as Rube knew it, was an active process of continual adaptation. In Rube's world of gadgets and automatic everything, people demand progress, but when they get it, they cast a suspicious eye. They may puzzle over an electric can opener, but they forever try to adjust. In Goldberg's mind, the tolerance level for injustice, pain, or insanity soars with each technological advancement. A dinner host will slice himself while using his new electric carver, then explain to his guests at the table just how wonderful it *really* is. Goldberg invites his public to listen in on marching feet and voices raised in song:

> We sing our song
> When everything's wrong,
> Yok, Yok, Yok:
> We feel so strong
> When everything's wrong,
> Yok Yok Yok:
> We make life hard for everyone,
> We fill the world with woe;
> We're jolly, little, impish brats
> We mess up things and so—
> We very, very merrily march along
> And sing our song when everything's wrong,
> Yok Yok Yok Yok Yok Yok Yok Yok
> Yok Yok Yok!

And he tempts his readers to picture a great army of little green men with "very long, straight noses and . . . red-and-yellow striped gloves." They'll be carrying an assortment of tools, including axes and screwdrivers and hammers and saws and monkey wrenches. These are the Yokyoks, the little bugs found in all

PROFESSOR BUTTS' LANDLADY HITS HIM OVER THE HEAD WITH A PITCHER FOR NONPAYMENT OF RENT AND HE DISCOVERS A SURE WAY TO KEEP THE HEAD DOWN DURING A GOLF SHOT.
GOLFER(A) SWINGS CLUB(B) AND HITS BRANCH OF TREE(C) SHAKING APPLES DOWN ON KETTLE-DRUM(D). CADDIE(E) HEARING NOISE, THINKS A THUNDER STORM IS APPROACHING AND RUNS FOR CLUB HOUSE, STUMBLING OVER GOLF BAG AND PUSHING FLAG POLE(G) AGAINST BAG OF PEANUTS(H) WHICH BREAKS AND THROWS PEANUTS IN BASKET(I). AS SQUIRREL(J) JUMPS INTO BASKET TO GET THE PEANUTS, HIS WEIGHT RAISES END OF PADDLE(K) AND DRAWS FISH(L) OUT OF WATER HAZARD. HUNGRY SEAL(M) SEEING FISH FLAPS HIS FLIPPERS(N) FOR JOY AND CAUSES BREEZE TO ENTER FUNNEL(O) THEREBY BLOWING MARDI-GRAS TICKLER(P) WHICH STRAIGHTENS OUT AND DEPOSITS DOLLAR BILL(Q) NEXT TO GOLF BALL, FOCUSSING EYES OF PLAYER ON THIS SPOT DURING SWING.
IF YOU MISS THE BALL AND SWING INTO APPLE TREE OFTEN ENOUGH YOU CAN HAVE APPLE SAUCE FOR DINNER.

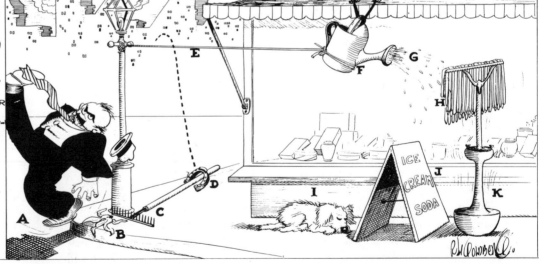

PROFESSOR BUTTS STANDS IN FRONT OF AN X-RAY AND SEES AN IDEA INSIDE HIS HEAD SHOWING HOW TO KEEP SHOP WINDOWS CLEAN.
PASSING MAN(A) SLIPS ON BANANA PEEL(B) CAUSING HIM TO FALL ON RAKE(C). AS HANDLE OF RAKE RISES IT THROWS HORSESHOE(D) ON TO ROPE(E) WHICH SAGS, THEREBY TILTING SPRINKLING CAN(F). WATER(G) SATURATES MOP(H). PICKLE TERRIER(I) THINKS IT IS RAINING, GETS UP TO RUN INTO HOUSE AND UPSETS SIGN(J) THROWING IT AGAINST NON-TIPPING CIGAR ASH RECEIVER(K) WHICH CAUSES IT TO SWING BACK AND FORTH AND SWISH THE MOP AGAINST WINDOW PANE, WIPING IT CLEAN.
IF MAN BREAKS HIS NECK BY FALL MOVE AWAY BEFORE COP ARRIVES.

110. Professor Butts' Sure Way to Keep the Head Down During a Golf Shot, 1930

111. Professor Butts [shows] how to keep shop windows clean, 1929

machines which cause breakdowns and mechanical failure. Like the common ant, which practices a strict division of labor, each Yokyok has a particular task. One clogs up the holes in saltshakers while another makes fountain pens leak. Others change the faucets in shower baths so the cold runs hot and the hot runs cold, or glue desk drawers shut, or cross the wires in telephones so that they always ring the wrong number. Their mischief is endless.

Rube discovered the Yokyoks (not unlike the Yahoos of Jonathan Swift) in the late 1920s but he never exposed them despite their constant assault on his physical well-being. They were funny little creatures, he philosophized, who helped him smile at times of technologically motivated frustration.

He knew too well that if he took the social problems of technology too seriously he would have developed a Tower of Babel complex, a fear that men would try to become gods and in so trying would kill themselves. To make his ideas even clearer he quoted, one time, from Peter Dunne's essay "Machinery." Through the sage Martin Dooley, that nineteenth-century Irish-American saloon keeper, Dunne wrote:

I go be Casey's house tonight an' there it is a fine storey-an'-a-half frame house with Casey settin' on th' dure shtep dhrinken' out iv a pail. I go be Casey's house to-morrah an' it's a hole in th' groun'. I rayturn to Casey's house on Thursdah an' it's a fifty-eight storey buildin' . . . an' the're thinkin' iv takin' it down an' replacin' it with a modhren sthructure. . . .

I've been up to the top iv th' very highest buildin' in town, Hinnissy, an' I wasn't anny nearer Hivin thin if I was in th' street. Th' stars was as far away as iver. An' down beneath is a lot iv us runnin' an' lapin' an' jumpin' about, puchin' each other over, haulin' little sthrips iv it' n to pile up in little buildin's that are-re called sky-scrapers but not be th' sky; wurrukin night an' day to make a masheen that'll carry us fi'm wan jack-rabbit colony to another an yellin', "Progr-gress!" Pro-gress, oho! I can see th' stars winkin' at each other an' sayin': "Ain't they funny! Don't they think they're playin' hell!" . . .

Technological progress, in Rube's mind, was just another phase of history. At the risk of spouting a cliché Rube called life a "merry-go-round." We jump aboard, the music starts, and away we go yelling and laughing. We fool ourselves into thinking that we're pushing ahead, but when we stop we're at the start. Then, as Mr. Dooley observed: "We get out dizzy an' sick an' lay on th' grass an' gasp." But we did have fun, and given half a chance we'll be back tomorrow.

HEAT FROM FLAME (**A**) EXPANDS HOME BREW IN BOTTLE (**B**) AND CORK (**C**) FLIES OUT WITH ATTACHED SAFETY RAZOR BLADE (**D**), WHICH CUTS STRING (**E**) - WEIGHT (**F**) DROPS ON STRENGTH-TESTING MACHINE (**G**) RINGING BELL (**H**) - BOXING DOG (**I**) THINKS ROUND IS STARTING AND JUMPS OFF CHAIR (**J**) FALLING ON HEAD OF SPIKE (**K**) - POINT (**L**) PUNCTURES BALLOON (**M**), DROPPING CHAIR (**N**), WHICH BOBS UP AND DOWN ON SPRING (**O**), CAUSING WHISKERS (**P**) TO BRUSH OFF CLOTHES WITH NEATNESS AND CARE.

CLANG

112. Try our new patent clothes brush

11

The Automatic Life

Despite his constant grumblings against the automatic life, Rube loved complex machinery. He marveled at its laborsaving potential, its rhythm, and even its beauty. But he also treasured simple human values and inefficient human pastimes such as daydreaming and laughing. Like many of us today who enjoy mechanization but curse its problems, Rube long ago puzzled over the modern dilemma: How could mechanization be introduced and used without demolishing the life-giving harmony between man and his environment?

This very question had troubled Thomas Jefferson (an inveterate tinkerer himself), who, while President of a vast, mostly unoccupied nation, felt helpless to fend off the evils of the industrial revolution. As chief executive of an unexplored wilderness, he opened the gates and let the new machines roll into the lush American garden. But as a gentleman-farmer, he despised the noise of a piston or the odor of an exhaust fume. Rube, too, felt this dualism.

Poets and journalists throughout the nineteenth century sang of the battle between nature and steam. Some cried; others ran away; but the machines grew bigger and faster and noisier. They seemed to reproduce themselves until their din could be heard day and night in every part of the land. Machines grew because people wanted them. Cold winds and hunger and ravaging beasts had to be overcome. But new, more subtle terrors lay hidden in these comforts: crowding, noise, pollution. Science fiction writers at the turn of the century began to see worlds which the machines would command. Even people would be run with machinelike precision. The Czech writer Čapek first used the term "robot" in his play *R. U. R.* (1923), and Americans immediately adopted it. Today biologists, physiologists, and medicine men of every stamp insist that the automaton is near. The stress of living in a mechanized world—the frantic pace, "the rain of excessive and bizarre information," as Dr. Ralph Waldo Gerard calls it—has become, ironically, one of the greatest destroyers of a high quality of living in America. "Automation and dial-watching," writes biologist-author René Dubos, "eliminate the hardships of physical effort, but monotonous environments and mechanical operations have their own deleterious effects on the human brain . . . the efficiency of production is producing the pathology of boredom."

Rube's cartoons predate most of the serious scientific inquiry into the social impact of technology. His observation that even useful gadgets, like radios and automobiles, will increase the rate of emotional wear and tear has proved correct. But Rube went a step beyond analysis and criticism and therein lies his optimism.

MAGIC LANTERN (A) THROWS PICTURE OF PIECE OF SWISS CHEESE ON SCREEN (B) - MOUSE, MISTAKING PICTURE FOR REAL THING, JUMPS AT SCREEN AND FALLS IN ROWBOAT (C) - HE ROWS AROUND IN TUB UNTIL HE GETS SEASICK AND WANTS TO END HIS SUFFERING - HE JUMPS OVERBOARD AND LANDS IN CAN OF YEAST (D) - MOUSE HAS HIGH FEVER WHICH CAUSES YEAST TO RISE AND LIFT HIM TO STEEL PLATE (E) - HIS HEAD PRESSES AGAINST STEEL UNTIL HE GETS SOFTENING OF THE BRAIN AND GOES CRAZY - HE THINKS HE IS A STREAM OF WATER AND RUNS THROUGH FIRE-HOSE (F) COMING OUT OF NOZZLE (G) AND LANDING ON PLATFORM (H) - PHONOGRAPHS (I), BELOW, MAKE NOISES LIKE BUNCH OF CATS - MOUSE IS AFRAID TO LOOK OVER EDGE OF PLATFORM AND HE CAN'T FLY - SO HE REMAINS IN ONE SPOT AND DIES OF OLD AGE.

113. The Only Humane Way to Catch a Mouse

He knew the cure for the industrial blues, and it did not require a governmental bureaucracy. Individualism, forged in adventure, hard work, creativity, and friendship, was the only answer. This individualism, which Rube had first proclaimed publicly in *I'm the guy,* was not the antisocial, poverty-bearing brand of the 1880s, but an individualism for psychological health. It did not forbid social planning, or even Medicare; it simply called for an industrial society which recognized the nonmaterial needs of life (Figs. 110 and 111).

Rube's greatest expression of how to survive with machines can be found in his most original contribution to the treasury of caricature: his invention cartoons, those dreamlike creations of disparate pieces precariously arranged in unusual groupings which harbor a mélange of truths (Figs. 112, 113, and 114). Today, of course, the name "Rube Goldberg" is synonymous with any complex mechanism (technological, political, or social) that exhausts itself, and everyone connected with it, as it performs a simple task. Rube experimented with the "invention" genre in numerous cartoons soon after arriving in New York, but the first full-fledged model did not appear in the *Evening Mail* until November 10, 1914 (Fig. 115). While it was an instant success, it did not become his single, all-absorbing personal trademark until the 1940s. As late as 1925, for example, Rube was billed as the creator of *I'm the guy, Father was right,* and *Foolish Questions.* The inventions didn't even get a passing mention.

From 1914 until 1934, Rube produced one invention every two weeks. From 1934 to 1964 his output dropped to an average of one a month. These cartoons taxed him enormously, for unlike the *Foolish Questions* or the sports cartoons, which came as sudden mental flashes, the inventions had a rhythm and an illogic all their own. Rube could never explain why they seemed so funny or what made them so popular: "I have indulged myself in many facets of human behavior" he wrote in 1961, "but . . . the machine-age slant on human frailties has grown to be widely accepted out of all proportion to my original conception. I am credited with any machine that looks crazy. People coming into my studio expect me to be hanging from the chandelier. It is always a disappointment to them and me, too, that I am a perfectly normal human being." Rube received numerous requests for his photograph from people who had difficulty convincing themselves that he was, indeed, human! In the mid-forties, for example, a casual friend wrote him about a strange guessing game he had witnessed at his job:

One day . . . one fellow started a discussion by saying he wondered what Rube Goldberg looks like. Each man and some girls told the things they had heard about . . . Rube Goldberg. You have not yet drawn a character which is as wild looking as they believe you to be. Neither could any character of Greek mythology or medieval conception of monsters in the sea quite measure up to the mental picture these people have of you.

By the time the inventions became synonymous with "Rube Goldberg," he was already approaching his sixtieth birthday. He looked as dignified as a bank president, one admirer noted—anything except a crazy gadgeteer.

Although in their final form the inventions appear as clear cases of spontaneity, they evolved in a manner consistent with Rube's placid appearance. They were far from random inspirations hastily assembled and inked. Rube worked sometimes as many as thirty hours over the course of a week on one drawing (Fig. 116). He had an innate sense of composition and pace, laboring over details like the facial expressions of the

PROFESSOR LUCIFER GORGONZOLA BUTTS A.K. INVENTS SIMPLE WAY FOR WET-DRY STRADDLE CANDIDATE TO PLEASE EVERYBODY: CANDIDATE (A) HANGS SIGN (B), THINKING AUDIENCE IS WET-DRY LISTENER (C) STARTS HISSING- DWARF (D) THINKS THERE IS SNAKE IN GRASS (E) - HE JUMPS, ALLOWING IRON BALL (F) TO DROP SO THAT POINT (G) PUNCTURES WATER PIPE (H) - THIRSTY BIRD (I) BENDS OVER TO TAKE A DRINK, PULLING CORD (J) WHICH REVOLVES WHEEL (K), EXPOSING OTHER SIDE OF SIGN, WHICH READS "PROHIBITION ENFORCEMENT" AND GETS DRY VOTE.

THIS IS THE LIFE

SHE DON'T KNOW FROM NOTHIN'

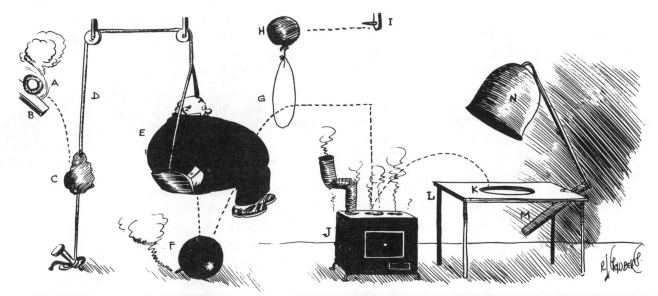

DOUGHNUT (A) ROLLS DOWN BOARD (B) AND BECOMES OVERHEATED FROM FRICTION - HOT DOUGHNUT FALLS ON LUMP OF WAX (C) MELTING IT AND PARTING ROPE (D) RELEASING FAT MAN (E) WHO FALLS ON BOMB (F) - BOMB EXPLODES, BLOWING MAN THREW LOOP (G) SUSPENDED FROM BALLOON (H) - BALLOON MOVES IN HORIZONTAL DIRECTION AND BUMPS INTO PIN (I) WHICH PUNCTURES IT, DROPPING SUBJECT ON RED-HOT STOVE (J) - HE NATURALLY RISES HURRIEDLY TO TABLE (L) AND FALLS INTO HOLE (K) - HE HITS LEVER (M) BRINGING BELL (N) DOWN TIGHTLY OVER HIS BODY - HE CANNOT PASS THROUGH HOLE AND CANNOT CALL FOR HELP BECAUSE BELL IS SOUND-PROOF - SO HE REMAINS WITHOUT FOOD UNTIL BODY IS THIN ENOUGH TO PASS THROUGH HOLE.

114. Professor Butts' Invention for Wet-Dry Straddle Candidate, 1932
115. Automatic Weight Reducing Machine, 1914

midgets and dogs, choosing each part carefully for its own laugh potential, its strange appearance, or its familiarity (Figs. 117 and 118). There were no ready-made formulas. Rube just felt his way, sensing with some strange visual power when an invention was right (Fig. 119). Often he found that the most difficult part was the ending: Who should be the dubious beneficiary of the latest contraption? Who will be the guinea pig? Usually he picked his unsuspecting victims right off the streets of New York City, accentuated their bald heads, fat stomachs, hairy lips, and stubby legs, then set them in place. The Goldberg galaxy of boobs participating in the automatic life is distinguished by empty-headedness, mock seriousness, and total nonchalance: a portrait gallery unknown in the history of art.

The inventions have made his name immortal. In the 1966 edition of the *Random House Dictionary of the English Language,* the term "Rube Goldberg" first appeared: "1. having a fantastically complicated improvised appearance: *a Rube Goldberg arrangement of flasks and test tubes.* 2. deviously complex and impractical: *a Rube Goldberg scheme for reducing taxes.*" But long before dictionaries had made it official, "Rube Goldberg" was a familiar part of the American language. In the 1940s it appeared continually in the *Congressional Record* as a slightly less than complimentary adjective to describe political programs and government red tape. In the September 1946 issue of *Mechanix Illustrated* Don Romero wrote that Rube "has so firmly established himself in American humor as the wizard of crackpot gadgetry, that now no zany-looking machine or device can ever appear before the public without some observer promptly remarking, 'Why, that looks like one of those cockeyed Goldberg inventions!'" This intense and constant usage proved

that Rube had filled a need in both the thoughts and the language of the twentieth century. He was the only American to have his name become a dictionary word while he was alive. None of his other accomplishments gave him greater satisfaction.

The lasting success of the inventions is due to their general, abstract quality. Since they eschew particular social issues and personalities, they seem more to the point today than when Rube first drew them. In 1927, for example, *Collier's* began to rerun the earlier inventions; later, numerous newspapers throughout the 1940s published at least one drawing a week. Many of the inventions had been concocted before 1920, but a new generation of readers soaked them up as if they were fresh from the drawing board. Again, in 1960–1964 the New York *Journal-American* featured the "Best of the Goldberg Inventions," and, if this twenty-year cycle continues, we will see once more Rube's progeny in the American newspaper not later than 1984.

But abstraction was not Rube's goal, for most of his machines had a special mission. They filled the gaps between the great technological discoveries of the early twentieth century and the simple needs of everyday life. Revolutionary inventions such as radios, automobiles, airplanes, and telephones gave the "astonished world fresher and louder gasps of incredulity," wrote Rube in 1928, but they failed to solve the little problems besetting mankind. Rube saw this deficiency and dedicated his humor to "solving" commonplace problems: "While large groups of inventors were toying with great forces of the universe, I looked around me in anguish." Rube saw gravy spots on freshly cleaned vests (Fig. 120) and cigarette butts burning holes into deep pile rugs. Good-natured boobs suffered through afternoon teas juggling cups and saucers and

HOW TO BALANCE WIFE'S CHECKING ACCOUNT

BANK

NIGHT DEPOSIT

WIFE MAKES OUT CHECK ON OVERDRAWN BANK ACCOUNT - INK SQUIRTS IN EYE OF MOUNTED COP'S HORSE - HORSE JUMPS THROWING COP WHO HITS FLAGPOLE BREAKING IT IN TWO - END OF FLAGPOLE DROPS INTO PUSHCART FULL OF FRUIT WHICH FLIES INTO MOUTH OF HUNGRY PIG - EXTRA WEIGHT OF FRUIT BREAKS ROPE, DROPPING HEAVY PIG ON BAGPIPE WHICH BLOWS MONEY INTO DEPOSIT SLOT JUST ENOUGH TO COVER WIFE'S CHECK.

116. Sketches for "How to Balance Wife's Checking Account," c. 1944

plates and napkins and cake, only to prove that the force of gravity was still triumphant. How could inventors deny these people? Rube saw cigar lighters that set fire to everything but cigars, and grapefruit that, with a touch of a spoon, "developed into the morning shower bath." Derby hats were putting ears out of shape, red flannel underwear scratched, and doughnut holes were becoming so large there weren't any doughnuts left. Inventors, where are you?

By the second decade of the twentieth century, inventing new things had become a corporate activity. The lone inventor seemed extinct. "With few exceptions," insisted Rube, "no single person can stand out as the inventor of any great mechanical appliance." The industrial research laboratories monopolized the nation's inventive talent, according to the Goldberg theory; the results of modern science seemed to outgrow any individual. Rube even knew of one hardworking technician who was trying to perfect a hair restorer. When this would-be inventor left his desk to go to lunch, his colleagues generously offered to continue the tests. Upon returning, the technician found his friends "sweeping up the floor after giving the doorknob a haircut!"

Although Rube consciously overstated his fears for the purpose of getting a laugh, he saw through the new, joint approach to planned invention. The industrial research laboratories of Bell Telephone, General Electric, and Westinghouse worked as new forces attempting to channel and program the ideas and the dreams of hundreds of basement tinkerers. Since Rube disliked any prolonged group activity, it was natural for him to shudder at the sight of cream-tiled laboratories. Predictably enough, however, these laboratories adopted him as their patron saint. The Packard automobile plants, for example, designed and manufactured airplane engines during World War II. This work involved thousands of blueprints, many of which were as confusing as Rube's inventions, and as one engineer from Detroit explained,

Men around the department who have trouble puzzling out something in the blueprints yell out after referring in some manner to the Lord, the Devil, or Rube Goldberg. They have far more respect for Rube Goldberg than for either the Lord or the Devil. Some man may yell out, "This **oo**!!!?! blueprint looks like something Rube Goldberg made!" Or, "If Rube Goldberg were here, he could tell us how this engine goes together."

In this city of machines [Detroit] you are a great god of perplexity who is called upon more often for help than any other person in the world.

Rube did not condemn the industrial invention factories, but, in a thoroughly consistent manner, he went his own way. He refused to live in a world that denied or belittled individual accomplishments. Teamwork, with its continual need for compromise and its "one for all" creed, appeared to deny the little things, the sensitive vibrations which make us individuals. The Goldberg inventions countered the corporate impersonality; they are the whimsical solutions of an independent gadgeteer bent on asserting his right to dream.

It is not a simple coincidence that "Rube Goldberg" now applies to complex human activities, particularly political schemes and cumbersome bureaucracies. The Goldberg caricatures of modern machinery are simply extensions of his other cartoon series into the areas of invention and automation. Their immense popularity was due not simply to their uniqueness but to their democratic attention to common human problems.

When seeking inspiration for one of his inventions, Rube would mentally transform his studio into the

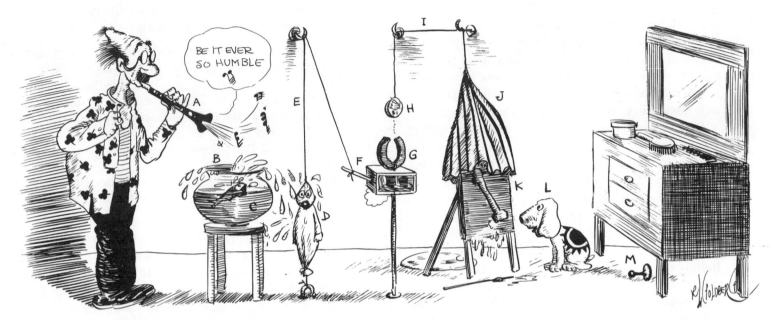

PLAY "HOME SWEET HOME" ON OBO (A) – HOMESICK GOLDFISH (B) IS OVERCOME AND SHEDS COPIOUS TEARS WHICH FILL BOWL (C) AND CAUSE IT TO OVERFLOW ON FLANNEL DOLL (D) – DOLL SHRINKS, PULLING STRING (E) WHICH MOVES LEVER (F), TURNING ON POWER IN ELECTRO-MAGNET (G) – MAGNET ATTRACTS IRON DOLLAR (H) DRAWING THREAD (I) AND LIFTING SUMMER COVERING OFF PAINTING OF SOUP-BONE (K) – THE PAINT IS STILL WET – WHEN INDIAN-BLANKET SPANIEL LICKS BONE THE PAINT GIVES HIM A STOMACH-ACHE – SEEKING RELIEF, HE MISTAKES HEAD OF COLLAR-BUTTON (M) FOR A PILL – WHEN HIS TEETH STRIKES THE HARD BRASS OF THE COLLAR-BUTTON, HE GIVES A HOWL AND YOU IMMEDIATELY KNOW WHERE IT IS.

117. The New Household Collar-Button Finder

laboratory of his other self, Professor Lucifer G. Butts, A.K. According to Rube, Butts—when sober and sane—had invented many of life's amenities: the park bench, the Christmas card, the pants-button-that-can't-come-off, to mention just a few. Butts was an emotional guy who condemned the "big wholesale laboratories" for ignoring the intimate needs of the people. "The social demands are growing more urgent and nothing is being done about them," the professor shouted one afternoon in 1928. Why haven't they invented a machine to remove the pins from laundered shirts, for example? So, the good professor did that. Just follow his instructions:

You place the shirt on this little traveling platform and press the button. The shirt moves along by means of a series of pulleys and passes through a bath of nitric acid. The acid dissolves the pins. The shirt is naturally partly dissolved too. So I have arranged a small mill at the end of the apparatus to grind up what is left of the shirt into small bits of the consistency of breakfast food. You put these bits in a saucer and eat them with cream. Then you put on your coat and a large old-fashioned ascot tie, that covers your whole chest.

The principal benefit of the appliance is that your fingers and hands are not injured by pin pricks and you can shake hands with as many people as you like if you are running for office.

One of Butts' greatest machines was the self-destroying memorandum pad. As soon as someone jots down a note, the pressure of the pencil squeezes a small accordion, which frightens a lightning bug. As the bug flies up, it ignites a row of candles on the edges of the memo paper. The candles burn the paper, and the bug, still exhausted from his flight, pants heavily and blows out the candles, leaving a fresh piece of white paper for the next notation. According to Rube, Butts drew a plan for this device, but "representatives

from white collar associations around the world hired crooks to steal Butts' only copy. They feared massive unemployment due to the elimination of unnecessary paper work."

The professor also made other devices, which Big Business had overlooked: collar-button finders (Fig. 121) mosquito-bite scratchers (Fig. 122), automatic tooth extractors, complex cork removers (Fig. 123), window closers (Fig. 124), soap retrievers, cigarette extinguishers, dishwashers (Fig. 125), garage door lifters (Fig. 126), and self-washing windows.

So these things really have been invented? Well, that's part of the irony of Rube's humor. Many of the "fanciful machines" he created anticipated real technological developments. His garage door lifter appeared more than twenty years before its practical counterpart. So did his complex cork remover, his olive extractor (Fig. 127), and his self-washing windows, to mention just a few. It's not that Rube consciously sought a prophet's mantle—nothing could have been farther from his mind. Rather, his fame as a prognosticator resulted from the fundamental truths about technology which he discovered. His vision was so accurate that even his own technological fantasies are no longer absurd. Real machinery has overtaken him. We do not smirk when we hear that someone has invented a *Simple Way to Light a Cigar in an Automobile Traveling Fifty Miles an Hour* (Fig. 2) or that there is a new machine for giving ourselves a haircut or that flying carpets are now on sale. We expect to find all these things in at least four colors with a time-payment plan.

The inspiration for the inventions came from Rube's college education—an experience which time and again seems like an episode from *Gulliver's Travels*. In the 1720s, when Swift's hero visited the Grand

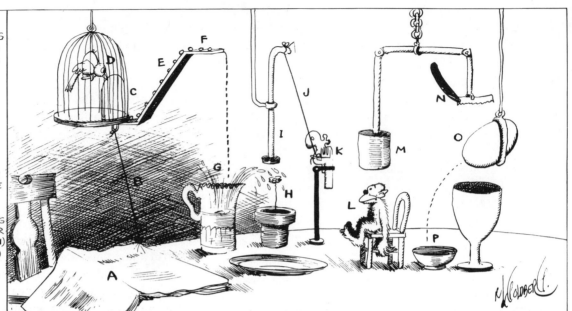

When you pick up morning paper(A), string (B) opens door of bird-cage (C) and bird (D) follows bird-seed (E) up platform (F), and falls over edge into pitcher of water (G) — water splashes on flower (H), which grows, pushing up rod (I), causing string (J) to fire pistol (K) — shot scares monkey (L) who jumps up, hitting head against bumper (M), forcing razor (N) down into egg (O) loosened shell falls into saucer (P).

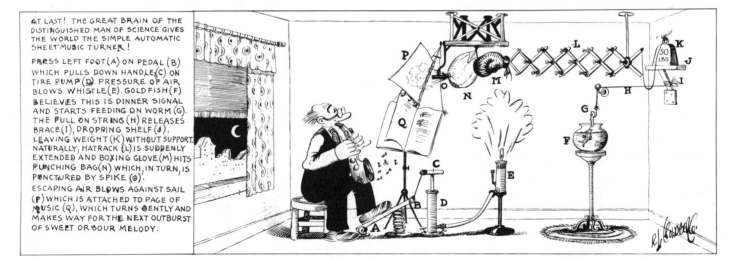

At last! The great brain of the distinguished man of science gives the world the simple automatic sheet music turner!

Press left foot(A) on pedal (B) which pulls down handle(C) on tire pump (D). Pressure of air blows whistle(E). Gold fish(F) believes this is dinner signal and starts feeding on worm(G). The pull on string (H) releases brace(I), dropping shelf (J), leaving weight (K) without support. Naturally, hatrack (L) is suddenly extended and boxing glove (M) hits punching bag (N) which, in turn, is punctured by spike (O).

Escaping air blows against sail (P) which is attached to page of music (Q), which turns gently and makes way for the next outburst of sweet or sour melody.

118. Simple Way to Open an Egg Without Dropping It in Your Lap

119. Professor Butts' Simple Automatic Sheet Music Turner

Academy of Lagado, he found a great assemblage of frustrated inventors, each pursuing an impractical solution to an insignificant problem. One scientist "of a meagre aspect, with sooty hands and face, his hair and beard long, ragged and singed in several places," was seeking a method for extracting sunbeams out of cucumbers. Another genius, who had already published a treatise on the malleability of fire, worked with a new plan for transforming ice into gunpowder. A third was perfecting a method for building houses, "by beginning at the roof and working downwards to the foundation." The most imaginative and practical idea, however, came from a fellow who discovered a way to plow the ground with hogs. His instructions were as follows:

In an acre of ground you bury, at six inches distance, and eight deep, a quantity of acorns, dates, chestnuts, and other mast or vegetables whereof these animals are fondest; then you drive six hundred or more of them into the field, where in a few days they will root up the whole ground in search of their food, and make it fit for sowing, at the same time manuring it with their dung. It is true, upon experiment they found the charge and trouble very great, and they had little or no crop. However, it is not doubted that this invention may be capable of great improvement.

Almost two hundred years before Rube Goldberg appeared, Jonathan Swift had imagined a thriving state-sponsored institution filled with amiable, but naïve, technologically motivated nitwits.

Like Gulliver, who felt uneasy while tramping through the corridors at Lagado, Rube never adjusted completely to life at the University of California. His rigorous three-and-one-half-hour daily commuting routine cut short any casual conversations with the Berkeley dons—those distinguished gentlemen who struck Rube as a humorless lot with lumpy heads and bristly chins. Rube viewed them as an outsider might have done by occasionally trying to peep behind the curtain of their professionalism, hoping to catch a closer look at their true characters.

He was struck by the professors' failure to see themselves as oddballs, and by their total incapability for performing practical work or transforming tons of their bookish genius into an ounce of simple common sense. Rube was a modern-day Gulliver with a difference: Rube was real, Berkeley was real, and the professors—believe it or not—were real as well.

Professor Samuel B. Christy, dean of the College of Mining, became Rube's stereotype for a funny college scientist. He radiated a pretentious air of profundity, and when he was lecturing on a matter of great importance, he would jut his severely pointed Vandyke beard a little farther away from his winged collar. This motion always caused hushed snickers in the classroom—the loudest from the desk occupied by Rube Goldberg. Christy's favorite theory came from the new time and motion studies of the efficiency expert Frederick Taylor. Having read Taylor's controversial treatise, *Scientific Management*, Christy pronounced that to get the most from a wheelbarrow when going uphill it should be held at an angle of thirty-two degrees! In a letter dated 1903, Rube stamped the wheelbarrow business a "lot of hokum." He knew too well from his Oneida experience that

no matter how many foot pounds were required to propel a wheelbarrow at a certain angle the thing which counted in the long run was the resistance of the pusher's back against breaking. Since a wheelbarrow will stand for a lot and the human back won't, it always seemed to me that it would be better if Professor Christy devoted more time

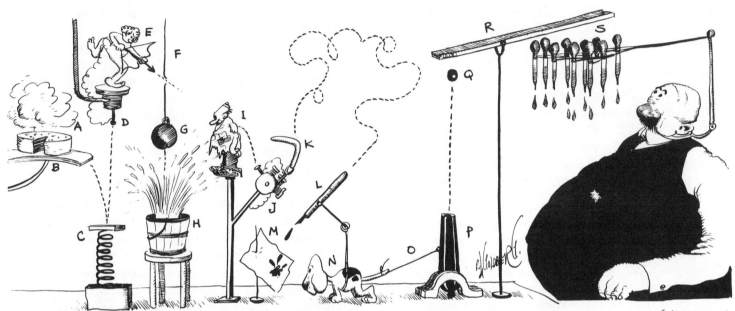

CHEESE (A), AFTER STANDING AROUND FOR SEVERAL WEEKS, GROWS RESTLESS AND FALLS OF PLATFORM (B), HITTING SPRING (C) AND BOUNCING AGAINST ELECTRIC BUTTON (D) WHICH RELEASES ARROW HELD BY MECHANICAL CUPID (E) - ARROW CUTS STRING (F) DROPPING WEIGHT (G) INTO BUCKET OF WATER (H) - WATER SPLASHES ON TRAMP (I) WHO FAINTS FROM THE SHOCK AND DROPS AGAINST BOOMERANG-THROWING MACHINE (J) - BOOMERANG (K) SHOOTS ALL OVER THE PLACE AND FINALLY STRIKES END OF FOUNTAIN PEN (L) KNOCKING INK-BLOT ON PAPER- (M) - ERASER-HOUND (N) JUMPS AT PAPER TO RUB OUT INK-BLOT WITH HIS NOSE- STRING (O) SETS OFF AEROPLANE GUN (P)- BULLET (Q) HITS BOARD (R) WHICH SQUEEZES BULBS ON END OF DROPPERS (S)- DROPPERS CONTAIN INK THE SAME COLOR AS THE GRAVY SPOT- THE INK DROPS FALL ALL OVER VEST MAKING IT IMPOSSIBLE TO TELL WHICH ONE OF THE SPOTS IS GRAVY— AND YOU HAVE A FANCY VEST IN THE BARGAIN.

120. Simple Way of Hiding a Gravy Spot on Your Vest, 1916

to a discussion of the angle at which one should hold one's spine. Scientific specifications go blooey when up against a good old-fashioned case of lumbago.

Sixty-five years later Rube insisted that Professor Christy was a chief inspiration for the inventions. "My pet mission," wrote Rube in 1968, "has been to rescue sundry backs from cracking under the strain of carrying inhuman loads." So Rube began where Christy had stopped. Of all the angles that held the professor's attention, the only one Rube was fascinated by was the slant of Christy's goatee. During one of the wheelbarrow lectures Rube cartooned Christy pushing a load up a 20 percent grade, with—as Rube noted—"the angle of his goatee indicative of how the foot pounds theory failed when a professor was the motive force." As the drawing was being passed around, Christy intercepted it and Rube found himself expelled from class for two weeks.

Christy did not monopolize all of Rube's humor; there was too much competition from the other lecterns. In 1916, for example, Rube insisted that the idea for the inventions grew out of a college course in chemistry (Fig. 128):

You know how the professor stands up behind a long table in the chemical laboratory with a lot of retorts and test tubes and bottles and lamps . . . all strung out in front of him, and starts at one end to demonstrate something and winds up at the other end with the absolute proof that something or other has one per cent of sodium in it.

This triggered an awareness in Rube's mind of the roundabout way some people have of doing very simple things. It was like the Oneida experience when Rube had dug through anticlines of quartz for a single ounce of gold.

While commuting by ferryboat every day, Rube also noticed that tons of coal, voluminous clouds of black, sooty smoke, and intense amounts of human energy seemed to replace the wind as the ship's propelling force. Even more amazing to Rube was the way the passengers seemed oblivious to all this effort. They sipped their coffee and ate their corn-beef hash (which was sold on the ferries) as if they were sitting snugly at home. Such matter-of-fact acceptance of mechanization, even at this early date, tickled Rube; he had to find a way to express the incongruities around him.

Once the Rube Goldberg inventions became a subject of national laughter, letters came streaming in asking, "How did you think it up?" At first Rube tried to give complete answers telling about Christy, chemistry, Oneida, and ferryboats. Soon he found this long-winded explanation a total bore, so he blamed the whole business on Berkeley's greatest oddball, Professor Freddy Slate, and his bewildering *Barodik*. Slate, a real-life character almost right out of Jonathan Swift, was blessed with a red beard, a protruding Adam's apple, and shiny gold-rimmed eye glasses which sat high on his pointy head. A devout student of physics, he mustered all his enthusiasm for his course in analytic mechanics. The main experiment in this course was to weigh the earth, and Freddy Slate's *Barodik* could do just that.

Both Slate and his invention exceeded even Swift's fantasies. According to Rube, the *Barodik* filled a large laboratory, and it consisted of a series of "pipes and tubes and wires and chemical containers and springs and odd pieces of weird equipment which made it look like a dumping ground for outmoded dentists' furnishings." The students were allowed six months of experimentation to determine the weight of the earth, and everyone got an A because no one really knew how much the earth did weigh.

When you find you've lost your collar-button again, you wave arms in anger—fist (A) presses bulb (B) and squirts water (C) into eye of Yiffik bird (D)—bird is temporarily blinded & walks off perch (E), falling into car (F) of scenic railway (G)—car descends, causing cord (H) to tilt bar (I)—wooden finger (J) presses referee doll (K) making it say "play ball"—pitcher (L) of midget giants grabs ball (M) which is attached to handle of phonograph (N) and winds up—phonograph record asks, "WHERE IS AT?"—philosopher father (O) of pitcher, who is even smaller than his son, is puzzled over question and walks around trying to figure it out—he is so absorbed in problem, he walks under bureau (P) and bumps into collar-button (Q), yelling "ouch" and showing you where collar button is.

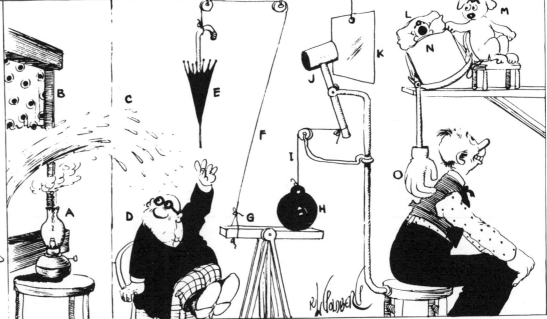

Flame from lamp (A) catches on curtain (B) and fire department sends stream of water (C) through window—dwarf (D) thinks it is raining and reaches for umbrella (E), pulling string (F) and lifting end of platform (G) — iron ball (H) falls and pulls string (I), causing hammer (J) to hit plate of glass (K)—crash of glass wakes up pup (L) and mother dog (M) rocks him to sleep in cradle (N) causing attached wooden hand (O) to move up and down along your back.

121. Another Professor Butts Invention for "Our Simple Collar-Button Finder"
122. Professor Butts' Automatic Mosquito-Bite Scratcher

The *Barodik* must have been a visual wonder, a totally useless but all-engaging contraption testifying to man's love for doing things the hard way. Rube never forgot it. He claimed that his own devices were direct descendants of the *Barodik*, with a few additions like midgets, kangaroos, rising cakes of yeast, hungry moths, shrinking pajamas, self-dunking doughnuts, and woodpeckers—just to spice things up (Figs. 129, 130, and 131).

The *Barodik*, by itself, was a laugh riot for Rube, but when Freddy Slate explained in his high squeaky voice some "important" detail about his masterpiece, Rube was uncontrollable. The incongruity of Slate's seriousness vs. the *Barodik*'s absurdity became an essential influence on Rube's comedy, for the effectiveness of the Goldberg contraptions rests on a simple theory of opposites. No matter how crazy the inventions, the instructions explaining how the parts interact are deadly serious: "Water from drain-pipe (A) drops into flask (B). Cork (C) rises with water carrying needle (D) with it etc., etc." The total lack of inflection or extraneous commentary makes the text read like the instructions on an engineer's stress and strain sheet for roof trusses. This was no accident. During his junior and senior years, Rube labored through thousands of tiresome calculations to determine the deadweight load for make-believe buildings and mines. It was close, tedious work, with complex diagrams showing vectors of force, stress polygons, and partial loads of stress. One of Rube's drawings was entitled "To Find the Reactions and Point of Rupture in a Loaded Beam," and the neatly inked instructions have the brevity and the tone of the Goldberg contraptions:

Draw force polygon; find resultant weight forces; construct funicular polygon and draw closing line. Draw CM // closing line, giving reactions R_1 and R_2. Draw line // closing line and tangent to funicular polygon. Draw ordinate through point of tangency. This ordinate is line of rupture.

What better inspiration for a humorous inventor?

The importance of contrast and incongruity learned at Berkeley became evident at every point of the inventions. The action is continually changing direction —up and down, in and out, back and forth—marking the longest conceivable path for any line of force. The parts also contrast from big to little, animate to inanimate, horizontal to vertical, fat to skinny. Change and variety are the only constants.

Rube's training in mechanical drawing also played an aesthetic part. Like the cutaway view of a motor in which the thickness and color of every line are constant, Rube's line is artless, depicting everything— dogs, midgets, fans, and buckets—with a consistently innocent lunacy. This was the ultimate incongruity. One almost expects each part to turn to the reader and ask, "What are you laughing at?"

Rube, in short, followed all the requirements for an A+ in mechanical drawing; only the subject changed. This deadpan approach dramatized the earnestness and the folly of our aggressive pursuit of automation. As Rube wrote years later, his inventions were symbols of "man's capacity for exerting maximum effort to accomplish minimal result."

But what, actually, classifies the inventions as humor? Like many of his other cartoons, the inventions appear as graphic dreams. They are often so absurd that they become believable. Sigmund Freud, in his neglected book *Wit and Its Relation to the Unconscious*, has postulated that the path of wit is broad but discernible. And its principal ingredients are the same as those of dreams: condensation and displacement. By condensation, Freud meant the compressing of both time and space, a denial of physical limitations,

191

When you say "have a drink", natural motion of hand (A) pulls string (B) and lifts lid (C), releasing vodka fumes (D) which make Russian dancing-bug (E) feel giddy - he starts dancing national dance of Russia and revolves platform (F) - pulley (G) turns corkscrew (H) and it sinks into cork (I) bringing down disc (J), which hits surface (K) and causes wooden hand to push iron ball (M) off support (N), causing cord (O) to pull corkscrew with cork from bottle.

The professor takes a pill and dopes out a device for closing the window if it starts to rain while you're away.

Pet bull frog (A), homesick for water, hears rain storm and jumps for joy, pulling string (B) which opens catch (C) and releases hot water bag (D) allowing it to slide under chair (E). Heat raises yeast (F) lifting disk (G) which causes hook (H) to release spring (I). Toy automobile-bumper (J) socks monkey (K) in the neck putting him down for the count on table (L). He staggers to his feet and slips on banana peel (M). He instinctively reaches for flying rings (N) to avoid further disaster and his weight pulls rope (O) closing window (P), stopping the rain from leaking through on the family downstairs and thinning their soup.

123. Our Own Self-Working Corkscrew
124. Professor Butts' Automatic Window Closer

and the creation of an intensified, compact image. Displacement, on the other hand, referred to the subject matter—the objects, the people, the emotions—experienced in the re-created, condensed dreamworld. Both wit and dreams, according to Freud, are made up of disparate elements which come together to reveal a new idea or experience. Whether Freud was correct or not may be debatable, but what too many critics have failed to see is that both condensation and displacement are essential to the Goldberg inventions.

The most misunderstood element in the inventions is the condensing of time. If we really used Professor Butts' moth exterminator (Fig. 132) in our own home, for example, it would probably take us four or five hours to get the entire mechanism to function. While waiting for "cake of ice (D)" to melt, we could run to the cleaners and have our clothes mothproofed, starched, and pressed, with sufficient time remaining to stop on the way home for a bite of lunch, a card game, or maybe even a movie.

Professor Butts' simplified pencil sharpener (Fig. 133) is even more time-consuming. To fly kite (B) from open window (A) requires a strong wind and a lot of patience. It might take weeks to get the thing into the air, unless, of course, the ingenious Butts could be persuaded to devise a foolproof kite launcher. Once moths (E) escape—assuming that they haven't died of starvation while waiting for kite (B) to pull string (C) which lifts door (D)—perhaps a month will be necessary before red flannel shirt (F) is sufficiently chewed to permit shoe (G) to trip switch (H). In a mere matter of minutes the smoke (K) from burning pants (J) will enter hole in tree (L), but it's tough to calculate just how long opossum (M) can hold out. Goldberg's choice of animal is uncanny. This prehensile-tailed marsupial is renowned for playing

dead whenever it senses immediate danger—a curious instinct which causes many opossums to burn to death in forest fires rather than flee to safety. Thus, the whole invention could break down at this point, but—for Butts' sake—let's assume that *this* opossum is willing to counter his genetic traits and behave in a sensible way. He jumps into basket (N) pulling rope (O) which liberates woodpecker (Q) from cage (P). And depending, I suppose, on how hungry the woodpecker is, the pencil eventually receives a new tip.

If the drawing were suddenly translated into a real pencil sharpener, it wouldn't be very funny to wait all that time for the completion of the action. The joke requires a condensing of time: immediate cause and effect, a still version of time-lapse photography which, by careful editing, can show the growth and bloom of a tulip in a single minute. But unlike this miraculous film technique, which requires thousands of feet of celluloid, all of Goldberg's action takes place within a single frame. There are no scene changes as in a play or a novel, no extraneous characters thrown in for relief, and no color—just simple, black-and-white fantasy: a stunning example of pure economy, the highest form of both art and humor.

The condensing of time is only one ingredient, for in a curious way the Goldberg inventions also condense movement and obviate chance by creating a new-styled efficiency. No one is unemployed in Goldberg's world; even mice and cats and squirrels perform social services. In the pencil sharpener every moth attacks the shirt, every wisp of smoke enters the hole in the tree trunk, and the liberated woodpecker uses every ounce of strength, not to fly away, but to sharpen the pencil. There is a rigid discipline, which may be misguided but nonetheless aims to get the job done. The discipline itself, resting on a chain of improbable

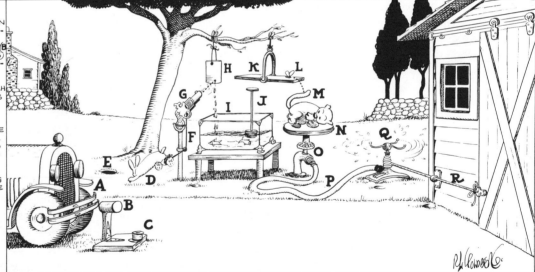

125. Professor Butts' Automatic Dishwasher

126. Professor Butts' Automatic Garage Door Opener, 1928

events, is funny because it violates everyday expectations. By putting a straitjacket on the flexibility of life, Goldberg pulls a laugh. This discipline of inefficiency is an acknowledged choice even within the imagined world of the inventions. There is an emergency knife (S), the instructions concede, which is "always handy in case opossum or the woodpecker gets sick and can't work." Only then may the entrepreneur violate the first commandment (according to Goldberg): "Do it the hard way."

This afterthought often works as a punch line, or what vaudeville pros called a "topper," and it is significant as both a psychological and an aesthetic device. Aesthetic because it snaps us out of Goldberg's dreamworld into which we had so willingly ventured, a world where time and improbability had been redefined and reshaped. Psychological because it makes us smile at our own laughter. "Oh how funny it was to laugh at Goldberg's free play of ideas, his weird notions about the automatic life. Pure fun," we say, and on we move to the more serious parts of our daily newspaper.

Getting the picture? A bit more analysis and Freud's second point of correlation between wit and dreams, displacement, should become apparent. In *The Interpretation of Dreams* Freud postulated that every human mind has a censor which profoundly influences conscious thought. In dreams we often counter this inhibiting force by pulling images and ideas from deep within us, things we had refused to cope with during waking hours. They usually seem jumbled and nonsensical, as we later remember them, with strange juxtapositions of images and events. They are deviations from our conscious trends of thought but apparently essential for a healthy psyche.

The displacement in Rube's inventions is as wild and yet as natural as that in dreams. The automatic screen door closer (Fig. 134) employs houseflies, a spider, a potato bug, a mechanical soldier who hangs himself, and a circus monkey who is an expert bowler. Other inventions use frogs, mannequins, false teeth, penguins, roasted chickens, bunches of garlic, old shoes, poison, rockets, and a host of unique gadgets designed by Goldberg himself (Figs. 135, 136, 137, 138, and 139). The inventions are no less than graphic dreams. Weird at first sight, they immediately enchant us and demand a closer look. Then, like an alarm clock which heralds the coming of the real world, the instructions finally turn against themselves: "The monkey who has just closed the screen door automatically is liable," Rube notes, "to get sore when he discovers that the bowling pins are phoney so it is a good idea to take him to a real bowling alley once in a while just to keep his good will."

While this kind of incongruity appears to have been a standard component of literary humor since laughter began, it occurred in pre-1900 art only on occasion. Rabelais's *Gargantua*, Cervantes' *Don Quixote*, and Pope's *Rape of the Lock* pit big against little, reality against fantasy, and simplicity against ultrarefinement. Weak and "helpless" maidens win a heroic battle in *Lysistrata*. Twenty centuries later Jonathan Swift, in *Gulliver's Travels*, employs six hundred pigs and innumerable bushels of vegetables to get a tiny plot of earth plowed. But this timeless ingredient for humor is in danger. Today our awareness of incongruity has become so dulled by the life-style of the real world that when someone tells us he has purchased an airline ticket to the sun we don't even crack a smile. Rather, our immediate instinct is to ask whether he also has a return reservation and whether he is traveling first-class or tourist. Interestingly enough, Goldberg was

At 6:30 WEIGHT (A) AUTOMATICALLY DROPS ON HEAD OF DWARF (B), CAUSING HIM TO YELL AND DROP CIGAR (C), WHICH SETS FIRE TO PAPER (D)—HEAT FROM FIRE ANGERS DWARF'S WIFE (E)—SHE SHARPEN'S POTATO KNIFE (F) ON GRINDSTONE (G) WHICH TURNS WHEEL (H) CAUSING OLIVE SPOON (I) TO DIP REPEATEDLY INTO OLIVES—IF SPOON DOES NOT LIFT AN OLIVE IN 15 MINUTES, CLOCK (J) AUTOMATICALLY PUSHES GLASS-CUTTER (K) AGAINST BOTTLE AND TAKES OUT CHUNK OF GLASS BIG ENOUGH FOR YOU TO STICK YOUR FINGER IN AND PULL OUT AN OLIVE.

ASSOCIATED CHEMISTS

127. Simple Way to Fish an Olive Out of One of Those Long-Necked Bottles

128. Illustration from University of California *Yearbook*, 1903

the only American in the 1910–1920 period to express this incongruity repeatedly in cartoon form. The rest of the technological art of the early years came from Europeans, who looked at the mechanized civilization from the outside. To them the inconsistencies were blatant.

For those who still enjoy *Gulliver's Travels*—it was the one book Rube reread often—the peril of incongruity is clear. The craftsmanship of Swift's prose can still be savored, but the scientific humor is something less than riotous. That distinction between reality and fantasy which was so clear in Swift's mind has all but vanished. The inventor at Gulliver's Academy of Lagado who spent his life trying to pull sunbeams out of cucumbers must have represented to Swift the craziest man on the face of earth. Today, sunshine vitamins and infrared lamps capture sunbeams without cucumbers and without the sun. Science has exceeded even Swift's wildest fantasy.

Living in a world of million-ton machines designed to crush the smallest unit of matter, people do not always see humor in the obvious contrast of big and little. But how much different in spirit is an atom smasher from Rube Goldberg's self-operating napkin (Fig. 140), or his automatic liquor tester (Fig. 141), or even his simple appliance for putting postage stamps on envelopes (Fig. 142)? The real test of Goldberg's humor is that despite the blurring of the real and the absurd his machines still make us laugh. Why? The answer lies in the richness and depth of the contraptions themselves and in their relationship to life.

The Rube Goldberg inventions are artificial exaggerations of the natural rigidity in real machines. They consist of totally incongruous parts which unintentionally follow a rigid chain of unlikely events (Figs. 143 and 144). As historian Henry Okun wrote

shortly after Rube's death, "Each machine is a play, with objects, animals, and people as dramatis personae, that, once the action is started, proceeds to its conclusion with the inevitability of the author's fantasy." In most of the contrivances man is a working part, as precise and predictable as a screw. We laugh at man impersonating a thing because in spite of the absentminded reaction to a stimulus, the result—however improbable—is always the same. It represents something mechanical encrusted upon the living.

Yet, while many Goldberg cartoons focused on the disruptive influence of machines, his larger message was brimming with optimism. The inventions ridicule the pretentiousness of the automatic life; they mock it; they even hurl shafts of pessimism—but they never intend to defeat it. They embrace modern machinery while taking a keen look at cracked electric plugs or loose bolts. They just happen to remind us that a $10,000 car will not run without a 10-cent ignition wire. With their tiny cannons, frightened mice, rubber tubes, leaky water buckets, pulleys, frayed ropes, and midgets, the inventions aim to convince us that machinery isn't all it's cracked up to be. Their very rigidity assures us that human values can survive in a society of steam power, electrical wires, and atomic reactors, so long as man is willing to remain flexible and to laugh at his own creations.

In 1959 columnist Walter Winchell caught the humane spirit of Rube's works: "Generations of Americans have roared with laughter at Rube Goldberg machines—but the combined scientists of the world can not—and never will—produce a machine which laughs at a man." Rube clipped this observation and noted in the margin, "Let's hope so."

PROFESSOR BUTTS TRIPS OVER A HAZARD ON A MINIATURE GOLF COURSE AND LANDS ON AN IDEA FOR AN AUTOMATIC DEVICE FOR EMPTYING ASH TRAYS.

BRIGHT FULL MOON (A) CAUSES LOVE BIRDS (B) TO BECOME ROMANTIC AND AS THEY GET TOGETHER THEIR WEIGHT CAUSES PERCH (C) TO TIP AND PULL STRING (D) WHICH UPSETS CAN (E) AND SPRINKLES WOOLEN SHIRT (F) CAUSING IT TO SHRINK AND DRAW ASIDE CURTAIN EXPOSING PORTRAIT OF WIGWAG PUP'S MASTER (G). AS PUP (H) SEES MASTER'S PICTURE HE WIGWAGS TAIL FOR JOY AND UPSETS ASH TRAY (I), SPILLING ASHES AND SMOULDERING BUTTS INTO ASBESTOS BAG (J) ATTACHED TO SKY ROCKET (K). BUTT (L), PASSING FUSE (M), IGNITES IT AND CAUSES ROCKET TO SHOOT OUT OF WINDOW DISPOSING OF ASHES.

YOU SHOULD ALWAYS HAVE TWENTY OR THIRTY HIGH-POWERED AEROPLANES READY TO GO OUT AND SEARCH FOR THE ASBESTOS BAG.

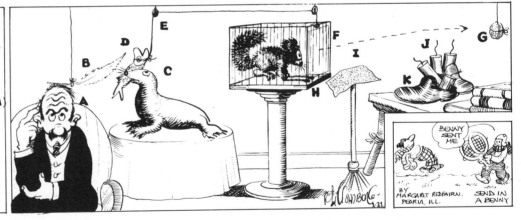

AS YOU TRY TO THINK WHERE YOU PUT YOUR RUBBERS, YOUR FOREHEAD (A) WRINKLES CAUSING THE TOP OF YOUR HEAD TO MOVE AND DISTURB SUSPENDED FEATHER (B) - FEATHER TICKLES SEAL (C) WHICH LAUGHS, OPENS MOUTH AND DROPS FISH (D) - WEIGHT OF FISH CAUSES STRING (E) TO OPEN DOOR OF CAGE (F), RELEASING SQUIRREL WHICH DIVES AT NUT (G) - MATCHES (H) ARE TIED TO SQUIRREL'S FRONT PAWS - AS SQUIRREL FLIES PAST PIECE OF SANDPAPER (I), MATCHES ARE LIGHTED AND SET OFF FIRE-CRACKERS (J) - NOISE OF EXPLOSIONS SHOWS YOU IMMEDIATELY WHERE RUBBERS (K) ARE. IF RUBBERS TAKE FIRE, SQUIRREL ON FINDING NUT IS AN IMITATION, BREAKS DOWN AND CRIES AND TEARS PUT OUT FLAMES.

McNaught Syndicate, Inc. N.Y.

BENNY SENT ME

BY MARGARET REDFAIRN, PEORIA, ILL. SEND IN A BENNY

129. Professor Butts' Automatic Device for Emptying Ash Trays

130. Simple Way to Find Your Rubbers, 1931

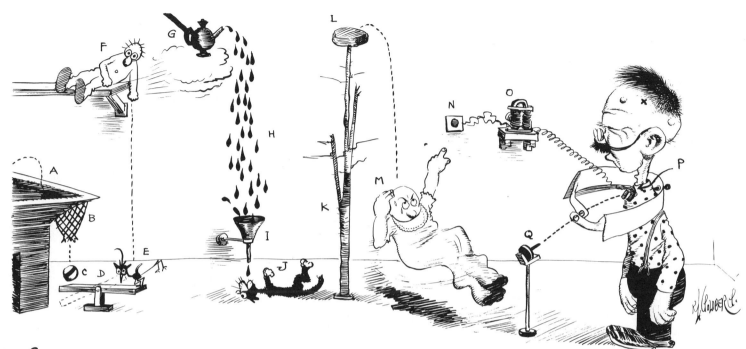

STAND NEAR POOL TABLE (A) — BALL (C) FALLS THROUGH POCKET (B) STARTING SEE-SAW (D) AND BOUNCING MEASLES-GERM (E) INTO THE AIR — GERM HITS DOLL (F) WHICH IMMEDIATELY CATCHES MEASLES AND DEVELOPS A HIGH FEVER — FEVER HEATS COFFEE POT (G) AND COFFEE BOILS OVER, DROPPING THROUGH FUNNEL (I) INTO CAT'S MOUTH, GIVING CAT (J) INSOMNIA — CAT CLIMBS TREE (K) FOR DIVERSION AND KNOCKS OFF BRICK (L) — BRICK HITS CHILD (M) IN HEAD — CHILD PRESSES BUTTON (N) THINKING IT WILL SUMMON HELP — BUTTON SETS UP CURRENT IN COIL (O) WHICH CHARGES MAGNET (P) WHICH ATTRACTS TACK (Q) THROUGH BUTTON-HOLES IN COLLAR, HOLDING COLLAR SECURELY IN POSITION.

131. Read this and learn how to button your collar in a hurry

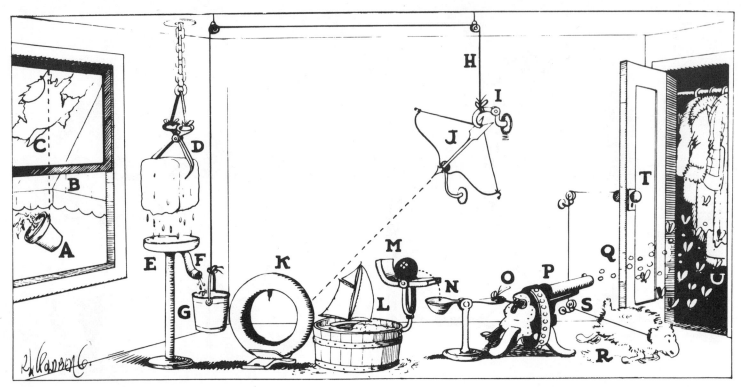

The professor emerges from the Goofy Booth with a device for the extermination of moths.

Start singing. Lady upstairs, when sufficiently annoyed, throws flower pot (A) through awning (B). Hole (C) allows sun to come through and melt cake of ice (D). Water drips into pan (E) running through pipe (F) into pail (G). Weight of pail causes cord (H) to release hook (I) and allow arrow (J) to shoot into tire (K). Escaping air blows against toy sailboat (L) driving it against lever (M) and causing ball to roll into spoon (N) and pull string (O) which sets off machine gun (P) discharging camphor balls (Q). Report of gun frightens lamb (R) which runs and pulls cord (S), opening closet door (T). As moths (U) fly out to eat wool from lamb's back they are killed by the barrage of moth balls.

If any of the moths escape and there is danger of their returning, you can fool them by moving.

132. Professor Butts' Moth Exterminator

PROFESSOR BUTTS GETS HIS THINK-
TANK WORKING AND EVOLVES THE
SIMPLIFIED PENCIL-SHARPENER.
OPEN WINDOW (A) AND FLY KITE (B).
STRING (C) LIFTS SMALL DOOR (D) ALLOW-
ING MOTHS (E) TO ESCAPE AND EAT
RED FLANNEL SHIRT (F). AS WEIGHT OF
SHIRT BECOMES LESS, SHOE (G) STEPS ON
SWITCH (H) WHICH HEATS ELECTRIC IRON (I)
AND BURNS HOLE IN PANTS (J). SMOKE (K)
ENTERS HOLE IN TREE (L) SMOKING OUT
OPOSSUM (M) WHICH JUMPS INTO BASKET
(N) PULLING ROPE (O) AND LIFTING CAGE (P),
ALLOWING WOODPECKER (Q) TO CHEW
WOOD FROM PENCIL (R) EXPOSING LEAD.
EMERGENCY KNIFE (S) IS ALWAYS
HANDY IN CASE OPOSSUM, OR THE
WOODPECKER GETS SICK AND
CAN'T WORK.

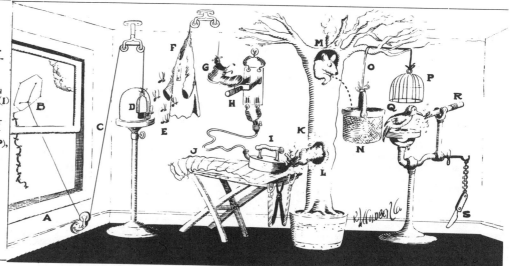

PROFESSOR BUTTS MAKES A PARACHUTE JUMP, FOR-
GETS TO PULL THE STRING AND WAKES UP THREE
WEEKS LATER WITH AN AUTOMATIC DEVICE FOR
KEEPING SCREEN DOORS CLOSED.
HOUSEFLIES (A) SEEING OPEN DOOR, FLY ON PORCH.
SPIDER (B), DESCENDS TO CATCH THEM AND FRIGHTENS
POTATO-BUG (C), WHICH JUMPS FROM HAMMER (D) ALLOWING
IT TO DROP ON PANCAKE TURNER (E) WHICH TOSSES
PANCAKE INTO PAN (F). WEIGHT OF PANCAKE CAUSES
PAN TO TILT AND PULL CORD WHICH STARTS MEC-
HANICAL SOLDIER (H) WALKING. SOLDIER WALKS TO
EDGE OF TABLE AND CATCHES HIS HEAD IN NOOSE (I)
THEREBY HANGING HIMSELF. WEIGHT IN NOOSE CAUSES
STRING TO PULL LEVER AND PUSH SHOE AGAINST
BOWLING BALL (J), THROWING IT INTO HANDS OF
CIRCUS MONKEY (K) WHO IS EXPERT BOWLER. MONKEY
THROWS BALL AT BOWLING PINS PAINTED ON SCREEN
DOOR THEREBY CLOSING IT WITH A BANG.
THE MONKEY IS LIABLE TO GET SORE WHEN HE
DISCOVERS THAT THE BOWLING PINS ARE
PHONEY SO IT IS A GOOD IDEA TO TAKE HIM TO A
REAL BOWLING ALLEY ONCE IN A WHILE
JUST TO KEEP HIS GOOD WILL.

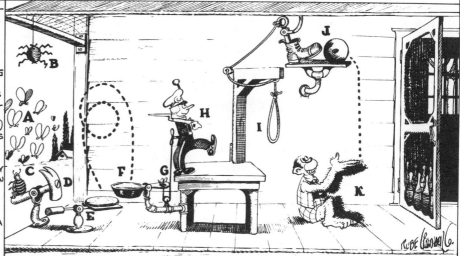

133. Professor Butts' Simplified Pencil Sharpener
134. Professor Butts' Automatic Screen Door Closer

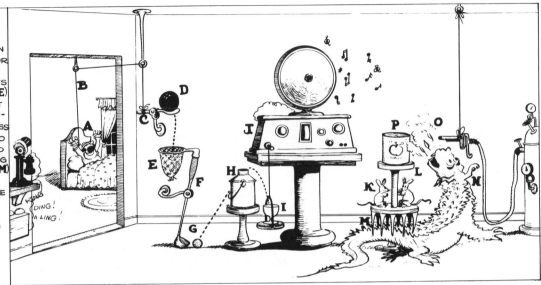

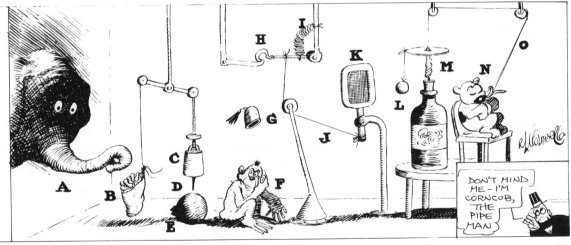

135. Professor Butts' Simplified Can Opener

136. Our Handy Bottle Opener

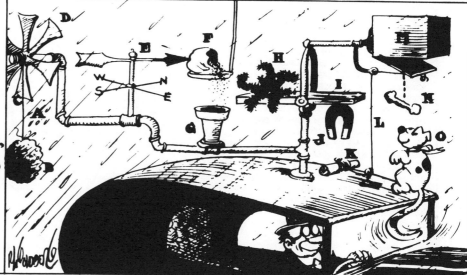

PROFESSOR BUTTS SWALLOWS HIS FALSE TEETH AND COUGHS UP A DESIGN FOR A NEW WINDSHIELD-WIPER.

WEIGHT OF RAIN (A) IN SPONGE (B) CAUSES STRING (C) TO SPIN FAN (D). BREEZE FROM FAN SWINGS WEATHER VANE (E) WHICH UPSETS BAG OF SEEDS (F) INTO FLOWER POT (G). AS SEEDS GROW & BLOOM CATERPILLARS (H) SPIN COCOONS WHICH NATURALLY BECOME BUTTERFLIES AND FLY TO FLOWERS, THEREBY ALLOWING WEIGHT OF BOARD (I) TO LOWER MAGNET (J), WHICH ATTRACTS IRON BAR (K) CAUSING STRING (L) TO OPEN BOX (M). SOUP BONE (N) DROPS IN FRONT OF ZOZZLE HOUND (O). HE WAGS TAIL FOR JOY WIPING RAIN FROM WINDSHIELD.

THE BIG PROBLEM IS TO GET THE BUTTERFLIES TO HATCH BEFORE THE RAIN STOPS. ASK THE KING OF SPAIN ABOUT THIS—HE HAS PLENTY OF TIME TO FIGURE IT OUT.

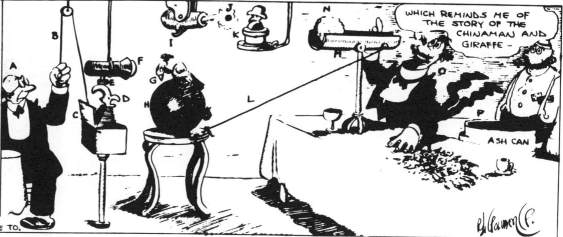

OFFICIAL BOUNCER (A) PULLS STRING (B), OPENING LID (C) AND CAUSING JACK-IN-THE-BOX (D) TO JUMP UP AND HIT BUTTON (E) WHICH TURNS ON FLASH-LIGHT (F)-SLEEPING BIRD (G), THINKING IT IS SUNRISE, WAKES UP AND FLIES AWAY, ALLOWING BALLOON (H) TO RISE AND HIT TRIGGER (I)-BULLET (J) HITS SMALL STATUE OF NAPOLEON (K), WHICH FALLS ON STRING (L), TILTING TROUGH (M)-SPONGE (N), SOAKED WITH CHLOROFORM, ROLLS DOWN TROUGH INTO FACE OF SPEAKER (U)-HE IMMEDIATELY FALLS BACK INTO ASH-CAN (P) WHICH IS QUICKLY REMOVED BY ATTENDANT (Q) BEFORE SPEAKER HAS CHANCE TO COME TO.

WHICH REMINDS ME OF THE STORY OF THE CHINAMAN AND GIRAFFE —

ASH CAN

137. Professor Butts' New Windshield Wiper

138. Professor Butts' Invention for Eliminating After-Dinner Speakers

PROFESSOR BUTTS GETS HIS WHISKERS CAUGHT IN A LAUNDRY WRINGER AND AS HE COMES OUT THE OTHER END HE THINKS OF AN IDEA FOR A SIMPLE PARACHUTE. AS AVIATOR JUMPS FROM PLANE FORCE OF WIND OPENS UMBRELLA (A) WHICH PULLS CORD (B) AND CLOSES SHEARS (C), CUTTING OFF CORNER OF FEATHER PILLOW (D). AS WHITE FEATHERS (E) FLY FROM PILLOW, PENGUIN (F) MISTAKES THEM FOR SNOW FLAKES AND FLAPS HIS WINGS FOR JOY WHICH DRAWS BUCK-SAW (G) BACK AND FORTH CUTTING LOG OF WOOD (H). AS PIECE OF WOOD FALLS INTO BASKET (I) ITS WEIGHT CAUSES ROPE (J) TO PULL TRIGGER OF GUN (K) WHICH EXPLODES AND SHOOTS LOCK FROM CAGE (L) RELEASING GIANT UMPHA BIRD (M) WHICH FLIES AND KEEPS AVIATOR AFLOAT WITH ROPE (N). AVIATOR BREAKS PAPER BAG OF CORN (O) CAUSING CORN TO FALL TO GROUND. WHEN BIRD SWOOPS DOWN TO EAT CORN, FLIER UNHOOKS APPARATUS AND WALKS HOME.
THE BIGGEST PROBLEM IS WHERE TO GET THE UMPHA BIRD. WRITE YOUR CONGRESSMAN.

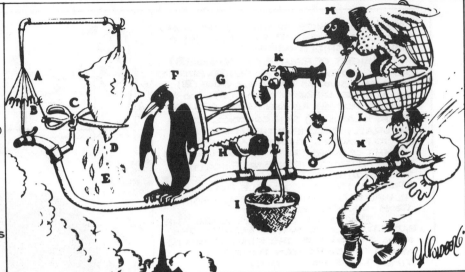

PROFESSOR BUTTS WALKS IN HIS SLEEP, STROLLS THROUGH A CACTUS FIELD IN HIS BARE FEET, AND SCREAMS OUT AN IDEA FOR A SELF-OPERATING NAPKIN.
AS YOU RAISE SPOON OF SOUP (A) TO YOUR MOUTH IT PULLS STRING (B), THEREBY JERKING LADLE (C) WHICH THROWS CRACKER (D) PAST PARROT (E). PARROT JUMPS AFTER CRACKER AND PERCH (F) TILTS, UPSETTING SEEDS (G) INTO PAIL (H). EXTRA WEIGHT IN PAIL PULLS CORD (I) WHICH OPENS AND LIGHTS AUTOMATIC CIGAR LIGHTER (J), SETTING OFF SKY-ROCKET (K) WHICH CAUSES SICKLE (L) TO CUT STRING (M) AND ALLOW PENDULUM WITH ATTACHED NAPKIN TO SWING BACK AND FORTH THEREBY WIPING OFF YOUR CHIN.
AFTER THE MEAL, SUBSTITUTE A HARMONICA FOR THE NAPKIN AND YOU'LL BE ABLE TO ENTERTAIN THE GUESTS WITH A LITTLE MUSIC.

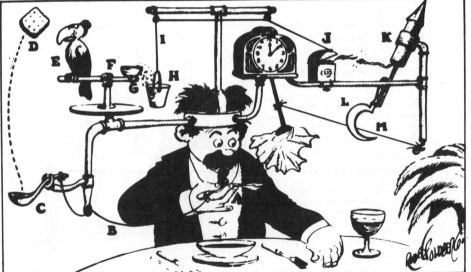

139. Professor Butts' Simple Parachute
140. Professor Butts' Self-Operating Napkin

12
No Time for Laughter

On July 4, 1928, Rube celebrated his forty-fifth birthday. Until then his cartoon career was characterized by a high degree of originality and a pot full of luck. Since he had hit his stride at the start of newspaper syndication, at a relatively early age he earned more money in a single year than the equally great nineteenth-century cartoonist, Thomas Nast, earned in a decade.

But 1928 was a bad year for many cartoonists, and Rube feared the end of his lucrative profession. Nothing very drastic occurred in 1928, yet the whimsy of public taste, the incessant yearning for change, the demand for a new-styled humor was all too apparent. *Boob McNutt, Father was right, That's life, It's all wrong, . . . , it's all wrong,* and all the rest were doomed. Writing in the *Saturday Evening Post* (December 15, 1928) Rube predicted a revolution in comic art:

In the dear old care-free days one vaudeville comedian would commit assault and battery on another vaudeville comedian with that marvelous instrument of hilarity, the slapstick, and the house would come down with a roar of unadulterated mirth. Where are the slapsticks of yesterday? You might possibly find one in the Smithsonian Institution catalogued as a bludgeon of ancient warfare.

Rube's vision was personally catastrophic, for his humor employed slapstick as its stock-in-trade. It aimed to evoke the belly laugh, a rib-splitting guffaw similar to the laughter of a jam-packed theater on Broadway when W. C. Fields or Ed Wynn or the Marx brothers were in town. He was the "Chaplin of the funny pages," as Al Capp remembered him, "the Master, at the peak of his powers." His caricatures were intentionally grotesque, striving to dramatize the foibles of the human race. His was an obvious sort of humor, with people falling out of windows or getting kicked in the pants, but Rube's cartoons were also more than knobby heads and flat tires; they possessed a mysterious attribute which Rube himself called *It. It* gave comic art commercial value. *It* meant "human appeal," according to Rube, a certain indefinable quality that dictates the success or failure of any public product. *It* was elusive and fickle, susceptible to the capriciousness of public taste. "Styles have changed violently in almost everything," wrote Rube in 1928, "but I can't see any contrast between the old and the new which is sharper than that relating to our daily dish of humor." Subtlety was replacing obviousness as the crucial element of *It.* And Rube saw the immediate future as a time of trial for veteran comics.

He succeeded in the "teens and twenties," he believed, because of his uncanny ability to anticipate the course of change. The real arbiter of humor, accord-

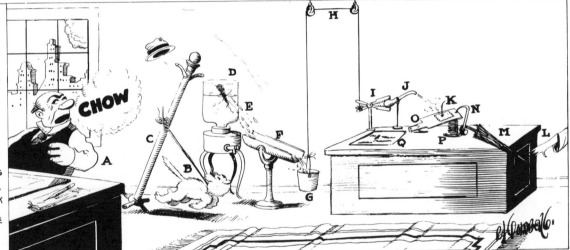

ing to Rube, was the public, not the producer. But by 1928 public demand for new and unusual ideas had driven most cartoonists from humor into adventure, philosophy, mystery, and romance. Heartthrob had replaced laughter, with Sidney Smith's *Gumps,* Harold Gray's *Orphan Annie,* and Percy Crosby's *Skippy* illustrating the new movement.

The comic strip was transformed into a "pathic strip," as Rube noted: "What used to make us cry, now makes us laugh." In this new order of emotions "humor and sadness are so badly scrambled that it is hard to identify one from the other, even with a microscope." While Boob McNutt would eventually become a casualty of this revolution, it was Rube's daily cartoons that felt the immediate danger. Grounded in a turn-of-the-century tradition, in only two or three years his most brilliant creations would vanish from the public eye.

Rube understood his fate with the precision of a physician who can take his own pulse. He was living that moment found in the Greek tragedies when the character sees the elements of his own destruction: "Any artist who tries to sell in 1928 the kind of stuff which went in 1900 is flirting with the same brand of tragic fate an ambitious bustle manufacturer courts. Go away, old joke, go away. Or who wants a bustle?"

This change preceded the stock market crash, but the economic collapse resulting from the Wall Street typhoon speeded the transformation. The demand for humor itself seemed to vanish, as Frank Sullivan reminisced in 1951: The frivolity of the old-time cartoons was considered bad taste in the 1930s, "a sort of fiddling while Rome burns," according to one eyewitness.

Even the sophisticated humor magazines disappeared one by one: *Vanity Fair* and *College Humor* and the old *Life* and the granddaddy of them all, *Judge.* Rube grieved:

It seems to me that something has gone slightly wrong with the daily routine of our lives. On the way home from work we read the comic page of our favorite evening paper —and cry. After dinner we listen to a doleful ballad on the radio—and cry. Then we see a movie of a particular heart-rending character—and cry some more. Where the laugh of the future is coming from is a matter requiring considerable elucidation. Maybe some big-hearted philanthropist will solve the problem by getting together a traveling exhibit of crutches. Or possibly the day will be saved for us by ma and pa putting on their skit of how to play bridge though married.

Thanks to the inventions of Professor Butts, Rube's name will never slip into oblivion (Fig. 145). But changes in the public attitude toward comic art have made most cartoonists as disposable as newsprint. The revolution of 1928 threatened the public images of even the most successful cartoonists. "The individuality of the artist is being lost and the personality of the character he creates is in the forefront," warned Rube. In 1915 people referred to Tad, Opper, McManus, or Goldberg; by 1928 *Mutt and Jeff, Little Orphan Annie,* and *Barney Google* had risen above their creators. How many readers know the cartoonists behind *Popeye* or *Nancy* or *Dick Tracy*? This loss of public identity was inevitable as continuity strips went on and on, but it was also due to the tremendous increase in the number of cartoonists. The comic industry ballooned in the 1920s until comic pages were replaced with one, and sometimes two, comic sections. "The market is so glutted nowadays," insisted Rube, "the reader . . . is losing track of which artist does which

143. Professor Butts' Automatic Picture-Snapping Machine
144. Professor Butts' Automatic Typewriter Eraser

comic. And this, it is easy to see, is not exactly stimulating to one's vanity."

Change for the sake of change has always been an American trademark. Much of Rube's humor rested on this single idiosyncrasy, but now it wasn't quite so funny. As in *Life's Little Jokes,* the success of 1920 was fast becoming the boob of 1930.

The revolution from humor to suspense and heart-throb did not begin with a sudden blast of destruction; it was a gradual transformation, a malignancy which gave warning. Despite the economic collapse of 1929 and the new interest in gloom, Rube's paychecks continued to arrive on time. From 1926 to 1931 he received generous salary increases from both Hearst and the McNaught Syndicate, but by 1934 his gravy train was headed for the junk heap. In 1926 his cartoons were reduced in size from one-third to one-sixth of a page, and by 1929 they appeared only three times per week. The humiliation was heightened on September 12, 1932, when the editors of the *Journal* transferred his cartoons from their favored position in the sports section to the confusion of the daily comic strip page. Buried in competition with *Blondie, Mutt and Jeff, Krazy Kat,* and the rest of the Hearst menagerie, Rube's wit was woefully out of place and pitifully small. Measuring only three inches in height, the new format did not allow for much detail—the very heart of Rube's style. And perhaps the greatest loss of all was the dropping of those individual titles which made each cartoon a contribution to homely wisdom. *That's life* became the catchall label, a feeble attempt to give Rube's work the look of a cartoon strip.

The public thirst for continuity and the new love of terror had caused the trouble—at least, that's what Rube believed. As he explained in one of his most hu-morous articles, "Read 'em and Weep" (*American Magazine,* August 1935), the newest fad in America was selling safety razors to babies. He had even heard of a strip featuring "Poorhouse Peggy," who within her first few weeks "got the measles, was run over by a truck, was bitten by a mad dog, and beaten to a pulp by a crooked lawyer named Cyrus Baxter." The good people of the United States, joked Rube, "took Peggy to their hearts."

While Rube's analysis of the main trends was generally correct, he overstated his case when it came to explaining his own difficulties. By today's standards, his cartoons from the 1928–1934 period simply are not as funny as the earlier creations. Occasionally his works are packed with humor, but most from this period lack *It.* They are usually true but seldom funny. In January 1934, for example, *That's life* appeared with a segment of Rube's older series *Why is it?* In two panels Rube asks: "Why is it—a growing boy will think it is foolish for his father to wait up for him late at night. But when he grows up and has a son of his own he does the very same thing. Why is it?" True, we hope, but somewhat less than belly shaking. No, if Rube's analysis of humorlessness was accurate, his own daily pieces should have thrived. Their failure suggests a misunderstanding of the 1930s which he never corrected.

One reason for the rise of continuity above single-thought cartoons during the 1930s was the popular need for consistency and familiarity. When a man fears for his job, he doesn't want to hear a philosophical statement about upper-class woes. Yet one of Rube's pieces, dated January 15, 1932, reported, "Gloom and pessimism have become so chronic that the directors of a well-known club have thrown out a member for

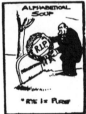

—By Rube Goldberg

145. That's life, New York *Evening Journal*,
January 2, 1934 (See detail above.)

daring to be happy." Funny? Only if you're not hungry. Again, look at a work from February 3, 1932: "Why is it the whole world is alarmed when a movie actor gets a pain in his toe—but, when a great and brilliant scientist is dying, nobody gives him a tumble? Why is it?"

By 1934 Rube's *It* had vanished, he had lost his golden touch, and he decided to develop a continuity strip that would fit the times. Occasionally during the 1920s he had drawn an ideal portrait to praise a hero like Lindbergh or to honor Uncle Sam (Fig. 146). Maybe in the ideal, the perfect, he could mine a new career. He worked intently throughout 1933 until he evolved a candidate who promised to bring him back into national prominence. His name was Doc Wright, a "kindly country physician, and the friend of every humble person." Lean, angular, honest, intelligent, shrewd, and gentle, *Doc Wright* was a mixture of *Dick Tracy,* *Superman,* and *Little Orphan Annie.* As the antithesis of *Boob McNutt,* Doc always did the right thing, he avoided any love affairs, and he seldom concerned himself with minutiae. The rural setting and the absence of technological problems made the revolution complete. Rube was out to remake his name.

The decision to go with *Doc Wright* as a fully qualified replacement for his daily cartoons amazed most of Rube's friends. Milt Caniff and others felt as though Rube had exchanged a sure hit for a subject which he knew too little about. Many predicted failure, but Rube had a fistful of answers. He insisted that all people were basically the same whether they lived in sleepy towns or bustling cities, and—after some commercial mindbending—he consented that the depression called for a change:

I think people are tired of laughing at a kick in the trousers. We have had so many misfortunes in the last four or five years that we need a little kindly humor and a pat on the back to reassure us that the world isn't such a bad place to live after all. We know now that we sacrificed too many of the fundamentals—the ordinary courtesies, the pleasant smile, the helping hand, the appreciation of simple things—in the mad rush for money.

Written early in 1934, these feelings pervaded all the *Doc Wright* material, and—as we might expect—Rube correctly analyzed the public's emotions. Within three weeks after the McNaught Syndicate sent out the promotion brochures, more than a hundred newspapers had wired for subscriptions and *Doc Wright* was a guaranteed success. The first installment, entitled *Here he is,* appeared on Monday, January 29, 1934 (Fig. 147). Since the final installment of *That's life* had appeared on Friday, January 26, Rube switched his format without missing a day of work (Fig. 148).

There was only one problem, which no one, including Rube himself, had foreseen. Seven months of etiquette, morality, and goodwill tore at the heart of a natural-born comic. "He didn't have the talentlessness for it," wrote Al Capp in 1970. "Goldberg trying to become a mirthless maudlin 'suspense' cartoonist was as hopeless as Bernard Shaw trying to become Lawrence Welk."

From January 27 to August 25, Doc Wright failed to soil his clothes, nobody kicked him in the butt, his diction never wavered, and his heroics seemed endless. He was more of a distortion than the older characters with their lumpy heads and their baggy pants. If only Wright could be wrong, just once! If only he would trip and bang his nose on the floor or get run over by a truck, just once, or fail to arrive in the nick of time. But no, Wright was perfect. Too perfect for Rube, and his interest soon began to flag.

146. Welcome home, Big Boy! 1927

Al Capp, a young cartoonist at the time, witnessed Rube's travail and, with his innate sense of modesty, offered to help the "master":

Rube's studio was elegant, orderly and decorated with pictures by other great men and pictures of Rube with other great men. I remember that when I was shown in, he was on the phone, talking to his syndicate about a request from some city in the Midwest, a two-day journey by train, for a personal appearance on some important public occasion. He grunted and asked if it would help "Doc Wright" with the local paper. The answer must have been that nothing would help "Doc Wright" because Rube grunted again and said something like to hell with it.

I began by saying that I thought he was the funniest cartoonist in the world and that . . . the public still wanted to laugh and that if he *combined* his comedy and the new "suspense," "Doc Wright" could sell more papers than anything.

Capp failed to convince Rube, and with more than one hundred papers still running the strip, *Doc Wright* vanished on August 25, 1934.

Before tossing in the towel on comic strip humor, however, Rube attempted to refurbish his ego with a new strip, *Lala Palooza*. Part of the incentive came from an unintended insult late in 1935. At that time the New York *News*–Chicago *Tribune* syndicate offered Rube the chance to revive the late Sidney Smith's character Andy Gump; and although the syndicate had the best intentions, Rube was speechless. The notion that someone would even think of Goldberg drawing another cartoonist's characters deeply hurt him, for it was the kind of job a young cartoonist would savor or an old-timer would resign himself to and Rube saw himself as neither.

For six months he juggled plots and characters and jokes in his head, working to concoct an original winner. Despite the trend toward adventure and sentimentality, he settled on humor and slapstick. By May of 1936 he had five characters set in his mind, each an updated version of an older type. The star, Countess Lala Palooza, was fresh from the *Weekly Meeting of the Tuesday Ladies' Club*. In Rube's words, she had

inherited a title, a garage full of dough, a yen for romance and a tendency towards overweight. But she figured out for herself that Society with a capital S is her dish—and is trying hard to break it. Lala is a direct action dame with few inhibitions but has a heart of pure gold, well sheathed in avoirdupois.

Her husband, Gonzales, was a natty dresser but "as phoney as a movie star's eyelashes." Earlier he had appeared as a crooked politician in *It's all wrong, . . . , it's all wrong*. Vincent Doolittle, Lala's unambitious brother, appeared as a slightly more corrupt version of the average dope whom Rube had drawn early in his career, while Hives the chauffeur, previously a waiter, was characterized as a guy "who puts up with as much as he gets away with or vice versa." And finally, there was Pinto, the pet pooch and "universal pain in the neck," who demanded "more breaks than an imported mezzo soprano."

The strip was promoted by a new syndicate headed by Frank Markey, previously with the McNaught organization. Following the old but successful technique of Virgil McNitt, Markey promoted Rube first, the strip second. "Rube Goldberg has always been an originator," noted the advertising brochure. "He has styled American humor for twenty years. . . . His utterances have added pace and flavor to the American language, become commonplace in the common speech." As for

147. Doc Wright: Here he is,
New York *Evening Journal*,
January 29, 1934
(See detail above.)

the failures of 1934 and 1935, Markey looked on the brighter side: "Rube has spent two years in rehearsing Lala Palooza!" Markey also assured any doubtful editors that Rube could turn back the clock:

The peak of interest in the heart wringing, tear jerking, hard luck serial has turned. The depression emptied everybody's tear ducts, used up everybody's worry glands. The time has come for the strip with the SMILE. I've talked with editors, watched with comics, followed the periodicals, studied the public. And I'm not guessing.

Certain that "real" humor would return, Markey proudly observed that there wouldn't be any "orphans in storms, embezzling bankers, gat slinging gangsters, wistful widows, cold-blooded crooks or crime-dogging detectives in this strip. It's something almost new these days—a COMIC strip. Not a gag a day, but a comic with continuity."

The initial signs were encouraging. Publication started in September, and more than seventy papers had subscribed by the first week in November. The Goldberg-styled furniture and architecture, the slam-bang antics of Lala, and those beautiful names (Professor Zeero) signaled another Goldberg coup. As in the earlier days with *Foolish Questions* and *I'm the guy*, Rube added extra jokes in side and top panels, cramming each episode from his broad arsenal of humor. The Sunday color page, which replaced *Boob McNutt*, usually had sixteen separate frames and a total of four hundred words (Fig. 149). The daily version was black and white and one line long (Fig. 150).

For more than a year Lala socked people in the nose, dumped food on their skirts, and treated doggy Pinto as a member of a royal family. All the human frailties from the single-frame cartoons were there, but Lala did not make the grade. As Markey's publicity suggested, Lala was a step backward into the past. She failed to take on her own personality and her own environment. Unlike Boob McNutt, who always held center stage, Lala seemed lost in the plethora of gags and predicaments. Rube drove himself to bring her up to date; but the harder he tried the more he grew to hate her. Knowing when to quit, he stopped the strip early in 1938. It was to be his last sustained effort at visual humor until the 1960s.

Though Rube understood the whims of his public, he was unable to adapt the new styles of comic art to his own work. For the first time since his childhood he was powerless to chart a course for future work. As in *Life's Little Jokes*, Rube had become the victim of change.

This defeat was heightened by the tactless gibes of a fellow McNaught cartoonist, the creator of the successful *Joe Palooka*, Ham Fisher. Fisher was a complex, testy individual who was climbing to the top just as Rube was tumbling into oblivion. They belonged to some of the same clubs in New York, and Fisher seemed to take abnormal delight in ridiculing Rube's misfortunes before all of his friends. By attacking the former king of comedy, Fisher apparently hoped to dramatize his own success. But he succeeded only in alienating others and in driving Rube to a psychiatrist for one short session of emotional relief. "Why does he bother you?" the doctor asked Rube. "Just don't worry. That'll be seventy-five dollars."

But Rube did worry. He was frightened by failure; the very word was anathema. He poured his grief into a "short, short story," as he called it, entitled "The Old Man Takes His Boy Back Home" (*Cosmopolitan*,

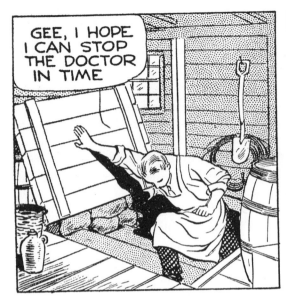

148. Doc Wright, 1934

January 1932). Ironically enough, this tale was his greatest literary success, being published in six languages and reprinted continuously until the start of World War II.

Rube may not have intended the story to mirror his own plight, but the tone of remorse, the bitter ironies accompanying "progress" have a deep personal ring which give the story an autobiographical quality. As a symbolic statement of Rube's dilemma, "The Old Man Takes His Boy Back Home" is quoted here in its entirety.

It is not quite the thing for people to be laughing and shaking hands when a hearse moves off. But that is the very thing that happened when Lem Smiley left Willsboro, Virginia, which is exactly three hundred and fourteen miles from New York.

Lem sat in the driver's seat of the dilapidated four-plumed affair and inside, instead of the somber black box, was a limp suitcase which was not quite dead enough to deserve its present resting place. It contained everything that Lem vaguely knew as his worldly possessions.

"Goodby, Lem," called Elijah Tilford. "Have a pleasant trip and give my regards to the boy."

"Say Lem," yelled Gimpy Schultz, known all over town for his smart sayings, "them covered-wagon fellers ain't got nothin' on you!"

Lem, perched high on his box, waved a cheery goodby and whipped up Michael, the spavined gray mare that had been his devoted beast for fourteen years. Lem had been the local undertaker in Willsboro as far back as anybody could remember. Whenever nature willed that a heart should stop beating, the attendant wailing and moaning were momentarily interrupted by a call from Lem Smiley, who comforted the family with the encouraging remark that the deceased would look fine when he got him all fixed up. It was a matter of course that the distinguished remains would be gently deposited in Lem's private hearse and delivered personally to the cemetery by Lem and Michael.

There were not many deaths in Willsboro, for the simple mathematical reason that there were not many people in Willsboro. But Lem was not an unreasonable man and there always had been a sufficient quota of funerals to sustain his self-respect. The interior of the hearse was never allowed to get too dusty.

But about a year before our present reckoning Lem noticed crepe on a door here and there without receiving any official notification of the sad rites. He was slightly bewildered until his friend Elijah Tilford cleared up the mystery.

"People in this town are getting too swell," declared Elijah. "They're all running to that new undertaker over in Lampton just because he's got a hearse that runs by gasoline. He calls himself a mortician or something."

Lampton was three miles away and it was only natural for people to use the new funeral director, who was entirely up-to-date and wore a new pair of black gloves for every customer. After all, the best is none too good when it comes to the last earthly favor you can bestow upon one who has been called to his reward.

The wheels of progress revolved so inexorably that Lem's business was almost gone before he realized it. Between buying feed for Michael and losing an occasional quarter at checkers, Lem was down to his last forty-four dollars and ten cents. His son John had gone to New York and obtained a job as night clerk in an up-town hotel.

No one suspected Lem's great love for his son because he always spoke of the boy in the most perfunctory terms. In his crude way he felt that it was vulgar to talk openly about something that was sacred and, for that matter, the concern of only two people. But when Lem was alone, which was often, he thought of nothing but John—John Smiley up there in New York—the best boy in the world.

Then Lem did a lot of planning. He figured that as long as there was nothing left for him to do in Willsboro, he might as well go to New York. Perhaps John could get him

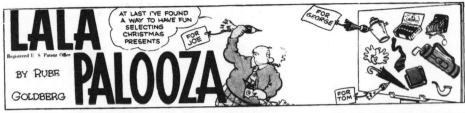

149. Lala Palooza, 1937
(Sunday page)

a job as a watchman or porter in the hotel where he worked. Lem was not much of a scholar but when he got an idea it was original and practical.

"I've been thinking," he said to Elijah Tilford, "that if I landed in New York with the money I've got left, I could afford to wait around awhile until the boy fixed me up. You know, it may take a little while to convince his boss I'm not too old to work."

"You'll never get away from your chosen profession down here, Lem," put in Elijah. "It's a part of you. Besides it'll take most of your money for carfare to New York."

"I said I've been thinking," answered Lem. "My carfare won't cost me a nickel. I can't sell Michael, and the hearse is only good for kindling. So, as long as I'm in no hurry, I thought I'd take the outfit as it is and drive to New York."

"What, drive over three hundred miles on top of a hearse?"

"Why not? I can make it in two or three weeks and my meals won't cost me much."

Elijah gulped a few times and finally said, "Well, I'll be gosh darned." He could not think of any argument to offset Lem's simple logic.

So Lem, in the driver's seat of his improvised coach, drove off with the grand farewell gesture of an explorer seeking a new world. His destination was the Rex Hotel on 115th Street, New York City.

* * * *

"Stick 'em up!"

A beady-eyed youth with a pasty face stuck the muzzle of a sawed-off shotgun into the stomach of the night clerk of the Rex Hotel. "One peep outa you and I'll plug you full of holes. Hand over what's in that drawer and be quick about it."

The night clerk was a lanky blonde youth with clear blue eyes. The delicate curve of his nostrils somehow suggested that he had smelled more flowers than gunpowder. He had

the simple courage of the country rather than the synthetic bravado of the city. He reached under the counter for the pistol that was kept there for such an emergency. The sawed-off shotgun in the hands of the intruder went off and the boy behind the counter sank to the floor. When the smoke cleared away the pasty-faced gunman was gone, several guests were standing disheveled in the lobby, somebody was telephoning to somebody else and John Smiley, the blonde night clerk, was lying dead on the floor.

During Lem's long trek towards the metropolis, farmers in the fields and women and children sitting on sagging doorsteps stared at the lone hearse as it rattled by. The silent figure in the high seat suggested a man driving himself to his own funeral. But the trail of wondering gloom he left in his wake had nothing to do with the feelings of the man himself. There was a song in his heart as he drove ahead to join his boy.

It was a relief to Lem to find that when his strange conveyance once reached the crowded streets of the big city, no one seemed to inquire or care where it came from or where it was going. The shadows of the giant buildings wrapped Lem and Michael in a cloak of unimportance.

Lem had little trouble in finding an outdated stable, where he parked his battered funeral coach and tired horse. With his disreputable suitcase in his hand and most of his original fortune in his pocket, he made his way straight to the Rex Hotel.

There was a talkative clerk with a little mustache standing behind the counter when Lem entered. Lem had to wait for him to finish an excited phone conversation before he could get his attention.

"I would like to ask about a young fellow named John Smiley. He's—"

The talkative young man interrupted him. "Gee, that was certainly a tough break. They say he was liked by everybody around here, too."

"Why what's the matter?" asked Lem, a little curious. "Isn't he here any more?"

150. Lala Palooza, 1937

"Oh gee, I guess you haven't heard. It was in all the papers this morning. He was shot last night by a guy who tried to rob the till. Killed outright. They don't seem to be able to locate his people. He came from somewhere in the South. It was certainly a tough break for a nice guy like him. But I guess that's New York. What's the matter, Mister? You look sort of bleary-eyed."

Lem wanted to scream. He wanted to sink through the floor. There was a double pounding—one in his head and another in his heart. But as we have observed before, he never could show his feelings about his boy in public.

"Where is he now?" he asked.

"Down at the morgue," answered the young man.

Lem found himself out in the street breathing as though there were not enough air to go round. His boy shot. His boy dead. Odd things popped into his head. The small family plot in the Willsboro cemetery. Lucy was waiting there for him and John. He couldn't disappoint Lucy.

He found himself back at the stable where he had left Michael a few hours before. "Hitch him up again," he told the listless attendant. "Okay," was the answer without any further comment.

As Lem drove out into the street he stopped just long enough to ask a cop, "Where's the morgue?" When he found it he paid twenty-five dollars for a plain wooden box, placed it gently inside the wagon with the four drooping plumes and started to drive back to Willsboro.

The trip took over a month this time because Michael was very tired and Lem had to stop a day here and there to beg or earn a little food.

When he finally drove through Willsboro and pointed towards the cemetery with his precious burden, someone stopped and said, "Look. There's Lem Smiley back in town again. I knew they couldn't keep him out of business. He's too smart. He's got a customer."

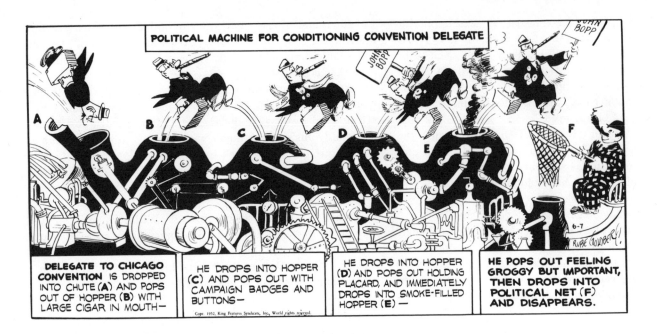

POLITICAL MACHINE FOR CONDITIONING CONVENTION DELEGATE

DELEGATE TO CHICAGO CONVENTION IS DROPPED INTO CHUTE (**A**) AND POPS OUT OF HOPPER (**B**) WITH LARGE CIGAR IN MOUTH—

HE DROPS INTO HOPPER (**C**) AND POPS OUT WITH CAMPAIGN BADGES AND BUTTONS—

HE DROPS INTO HOPPER (**D**) AND POPS OUT HOLDING PLACARD, AND IMMEDIATELY DROPS INTO SMOKE-FILLED HOPPER (**E**) —

HE POPS OUT FEELING GROGGY BUT IMPORTANT, THEN DROPS INTO POLITICAL NET (**F**) AND DISAPPEARS.

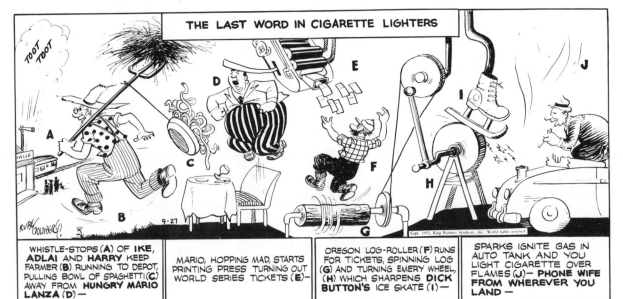

THE LAST WORD IN CIGARETTE LIGHTERS

WHISTLE-STOPS (**A**) OF **IKE, ADLAI** AND **HARRY** KEEP FARMER (**B**) RUNNING TO DEPOT, PULLING BOWL OF SPAGHETTI (**C**) AWAY FROM **HUNGRY MARIO LANZA** (**D**) —

MARIO, HOPPING MAD, STARTS PRINTING PRESS TURNING OUT WORLD SERIES TICKETS (**E**)—

OREGON LOG-ROLLER (**F**) RUNS FOR TICKETS, SPINNING LOG (**G**) AND TURNING EMERY WHEEL, (**H**) WHICH SHARPENS **DICK BUTTON'S** ICE SKATE (**I**) —

SPARKS IGNITE GAS IN AUTO TANK AND YOU LIGHT CIGARETTE OVER FLAMES (**J**)— **PHONE WIFE FROM WHEREVER YOU LAND** —

151. Political Machine for Conditioning Convention Delegate, 1952

152. The Last Word in Cigarette Lighters, 1952

13

Hey! Rube!—The Editorial Years

If Rube Goldberg had a critical weakness it was his ravenous need for a receptive audience. And not just any audience. Rube gauged his achievements as a professional cartoonist neither by his salary nor by the extent of his national syndication but almost exclusively by the mass reactions of his fellow New Yorkers. He had an ardent faith in democratic taste, particularly as it was expressed in his own city. Believing that a cartoonist's success depended upon his ability to put complex ideas in clear and simple forms, he was always skeptical of those who blamed their failures on public stupidity. "Very often you will hear that one doing creative work must 'play down' to the popular mind," observed Rube in 1949. "This is a rank fallacy. The public is not dumb. Sometimes they are 'way ahead of you." And New Yorkers seemed to Rube to live a step or two ahead of the rest of America. By meeting their constant demand for innovation, Rube felt as though he were working in the vanguard of all that was new and exciting. New Yorkers, he insisted, kept him alert, honed his swordlike wit, and taught him how to wield it without gashing himself. Obviously,

hey' rube', 1. a fight between townspeople and the members of a circus or carnival. 2. come help (used as a call to carnival or circus personnel in a fight, esp. in a fight with townspeople). *The Random House Dictionary of the English Language* (New York: Random House, 1966).

for Rube, New York was both the proving ground and the main arena.

The one-year layoff (1937–1938) made Rube hungry for public praise. His monthly magazine articles couldn't begin to fill his yearning for a daily deadline. In 1939 he summarized his conviction of why cartoonists often fall from popular favor: "First, the public's insatiable hunger for novelty. And second, the flabby complacence of the artist himself." A cartoonist could enjoy a long career, insisted Rube, only if he perceives the changes that are going on about him. He must be willing to adapt his work to the demands of the changing times. He must savor eternal youth. He must recognize that nothing he does is absolute.

Rube's flexibility was the basis of his durability. He consciously avoided the predicament of being an artist in search of an audience by making sure that his work was what the public wanted. He ridiculed any old master who preferred to sulk rather than to change his style. "The craftsmanship he has acquired during his years of rich success should make his talent more elastic," scolded Rube in an unpublished manuscript (1939). "Instead, he is a stubborn old fogie. The young birds can't possibly be as good as he. The old bird mopes in his lonely nest bemoaning the decay in public taste and the baleful existence of the common human

153. Going Too Far, 1943

weakness, ingratitude." During his layoff Rube correctly believed that he was slipping fast from the public eye. He heard unending praise for the brilliant wits of the *New Yorker*, cartoonists such as Gluyas Williams and James Thurber and Peter Arno. Ironically, many of their pieces, particularly the social cartoons of Williams, were updated, sophisticated renditions of early Goldbergs. But the *New Yorker* tone was not for Rube. It was a little too smug, a little too prim, and far too intellectual. Most importantly, the magazine had a piddling circulation.

By late October 1938, he felt like a "hardy but slightly frayed veteran," and he was anxious to "get back to work." One afternoon he claimed to have overheard a restaurant conversation: "Goldberg? Oh, is he still around? What's he still working for; he's got enough to quit. Old stuff." Hearing this, he was determined to prove that he was "better than ever." Soon afterward, he received a telephone call from Edwin S. Friendly, business manager of the New York *Evening Sun*.

"Hello, Rube, how'd you like to draw political cartoons for the *Sun*?"

Rube said, "What?"

Friendly repeated, "How'd you like to draw political cartoons for the *Sun*?"

"Are you kidding?"

"No."

"Well—er."

"Well, nothing. How about it?"

"I've never done it before, really. I did make a few political cartoons after the San Francisco earthquake but that was so long ago."

"But, you haven't answered my question—how'd you like to draw political cartoons for the *Sun*?" pressured Friendly.

"If you're going to be that way about it, I'd like to very much. But—"

"All right, Rube. Let me know in a couple of days." And Friendly hung up.

Rube's apparent hesitation was part of his disarming personality. Milt Caniff, creator of *Steve Canyon* and *Terry and the Pirates*, observed that Rube would often have his mind made up long before he'd tip his hand. He enjoyed procrastination, rubbing his toe in the sand. The *Sun*'s offer seemed to be an exceptional case, for Rube lunched with the paper's editors the very next day. The *Sun*'s editorial policy was explained, and Rube signed on the dotted line. "It was the one thing I needed all along," Rube confessed, "a new setting for my all-too-familiar talents."

As we have seen, Rube was not a novice when it came to politics. Life with Max Goldberg and Billy Seeman, as well as frequent trips to national nominating conventions, had put him in close touch with a stunning array of politicians. In numerous cartoons from 1907 to 1935 he jokingly portrayed the democratic electoral process as something less than pure and honest. During the late 1920s he took his sons to Washington, D.C., where they met President Herbert Hoover. Rube remembered the conversation "very, very well" because the ill-fated leader greeted him with a dry witticism. "We're two mining engineers who have gone astray." In later life Rube continued this habit of hobnobbing with masters of the White House by visiting Presidents Truman, Eisenhower, Kennedy, Johnson, and Nixon. He even offered Ike the tutorial services of his elder son Tom, a serious painter, just in case the weary President wished to improve his artistic talents.

When Rube started on the *Sun*, he agreed to draw three cartoons a week. There was no syndication. His only other stipulation was that the *Sun* should not advertise his arrival. "He wanted to 'sneak in,'" wrote his

154. Stalingrad's Welcome, 1942

good friend Grantland Rice in 1949, "so that if he failed he could sneak out just as quietly. Rube is like that." The first cartoon appeared on November 21, 1938. It was three columns square in size. For most of its 105-year history, the *Sun*'s editorial page sported nothing but tiresome words from corner to corner. The last editorial cartoon had appeared in 1920, so this radical change in layout policy made Rube's second coming as dramatic as possible. *Newsweek* observed on December 5,

Last week the ultraconservative New York *Sun*'s 300,000 readers [saw] . . . on the editorial page . . . its first cartoon in eighteen years—a whack at the Wagner Act by Rube Goldberg. Edwin S. Friendly, the *Sun*'s business manager, signed Goldberg to a no-time-limit contract and gave him free rein in selecting topics. But he took little chance of embarrassing his paper's policies, for Goldberg and the *Sun* see eye to eye politically.

Rube found the new work easier than his old format because the draftsmanship was simple and the ideas were straightforward and pure. While he occasionally used several of his older formats—such as the multiple portraits of various personalities and the inventions (Figs. 151 and 152), on the whole, his editorial cartoons were neither better nor worse than those of most of his colleagues. The ideas were usually clever, but somehow they failed to infuse life into the cornucopia of conventional political images. Rube's best editorial works were packed with a piercing vision; the rest of the lot simply marketed a pretended insight. The depth of the pre-1935 works was lacking, and most historians and cartoonists regard his editorial cartoons as little more than run-of-the-mill.

At least five factors contributed to the impotency. First, on the day he signed his contract, Rube darted to art stores inquiring what kind of materials were best for "drawing pictures of Uncle Sam," as he put it. "I bought 'em all. Previously I had worked in no other medium but pen and ink. Now I had a complete set of new tools. And it turned out that they were really easy to handle. In fact it was lots of fun." Despite his elation with fat greasy crayons and hard, shiny drawing boards, the new tools—while popular among editorial cartoonists since about 1930—were neither distinctive nor adaptable to Rube's talents. His firm belief in change worked to his own disadvantage. He had learned to think in the hard nervous line of pen and ink. Although his energetic drawing style of the 1920s was far from great draftsmanship, it was so individualistic that it disarmed any art critic who sought to apply fixed aesthetic standards. Rube had made his own rules, but the new materials required a new style which he failed to develop.

Secondly, the editorial format was rigid and singular: one cartoon, one idea, no second thoughts, no bonus side panels or little men shouting "boloney!" and—most importantly—scant detail. Rube inspired at least two generations of cartoonists with his pre-1936 creations. Almost to a man, those who survived him insist that it was his profound understanding of the little things which put him a step above his competition. Check the door numbers in Figure 73 or the facial expression of the cat in Figure 29 or the twists and kinks in the objects that made up his inventions. His total vision was his great strength. The flashy strokes and murky lines of the editorial pictures are the products of a new philosophy and new style—a style, Rube believed, dictated by public taste.

His third failing is related to both the first and second because it grew out of his philosophy of editorial cartooning. "The successful cartoonist deals

155. Evolution of a Moustache

principally in emotions," wrote Rube. "His work cannot be pleasing to everyone. Editorial cartooning is essentially destructive. It is an art of protest." This negativism troubled him. While he deeply admired the craftsmanship of "Herblock" (Herbert Block) and Bill Mauldin, he could not help condemning them for their basically vicious concept of current events. "They're too bitter," he said in 1969. "They should use their talents for something good." Yet Rube too practiced this "dark art" for twenty-six years and rarely hinted at his basic optimism. As the author of Lesson 19 in the *Famous Artists' Cartoon Course* (1949), Rube took a middling stance on the problem of editorial negativism. "Readers enjoy a lusty, slam-bang cartoon. But their better feelings must not be offended. If you have any doubt in the matter of taste after you have drawn a cartoon, it is good to show it to someone around you—like parents or other members of your family—to get their reaction. You will soon know whether or not there is anything in it that is an affront to Good Taste." Although Rube followed this philosophy in most of his work, *Going Too Far* (Fig. 153), drawn in 1943, could not have endeared him to many coal miners.

In the pre-1936 pieces Rube seldom thought about "bad taste." The anonymity of his characters gave him a free hand. His new concern for propriety cramped his style because it removed the possibility of a sudden lunge into an extreme position. Anything that was nutty, whacky, or even whimsical—the very characteristics which made his "inventions" so popular—was now taboo. Yet, almost in spite of his bondage, Rube's best political cartoons, such as *Peace Today* (Fig. 164) have the same double edge and the same power of condensation that made the inventions so profound.

The European art historian E. H. Gombrich has noted that the terrifying balance of *Peace Today* telescopes "all our fears into the picture of a peaceful home precariously poised on the bomb on the brink of the abyss. . . . For one brief moment we seem to see our predicament, face to face, as it were, in this nightmare picture which persuades us of its reality." But the power in this picture comes from the essence of the predicament itself. Rube's depiction is a clever diagnosis of a dangerous and frightening situation; it is not a forecast of doom. Even the anti-Hitler cartoons (Fig. 154) of the early 1940s are not essentially negative. By confirming Hitler's stupidity Rube bolstered American spirits, and the social impact was surely positive. Unfortunately Rube himself failed to see this fine distinction of attitude in his cartoons.

Fourthly, the most disastrous loss in the editorial cartoons was Rube's prose. He believed that great editorial cartoons have as little writing as possible. This curious notion is difficult to explain, for much of the wit in Rube's pre-1936 cartoons came out of his captions and his dialogue. By banning his own words from the drawing board, Rube deprived his cartoons of the explosive punch of his older, more popular works. Many of his acquaintances puzzled over this new reticence. One letter dated November 11, 1950, from Roy Howard, president of the Scripps-Howard newspaper chain, encouraged Rube to combine his prose and drawings once again: "At 67 it confirms a sincere belief that I acquired at 34 that you are a damned swell performer with a typewriter. When you have stuck to any idea for half your life and still entertain it without any if's or but's, the idea must have had merit in the first place. That you always were and still are as swell a writer as you are a friend, is my story and

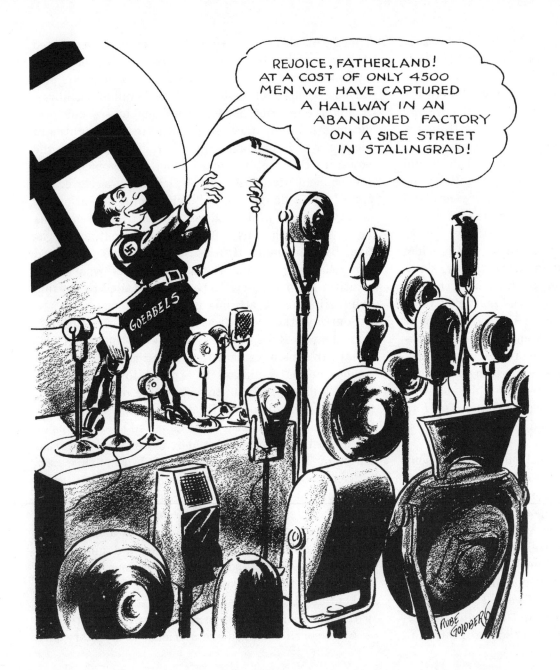

156. Blitzkrieg—Late 1942

I'm going to stick to it." Rube took the new position, he said, because when dealing with serious subjects words were an "unmitigated bore."

The abandonment of the pure (and complex) Goldbergian style with its ruffles and flourishes, its frills and fancies, was noticed by his friends and fans. Again, Rube's desire to be up to date, to remain in the vanguard, worked to his ultimate disadvantage.

Finally, although the New York *Sun*, as the first successful penny paper in America, had been daring and innovative during the nineteenth century, featuring writers such as Frank Parcellus Church (of "Dear Virginia . . . Yes, there is a Santa Claus" fame), its twentieth-century character was less distinguished. Fluctuating between a conservative and a middle-of-the-road position on most political issues, the *Sun* was a stiff, unimaginative news organ that was neither exciting nor profound. Visually it had little to distinguish it from the host of dailies which flooded America. While Rube did not take part in morning editorial conferences, his Republican sympathies kept him in tune with the *Sun*'s views. The paper's mediocrity, however, seeped into his work, and there seemed to be no one prodding him to perfection.

During most of his editorial career Rube was assisted by Warren King, the future editorial cartoonist of the New York *Daily News*. King had been an artist of comic books (the one cartoon medium Rube never entered) and was particularly adept at drawing animals. He taught Rube some conventional drawing techniques and—in so doing—had a greater influence on Rube's work than any of Rube's previous assistants. King described Rube, shortly after his death, as a relentless worker, a prolific mind, who had developed a process of thinking which guaranteed a cartoon idea on any subject. Rube's technique was simple. As soon

as he would awaken, he would turn on the morning radio news. By 9:15 he'd meet King at the studio and together they'd read several newspapers until 10:00 and then discuss the current issues. Rube would suggest the theme and the general approach and follow up with a batch of rapid sketches. After lunch Rube would decide on the best, and he and King would draw up the finished work.

Rube was convinced that his pre-1936 style was finished, but it is hard to explain why he abandoned it so completely. At the risk of being a second-guesser it seems safe to suggest that his *Foolish Questions, Life's Little Jokes, That's life, Father was right, It's all wrong, . . . , it's all wrong*, and others could have been used for brilliant editorial cartoons. Take the *Weekly Meeting of the Tuesday Ladies' Club*, for example. In an unpublished spoof, "A Letter from Hitler to Roosevelt" (1944), Rube aimed a few witty barbs at Eleanor Roosevelt and her aggressive gregariousness. Addressing the Azalea Growers Association of Wisconsin at her Hyde Park estate, the First Lady opens her speech with words which were typical of the Tuesday Ladies' Club: "It's lovely to know there is so much beauty in the world. Flowers are like people. They smell—I mean they exude an aroma that corresponds to human sweetness." Surely in the pre-1936 days this would have been the nucleus of a cartoon.

Later on, in the same story, Joseph Goebbels, the Nazi leader, introduces himself to Mrs. Roosevelt. The sequence is loaded with cartoon potential:

"Mrs. Roosevelt, I have no time to lose. You don't know who I am—"

(Mrs. Roosevelt interrupting) "Why certainly I do. You're the gentleman who introduced me when I spoke at Boulder Dam."

(Goebbels revealing) "I am Herr Paul Joseph Goebbels,

157. The Boy and the Dike, 1939

Propaganda Minister of the Greater Reich. Heil Hitler!"

(Mrs. Roosevelt smiling) "Won't you come and meet some of the Azalea growers from Wisconsin."

(Nazi leader impatient) "I have a letter from Herr Hitler to your husband, the President. Will you please see that he gets it?"

Opening his coat, he takes the letter from a secret flap in the lining and hands it to her. He raises his hand in salute, turns abruptly and walks down the path. Uncomprehendingly the First Lady takes the letter and says, still smiling, "It's too bad you won't stay for hot dogs." Goebbels is so elated over the completion of his mission, he does not bother to look back as he walks away. It is just as well, for he would have seen Mrs. Roosevelt standing before the open-air grill where hundreds of frankfurters are sizzling over charcoal. Talking gaily to her azalea-growing guests, she puts a cigarette in her mouth and seems to be fiddling around in her handbag for a match. Then a horrible thing happens. Without turning her head away from the person with whom she is chatting, she holds Hitler's letter over the burning coals. "As it burst into flame she lighted her cigarette with it and tossed the charred envelope on the ground where a gentle summer breeze scattered the particles to the winds."

The potential for visual caricature in these lines is strong. One can only bemoan the great loss which resulted with the unfortunate split of Rube's words from his pictures.

The precise line of demarcation between the editorial years and his earlier career is even more confounding when we read Rube's self-analysis. "There is very little difference in the effort and brains it takes to draw the Republican elephant and those it takes to draw Boob McNutt," wrote Rube in 1939.

Making people think is no more noble than making them laugh. The difference lies in the attitude of the audience. To many, a clown is an irresponsible, irreverent buffoon. The sage, on the other hand, is the sombre-visaged thinker with a cryptic answer to all the question marks on the design of life. Neither characterization is quite correct.

Of the two I think the clown has the most exacting role. When people stop laughing at a clown he ceases to be a clown. But the so-called thinker can go on being a thinker long after the bats have come to swing on the rafters in his belfry. As long as he keeps quiet and assumes an attitude of deep meditation people will think he's thinking. . . .

I have been both clown and sage. I have tried to keep from being absorbed by either. You can put a little philosophy in humor and a little humor in philosophy. Or, if you're able, a lot in each.

158. Helping to Solve the Food
Problem, 1943

14
Peace Today

World War I had impressed Rube as a futile effort to cure worldwide aggression. He had seen the shadow of modern warfare during his visits to the Continent between 1910 and 1920, and although the United States involvement had been considerable, that distant battle did not strike him as a struggle for human survival. World War II was a different matter. Rube began his editorial cartoons one month after Adolf Hitler blew into Czechoslovakia spewing lies and destruction. The fanatical German dictator had already denounced the Treaty of Versailles and in 1936 had entered the previously demilitarized zone of the Rhineland. The free city of Danzig fell in 1937, and in March of 1938 the German forces moved into Austria. Although numerous pacifists and isolationists insisted that Germany could be appeased, Rube sounded a note of alarm. By 1939 only ten out of twenty-seven European nations practiced democracy. Dictators rose like weeds, and as Rube suggested in his *Evolution of a Moustache* (Fig. 155), the victors of the first war were partially to blame.

The indifference of many citizens to the crumbling of European freedom angered Rube. Although he refrained from overt protest, he attempted to publish his ideas in a series of ill-fated short stories. In one rejected manuscript he had Dr. Goebbels, the German propaganda chief, analyze the inanity of U.S. radio broadcasts during these critical years:

. . . oily-voiced announcers pleading for all-healing laxatives, begging the American goof to borrow money on his ice box, his car and his wife, imploring "thinking gentleman" to smoke stinking five-cent cigars, and inviting idiots to visit air-cooled second-story establishments to purchase tissue-paper suits with two pairs of pants. . . .

If they believe this drool, they'll be a pushover for my stuff.

Rube was convinced when he began his editorials that the Nazi oratory was not the gruff hyperbole of a boxing promoter but a clear case of insanity. Once the war began, he illustrated this message in *Blitzkrieg —Late 1942* (Fig. 156). He didn't laugh very much as a new editorial cartoonist, for he began his career in serious times. Occasionally he combined tenderness and wit to illustrate a bitter point of view. *The Boy and the Dike* (Fig. 157) is one example, but usually he favored the direct approach. For six years he carried on a personal attack against the dictators of the fascist countries. In one 1943 cartoon he drew a caricature of Hitler seated alone at a banquet table in a gigantic but *empty* room. On the table is birthday cake blazing with candles. The caption reads, "This is a picture of

159. Goofy Contraption

Adolf Hitler celebrating his 54th birthday with all his friends."

Hitler was an editorial cartoonist's dream. The eccentric German, with his practiced goose step and his love of ceremony, was a powerful opponent. He required an all-out effort, a no-holds-barred approach, to pin him to the drawing board. The swastika, as his symbol, served as a potent element in the German propaganda campaigns; but like any well-known image, it was easily reversible. A bright cartoonist could use it as a shorthand label for evil, and this symbol aided Rube in his quest for brevity.

Since few people doubted that Hitler was Satan's partner, Rube did not have to worry about offending anyone—at least, so he thought. But two of his cartoons, *Clear everything with Sydney* and *Not Funny to Them,* which appeared on September 26 and October 3, 1944, respectively, drew heated objections from Jews, who accused Rube of drawing too much attention to anti-Semitism. Several times during his career he received obscene notes from anti-Semites, but ever since the day he was ousted from a San Francisco synagogue for laughing at the blowing of the shofar, Rube minimized his Jewish heritage. Once in Atlantic City, New Jersey, he was refused a hotel room because of his name, but generally throughout his eighty-seven years he did not suffer from anti-Semitism. He ignored the Jews' protests to his work, simply because he did not know what else to do.

The antifascist cartoons were mostly very popular, and Rube tried to crank out at least one a week. Readers sent in many suggestions, much as they did in the days of *Foolish Questions* and *I'm the guy.* "There must be something cockeyed to be done about the Japanese sense of politeness," wrote one admirer on January 27, 1942, "—for example, a Jap ramming into one of our boats with one of those one-man suicide submarines, and as the Jap commander and the American commander pass each other in the air, the Jap bows, grins, and hisses, 'Many pardons. I didn't know it was loaded.'" E. Melville Price, managing editor of the *New Yorker,* also offered an idea: "How about a cartoon showing Hitler as a . . . truffle pig used by Stalin to root up delicacies which he is not allowed to eat himself?"

Rube's career as an editorial cartoonist reached its peak in the mid-forties. In 1942, the management of the *Sun* directed Rube to increase his output to five cartoons a week, thus giving him more opportunity to swipe at several domestic targets (Fig. 158). At this time he also resurrected his old character the "average guy." By some miraculous feat of misguided cartoon surgery, the anonymous hero lost his lumpy head, pot belly, and stubby legs; but no amount of genius could enlarge his brain. While he was still the butt of society-at-large, the enemy was no longer completely invisible. The social impact of technology had paled before the horrendous injustices of the federal government. Bloated tax rates, gargantuan bureaucracies, and astronomical budget deficits were hammering the innocent, naïve citizen into helplessness and bewilderment. The simple life of goodwill and fairness used as Rube's ideal in the technology cartoons now appeared as a ludicrous dream. The incongruity of the single taxpayer fighting against the federal conglomerate was drawn repeatedly with the hope that the older spirit of *I'm the guy* would seep into the public consciousness. There is a sense of desperation in these works, a feeling that the last wild stallion is about to be corralled. They are sad pieces. The cartoon character, a nameless homogenization of physiognomic irrelevancies, is a likable but pathetic figure with a

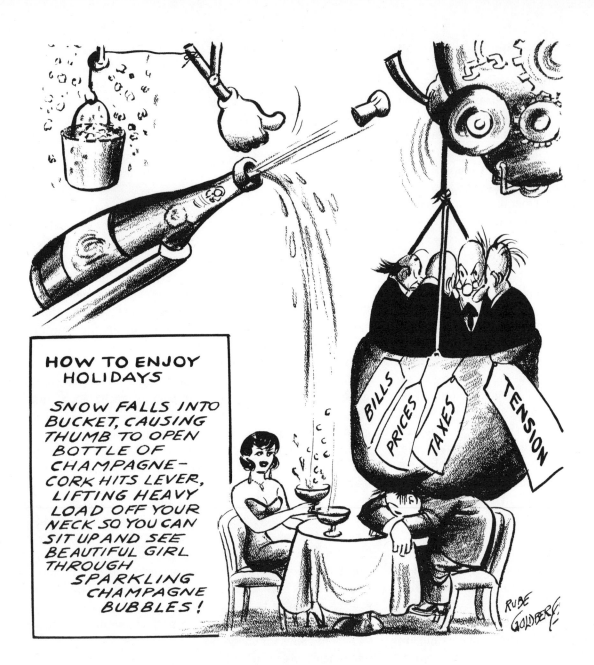

160. Happiness Machine, 1949

narrow range of intellectual and emotional activities (Fig. 159). He's made from a mold; he's an automaton who has been sterilized, not by technology, but by the incessant demands of government. When President Truman submitted his record-breaking peacetime budget to the Congress in 1949, Rube cartooned a barrage of protests, all based on the simple notion that in the end the average guy will foot the bill.

One solution to the dilemma of accelerated deficit spending was the Rube Goldberg *Happiness Machine* (Fig. 160), drawn on January 5, 1949. A more realistic alternative, however, was suggested in *Willing to Learn* (Fig. 161). During the 1948 presidential election Rube confidently displayed his Republican sympathies. Certain of victory for New York Governor John Dewey, he drew up two cartoons for the *Sun* before the ballots were counted. One showed a piano being carted from the White House. Early the next morning when the tide turned in Harry Truman's favor, Rube was stunned. Too depressed to draw a congratulatory sketch, he had three words, set in small type, printed in the empty space regularly set aside for his works: "Rube Goldberg Regrets." Like most experts who predicted a Dewey landslide, Rube ate crow, to the polite satisfaction of the man from Missouri:

Dear President Truman:

My sincere thanks for making it possible for me to achieve my biggest hit with the only drawing I ever made with no drawing in it at all!

Truman requested the Goldberg rejects and hung them in the White House anteroom.

The surprise of 1948 and the confusion in 1952 showed that elections were becoming complex affairs; television and pollsters were making sure of that. Time and again, Rube spoofed public opinion polls and image makers—*If Washington Ran Today* smacked of his older concern for styles and fads (Fig. 162). The good-natured spoofing in *But Only One Wedding Ring* poked fun at the Democrats' wealth of candidates in 1960 (Fig. 163). Another cartoon provided a foolproof formula for selecting a winner:

MANHUNT

WANTED

1960 CANDIDATE

NOT TOO YOUNG

NOT TOO OLD

NOT TOO PRETTY

NOT TOO UGLY

TELEVISION APPEAL

ALL THINGS TO ALL MEN

On July 22, 1947, Rube's most famous editorial cartoon, *Peace Today*, appeared in the *Sun* (Fig. 164). It was a legerdemain master's dream: concise and vivid. Eight months and three days later it won the Pulitzer Prize as a "distinguished example of a cartoonist's work." Its strength was its clarity, its power to let the reader *see*, rather than merely *know* in an intellectual way, the fragility of postwar America. As a caricature of society, it transformed vague fears and wispy ideas into visual substance. The subject matter was almost a cliché. Ever since the bombing of Japan in 1945, the whole world seemed to suffer from a chronic case of the atomic shakes. Rube had drawn several A-bomb editorials before *Peace Today*, and cartoonists of every persuasion had stated their concepts repeatedly. The elements in the cartoon were also familiar to everyone, but their juxtaposition provided the vision that world destruction was imminent.

161. Willing to Learn, 1949

The award gratified Rube more than he cared to admit, for it represented the highest praise a cartoonist could earn. The Pulitzer Prize, first awarded in 1916, had been established in the will of Joseph Pulitzer, publisher of the notorious New York *World* and the highly respected St. Louis *Post-Dispatch* and founder of the Graduate School of Journalism at Columbia University. With his promotion of the *Yellow Kid* in the *World* during the 1890s, Pulitzer had been a primary force in the beginning of the American comic strip. For the awards, he left the School of Journalism the sum of $2,500,000, with each winner receiving a cash prize of $500.

Younger editorial cartoonists had preceded Rube to the throne. Herblock received his first plaque in 1942, and Bill Mauldin, only twenty-four years old, was awarded the coveted prize for his *Willie and Joe* series in 1945. Now it was the old man's turn, and he didn't try to hide his elation: "I've hoped to win a Pulitzer Prize ever since I joined the *Sun*," he wrote. "I only wish my father could have been alive to see it." (Max had died five years earlier after suffering a heart attack while chasing a cable car. He was ninety-three.)

Fourteen Pulitzer awards were presented in 1948 and Rube found himself in a rather select crowd. Tennessee Williams' *A Streetcar Named Desire* won the prize for the best original American play. Bernard De Voto was the winner for the "most distinguished book of history of the United States," *Across the Wide Missouri*. *Tales of the South Pacific*, by James Michener, was chosen as the "most distinguished fiction written in the year in the United States." Most of the winners, including Rube Goldberg, focused either on the general anxiety about the world's future or on the need for digging into the past to find new spiritual strength.

Actually, Rube was rather experienced at picking up prizes by the time the Pulitzer came his way. In 1945 he won the yearly award of Sigma Delta Chi, national professional journalistic fraternity. At that time the judges perceived the formula which led to *Peace Today*. Rube's winning cartoon, they noted, was "a simple and direct editorial, unbestrewn with labels and lettering, which man or child could understand at once and with some appreciation of the humor of the situation." In 1947 the same organization presented him with a medal and plaque "for distinguished contribution to journalism." And that same year the *Encyclopaedia Britannica Book of the Year* selected his *Four-headed Bear*, published on November 19, as one of the twenty-nine outstanding cartoons of 1947. Yet all of these honors only served as dress rehearsals for the Pulitzer ceremonies.

Rube's friends were ecstatic. Most of them felt that a major award was long overdue, and if it came for a cartoon which didn't quite measure up to Rube's earlier masterpieces, it didn't really matter. Milt Caniff, then a "young buc" (to use his own phrase) whose *Terry and the Pirates* was the hottest cartoon strip in America, noted with typical precision, "To change in the middle of one career, as Rube did, and to rise to the top again in another is simply a masterful achievement." Caniff also could have noted that Rube's switch from comic strips and social cartoons to editorials was against the tide of his profession. Historically, many cartoonists had gone from the editorial page to the comic section, but Rube—with his penchant for the unorthodox—was the only major figure to reverse the trick.

Curious as it may seem, not a single man in the *Sun*'s front office offered his personal congratulations. On

162. If Washington Ran
Today

their dry-as-toast opinion page, the *Sun*'s editors officially referred to the coup as a "deserved honor." Their restraint was almost comical:

To use a popular expression, it couldn't have happened to a better fellow. Or to one more deserving. From an established reputation as a maker of comic pictures, Mr. Goldberg several years ago moved over into the editorial page. The leap was broader than most laymen can realize. An editorial cartoon is more than an amusing bit of draftsmanship. It is an essay in a single picture. It must be simple; it must tell its story at a glance; it must give a lightning-glimpse of an idea or an ideal; it must awaken in the mind of an observer the recognition of something fundamentally true and appropriate. Since he under-took this medium of expression Mr. Goldberg's development has been steady and sure. Those of us who know him best can say that his skill and versatility are matched by his personality as a man and a friend.

This official reserve and personal neglect hurt Rube. He muttered satirically one time, "They could have given me a gold pencil or somethin'." He felt this lack of sensitivity right up to the time of the *Sun*'s death in 1950. Visiting relatives in California, Rube learned of the *Sun*'s fate from a radio broadcast. He never received official word from the paper—not even one of those icy form letters "terminating employment." "At least," quipped Rube, "they were consistent in their lack of concern."

Rube's friends at the Illustrators Club seized on his success as a good excuse for a rousing party. Numerous members drew original sketches, which were bound as a special presentation volume. Those who contributed included Otto Soglow (Fig. 165) and Walt Disney (Fig. 166). Rube had just returned from Hollywood, where he had been discussing vague ideas for doing either an animated film or a feature scenario. Unable

to attend the fete, Walt Disney telegraphed a congratulatory note which echoed the unspoken sentiments of many:

DEAR RUBE:

LITTLE DID I REALIZE WHEN I SAW YOU OUT HERE THAT I WAS SHAKING HANDS WITH A COMING PULITZER PRIZE WINNER. I AM HAPPY FOR YOU AND THINK IT'S A STROKE OF GENIUS THAT YOU MADE SUCH A GREAT TRANSITION FROM THE RIDICULOUS TO THE SUBLIME, BUT FOR MY MONEY DON'T GIVE UP THE RIDICULOUS—IT'S EQUALLY IMPORTANT. HEARTIEST CONGRATULATIONS FROM ALL OF US.

Notes of praise streamed in for weeks, but the real mark of recognition came when Jack Wheeler of the Bell Syndicate of New York City agreed to distribute Rube's cartoons to other newspapers. During a two-year relationship Wheeler's list of subscribers ranged at any one time from forty to sixty newspapers. Although this added circulation and salary failed to compete with Rube's 1925 figures, the new syndication symbolized his total mastery of the new profession. As Lowell Thomas noted on his May 4, 1948, CBS radio broadcast, "He made the transformation—from Boob McNutt to the atomic bomb, and won the Pulitzer award."

The irony of winning the Pulitzer Prize is that Rube himself did not savor his role as an editorial cartoonist. Several times during the postwar period he tried to convince himself that his notorious inventions and his cartoons for the *Sun* were really interrelated parts of a general philosophy. In 1968 he rationalized,

Life is kind of futile and people go in a roundabout way to do the simple things. The best example I can give . . . is the world. Russia is doing things. We have to sit back and watch Russia invade a little country like Czechoslovakia and inflict all of its misery on people, like we did with

163. But Only One Wedding Ring, 1960

Hitler, to finally arrive at the fact that freedom is the only thing. . . . It's the only thing, and the people of Russia have to find that, but through these devious ways, which are tragic.

In a negative sense, of course, Rube was right; but the multifaceted nature of the inventions was not borne out in the political cartoons. Take international affairs. For Rube, the United Nations became a vivid political symbol of "Do It the Hard Way." The tedious formalities, the endless debates, and the innocuous decisions made the U.N. appear as a brainchild of Lucifer G. Butts himself. Throughout the fifties Rube roasted the U.N., and although he never said so publicly, he mistrusted all the strange-looking characters who filled the assembly rooms. The plethora of foreign customs, languages, and races gave the appearance of chaos, a wealth of raw material for a creative comic. But comedy was never part of a U.N. agenda; deadpan seriousness, mutual respect, and equality for all made it a "wishy-washy place of stand-up parties and meticulous memos," wrote Rube. Appearances, the stock-in-trade of cartoonists, played only a minor role in the life of the U.N. Since everyone was different from everyone else, nobody seemed "funny looking." All the reliable signs of oddballism were being transformed into symbols of power and respectability. The caricaturist's arsenal was being assaulted, but deep within himself Rube couldn't help laughing at men who wore earrings or women with sticks in their noses. All of his pre-1936 caricatures were funny because they spoofed the socially acceptable definition of "handsome" or "pretty." Now at the U.N., where these norms were not applicable, caricature was meaningless. So Rube simply backed away, fearing that any African caricature, for example, would be misconstrued as a racial slur. He preferred the safer plane of abstraction,

gibing the institution in its entirety and restraining from personal barbs. The world of diplomacy might relate to modern technology, but not for a comic logician. The U.N., according to Rube, held little promise of success whereas the electric toothbrush showed the way to a new utopia. The difference was crucial in Rube's mental set.

Following the Pulitzer award, Rube fell into a period of extreme disillusionment. During World War II he had cartooned his enemies in a masterful way, exposing Hitler and his "friends" as barbarians incapable of civilized work or love. But the Nazis were an easy target. There was no doubt of their guilt. If they could be ousted from power, everything would be grand. But the wish was never fulfilled.

Historically, America, too, has often undergone years of stress and sacrifice only to sink into despair and discouragement. The Civil War, culminating with the death of Lincoln, and World War I, followed by the collapse of Woodrow Wilson, for example, played intensely on the nerves of the nation. Rube Goldberg felt a deep sense of emptiness and frustration following the world crusade against Adolf Hitler. During the war, Rube saw good guys and bad guys, and his cartoons portrayed the wholesome all-American foot soldier combating and defeating the sinister Nazi. But somehow, in Rube's mind, the war did not result in a real victory. That crisp line which divided good from evil, that line which had been the reference point for sixty-five years of his life, became fuzzy and indistinct. Labor unions called for national strikes despite the pleas of Roosevelt and Truman to "hold the line." Yet these unions (especially coal and railway) were filled with men who had served as dedicated G.I.s in the world crusade. Scandals of misappropriated government funds appeared in headlines. Taxes soared.

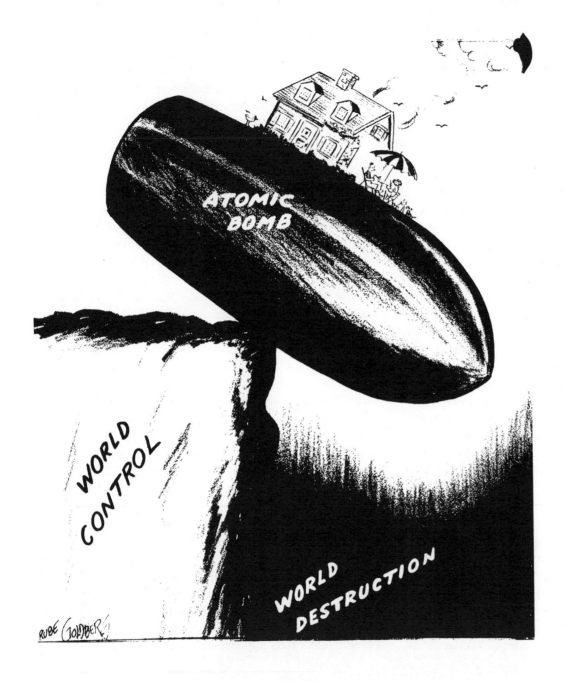

164. Peace Today, 1947

Living conditions declined in some cases. (A cartoon from August 9, 1948, shows a family of three sitting on a bench in a zoo. The little boy, turning to his father, asks, "Look, Daddy, the monkeys have a nice place to live—are they smarter than we are?") New wars smoldered in Korea, Southeast Asia, and the Middle East. For what had America fought? Who were the culprits? No one seemed to know.

At first Rube was determined to keep his mind clear and alert, but it was a losing fight. His emotions had showed occasionally during the early forties; after the war his anger boiled. "Rube doesn't like red Russia or red tape," headlined the San Francisco *Call-Bulletin* on January 11, 1951, in a humorous interview. Noting that "democracy is the greatest invention of man," Rube insisted that the little guy, the Willies and Joes, suffered the most in postwar America. Had they fought so gallantly just to be stepped on again? Everyone wanted their money (Figs. 167 and 168). Leisure time seemed to seep through their fingers as they reached for a better life. Science failed to bring utopia. Technology was threatening, expensive, and often a nuisance. Meanwhile, bureaucracy drained away billions of dollars per year without accomplishing much. As Rube stared at this unabashed insanity, he could only echo his old refrain: "What's it all about?"

The crowning blow, the grand disillusionment, came early in 1951. Senator Joe McCarthy of Wisconsin claimed the nation was infiltrated with communists. The government and the universities were suspect. The country was being undermined by a red cancer which would eventually overthrow and smash the American dream. Rube, who usually analyzed claims and dissected his facts with care, no longer had the patience or the will. His cartoons from 1951 to 1953

depicted McCarthy as *The Crusading American,* fighting to protect the bone and sinew of the nation. Emotion triumphed in these years, and Rube the humorist-thinker bowed to Rube the disillusioned and confused American.

He was not alone.

As early as September 9, 1948, Rube blurted out his sense of frustration in a cartoon entitled *A Few Words from the Average American*: "I don't give a hoot what political reasons there are for any investigation—if there are communists in our government let's get rid of 'em—and I'm against anybody who plays along with treacherous jerks who want to overthrow our government—how dumb are we supposed to be, anyway?" Rube maintained this emotional stance until the middle of 1953 when Senator McCarthy's crusade dissolved into a pitiful display of demagoguery. Yet Rube pulled his sympathies out of the McCarthy camp long after other "thinkers" had deserted the senator. When McCarthy was finally censured by his colleagues in the Senate on December 2, 1954, Rube saw his own overreaction.

Earlier, in 1950, Rube had moved from the *Sun* to Hearst's New York *Journal.* He was happy there in a professional sense, but he grew to distrust politicians and world leaders more and more. In a short story written sometime late in the 1950s he expressed his skepticism toward the real possibility of world disarmament:

You have had wars for thousands of years. Wars are real. Now you have disarmament. Disarmament is a myth. . . . Leaders have always arisen to incite their people to feats of valour—feats of conquest. They became leaders because they were talented in oratory—capable of making the longest and loudest speeches.

They built empires through terror, empires that were

165. Cartoon by O. Soglow honoring Rube
Goldberg's Pulitzer Prize, 1948

PLUTO (**A**) JUMPS AFTER BALL (**B**), BREAKING WINDOW (**C**), WHICH LETS IN FLY (**D**). CAUSING FLY-CATCHER PLANT (**E**) TO GRAB AT IT, PULLING STRING (**F**) THEREBY SHOOTING ARROW (**G**) FROM BOW (**H**) INTO MICKEY'S BACK (**I**), (MICKEY THINKS IT'S CUPID) CAUSING HIM TO KISS MINNIE (**J**). BIG HEART (**K**) POPS OUT, SCARING PUFFER FISH (**L**), MAKING WATER (**M**) OVERFLOW ONTO PADDLE WHEEL (**N**) WHICH TURNS ON TELEVISION SET (**O**). BEAUTIFUL VISION (**P**) CAUSES GOOFY'S EYES TO POP OUT, HITTING LEVER (**Q**), WHICH CAUSES HAND WITH PIN (**R**) TO STICK DONALD IN FANNY (**S**) MAKING HIM RAVING MAD. HIS YELLING CAUSES WINDMILL (**T**) TO TURN, WORKING COGS (**U**) WHICH IN TURN MAKES HAND (**V**) WRITE OUR BEST WISHES (**W**) TO RUBE GOLDBERG ON HIS WINNING OF THE PULITZER PRIZE.

166. Cartoon by Walt Disney honoring Rube Goldberg's Pulitzer Prize, 1948

destined to crumble, leaving their once-triumphant leaders to die in shell holes, in sewers, in bunkers and by assassination. Then there was a short respite of peace—until new leaders came along to rave and rant and teach their people to hate other people. Morality died and revived for a brief moment only to die again like a delicate flower in the fist of a brute.

Then there were new wars. And there will always be new wars until the real weapons of war are destroyed. There are only three weapons of war—hate, greed and envy. When they are abolished, and only then, there will be no new war.

By the mid-sixties he had had enough. Despite an offer to renew his contract in 1964, Rube declined. As he explained five years later:

When my contract on the *Journal* had expired they sent me a renewal which looked like a conscript to further bondage. . . . I had said everything I could in pen and ink. I could only start repeating myself. You have to stay angry to draw editorial cartoons effectively, and I had reached a stage where I was inclined to say "So what?" when someone predicted the end of the world.

Rube might well have written the same words ten years earlier.

His last editorial cartoon appeared in 1964. He was eighty-one years old, but he still had his pride. A rumor circulated among his friends that he had been released involuntarily by King Features, so Rube carried his new contract offer in his breast pocket and showed it to anyone who appeared as a doubting Thomas.

15

Juggling the Alphabet

Throughout his career Rube wrote short stories for the highest-paying magazines in America: *Collier's, Saturday Evening Post, Cosmopolitan, Redbook, Life,* and *Vanity Fair.* From 1922 to 1930, nineteen of his articles appeared in print. Often he found himself in the same issue with F. Scott Fitzgerald or Grantland Rice or Ring Lardner or P. G. Wodehouse or Ernest Hemingway. As early as 1924 one editor reported that Rube was "secretly hoping to write the Great American Novel," but most of his pieces were crisp and short, seldom exceeding 2,500 words (Fig. 169). Unlike the writings of other American humorists, which are too often the product of unabashed pilferage, Rube's jokes and philosophy were pure. His passion for originality, though, when taken to the extreme, was a detriment to his own mental growth. Seldom did he read the works of other humorists, as if fearing that his own mind would become infected with ideas, phrases, and story lines that were not entirely his. He often criticized Will Rogers for "borrowing" jokes without giving due credit. As for Rube himself: "I'm the guy who writes the words."

Rube always seemed on the brink of literary fame, but his writing was often undisciplined and inconsistent. His articles were more restrained than his cartoons, making the reader feel that Rube was holding back.

Nevertheless, at one point in 1928, five of his stories were on the newsstands at once. But this was the high point, for just as cartoon humor vanished, the recipe for literary humor also changed by the time of the Depression.

Rube wrote intuitively, in a manner reminiscent of his famous inventions. Occasionally he would stop in the middle of a paragraph, for example, and calmly announce to Irma that it was time to use a big word. "Why?" she'd ask. "I don't know," he'd respond. "Just to show the reader I know something fancy." And with that he'd put in "sycophant" or "wizened" simply for the hell of it.

Of the few literary artists he did read, Charles Hanson Towne gave him the greatest inspiration. Towne, six years older than Rube, published twenty-eight books between 1898 and 1945 as well as numerous magazine articles. He and Rube were close friends, and one of his poems, "Around the Corner," found itself framed and hung on Rube's library wall:

AROUND THE CORNER

Around the corner I have a friend
In this great city that has no end;
Yet days go by, and weeks rush on,
And before I know it a year is gone,

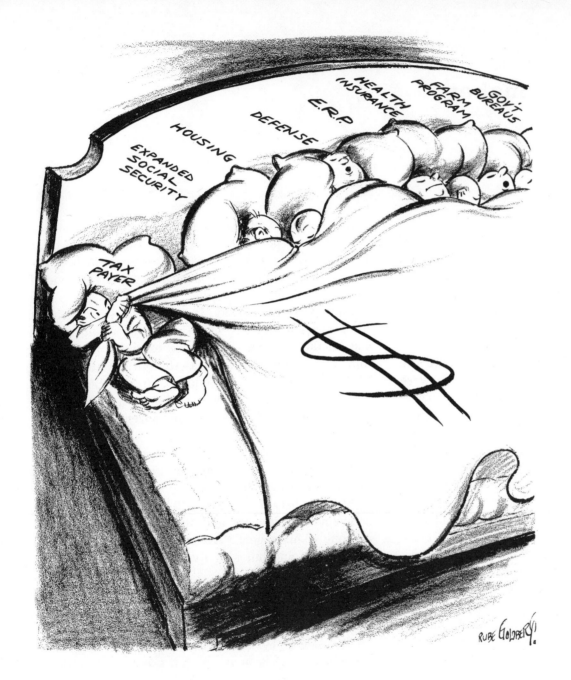

167. Hogging His Covers, 1949

And I never see my old friend's face,
For Life is a swift and terrible race.
He knows I like him just as well
As in the days when I rang his bell
And he rang mine. We were younger then,
And now we are busy, tired men:
Tired with playing a foolish game,
Tired with trying to make a name.
"Tomorrow," I say, "I will call on Jim,
Just to show that I'm thinking of him."
But tomorrow comes—and tomorrow goes,
And the distance between us grows and grows.

Around the corner!—yet miles away. . . .
"Here's a telegram, sir. . . ."
 "Jim died today."
And that's what we get, and deserve in the end:
Around the corner, a vanished friend.

 Charles Hanson Towne

The tender ironies in Towne's writing can be found in many of Rube's pre-1935 cartoons and short stories, but after the war Rube tried to develop a sort of poignancy as a major literary theme. In 1949, for example, he completed a Wizard of Oz–type fantasy of 18,000 words, entitled "Johnny Wonder and the Secret of the Toys." The story tells of a timid but curious boy who has learned to win the trust of all good people. In the final episode he visits the Kingdom of Zugg, where an evil king has decided to burn all the stuffed animals in the land. As Johnny Wonder arrives, a live giraffe approaches and explains the tragic meaning of the king's deed:

You and other children—and even grownups—believe that toy animals are nothing more than cloth and wood and metal. But you are mistaken. They are really the Souls of live animals. . . . Some of us are too big to play with children. We are too clumsy and wild and might hurt them.

But we love children just the same. So we have given our Souls to the little toy animals because that is the only way we can express our love.

This tenderness was not a sign of old age but a conscious effort to express a fundamental quality of Rube's character. He never carried it to the soupy extremes of Charles Hanson Towne, preferring to use it as a foil for his humor. In most of his stories from the editorial years one of the main characters inevitably is doomed to suffer the role of a Boob McNutt, who battles the world for dignity—and loses. As humorous anecdotes, his later stories are literary transformations of his early cartoons. Titles such as "Don't Worry Any More About Spots on Your Lapels," "Hors de Combat," "Life Is Too Complicated," "I Always Make It a Rule," and "You Gotta Be Phoney" are takeoffs on *It's all wrong, . . . , it's all wrong, Phoney Films, Telephonies,* and the rest. While he lampooned opera, exercise, politics, modern art, and physicians, Rube's stories espoused individualism, honesty, and simplicity. Unfortunately, only eight of forty-two stories written between 1945 and 1970 found their way into print. As one editor wrote to Rube, "Your funny sentences and vivid imagination do not fit the format of our magazine. Presently, we are focusing on current events. Please try us at a later date." Few magazines after the war welcomed Rube's style of humor, so despite his continual efforts and the high-priced attempts of literary agents, he died with a host of unused manuscripts stuffed haphazardly in desk drawers.

Rube's failure to establish a viable literary career was due in part to changes in public taste, but it also stemmed from a lack of understanding among scholars as to the literary significance of the comic page. From the earliest drawings of Frederick Burr Opper to the current antics of *Li'l Abner,* the American cartoons

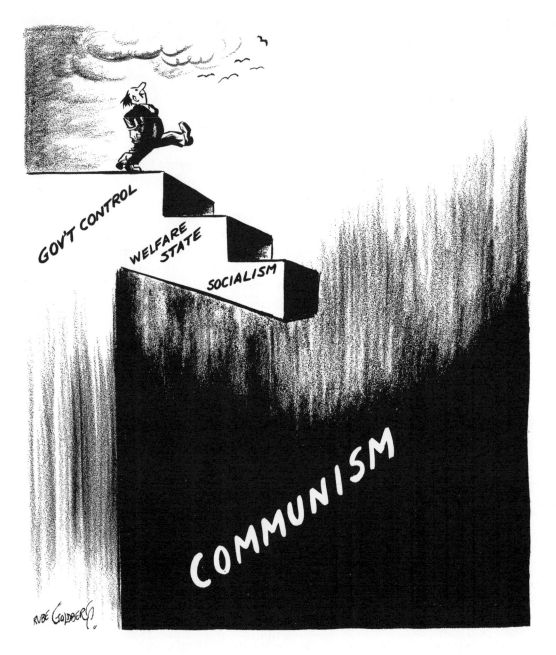

168. Stairway of No Return, 1950

and comic strips have enriched our speech with new words and phrases, with verbal twists which aim at nothing less than to generate a smile. Opper's classic, "After you, my dear Alphonse," is only one of many contributions. Strangely enough, it has taken some lexicographers seventy-five years (nearly the entire lifetime to date of the modern cartoon strip) to see the creative power, the inventive genius, of newspaper humorists. Cartoon phrases such as "time's a-wastin' " or "you sassy thing" have been used by millions of Americans for years, yet many of the scholastic rulers of the language have marked them as aberrations, verbal pollutants in the land of "the correct."

But the walls are slowly crumbling. Cartoon words and phrases are being admitted into formal works such as the *Random House Dictionary of the English Language*. "Dagwood sandwich" from Chic Young's *Blondie* has been enshrined, along with "goon" from E. C. Segar's forgotten strip *Thimble Theatre*, Billy DeBeck's "heebee jeebies," and other creations such as "twerp," "hot dog," and "tank town." While Rube Goldberg himself is an entry, his "boloney" is still not included in all dictionaries, waiting to be corralled by some sensible grammarian who is willing to admit that "bologna sausage" just won't do.

And of all the cartoonists who have won fame as phraseologists, only James Thurber and Rube Goldberg persistently rummaged the English language for its richness and color. Although Thurber's stories have a consistency and flavor which most critics favor above Goldberg's, even the *New Yorker* wit lacked Rube's range. Beginning with the characters of the alphabet, which he cartooned in several series, Rube worked his way up from words and punch lines to poems, song lyrics, short stories, plays, motion-picture scenarios, and novels. His lifelong passion was to publish a musical

comedy, where he could "put it all together," as he used to say. Only this final goal eluded him.

Rube's willingness to work in all literary forms reflects his interest in the English language itself. Unlike a full-time student of words who explores roots and usage and varieties of spellings, he saw language as a vehicle for ideas. Nothing more. He was an inveterate misspeller who refused to crack a dictionary until his own name had become a regular entry. He depended on copy editors to correct his miscues, but in the early forties several misspellings slipped through the *Sun*'s faulty machinery and found their way into print. Ever alert to a mistake, his fans pounced on him immediately. A handwritten note from one renowned sleuth in California read:

Hello Rube—

sure Glad to hear from you
and know you ll do a
Banged up Job—and if
you mispell any words I ll
be the first to discover them—
Will be Getting the sun every
day out here, wait a minute
I mean the N.Y. sun—as
I m writing this its Raining—

. . . .

Your Pal

Jimmy Durante

Rube's dedication to the written word grew with the years. Early in his career he drew a series for his side panel entitled *Bughouse Alphabet* using each letter from A to Z as a symbol for the theme of the central cartoon. Figure 170 is one example. Between 1910 and 1920 he worked *Old Man Alf of the Alphabet* (Fig. 171) and later, in the 1920s, he originated an unsuc-

169. History in a Modern Picture Frame, 1911

cessful series, *Alphabeticals*. Then, between 1929 and 1934, he published thirty-five cartoons which he called *Alphabetical Soup*. In this group he'd take a set of familiar initials and alter their meaning to fit a particular situation. One cartoon, for example, used "B.C." for its conventional meaning and then twisted it into "Bathtub Crooner." Caricaturing the "characters" often took ingenuity; it was a mental puzzle more difficult than spoofing social maladies. But it broadened the base of Rube's readership by offering something to bookworms and intellectuals.

In several frustrated efforts during the mid-thirties Rube tried to develop a story about an alphabet factory complete with college professors who shoveled letters into distribution machines just "to see what happens." These factories were shaped like dictionaries with twenty-six entrances, one for each letter.

Each of the enclosures is filled with letters of the alphabet that correspond with the large letter at the entrance. For instance, the "Q" enclosure is filled with "Q's" of all shapes and sizes with some semi-colons and periods and question marks added for good measure. Each Professor shovels his letters into a trough and they flow down into a great revolving cylinder . . . in the center of the auditorium.

Then each shovelful would trigger a neon sign in the Central Word Room:

1. DSVHORSEAGT
2. JDTSGLUEMXV
3. PFDOORSLOOV
4. FRDATMEALZBK
5. UZNFROGWSSBJ
6. CQRSPILLOWVOOZ
7. RAFFBOOTQUEGG
8. VWGROAPPLEIF
9. SCARPETJ
10. GROMFOOTBALLUOOX

Chances were good, theorized Rube, that within each scramble there would be an old but useful word, or maybe even a new creation too irresistible to ignore. The current word board contained (1) horse, (2) glue,
(3) door, (4) meal, (5) frog, (6) pillow, (7) boot, (8) apple, (9) carpet, and (10) football. Many of the alphabetical jumbles didn't make any sense at all, but Rube assured us that politicians would use them for public speaking. He illustrated this point in one story by having the Mayor of Sandwich Town give Johnny Wonder, one of Rube's fictional heroes, a tour of the alphabet factory. While standing in the Central Word Room, the Mayor suddenly began to look apprehensive.

"What's the trouble?" asked Johnny.

"I was hoping," said the Mayor, "to see another word or two that would help me out in my work." Just then some more bells rang and the word

PLAVITT

appeared in neon lights.

The Mayor jumped for joy. "That's it, that's it!" he cried.

Johnny concentrated again but could not make head nor tail out of the word. "No matter which letter I take away, it doesn't seem to make any sense."

"Of course it doesn't. That's just the word I want for my next speech. I will promise the people . . . lots of Plavitts."

"If you don't know what it means, they won't know what it means either," said Johnny, very naturally.

"A perfect observation," said the Mayor. "If they don't know what it means, they won't miss it if they don't get it!"

With that, the Mayor rushed from the building closely followed by Johnny. The Mayor stood on top of his golden chariot as thousands crowded around him. He cleared his throat and shouted, "I know you all love me and I do not really need to do any more for you than I have done before. But today I feel especially generous. So I have decided to give every man, woman, and child in Sandwich Town a nice, big juicy Plavitt!"

A great cheer arose from the crowd as the Mayor drove off, feeling that he was safely enshrined in the hearts of his people.

WHY IS A JOY RIDER ?—By Goldberg.

170. Why is a joy rider?

Rube loved to think up Swiftian words like "Plavitt," and throughout his life he searched for bizarre juxtapositions or unusual groupings which would conjure a humorous image. By juggling the alphabet in his mental conversation factory, he gave us "boloney," "telephonies," "Boob McNutt," "Adenoid Sourgrapes," "Ignacius Winnets," "Mincemeat cemetery," "Graveyard sleeping pills," "Croak insurance company," "Spike McBuska," "the good ship Detainia," and many more.

Undoubtedly it was Professor Freddy Slate's *Barodik* which intensified his love for unusual words and incongruous sounds. "Think of anybody calling anything a *Barodik!*" wrote Rube in 1968, "you could spend years juggling the letters of the alphabet without getting a name as beautiful as the one Professor Slate had snatched out of thin air." The *Barodik* was particularly influential because it was more than a funny-sounding word; it was a real invention Rube could see and use. This direct relationship between a strange-looking contraption and a comic name led Rube, in the 1920s, to create a menagerie of animal cutouts on the top right-hand corner of his Sunday comic page: the "Humdrums," the "Weeping Wuks," the "Cruller-Tailed Loafodoughs" (Fig. 172), and the "Prowling Soot-Soots." These silly creatures reveal Rube's concept of language; an innate ability to perceive the direct relationship between an object, its sensual features, and the abstractions we call "words" which attempt to communicate those features. Rube's new words sound funny and *look* funny but they have an unusual precision and clarity.

They are far less abstract than the original creations of the other intellectual humorists with whom he shared center stage during the 1920s: Dorothy Parker, Frank Sullivan, Robert Benchley, and Corey Ford (to

mention just a few). The new words by Frank Sullivan, acknowledged by many critics as supreme examples of giddy idiocy, derive much of their charm from their suggestive vagueness, their rich, open-ended generality. Sullivan's "cassorwaries," "gambusia," and "kettle-drummers" plunge us into a wild-eyed world of variety and nuance, but Goldberg's creations make us smile because of their precision and their imaginative detail.

Rube also had a receptive ear for the vernacular; he gave words like "boob," "bughouse," "guy," "loon," "gum," "gink," and "bunk" a continual workout. He believed that slang revealed the quality of humor in any nation. Americans love "to invent jazzy-sounding substitutes for much used words," he observed; "we do a great deal of expressing ourselves in terms of slang, and it seems to please our imagination most when we can devise some odd-sounding word or phrase that applies to the ancient art of sham." Goldberg's "boloney," for example, was a synonym for "bluff," "fake," and "hokum," and it joined a storehouse of other foods—including "applesauce" and "banana oil" —used to release the hot air from annoying windbags.

Puncturing pretension was only one reason for playing with words. Sometimes, as in the puns of *I'm the guy* and the *Chamber of Horrors* (Fig. 173), it was done for fun. When Mike and Ike weren't acting up with Boob McNutt, for example, they could be found in a side panel wrestling with the definition and usage of acceptable words, doing their best to obscure the conventional meanings and to replace them with a zany line of puns and a grab bag of Goldbergian nonsense (Figs. 174 and 175).

This lexicographic playfulness gained Rube an intimacy with the English language achieved by few other authors. His crisp labels, hard punch lines, and self-fulfilling prophecies were the products of this easy

171. Old Man Alf of the Alphabet, 1916

familiarity. His cartoon for July 9, 1915, for example, anticipated the domestic humor of Robert Benchley by playing up the sound of a single word: "A vacation is something like an epplewoggle—there's no such thing."

From the start of his career Rube had proved himself a master of one-line humor, but in many of his short stories he spun out sentences that revealed an undeveloped talent for poetry. "That delicatessen man . . . is a profiteer," complains one character. "The dill pickles look like olives and the olives look like Hell." This lyric energy produced *Life's Little Jokes* for twenty years. Rube's news articles, too, occasionally sported a Goldberg doggerel, but it was after 1948 that he worked to make himself a poet of laughter. His one novel, *I Made My Bed,* by Kathy O'Farrell as told to Rube Goldberg (1960), contained his best rhyming witticisms.

THE YAK'S CURSE

A cashmere yak lay dying
In the mountains of Tibet
And a passing llama asked him,
"Is it something that you et?"
"Oh no," the poor yak answered,
"It is shame of which I die,
To think I'll be a jacket
On a moving picture guy.
A coat of many colors
On his torso I will be.
Me, the Himalayan beauty
Of such great nobility!
He'll belch and sweat profusely
And he'll slobber me with gin,
I'll be a helpless captive
Quite adjacent to his skin:
I'll be buttoned round his stomach
While he eats and then, alas,
I will only hear the rumblings
Of a belly full of gas.

So, to every cashmere wearer
Through the ages I will bring
The soul-destroying, mortifying,
Fatal, lethal, ever-dying
Curse of appis fring!"

KILLER WILL

There's something rotten in Denmark,
Where daggers drip with gore,
Where Shakespeare, known as Killer Will,
Was there to torture, maim and kill,
In the castle of Elsinore.
"There's something rotten in Denmark,"
Said Hamlet, the sad-eyed Dane.
His mother slew his dad, the King
And wed his uncle (the nasty thing),
To begin an evil reign.

Chorus:

Yes, Shakespeare was a writing fool,
Oh, brother, was that scribbler cool;
He rubbed out Claudius and Gertrude, too,
And Polonius got the bofferoo:
He knocked off poor Laertes fast
And mad Ophelia breathed her last;
When all the characters were dead,
He filled his glass with blood and said,
"To violent death a merry toast!"
Oh, Bard of Avon, you're the most!

Rube joked that he sent one of his poems to Gertrude Stein, who graciously responded:

THANKS FOR YOUR LOVELY POEM.
IT WAS VERY VERY VERY VERY.
FISH CANNOT WEAR HATS.
RAIN RAIN RAIN RAIN
 thanks thanks thanks

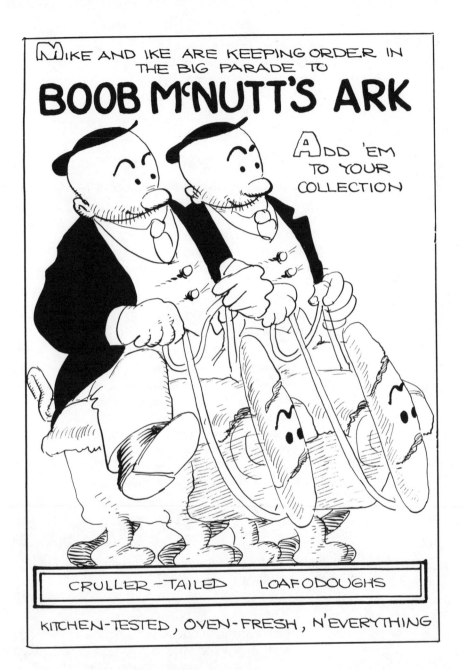

172. The Cruller-Tailed Loafodoughs

CHAMBER OF HORRORS

HOLD ON TO YOUR HATS WHILE WE TAKE THIS TURN.

SMILING JACK OZK, THE GAS-HOUSE COMEDIAN, WHO DONATES TODAY'S FOOLISHNESS.

WHY IS A PERFECTLY-GOOD COW THAT WAS LEFT TO MOTHER BY A DEAR FRIEND WHO SHOT HIMSELF IN THE ADAM'S APPLE WITH A DILL PICKLE, LIKE ONE OF THE LARGEST CITIES IN RUSSIA?

ECHO!- BECAUSE IT'S MA'S - COW.

YES, YES, I KNOW ALL - BUT THINK OF OUR CHILD!

173. Chamber of Horrors, 1912

174. Mike and Ike, they look alike

175. Mike and Ike, they look alike, 1920

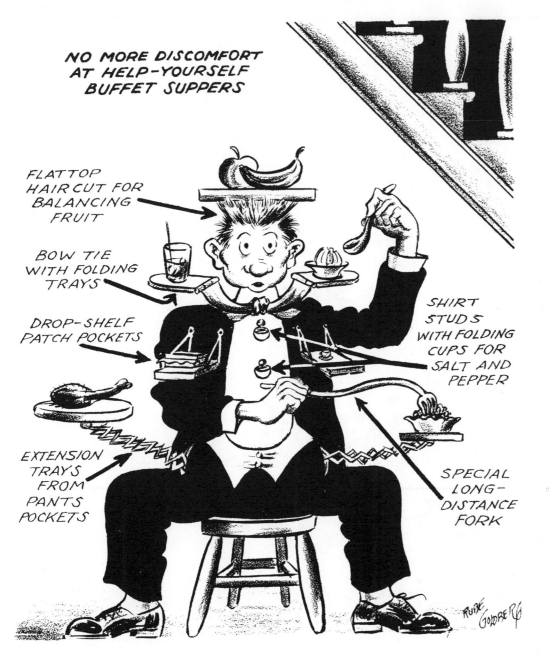

NO MORE DISCOMFORT AT HELP-YOURSELF BUFFET SUPPERS

FLATTOP HAIRCUT FOR BALANCING FRUIT

BOW TIE WITH FOLDING TRAYS

DROP-SHELF PATCH POCKETS

EXTENSION TRAYS FROM PANTS POCKETS

SHIRT STUDS WITH FOLDING CUPS FOR SALT AND PEPPER

SPECIAL LONG-DISTANCE FORK

176. No More Discomfort at Help-Yourself Buffet Suppers, 1948

In addition to poetry Rube composed numerous song lyrics throughout his career, but only "I'm the Guy" attained real fame. He also wrote at least three unpublished musical comedies, the librettos stashed away with the disappointing pile of other witty but unwanted words. Even Hollywood gave him a try. In 1930 Rube signed a contract with Twentieth Century-Fox to write a movie scenario. Like most writers who made their way to Hollywood at this time, Rube found himself virtually locked in a trailer on a movie set, being pressured to produce at the whim of celluloid executives. He hated it but did complete his assignment on schedule. Entitled *Soup to Nuts*, the film was neither funny nor entertaining, and Rube returned to New York feeling as though he'd "aged ten years."

Rube's writings were not his major achievements, but they represented his determination to be heard. He felt a keen urgency to project his wacky view of the world, to reach out and touch any reader who cared to laugh. While he refused to give himself entirely to his writings—even after his first career collapsed in the mid-1930s—he did enjoy occasional successes, for most of his short stories and articles were created in the spirit of his cartoons: spoofs on the everyday problems of everyday people. At the time of his death in 1970 his bibliography included forty-eight major articles and ten books.

NO MORE
UNLUCKY
FISHERMAN-

AFTER FISHING ALL DAY WITHOUT A BITE, YOU
SHED TEARS OF CHAGRIN—MIDGET ROWBOAT CAPTAIN (A),
THINKING IT IS RAINING, LIFTS UMBRELLA (B), UPSETTING
CAN OF SNEEZE-POWDER (C)—PARROT (D) SNEEZES,
BLOWING POOL BALL (E) INTO POCKET (F)—STRING (G)
PULLS TRIGGER OF ATTACHED STEEL AQUARIUM (H),
SHOOTING FISH (I) ON TO HOOK (J)—YOU CAN CATCH A
NICE BROOK TROUT WITHOUT TAKING AN EXPENSIVE TRIP
TO THE MOUNTAINS AND GETTING EATEN UP BY MOSQUITOES.

177. No More Unlucky Fishermen,
1944

16
℞

The fun-loving Goldberg found it impossible to live in the restrictive world of his editorials so he continually ventured beyond his cartoons in order to fulfill himself. That splendid harmony of living and working, that near-perfect integration and orchestration which had distinguished his life from 1907 to 1937, was now marred by a discordant note. He needed to roam, to dream, to socialize, and to experiment. And to do these things he was forced to labor and to laugh in separate worlds.

This dual existence began in 1944 with the publication of *The Rube Goldberg Plan for the Post-War World*. "After the war . . ." had become a conversational cliché; newspapers and magazines were laden with glowing descriptions of what postwar life would be like. Sociologists, historians, journalists, and engineers foresaw vast technological growth: plastic houses, atomic monorails, domed cities. The *National Geographic* (October 1945) predicted electronically produced newspapers, flying moving vans, disease-preventing vaccinations and immunizations, and a Precipitron (a handy gadget which promised to dust the house on the flick of a switch). *Life*, in 1948, fancied that home life in the world of tomorrow would be "mechanically and electronically perfect, and people

presumably will be happy as larks." David Sarnoff, the genius of R.C.A. and a lifetime admirer of Rube's work, prophesied atomic automobiles, satellites, and personal helicopters. More, he anticipated a perpetual chain of progress. Technology would bring abundance, and abundance would give rise to social harmony, which would expand the minds and visions of everyone. The ultimate good, as Sarnoff saw it, would be a "greater ethical and moral stature."

With only a few exceptions, such as Aldous Huxley, who saw ahead the progressive disintegration of life and society, professional forecasters expected technology to solve all human problems. Surely by the 1970s, they said, utopia would be realized.

This simplification and misunderstanding of the social impact of modern automation simply stunned Rube and resulted in *The Goldberg Plan*. As Voltaire's *Candide* exploded the "best of all possible worlds" into bits of ridicule, so Rube lampooned the dreams of contemporary sages with twenty-six new inventions by Professor Butts and several apt quotations from profound prophets, including Asparagus de Lumbago.

Unlike the utopians, who dealt with "full-grown people, geographical boundaries and abstract political philosophies," observed Rube, "I attack the problem

178. Predictions for the year 2070 A.D., 1970

in terms of midgets, animals, and concrete scientific principles." His new inventions carried on the tradition of the earlier masterpieces by "helping men with little, everyday problems," but they did not have the enigmatic lines and the depth of the earlier pen-and-ink creations. This failing was due, in part, to Rube's new drawing tools. The thick, soft graphic pencils and the heavy, smooth drawing sheets, which he used in the editorial years, produced lazy, murky lines lacking in that crisp vitality, that wild-eyed nervousness which had become a Goldberg trademark. Nevertheless, many of the basic ideas are ingenious, exposing the postwar dreamers to the barbs of a marksman.

The Goldbergian utopia began, not with machines, but with animals. Beavers, for example, would be trained "to build their dams in the mouths of demagogues and slogan-shouters. They will be trained to wall up the warlords in one great arsenal where they will have nothing to do but shoot one another," insisted Rube. The praying mantis, "a slight insect that has been praying for centuries without portfolio," will have a special task:

In the post-war world we will be so busy enjoying all our planned pleasures we are liable to be too tired at night to say our prayers. That is where the praying mantis comes in. Every bed will be equipped with a mantis. As you sink into the slumber of exhaustion you will hear the insect's voice saying, "Now I lay me down to sleep," and rest with a clear conscience—by proxy, at least.

And the aardvark, which had been overlooked in the prewar world, would be indispensable. "He spells funny, sounds funny and looks funny," wrote Rube. "In my post-war plan every family will have an aardvark sitting around the house just for laughs."

In a few simple paragraphs Rube isolated some of man's eternal afflictions: gloom, pride, and politicians. He intimates the absurdity of a technological dreamworld and reinforces his message with new inventions by Professor Butts: a gadget entitled *No More Discomfort at Help-Yourself Buffet Suppers* (Fig. 176), aimed to resolve the ancient dilemma of dining without the benefit of a table; machines to guarantee every woman a perfect figure, to insure eyeglasses against loss, and to bring about the extinction of the divorce. The automatic hat-remover would be a social boon. Even fishermen would prosper (Fig. 177).

Rube's satire of postwar utopians expressed his belief that people and their problems never really change. Twenty-six years after the book appeared, he reiterated this idea in the last cartoon he ever drew, *Predictions for the Year 2070 A.D.* (Fig. 178).

To Rube, change and reform and basic improvement were illusions dear to the hearts of human beings. Through the lips of Rumford M. Ashtray, Rube expressed a more practical philosophy:

My family has been in this country over three hundred years. If it took my ancestors that long to mess up the pre-war world, how do you expect me to fix up the post-war world in the few meager years I have on earth? In fact, I don't think it's necessary because your outlook on life depends entirely on a good bowel movement.

If Mr. Ashtray's vision of the future lacked the enthusiasm and the glow of other visionaries, it was far more realistic and adaptable. Rube couldn't help his cockeyed view of an unpredictable future, for imperfection was his stock-in-trade. He assumed that men will always cheat and lie, that roofs will invariably leak, that television sets will go out of whack just when they are wanted the most. To a humorist like Rube, the key to a rosy future was in the spirit and mind of every

Rube and President Dwight Eisenhower, 1954

human being. An acceptance of man's condition, eternally imperfect, and a humorous approach to life itself were the absolute requisites for attaining any kind of earthly Valhalla.

This same philosophy appeared in his second postwar book of cartoons, *Rube Goldberg's Guide to Europe*, published in 1954. Complete with captions by feature writer Sam Boal, the book was an unimaginative rehash of *Boobs Abroad*. The incompetence of customs officials, the strange languages and fashions, the abundance of wine and ancient history, and the incessant clicking of camera loons all appear; each cartoon seeks to expose the flaws and the humorous disappointments of an expensive European tour. By this time Rube had visited the Continent at least seventeen times, but only his impressions of European art had changed: an early negativism slowly transformed into a polite skepticism. Rube's awakening in fine art later became an important part of his life and blossomed into a new career during the 1960s.

But coupled with the seriousness of his war year editorial cartoons, this preoccupation with the philosophical aspects of man's life was surely a psychological albatross. Rube yearned for the carefree hedonism of the twenties. He missed the big parties, the drinking bouts, the spontaneous laughter, and the unscheduled nights on the town. He felt as though a shade of solemnity had been pulled over the windows of his social life. He aimed to give the cord a good tug, send the old screen flying, and reveal a refurbished sense of light and ease.

One solution came from his volunteer work during the war. In the early forties, Rube and several other cartoonists traveled through America entertaining the troops. Most of these assignments were scheduled by the American Theater Wing, and despite his queasy attitude toward flying, Rube soared to military bases and hospitals from coast to coast. He could never think on a plane, much less draw or sleep, so the tours were always hectic and tiring. With each landing he would race to the barracks and isolate himself for an hour or so to draw his daily editorial. Then off to the show until late in the evening, back to his bunk for a night's sleep, and an early takeoff the following day. He turned sixty in 1943, and even though this daily regimen was not entered into with complete ease, Rube seemed to enjoy himself. The endless assortment of practical jokes, the booze, the friendships reminded him of Goldfield, Nevada, and his busy life in the early twenties.

Performances included Rube's vaudeville routines, his after-dinner speeches, and his cartoons. They were a bit crude and racy but generally fun and well received. One of the cartoonists, usually Bob Dunn (*Little Iodine*), would appear first to warm up the audience:

"Cartoonists are always on the lookout for new, odd-looking characters. And looking around the hall tonight we certainly hit the jackpot. How about you sir? Would you stand up?"

The soldier would rise hesitatingly and "Ugh, no," Dunn would joke, "I didn't realize you looked *that* bad!"

Later Rube would enter and draw several inventions on enormous sheets of white paper. Russell Patterson soon joined him as a "straight man" and together they staged a friendly contest. First Patterson would pull a pretty nurse from the audience and draw one of his luscious portraits. The audience would applaud with delight. But it was always Rube who scored by countering Patterson's artistry with his own crazy, exaggerated portrait.

After numerous skits, the show would end with a

179. Drawing used by Rube Goldberg entertaining troops, 1941-1945

classroom routine entitled "What We Learned from Professor Rube Goldberg." Rube, dressed in scholastic garb, would ask one of his students (i.e., his fellow cartoonists) to draw a picture on the blackboard and then identify it for the audience.

Otto Soglow would step out, draw several lines [Fig. 179A] and conclude "It's a music stand without the music."

"No, no," Rube responded, "sit down. Would Gus Edson please come forward? Gus, try to make something out of that."

"Here, it's a Duncan Phyfe table" [Fig. 179B], quipped Edson.

"You're no help at all," Rube shouted back. "We'll call on C. D. Russell."

"Here, professor, it's a lamp" [Fig. 179C].

"Well, er-r-r, none of you are any good," said Rube. "Alex Raymond, get up here."

"It's a light bulb, professor, in honor of Thomas A. Edison's birthday" [Fig. 179D].

"That's a little better, but you're all lousy," Rube said while shaking his head. "Now somebody else. Ernie Buschmiller, tell us what it is."

"It's a vase, see!" [Fig. 179E].

"No! You all flunk." And with that, he'd turn the drawing upside down and reveal the true identity. "Now see, it's a picture of a WAC taking a bath in her helmet!"

Rube had enormous appeal, and before long he became the star of these benefits and the leader of the touring cast.

One night in the winter of 1944–1945 he and Russell Patterson were bedding down at the Quantico Marine Base in Virginia, and talking about perpetuating the troupe's special camaraderie by forming some kind of cartoonists' association. It was not an original notion, for as early as 1913 America's "funny men" had been trying to organize. (At one of these early meetings Rube even met the aged Mark Twain.) Later, in 1927, a group which included Walt McDougall, Clare Briggs, Winsor McCay, Harry Hershfield, and Rube sponsored a dinner to discuss establishing the "Cartoonists of America." The guest list was impressive: Jimmy Walker, General Pershing, Al Smith, George M. Cohan, Ring Lardner, George Ade, and others. Yet this, too, failed. It seemed as if the individualistic artists were reluctant to share anything—even their social lives—with their competitors, and their stubbornness became legendary.

According to several accounts it was Russell Patterson, the multitalented decorator, illustrator, cartoonist, and artist, who convinced Rube that *this* time it would work. In the next room Rube listened to Otto Soglow, Gus Edson, and C. D. Russell do their best to re-create the chaos of Tad's famous poker games. "Listen to those anarchists!" shouted the skeptic Goldberg. "They'd never come to meetings." Patterson persisted, and slowly eroded Rube's resistance. "All right," Rube finally said, "but no more than twenty-five members." Patterson had him and later noted,

We'd been in bed about ten minutes when Rube raised himself to one elbow, snorted, and said, "All right. But no more than fifty members." After that he went to sleep. I waited for him to bring it up in the morning, but he didn't say a word about it. Then we got on a plane to go back to New York, and when we were in the air a couple of the spark plugs turned out to be faulty. Rube was a little worried. He was mangling a cigar and looking out at the engine. Every once in a while he'd look down, as though he were estimating the fall.

"Why don't you be the focal point of a society, Rube?" I asked him. "We can send out invitations in your name."

"Yeah, sure," he said. "Anything." He peered out at the

180. Reuben Award

engine. "There's no way to get out of this damn machine, I suppose."

"Sometime when the war ends," I said, "we ought to call a dinner meeting."

"Absolutely," Rube said. "How high up do you figure we are?"

"We'd have to get it well organized at the first meeting. Officers, by-laws, and maybe a regular meeting-place. You're the logical man to be president for the first year."

"Whatever you say," he growled. "You think this pilot's ever flown before?"

The first meeting was held at the Barberry Room in New York City (January 1946), and nine cartoonists attended. The second meeting counted twenty-three heads, and after that the ranks swelled. An early decision of the group was to dedicate itself to helping cartoonists meet one another and generally having a good time. Most cartoonists and illustrators were invited to join, but many notables (such as Peter Arno) declined, preferring a splendid isolation. To attract members the officers decided to sponsor yearly awards; the grand prize, a cigarette case, was given in honor of the late Billy DeBeck. Several years later the case was replaced with the cartoonist's version of the "Oscar," appropriately named the "Reuben." Designed by Rube and cast by Bill Crawford, the whimsical trophy is a comical testimony to cooperation and group participation (Fig. 180). Milt Caniff, creator of *Terry and the Pirates*, won the first Reuben and subsequent winners have been:

1947—Al Capp (*Li'l Abner*)
1948—Chic Young (*Blondie*)
1949—Alex Raymond (*Rip Kirby*)
1950—Roy Crane (*Buz Sawyer*)
1951—Walt Kelly (*Pogo*)
1952—Hank Ketcham (*Dennis the Menace*)

1953—Mort Walker (*Beetle Bailey*)
1954—Willard Mullin (*Sports*)
1955—Charles Schulz (*Peanuts*)
1956—Herbert L. Block (Herblock) (*Editorial*)
1957—Hal Foster (*Prince Valiant*)
1958—Frank King (*Gasoline Alley*)
1959—Chester Gould (*Dick Tracy*)
1960—Ronald Searle (*Advertising & Illustration*)
1961—Bill Mauldin (*Editorial Cartoons*)
1962—Dik Browne (*Hi & Lois*)
1963—Fred Lasswell (*Barney Google* and *Snuffy Smith*)
1964—Charles Schulz (*Peanuts*)
1965—Leonard Starr (*On Stage*)
1966—Otto Soglow (*The Little King*)
1967—Rube Goldberg (*Humor in Sculpture*)
1968—Oliphant (*Editorial*)
 Johnny Hart

 (*B.C.* and *Wizard of Id*)
1969—Walter Berndt (*Smitty*)
1970—Alfred Andriola (*Kerry Drake*)
1971—Milt Caniff (*Steve Canyon*)

Rube himself explained the Reuben in 1953:

If you have been influenced by Freud you might say that the Reuben represents four cartoonists who hated their mothers for allowing them to become cartoonists, and groping for an acrobatic answer to the questions of why sculptors and pretzel makers have so much in common. Or you might say that the Reuben represents the people of the world striving for a perfect balance to escape the same fate as the leaning tower of Pisa. You'd be wrong on both counts.

The Reuben is pure fantasy, including the bottle of India ink that Bill Crawford placed on the posterior of the top man to give the design a little more symmetry. If the Reuben has an underlying significance in its present form, I will say that I created it to keep it from looking like a golf trophy, an Oscar, or a statuette presented to Miss Kitchen Utensils

of 1953. My only hope is that each recipient will look upon it as a symbol of the admiration and love of his fellow cartoonists.

While numerous cartoonists helped the society to grow and mature, it was Rube Goldberg who ensured its success. Rube always wrote a foreword to the program pamphlet and often served as master of ceremonies at the monthly meetings. He was so admired that several friends paid him the ultimate compliment: "You are a better master of ceremonies than George Jessel!"

Rube's popularity came in part from his new rough-and-tumble style. The tours during the war had banished any fear of public speaking; in fact, he enjoyed debunking formalisms and public pleasantries. He poured an immense amount of energy into getting famous guests to attend. One special night was designated to honor Bud Fisher, creator of *Mutt and Jeff*. Known as the "old man," Fisher was a year younger than Rube! On another occasion, Bernard Baruch put in an appearance. Though elderly and ill at the time, he seemed to thrive in the society's company. "What an enjoyable evening!" wrote Baruch to Rube. "I am supposed to go to bed at 10:30. I got there this A.M. at one. All the speeches were wonderful—as a presiding officer you are tops."

In addition to the Cartoonists Society, Rube held a long-standing membership in New York's Lambs Club, the Dutch Treat Club, the Friars, the Society of Illustrators, and the Coffee House. He took an active part in these star-studded, gentlemanly organizations; even today, each group remembers Rube's antics with a particularly warm reverence. During the 1940s and 1950s—when his work failed to absorb him completely—he found these social gatherings "agreeable hours of illusion," serving as antidotes for the anger and seriousness of his editorial philosophy.

One of these celebrity-packed organizations was the Artists and Writers Golf Association, which chartered a train annually and repaired to Florida for golf and good times. According to Rube (who was the club's second president), the spirit of the society could be "traced to its utter lack of respect for anything that savors of pomp or sham." The group dedicated itself to countering the intensive gloom and despair of the 1940s. As Rube said in the Foreword of the 1948 Yearbook,

... Every man must ... devote his entire waking moments to an effortless enjoyment of the fundamentals of life—eating, drinking, gambling and a childlike faith in his fellow human beings. As one of our less intelligent artist-members was wont to say in the formative period of our existence "nothin' means nothin'."

Although we are a little ashamed to say it for fear of being charged with Babbittry we are proud of this outfit and shall try to guard the strange spirit that holds us together with a jealous love and devotion. Now let's relax!

The train to Miami was a traveling time capsule, filled with the gay style and hardy laughter of the 1920s. It was, indeed, the spirit of a passing era to which Rube tenaciously clung. Reminiscing about these carefree holidays, Rube noted,

The first year we went down to Miami they posted our names on the doors of our drawing rooms. We were met at the station by a twelve-piece colored band. Our rooms at the hotel were full of fruit and flowers. When we appeared on the beach or at the popular night clubs we were waylaid by lady reporters who wanted to interview us collectively and individually. They printed everything we said.

I told one cute little pencil-pusher that cartooning was

a side-line with me. I was really a specialist in table luxuries. I explained how anchovies were coiled on round crackers to be used as appetizers. The live anchovies were placed side by side on a marble slab in the kitchen. The chef started to walk around the slab looking about him in a furtive manner. The anchovies, being suspicious by nature, would follow the chef with their eyes coiling themselves into a complete ring. Then the chef would slip the crackers under them and the poor little things would die of fright. Then they were ready to serve.

I explained to one avid lady scrivener how cloves were stuck in Virginia hams. The hams were placed on the ground and the cloves were dropped from overhead by a group of aviators flying special clove-bombers. We told another reporter we were organizing a new newspaper syndicate which would feature a daily gossip column by the King of England. They printed everything word for word.

Wherever we went we were lionized. Society forgot its customary reticence and took us to its bosom.

The second year we came our drawing rooms on the train were not tagged. In fact some of us were assigned to upper berths. The third year there was no band at the station to meet us. And the fourth year the gullible lady reporters were entirely absent. And so on until the twelfth year when we counted no more than a group of windswept palmettos standing disconsolately in a sand dune.

Then one of the executive committee conceived the bright idea to move to another hotel, bathe at a different beach and play golf on a different course. The new hotel management was so pleased to get us it placed cars and liquid refreshment at our disposal. The new beach offered cabanas and a less turbulent ocean. Even the weather seemed nicer. We met new people who fostered our old celebrity. The lady writers flocked back. It was all as simple as that—just a few minor changes in our surroundings with no change at all in ourselves. We had waited too long to move.

Rube had always been a joiner, a charter member of numerous organizations. But during the postwar years he took an even deeper interest in these friendly fraternities by moving them from the periphery to the center of his activities. Until World War II, Rube had kept a large part of his character hidden from public view. In many ways he had opened himself wider to millions of anonymous newspaper readers than to his closest friends. But the crumbling of his cartoon humor in the 1930s changed all that, and he looked for laughs in his social affiliations. He needed his friends more during his last twenty-five years than at any other time in his life. But friends there were, and through these years and to these friends Rube became the ready dispenser of philosophy, the sage of humor and laughter, and the true "dean of American cartoonists."

181. Hannibal Butts, 1969

17

And the Whole World Laughed

Rube's thirst for work, his continual search for success, was a natural by-product of his philosophy of life. During his youthful years (1909–1930), people marveled at his salary and his wisdom—he seemed to have an abundance of both, they said, for being such a *young* man. After World War II the popular admiration continued, but now it focused on his energy and creativity, for *despite* his advancing age, he seemed so fresh and vibrant.

Rube had pondered old age long before it caught him. On December 3, 1932, he published in the *Saturday Evening Post* a short article entitled "What Do I Know After Forty?" He acknowledged that time took a physical toll, brought a deterioration of bodily functions, but its full impact varied from person to person. It made some people wise and others slow. It discouraged. It prodded. It refined. It destroyed. But for Rube himself, time was an overrated nemesis, totally irrelevent to a person's social usefulness. He strengthened this conviction eighteen years later in a piece for the *Rotarian* entitled "On the Privilege of Being Over Sixty." As for "that dreaded human affliction frivolously referred to as *old age,* I just don't believe in the stuff." And again, a year before he died, he turned the tables on Father Time by emphasizing not the pains or the fears but, rather, the joys of senior citizenry.

"Grow Old and Like It," featuring Hannibal Butts, was a hardy acceptance of life couched in a slightly uncharacteristic effusion of universal goodwill. Butts was an aged Boob McNutt radiating a quiet gentleness and exemplifying a devilish saintliness. Drawn in his own image, Hannibal Butts represented what Rube himself tried to emulate: a harmless man imbued with wisdom and sedate dignity (Fig. 181).

The manuscript included forty-seven drawings with captions and an introduction, but it was never published. Doubleday, Prentice-Hall, Simon and Schuster, Bobbs-Merrill, Dodd, Mead, and Dutton all turned it down. Rube was disappointed but by no means crushed. His concept of geriatrics gave his ego a healthy resilience:

When Somerset Maugham's friends gave him a party on his eightieth birthday he said, "I know there are many advantages in old age but I can't think of a damned one."

I'm afraid that Somerset Maugham was a victim of the Lump System. The Lump System is a manner of thinking in which you put supposedly-related elements in one lump in complete disregard of individual characteristics. For instance, all well-stacked blondes are sex pots, all men carrying briefcases work on Madison Avenue, all artists are starving, all society people are snobs, all criminals are the victims of parental neglect, all dancing partners have underarm per-

182. Hannibal Butts, 1969

spiration, all husbands have to take out the garbage and all people over eighty are defeated derelicts.

I worked out a personal philosophy as the years started to pile up. A person over eighty needs a personal philosophy to combat the general prejudice that exists against advancing years. You need to delude or convince yourself with soothing thoughts just as younger people must dream about the mysterious wonders they will encounter when life begins to unfold.

My self-induced reasoning is this: the accepted hypothesis is that everybody wants to be healthy. You rush to the doctor when you get a pain in your colon. You leap out of the way of rushing taxi cabs to keep from getting killed. You take out insurance against future misfortune. You pray for good luck. In other words, you want to keep on living. And, if you keep on living, you are bound to get old. So longevity is a reward for living—not a penalty.

Again, you must contend with the unmerciful mathematics of time. All around you are voices which whisper, "you are old." Inside you is the same voice taunting your old bones when you get up each morning. If you do not make an effort to muffle this sinister voice, you will stoop a little more, you will develop another wrinkle in your forehead, your throat will accumulate a little more gravel and all your natural aches and pains will grow more annoying.

You must say to yourself, "eighty, seventy, sixty, fifty—these are only numbers. They all appear in the obituary columns regardless of their position in the actuarial tables of the insurance companies. Today, and the immediate tomorrow, are what's important. If you spend too much time looking at those awesome numbers of the past your perspective will grow dim and you will not be able to see the blue sky of today."

My little friend, Hannibal Butts, and I are both over eighty. He has gone through all those awesome years without losing his sense of humor. He has not stepped on other people's faces in the climb to power and fame, because he did not particularly desire either. As he went along he made an effort to see what was happening today and what would happen tomorrow and eased himself into his advancing years examining the good, gentle, peaceful reflections that are always there to be enjoyed but have to be met halfway.

I hope his light touch will make you feel a little easier, make your bowels work a little more regularly and make each remaining day of your life a special reward of contemplation and well-earned contentment.

The Hannibal Butts pen-and-ink illustrations, drawn on a smooth cardboard, show a curious return to his pre-1935 style. Awkward lamps and statues, gawking women, and gnarled faces are welcome flashbacks to the golden years (Fig. 182). Although the pictures in the series lack independence and self-fulfillment, they nonetheless create a mood and vision which are remarkably strong for a man of eighty-six years.

The comic cannot deal with death unless he sees the "afterlife" an as ethereal continuation of earthly existence. Rube never drew a picture of God and he refrained from seeing old age as a step away from death's door. His humor and philosophy were earthbound. Only the present mattered. As he wrote in 1950, "Each day is a full job of living no matter where that day is located in a lifetime. The joy of the day of an old man may not be the same joy as in the day of a young man, but it is joy nevertheless and each one can crush it to his bosom without envy, recrimination or mental reservation."

This practical attitude called for universal tolerance and supreme optimism, but it did not give the elderly carte blanche to run the world. Actually, beneath Rube's philosophy was a strain of intolerance aimed at anyone who masquerades as the paragon of eternal youth. Early in the 1930s, for example, Rube experimented in his daily side panel with a cartoon series entitled *What are we goin' to do with Grandpa?* It was inspired by an incident in San Francisco during a

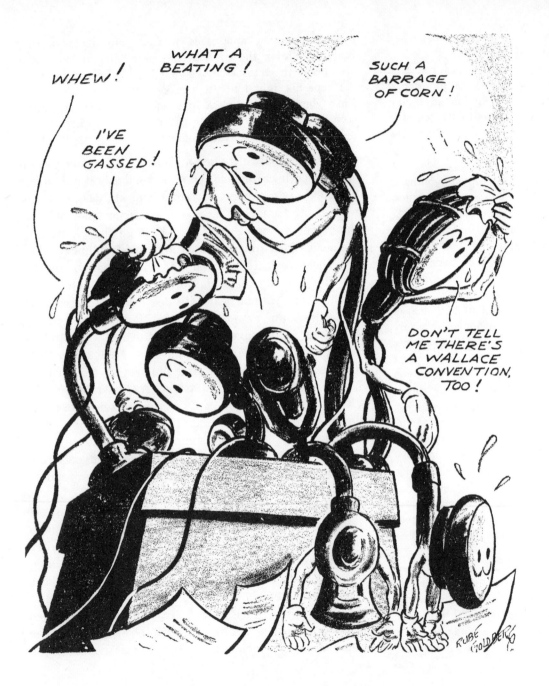

183. The microphones talk back, 1948

visit with Max. One afternoon Rube and Irma planned to pick up friends and head for the redwood forests to picnic and relax. Max *assumed* that he was going too, but Rube said no. The couples wanted to be together, he explained, without another generation peering over their shoulders. Max, of course, was hurt; but he stayed home. Several months later this situation crystallized into a cartoon, but the idea died before it ever had a chance to grow. Senior citizens across America bombarded Rube with letters of protest, insisting that his position was vulgar and destructive. Though he disagreed, he acquiesced. He wanted to stay young but not to be like the young, for the fount of his youth was in his work, a product of both his individualism and his creativity.

The greatest testimony to Rube's philosophy was his determination to find a new career. Writing and fraternizing were somewhat rewarding, but, for a man who had the nation roaring in the 1920s, Rube needed a bigger success. His editorial cartoons hardly fulfilled him. He tried radio, television, painting, and sculpture —the last opening a new, all-consuming career which was cut short by his death in 1970.

Rube's fame as a master of ceremonies in the 1940s made him an ideal guest for radio talk shows. During the thirties and early forties, his mellow voice, his original wit, and his disarming mannerisms traveled the airwaves often. Finally, in 1944, Major Bowes of NBC convinced Rube to sign a contract for thirty-nine weekly broadcasts. The show was to feature interviews, brief skits, and "inside" gossip about the lives and work of famous people. Rube seemed to know everyone of any consequence, he had a broad range of experiences, and he was a national celebrity. He decided to give radio a try.

It was disastrous. Like the irony in many of his earlier cartoons, Rube's radio experience proved that all the proper ingredients do not necessarily spell success. If he had dreamed of making a new career out of that little noise box he had satirized so mercilessly, retribution lay in wait (Fig. 183). After several half-hour programs he developed an intense fear of reading a polished script over the microphone. It was a kind of psychological regression to the days of Garry's dominance over him in San Francisco. He even made the drastic move of visiting a psychologist. After a short session the doctor advised him to be a little less conscious about what others thought of him. This was the same prescription he had received in 1928 after his false heart attack and in 1935 after Ham Fisher had driven him to despair. "Learn to say 'bullshit' into that microphone," the doctor advised.

Rube, of course, had been practicing the vernacular while entertaining the troops, but now "bullshit" became his favorite word. What amazed him most, however, was the doctor's common sense. Expecting a bewhiskered, mumbling, illogical knucklehead, he found a clear-thinking paragon of practicality. Later, he even tried reading Sigmund Freud's *The Interpretation of Dreams* and summarized his impression in an immortal verse "To Dr. Ludwig Schoenwasser-Koenig":

> The Libido said to the Id
> "You're a mixed-up sort of a kid;
> That's why you're psychotic
> And hyperneurotic,
> With cockroaches under your lid."
>
> The Id then addressed the Libido,
> "You resemble my friend from Toledo—

184. Rube's View of Modern Art, *Cosmopolitan Magazine*, 1928

He was touched in the head,
So he crawled into bed
With a moose in a purple tuxedo."

A neurotic was living on sago
Which he shipped from remote Pago Pago;
He needed a flair
So he had an affair
With jolly old Dr. Zhivago.

An Ego was split down the middle,
Which posed quite a difficult riddle;
For his psyche was weak
And it started to leak,
Which constantly caused him to piddle.

Neuroses, hypnoses, taboos, and repressions,
Schizophrenia, anemia, psychotic obsessions;
Rejections, dejections, and sexual perversions,
Paranoia by Goya, Narcissus inversions—
Which according to Freud,
To make it simple and quick,
Seems to mean very briefly,
"You're sick, boy, you're sick!"

Despite his radio trauma Rube did not give up the idea of establishing a new career in broadcasting. For three or four years after the war, stars from Hollywood, Broadway, and radio scrambled for a place on the newest electronic wonder, television. Rube, too, became part of a TV rush. He first appeared on WPIX, Channel 11 in New York, on June 29, 1948—only fourteen days after the station had made its broadcasting debut. Channel 11 was owned by the New York *Daily News,* so in typical fashion Rube's own New York *Sun* did not carry the initial blurbs about his new undertaking. The "Rube Goldberg Show" (or "The Drawing Game" as it was later called) appeared every Tuesday evening, sometimes at 7:40 and other times at 8:00. It

was one of the few original productions on WPIX, where most of the air time was spent showing movie newsreels, animated cartoons, and silent films.

The show would open with happy carnival music and Rube signing the "g" on the end of "Goldberg." The guest list was impressive, including Ed Sullivan, Helen Wills, Dunninger (the famous mind reader), tennis champion Alice Marble, George McManus, Jack Dempsey, Joe DiMaggio, Toscanini, and others. Rube served as moderator, and a panel of three would guess the titles of Rube's drawings.

The program, one of the first TV game shows, was only a moderate success. It might have been more popular but it competed against the number one television program, "Star Theatre" of NBC. Hosted in the beginning by Sid Caesar, Phil Silvers, Jack Carter, and Morey Amsterdam, "Star Theatre" soon found a regular headliner in the future Mr. Television, Milton Berle. Uncle Milty's antics, a throwback to a style of comedy when Rube was Mr. Cartoonist, won a majority of the TV viewers.

Ironically, few people enjoyed a kick in the pants or a pie in the face better than Rube. His whole argument in the mid-thirties about the decline of comedy rested on his conviction that slapstick was a basic ingredient for laughter. While Uncle Milty borrowed some of Rube's recipes and succeeded, Rube himself ran a semi-intellectual game show where everything was proper and witty and boring. After the tenth week (September 7, 1948) Rube quit. He found himself filling a role which he had ridiculed bitterly fifteen years earlier. This ironic twist made it seem that he was living in a panel of *Life's Little Jokes.*

His friend Bob Dunn replaced him and ran the show on various stations for two more years. During the remaining twenty-two years of his life Rube harbored

POOPED!

185. "Pooped"

a strong desire to find a unique approach for a new television program. But with the exception of appearances on Edward R. Murrow's "Person to Person" and several other less celebrated interview shows, he failed to break into the most pervasive of all entertainment mediums. The vast audience potential, the reach, and the power of television eluded him.

Following television he tried his hand at oil painting in the 1950s but junked the idea after several canvases turned out to be nothing more than indiscriminate gray blobs. Rube was annoyed by his failure to become a "fine artist"; it was as if he were letting down the ghost of his old teacher, Charles Beall. Rube's own son Tom, on the other hand, had succeeded—first as an objective painter and then as a creator of abstract images. Rube disliked any kind of nonobjective art, so he and Tom experienced a few strained moments whenever the subject of art surfaced in their conversations.

In one unpublished story Rube portrayed a frustrated father who exclaims to his artist son: "Couldn't you just paint a picture of a horse or a flower or a fish, somethin' you could recognize?" Rube did not believe in abstract art and he had less sympathy with the public image portrayed by most modern-day creators:

The general idea of an artist seems to be that it is necessary for him to wear soiled linen, flowing neckties, long hair, a beard, and to drink a quart of furniture polish and hang by his toes from the chandelier while working. The principal reason so few win success is that they start with the furniture polish and chandelier, and expect some divine inspiration to do their work for them.

One of the grandest ironies in Rube's career occurred in 1921 when the artist Marcel Duchamp published a Goldberg invention in *New York Dada*. Duchamp, who had inspired the Dada school of art in America, saw Rube's cartoons as works of art addressing themselves in an aesthetic manner to the problems of everyday life. In fact, while Rube detested Dada, as well as Surrealism, Op, Pop, and Minimal Art, he nevertheless drew cartoons which harmonized with the technological art of the twentieth century (Fig. 184). Until the rise of Italian Futurism, artists seldom looked at machinery with a professional eye. When the famous Armory Show of modern art opened in New York in 1913, European artists who traveled to America were stunned by the visual potential of the automatic life. One of the earliest abstract painters, Francis Picabia, wrote at that time, "I have been profoundly impressed by the vast mechanical development in America. The machine has become more than a mere adjunct of life. It is really a part of human life . . . perhaps the very soul. . . . I have enlisted the machinery of the modern world, and introduced it into my studio." Picabia's machine art began in 1914, the year of Rube's first pure invention, so both the fine artist and the cartoonist pointed the way to life today.

This curious phenomenon of simultaneous discovery proved Rube's sincere observation that his success in spoofing technology was a simple matter of timing. Pure luck. He never saw his cartoons as works of modern art, but his failure to recognize them as such does not diminish their aesthetic value.

Rube believed that fine art was good only if it won public acceptance. Sales were Rube's test of beauty. Whenever he visited museums in search of his new career, he would become confounded by "strange sculptures that looked like worn tires and old bathtubs." And if he tried to find someone to "explain" the "junk" to him, all he ever saw were onlookers standing "shocked in open-mouthed, snickering wonder."

Had the human race finally lost its marbles? Was it

186. "Camel"

time to revive *Lunatics I Have Met*? Rube was sure of only one thing—men needed a laugh in the 1950s and 1960s more than at any other time of his life, and he needed a new career. Why couldn't he fill the need for humor?

Rube dated the beginning of his third career—sculpture—June 7, 1963, which was the day after more than five hundred celebrities took over the Waldorf-Astoria to give him a surprise eightieth birthday party. It was held a month early, joked Rube, because they "thought I wouldn't make it to July 4." The invited guests included Joan Crawford, Jack Dempsey, Walt Disney, Bernard F. Gimbel, Arthur Godfrey, Barry Goldwater, Helen Hayes, William Randolph Hearst, Jr., J. Edgar Hoover, Clark Kerr, Henry Cabot Lodge, Mary Martin, Elsa Maxwell, Stan Musial, Richard Nixon, Walter Winchell, and 484 more. Fannie Hurst's RSVP read: "Of course I say a loud and enthusiastic YES to your letter. . . . But if you want to include the number of people who love Rube, one of whom I beg to remain, I suggest you hire Yankee Stadium, Madison Square Garden and the Colosseum."

The National Cartoonist Society prepared a book of original cartoons and the party began with a typical Goldberg-fumble. A young rabbi was asked to give the grace, but he was unsure just who the guest of honor really was: "Lord, please look down and favor us with your grace and we bid you to look with favor on the former boxing champion, Rubbi Goldstein." Let the party begin!

Rube's eightieth year was a time of transition—not from work to leisure but from drawing to sculpture.

I had watched some of my older friends floundering in the sea of retirement, Rube reminisced in 1970. The word "retirement" became anathema to me. I would never let the muddy waters of retirement swallow up my old carcass while my mind was still functioning and my hands were free of the stiffness of arthritis and inertia. I was only eighty years old. I had to keep busy.

Each day during 1963, as he walked from his apartment to his studio, he'd pass by a sculpture shop, and slowly he began to develop the idea of "depicting the human foibles in a three-dimensional medium." He even went so far as to purchase some children's clay, "just to give it a try." He molded the form of a thin politician complete with dramatic hand gestures and then went home, confident of a new career. When he returned the following day, however, the politican was shorter and stouter and his hands had melded into his body. Rube had known nothing of armatures and had not realized that "play clay" was hardly the medium for a serious sculptor. Even a sign painter could have told him that.

Rube had "designed" some sculpture, in the form of an "electrolier," early in the 1920s for his home on Seventy-fifth Street, but even at that time he observed that he knew as much about statuary as a tailor knows about anatomy. Yet, in his own strange way, he understood the social importance of any unique work of art. At the height of his career, when he could have bought virtually anything he needed, he began to question the homogenized look of his elegant home decor. He felt he had to do something "foolish" to prove that he did not "purchase his house in a mailorder catalog":

When I remodeled my house in New York, it suddenly dawned on me, one day, as I was trying to match the dining-room wall-paper with the colour of the soup tureen, that my home was rapidly developing the regulation own-your-own-home aspect, which undeniably betokens the machine-made habitat of the retired butcher.

It was beginning to look like one of those places for which you could buy spare parts in any good delicatessen store. You could find a picture of my shower bath in any household

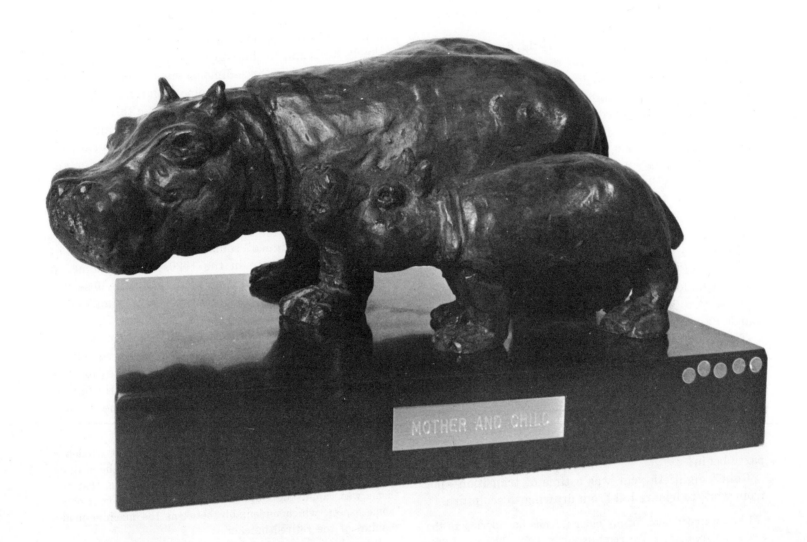

187. "Mother and Child"

magazine. My garbage can bore the factory number, 574,-930,172. My bed was hand-painted. The books in my library were exactly the same, in number and size and age, as those found in the home of any respectable and successful bird-store proprietor. I was panicky.

His sculpture of the 1960s had the same social function as the notorious electrolier. After a few modeling lessons and some important tips about the proper materials, Rube completed approximately three hundred pieces between 1964 and 1970. He read art books during this period, being fascinated with Michelangelo and Rodin; he made thousands of rapid sketches, always trying to design the whole before he began; and he sought the advice of numerous people as he progressed —a practice which probably had never occurred to him as a cartoonist. He had to consider anatomy and figure proportion, as well as weight distribution and three-dimensional spatial harmonies. No longer could he defy gravity or time as he had done so splendidly in the 1920s, for even his drawings and plans had to be correct.

It was painstaking work. He described the technical procedures in a Smithsonian Institution catalogue appropriately titled *Do It the Hard Way*:

I model my figures in a special clay called Plasteline. When this is finished I take the figure to a shop where first a rubber mold and then an exact wax reproduction are made. Then the wax is sent to the bronze works where it is cast in bronze. These various stages have to be watched to see that there is no detail lost in the final sculpture. It is not nearly as simple as sitting down and dipping a pen into a bottle of ink, but my enthusiasm for the work alleviates the effort of production.

He might also have noted that it was a costly process which only a well-heeled sculptor could have financed.

His sculpture brought him into closer touch with art critics and highbrow intellectuals. They called his creations "literary," a polite word which questioned their "artistic" validity. Deep down in his heart he wanted to be accepted by the art world—to have a piece of his sculpture in the Metropolitan Museum of Art was his dream. It didn't happen, but Rube was braced for disappointment. "I work hard at only one thing," he told a writer for *Reader's Digest*, "being funny."

His sculpture was for the average taste, he said repeatedly, but it wasn't for the average pocketbook, with prices ranging from $700 to $3,000. Nevertheless, the four major exhibitions of his work (the first two shows at Brentano's bookstore; the third and fourth at New York's Hammer Galleries) resulted in six hundred sales, a feat which pleased him very much, as he wrote to "Scoop" Gleeson, "because a buck is hard to come by these days for a young sculptor."

His original goal was to make a three-dimensional cartoon, so early works, like "Pooped" (Fig. 185), simply reflect his drawing style. Some of his friends flattered him by saying his works recalled the satirical creations by Daumier, but any real comparison fails to work in Rube's favor. In his cartoons of the 1920s he reveled in hard nervous lines and jagged figure contours, and he attempted to preserve these elements in the sculpture by leaving the surfaces rough and temptingly tactile. Most of his works look as though they came to life before he had finished them; they seem to have run away from his studio while he was out to lunch.

To create three-dimensional cartoons was far different from drawing *Life's Little Jokes*. "I selected my subjects carefully, not in the way I had evolved the ideas for my cartoons, but with the emphasis on character, movement, and composition." Each piece re-

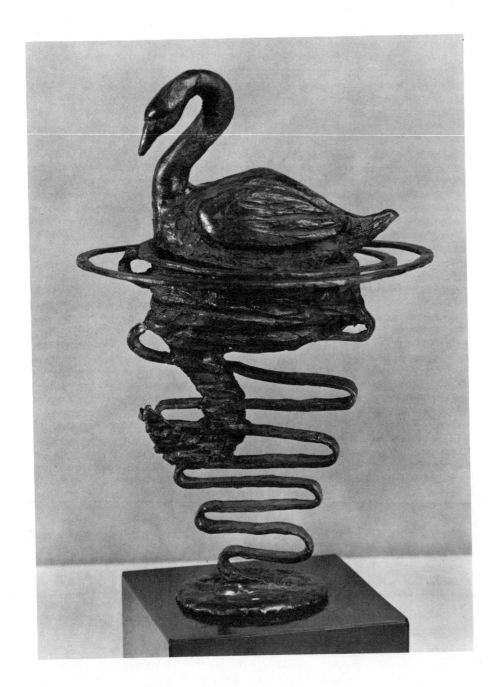

188. "Reflection"

quired piles of sketches and hours of observation and, as in the case of his "Camel" (Fig. 186), an extraordinary amount of patience.

Camels were Rube's favorite animals. The mere thought of them with their humps, disproportionately thin legs, C-shaped necks, and swivel jaws always filled him with a contented glow. When someone told him that these thirstless wonders could hide their feet while sitting, Rube decided to see for himself. So early one morning in June of 1966 Rube (who was almost eighty-three) and Irma made their way to the Bronx Zoo in search of a reclining dromedary. As soon as they arrived, it began to rain. Irma opened the umbrella and made a vain try at protecting both herself and Rube while he paced about the aloof camel, sketching from every angle. After an hour or so there was just one more drawing to do—the sitting position. But camels do not enjoy resting their tender bellies in mud, particularly when a slightly daffy cartoonist is staring. Rube pleaded, coaxed, and then threatened, remembered Irma. "He stood in the rain for more than two hours getting madder by the minute." Then, with the superior demeanor which only a camel, or a member of the *Weekly Meeting of the Tuesday Ladies' Club,* can achieve, the Bronx Zoo resident squatted ever so slowly on a pile of hay. Seated, feet in, the regal camel posed for Rube's final sketch.

The artist jumped into a cab and went straight to his studio, kissed Irma good-bye, and modeled for almost seven hours. Within three days he finished the sculpture, had it molded, and sold it. Today it is in the North Carolina State Museum in a special gallery for blind children, where it teaches them to "see" art with their hands and to learn how a camel arranges himself when he is sitting.

The outcome of Rube's persistence was greater than his initial purpose, for *despite himself* he began to move from cartoons to fine art. (It was like a repeat of the acceptance of his inventions as creative masterpieces.) The plasteline was becoming an ever present friend ("my typewriter fingers are covered with clay," he wrote to "Scoop" Gleeson), and Rube's pieces in 1968 and 1969 were assuming an independence, a totality which no longer required snappy titles. His "Mother and Child" (Fig. 187) suggests a sophistication which might have blossomed fully, given a few more years to grow (Fig. 188).

Rube felt this transformation in a subliminal manner, but he cautiously restrained himself from talking about it. "I'm getting pretty good at doing hippos," was his way of saying "I'm learning about art and I'm doing some excellent stuff." But he still distrusted the high-culture buffs who tried to imbue his work with profundities. "The Climber," a goat perched on a mountain, was given endless interpretations. "I sculptured the goat on a mountain peak because I liked the composition and deemed it mildly humorous," wrote Rube in 1968. "Now I hear it's a commentary on the futility of greatness and the lonesomeness of persons in high places: up there you have no place to go except down, etc., etc." The real joke of all this symbolism is that "The Climber" was originally designed as part of a large landscape complete with a camera-clicking tourist, but the piece fell apart before completion so Rube had the goat bronzed just to salvage something from his arduous labors.

His new career was highly publicized by the news media, and his shows were well attended, but the topper to Rube's illustrious life was a retrospective exhibition at the Smithsonian Institution—the very same establishment that Rube had one time described as a "depressing edifice where all the symbols of democracy's

189. Goldberg is the name—Rube Goldberg,
by Karl Hubenthal, 1970

stupidity were so ingloriously stored." Entitled "Do It the Hard Way," the show opened on November 24, 1970, not to a "few drowsy attendants who lolled on various pieces of ridiculous American bric-a-brac," as Rube had predicted, but to more than two thousand invited guests. Formal museum openings were new to Rube, and this particular show was mildly shocking for the Smithsonian. Bicyclists weaved through the pedestrain traffic while a small orchestra, housed in a complex composition of scaffolding, played special Goldberg tunes. It was a celebration similar in spirit to the New Year's Eve parties of the 1920s; only Houdini was gone—we think. Rube was dazed. When presented with a special cake decorated with "Mike and Ike," his cancer-filled throat could still whisper a joke: "Well, I have my cake and now I have to eat it!"

The exhibition was the brainstorm of historian-philosopher Daniel J. Boorstin, who had been appointed fifteen months earlier as the new director of the National Museum of History and Technology. Dr. Boorstin was a novice in the musuem world and he did not realize that the "Octopus on the Mall" was unfamiliar with exhibiting objects and drawings designed for laughter. His ignorance in such time-honored prejudices proved to be his ace in the hole, for while he assured Rube and Irma that all was smooth and easy, he nearly turned the museum on its ear as he pursued his goal. In less than one year the exhibition was ready—a rare feat in Smithsonian annals. There was a special seven-and-one-half-minute movie documenting Rube's relationship to America's three-hundred-year tradition of gadgeteering. More than one hundred cartoons, examples of his sculpture, recordings of his songs, and thousands of brochures and catalogues made the exhibition a profound tribute to Rube's energy and vision.

As he walked through the exhibit, Rube marveled at how powerful his old creations looked—particularly those that had been enlarged—and he felt overwhelmed with pride that he, the shy boy from Vallejo Street, could have come so far. As his twinkling eyes scanned this wealthy panorama of creativity, he remarked, "It frightens me to think that I did all this work. It's like seeing my own obituary written large and bright."

The wire services and hundreds of the newspapers picked up the news, reviving a popular interest in Rube's work. The New York *Times* reminded readers:

Rube Goldberg, 87, is the cartoonist who invented the fantastic machine that struck the universal chord. His drawings spoofed man's ability to make the simple, complex, and showed man a lot lower than the angels—down-right human.

The Baltimore *Sun* came on even stronger:

As we see it, Rube Goldberg himself has been a one-man show all his life, a spoofer like no other spoofer, for decade after decade in pen-and-ink, and lately in sculpture. And of course a constant target of his spoofing, notably through his brilliant "inventions," has been precisely technology.

Rube died on December 7, 1970, thirteen days after opening night. He had been suffering from cancer for more than seven months, and his physicians gave him slim hope of seeing 1971. His life cycle had a perfect symmetry, so perfect that his death, while sad, was not a time of wails and moans. The newspaper eulogies, as well as Milt Caniff's funeral oration, brought laughter—a nationwide Irish wake for an occasional Jew. (Caniff reminisced, for example, that Rube insisted Caniff's "voice was so high only a tall dog" could hear him.) Virtually everyone agreed that his inventions were immortal, but, interestingly enough, his thirst for work and his genius for pulling a laugh had become part of the newspaper folklore. The cartoons by Karl Hubenthal (Fig. 189) and Johnny Hart (Fig. 190) relayed

190. Johnny Hart's Salute
to Rube Goldberg, 1970

how cartoonists felt, and the editorials spoke for the rest of the journalism profession.

The Chicago *Sun-Times*:

Rube Goldberg has retired at the age of 87. Only death could make him give up his tireless creativity after 66 years.

Just two weeks ago, the great cartoonist attended the opening of an exhibition of his work at the National Museum of History and Technology in Washington which permanently stamped his name upon our culture.

Indeed, his fantastically complicated devices to achieve ludicrously simple ends are today more profound commentaries on our times than they were when his mischievous mind first conceived them several generations ago. The contraptions Rube Goldberg invented in his younger years were the progenitors of the complex mechanical creatures which are now engaged in the amazingly simple occupation of picking up stones on the face of the moon.

Physically, the impish Mr. Goldberg looked like a flattering portrait painter's version of Al Smith. He was a man of many facets, each of which, in the course of the years, he gave an opportunity for full expression.

Trained against his wishes as an engineer at his father's urging, he later took revenge by spoofing man's natural inclination to overdo in everything he strives for. His ingenious character Professor Lucifer Gorgonzola Butts, after careful thought, always discovered a harder way to achieve the most commonplace results.

Boob McNutt reflected his early background, the awkward, simple-looking young man, a shlemiel. (What Jewish mother had not called her son a shlemiel at some time?)

In his mature years Rube Goldberg adopted the editorial cartoon as a vehicle to express his more serious concern with the state of man in the 20th Century. His efforts in this medium were crowned by the Pulitzer Prize.

Already in his 80's, Rube Goldberg had not yet finished with expressing himself. He turned to the difficult art of sculpture in bronze, and produced a collection of Americana, typically Goldbergian.

His name has already been enshrined in Webster's dictionary to describe man-made absurd complexities. He will always live in the English language, and in our memories.

The New York *Times*:

Cockeyed World

Long before "Parkinson's Law" and "The Peter Principle" and "Up the Organization" codified the notion that there are two ways to do things—the simple way and the way they actually are done—Rube Goldberg was telling Americans to watch out or the machines and technocrats would overwhelm us. His graphic inventions struck most people as funny, precisely because the knife slipped between the ribs so smoothly no one felt the pain.

Just before he died this week the Smithsonian Museum of History and Technology honored him with an exhibit of his drawings aptly called, "Do It the Hard Way." He saw the screwballs in a cockeyed world gone mad. His message is a lasting one: beware of the all-knowing computers, supersonic gadgets and the rest of the hard-ware. Beware, too, of their proponents who aim to dominate the human element in life.

The Washington *Post*:

Reuben Goldberg

"Goldberg, Reuben Lucius," the entry in Who's Who begins, "(Rube), sculptor; b. San Francisco, July 4, 1883." As you read along you get an idea of the dimensions of this extraordinary man who died on Monday—cartoonist turned sculptor in his 80th year, creator of Ike and Mike and Boob McNutt, bachelor of science in mining engineering (University of California, 1904) and author of numerous books including one titled "How to Remove the Cotton from a Bottle of Aspirin." Everyone will have his preferred Rube Goldberg creation. Lala Palooza, perhaps, or the serious peace cartoon that won the Pulitzer prize in 1948, or that most ingenious and memorable invention of 1942, the "Automatic Hitler-kicking Machine."

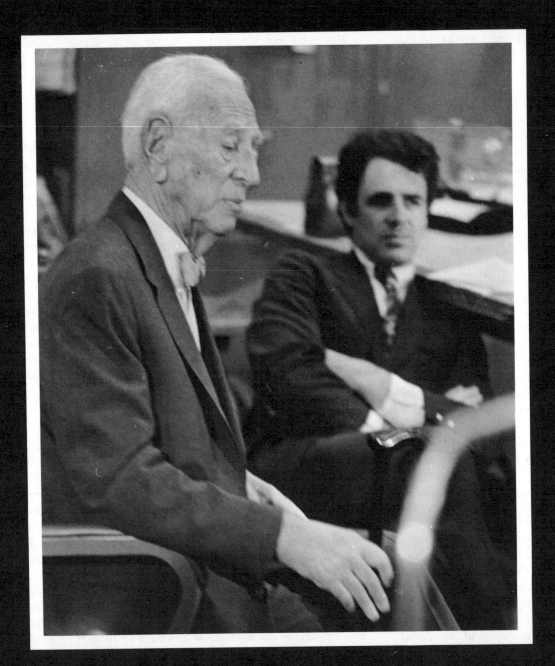

Rube and
Peter Marzio

When the Smithsonian Museum of History and Technology celebrated the opening of his show last month, Rube Goldberg managed that most difficult and unusual of feats: he spoke as a humorist about humor without becoming either pretentious or grim. On the contrary, he reflected upon the fact that to many of the young, Rube Goldberg was "just a name consisting of two words" which give you a picture of what they mean like "veal cutlets." He cautioned against taking too seriously any humorist's explanation of his art. And in the most graceful of ways he alluded to what made his so special and gave it meaning.

"At the time of my graduation, I thought the course I had taken (in engineering) was a complete loss. But later I came to the conclusion that nothing is wasted—especially if you have a sense of humor. I believe the idea of going through such outlandish complications of inventive effort to accomplish practically nothing struck a universal chord which I was not aware of when I first hit on the idea."

Outlandish complications . . . to accomplish practically nothing—the comment, made throughout an artistic lifetime, was less a comment on the machinery than on the men who concocted it, on the wondrous and wondrously funny processes by which we contrive to bring forth—indirectly and laboriously—so little. Perhaps it is just our particular mindset in this town, but when we observed Mr. Goldberg's classical machines the other evening, we thought first of the ways of government, of what you might call the Enactment of a Bill into Law Machine. Rube Goldberg's art was a triumph of wit, energy and imagination, and at 87 he was plainly still engrossed in it. He was one of those people who, whenever they die, seem to die in their prime.

But the posthumous accolades were also tinged with a curious lament about the decline of humor today. This song is sung whenever a brilliant humorist dies; the chorus following Mark Twain's passing in 1910 and Will Rogers' premature death in 1935 presaged decades of sadness. It was wrong. Shortsightedness is always the penalty of immediate tragedy. Rube's death deprived the world of a genius-humorist, but it did not turn off laughter. The jokes still come and men still laugh. There'll never be another Rube Goldberg, but there will be others who are just as funny and just as poignant. There are never too many humorists at any one time—but one original jokester is all we need.

Self-portrait bust

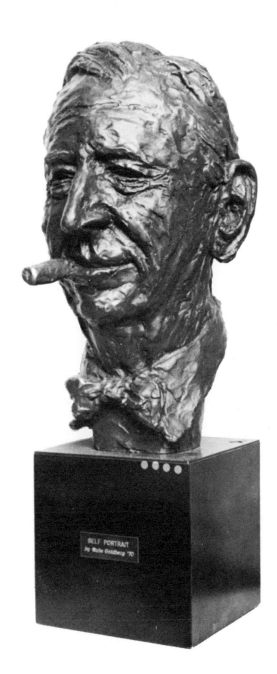

SELF PORTRAIT
by Rube Goldberg '70

Appendix I: Rube Goldberg's Cartoon Series, 1904–1938

I'm the guy, Foolish Questions, and *Inventions of Professor Butts* were Rube Goldberg's most enduring cartoon series, but he created at least fifty-eight others, many being continued for more than ten years. He usually employed two series a day—one for the main cartoon and the other as a side panel. Yet it was not unusual for three to appear, the third being a *Boloney* or a *Benny sent me* beneath the side panel.

In the list which follows, a title is considered a series if it made ten or more appearances. Undoubtedly, several have been omitted, but those noted here do form the body of Rube's creative efforts from 1904 to 1938.

Alphabetical Soup	1934
Are you saving jokers?	1934
Benny sent me	1914–1934
Bill	1931–1934
Bill and Professor Butts	1934
Blame it on Wilbur	1920–1926
Blind Boobs	1921
Bobo Baxter	1924–1928
Boob McNutt	1915–1934
Boob McNutt's Ark	1933–1934
Boob McNutt's Geography	1934
Boob News	1916
Boobs Abroad	1913–1914, 1918
Bozo Butts—they drive him nuts	1923–1928
Brad and Dad	1923
Breaking Even	1913, 1919
The Candy Kid	1908–1911
Cartoon Follies of 1926	

Doc Wright	1934–1935
Father was right	1912–1924
Fifty-Fifty	1913–1934
Foolish Questions	1909–1934
History in a Modern Picture Frame	1910–1919
If Plays Were Only True to Life	1909–1913
I'm cured	1913–1921
I'm the guy	1911–1934
I never thought of that	1910–1920
The Inventions of Professor Lucifer Gorgonzola Butts	1914–1964
It all depends on the point of view	1909–1913
It costs too much to live and you can't afford to die	1911–1926
It's all wrong, . . . , it's all wrong	1914–1929
. . . , sweep out padded cell . . .	1913–1930
Lala Palooza	1937–1938
Life's Little Jokes	1911–1935
Little Butch	c. 1928–1931
Lunatics I Have Met	1908–1913
Mike and Ike, they look alike	1915–1934
Mister Alf of the Alphabet (also labeled *Old Man Alf of the Alphabet*)	1915–1917
No Brains, No Brains	1915–1926
No matter how thin you slice it, it's still boloney	1926
Our Own Weekly Radio Ravings	1922
People Who Put You to Sleep	1918–1930
Phoney Films	1914–1921
Reincarnation	1908
Sapograms	1932

Appendix II: Selective Bibliography of Rube Goldberg's Writings

Rube was a voluminous writer who published an impressive number of short stories. The pages of the New York *Evening Mail* are particularly rich in Goldberg anecdotes (1908–1920). The entertainment programs, membership booklets, and albums of the Lambs Club, the Artists and Writers Golf Association, the National Cartoonists Society, and the Friars Club also present a notable account of Rube's writing activities.

The list which follows contains Rube's most significant published works. It does not include his unpublished pieces—many of which deserve to be in print.

Articles

"My Answer to the Question: How Did You Put It Over?" *American Magazine* (March 1922).

"The Growing Refinement of Prize Fighting," *Vanity Fair* (September 1923).

"My New Passion for Modernist Art," *Vanity Fair* (July 1924).

"Left-handed Golf Courses: Our Greatest Need," *American Golfer* (July 1924).

"What I Have Found Out About Money," *Good Housekeeping* (October 1924).

"The Ideal Home Life of Famous Film Stars," *Screenland* (March 1924).

"The Bobbed Hair Problem," *Life* (August 28, 1924).

"Bobbed Hair," *Collier's* (February 7, 1925).

"I'd Like to Know Why—" *Vanity Fair* (May 1925).

"Bums," *McNaught's Monthly* (February 1926).

"The Outcast," *Cosmopolitan* (April 1928).

"It Happened to a Rube," *Saturday Evening Post* (November 10, 1928).

"It's the Little Things That Matter," *Collier's* (November 3, 1928).

"Comics, New Style and Old," *Saturday Evening Post* (December 15, 1928).

"I, Rube Goldberg, Hereby Plead for Ether for Husbands, Too," *Cosmopolitan* (December 1928).

"Rube Goldberg's Lessons in Golf," *American Golfer* (September 1929).

"How's the Market?" *Cosmopolitan* (September 1929).

"Is College Spirit the Bunk?" *College Humor* (December 1929).

"Rube Goldberg's First Picture," *Photoplay* (December 1930).

"New Golf Ball Worse Than the Depression," *Life* (June 19, 1931).

"What Do You Do with Your Spare Time?" *Cosmopolitan* (August 1931).

"The Gentle Week-end Guest," *College Humor* (August 1931).

"The Old Man Takes His Boy Back Home," *Cosmopolitan* (January 1932).

"The Greatest Show on Earth . . . Every 4 Years," *Cosmopolitan* (July 1932).

"Some Call It Golf but I Call It Midget Insanity," *Cosmopolitan* (July 1932).

"Vacation Is a Necessary Evil," *Cosmopolitan* (August 1932).

"What Do I Know After Forty?" *Saturday Evening Post* (December 3, 1932).

"Thankless Children," *Saturday Evening Post* (March 25, 1933).

"Nobody Listens," *Saturday Evening Post* (November 4, 1933).

"You Gotta Be Phoney," *Redbook* (March 1934).

"I Am Always on Time," *Liberty* (March 23, 1935).

"One O'Clock Sunday Dinner," *Esquire* (September 1935).

"Buffet Supper," *Good Housekeeping* (September 1935).

"Horning In," *Redbook* (September 1935).

"Red 'em and Weep," *American Magazine* (August 1935).

"Speed the Parting Guest," *Esquire* (January 1936).

"We Need More Left-handed Courses," *Golf* (Winter 1939–40).

"Do We Play Golf for Pleasure?" *Golf* (Winter 1939–40).

"Pretty Soft," *Redbook* (October 1941).

"Cartoons," *Life* (November 27, 1944).

"Inventions We Need in 1949," *Cosmopolitan* (January 1949).

"On the Privilege of Being Over Sixty," *Rotarian* (October 1950).

"I Always Make It a Rule," *Rotarian* (September 1952).

"What Is Slang?" *Service* (October 1952).

"The Key to Home," *Perfect Home Magazine* (May 1955).

Introduction to Stephen Becker, *Comic Art in America* (New York: Simon & Schuster, 1959).

"Don't Brush Off All the Old Rules," *Seventeen* (September 1966).

"Sixty-Six Years," *Do It the Hard Way: Rube Goldberg and Modern Times* (Washington, D.C.: The National Museum of History and Technology, Smithsonian Institution, 1970).

Books

Goldberg, Rube, *Foolish Questions* (Boston: Small Maynard & Co., 1909)—reprint of cartoons from the New York *Evening Mail*.

Goldberg, Rube, *Chasing the Blues* (New York: Doubleday, Page & Co., 1912)—reprint of cartoons, poems, and essays from the New York *Evening Mail*.

Goldberg, Rube, *Seeing History at Close Range* (New York: Morris Margulies, 1914)—original text with reprint of cartoons from the New York *Evening Mail*.

Goldberg, Rube, *Is There a Doctor in the House?* (New York: The John Day Company, 1929)—reprint of two magazine articles.

Goldberg, Rube, *The Rube Goldberg Plan for the Post-War World* (New York: Franklin Watts, 1944).

Goldberg, Rube, *Music in the Zoo* (New York: Mills Music Co., 1946).

Goldberg, Rube, and Sam Boal, *Rube Goldberg's Guide to Europe* (New York: Vanguard Press, 1954).

Goldberg, Rube, *How to Remove the Cotton from a Bottle of Aspirin . . .* (Garden City, N.Y.: Doubleday & Co., 1959)—original cartoons.

Goldberg, Rube, *I Made My Bed*, by Kathy O'Farrell as told to Rube Goldberg (New York: Doubleday & Co., 1960).

Kinnaird, Clark, ed., *Rube Goldberg Vs. The Machine Age* (New York: Hastings House, 1968).

A Statement on Sources

The personal papers of Rube Goldberg form the bibliographical nucleus of this book. A small portion of Rube's correspondence and manuscripts is stored at the Bancroft Library, University of California at Berkeley, but most of his papers remain in the possession of his wife, Irma. Together these two collections contain advertising brochures, press releases, unpublished manuscripts, reprints of speeches and articles, photographs, drawings, correspondence, newspaper clippings, and—most importantly—the partial drafts of four incomplete autobiographies. While the autobiographies are not dated, internal evidence suggests that the first was composed in 1927–1928, the second in 1939, the third in 1954–1956, and the last in 1966.

In the introduction to his fourth effort Rube explained the course of his autobiographies:

Back in the thirties I was sitting on the sands of Palm Beach with my friend Dick Simon (half of Simon and Schuster) and, for want of something better to talk about, he suggested that I write a sort of loose autobiography. I told him I had kept no record or diary over the years and what data I had (notes, clippings, programs, drawings, etc.) were scattered in hopeless confusion over a wide area of cellars, attics and obscure garbage cans covered with the dust of forgetfulness. He said it might be a novelty to ramble along, dropping anecdotes, names, opinions and random thoughts with a total disregard of chronology and verbatim conversations. Dick's pleasant suggestion and the exhilarating effect of the beautiful Florida sunshine loosened my tongue. I gave him a sample of my feelings about life in general. I held forth a broad assault on the human race and its glaring weaknesses which, I added, were incurable. Living in the lap of Palm Beach luxury for a few weeks gave me a feeling of smugness. My voice mingled with the gentle breeze that came up from the sea. The palms that rimmed the beach nodded their approval.

When I had finished Dick said, "I've got the title for your book?"

"What is it?" I asked.

"Everything stinks."

What troubled Rube most was his sincere belief that his life was too dull for the average reader. As he wrote in 1954,

When a friend tells me he has received a vast sum of money as an advance on the publication of his life's story I get only one reaction. Who wants to read it? I may be wrong. But I have a feeling that people are interested only in the lives of others who have risen from reeking slums, who have endured unspeakable suffering, who have wallowed in the sloughs of criminal degradation or overcome physical handicaps. The smallest child knows that Toulouse-Lautrec was built too close to the ground and faded away in the mists of dissipation. Michelangelo had a caved-in nose. Abraham Lincoln suffered from the majesty of ugliness and the pangs of chronic depression. Famous women have recorded their early environment of poverty and sin to the music of fabulous royalties for books and pictures. But I never had to overcome a strong appetite for booze, I have never played piano in a house of ill-fame, I never sold dope nor did I ever have to fight all the plug uglies in a slum neighborhood on account of my religion. In fact, if anybody will want to read these words other than my immediate friends and relatives I will be greatly surprised. It really doesn't matter much. I think I will enjoy putting down some of the thoughts that have accumulated in my consciousness over so many years that it doesn't seem possible that I have lived them.

As in so much of Rube's writing, he seldom hesitates to bend the detailed truth to win a laugh, but his general outlines are always accurate, often providing the kind of unique personal insights that make autobiographies so welcomed by the biographer. In 1968 a small portion of these reminiscences (particularly the 1927–1928 manuscript, which had appeared in the *Saturday Evening Post* in 1928) was edited and published by King Features Syndicate: Clark Kinnaird, ed., *Rube Goldberg Vs. The Machine Age* (New York: Hastings House, 1968).

Despite the wealth of information from Rube's personal archives, there were numerous gaps. They were filled, in part, by researching all the issues of the San Francisco *Chronicle*, the San Francisco *Bulletin*, the New York *Evening Mail*, the New York *Sun*, and the New York *Journal*(-*American*) which carried Rube's cartoons. But it was the expensive and time-consuming process of personal interviewing that yielded the richest materials.

Most of the information I captured with my tape recorder is undocumented. Yet as a historian of the recent past I could not ignore such an important resource. In talking with Rube's friends and colleagues I gained an intimacy with him which surely would have eluded me had I remained strictly with the written record. In interviewing people I made every attempt to establish the truth of their testimony by checking for internal consistency and researching corroborative evidence. Still, in any informal reminiscence there is a great deal of material which cannot be proved, so I was forced to decide whether a story sounded right or not. When in doubt I have inserted qualifiers in the text to warn the reader that he is treading undocumented territory.

The interviews and the fragmentary autobiographies were most useful for their vivid anecdotes, but the historian of fact may frown on my employing dialogue which has been quoted from memory. Without the dialogue the anecdotes would fail to elicit Rube's speech patterns, and without the anecdotes the biography would have assumed a nonhuman quality. So I used those words which captured the essence or the nuance of a situation, caring less about what the precise phrasing might have been. At no point, however, have I made up the dialogue to fit a particular episode.

Beyond the normal difficulties of historical research, the historian of comedy is burdened by a lack of useful secondary sources. He forever finds himself in unplowed territory when he looks for a philosophy of humor or asks about the social importance of laughter. With the exception of the brilliant insights in Sigmund Freud's *Wit and Its Relation to the Unconscious* (London: T. Fisher Unwin, 1916), the intellectual statements on humor are unconvincing. Charles Baudelaire's *The Essence of Laughter* (trans. Gerard Hopkins; New York: Meridian Books, 1956), Henri Bergson's *Laughter* (New York: The Macmillan Co., 1911), Stephen Leacock's *Humor: Its Theory and Technique* (New York: Dodd, Mead, 1935), Max Eastman's *The Enjoyment of Laughter* (New York: Simon & Schuster, 1936), and George Meredith's *An Essay on Comedy* (New York, 1897) are standard references which simply suggest the work to be done.

The irony of this paucity of literature is the observation made by anthropologists that laughter appears to be a purely human phenomenon; it is one of the few things men do which animals, apparently, do not. The simple truth that this most human of earthy phenomena should go unstudied for so long reflects the curious biases and blindnesses of academia.

Less troublesome, but still almost as unbelievable, is the dearth of information about the history of caricature in general and of American comic art in particular. The perceptive art historian Ernst Gombrich and his influential teacher Ernst Kris made several pioneering studies of the relationship between psychology and caricature. These include: E. H. Gombrich, *Caricature* (London: King Penguin Books, 1940); E. H. Gombrich, "The Cartoonist's Armory," *South Atlantic Quarterly* (Spring 1963); and Ernst Kris and Ernst Gombrich, "The Principles of Caricature," *British Journal of Medical Psychology* (December 1938). But little has been done to assemble the fragments of information into a comprehensive work. Stephen Becker's *Comic Art in America* (New York: Simon & Schuster, 1959), on the other hand, is a readable attempt at a comprehensive history of American cartooning. As a pioneering study it is invaluable, but it suffers from misinformation and imbalance. The same is true for William Murrell, *A History of American Graphic Humor* (2 vols., New York: Whitney Museum of American Art, 1933–1938).

At numerous points in this book I have had to dig into primary material which did not relate directly to Rube Goldberg. And, time and again, the staff at the Library of Congress has assisted me in ascertaining facts buried in long-forgotten manuscripts or print collections which helped to illuminate the significance of Rube's career.

The Selective Notes and Bibliography, which follows, is arranged by chapter and aims to guide the reader to my principal sources of fact. Books, articles, letters, and interviews credited in the text are not repeated here. Moreover, the bibliography does not include either the unpublished autobiographies or the numerous interviews I held with Mrs. Irma Goldberg. Both sources pervade the manuscript. To include them in each chapter would be repetitious.

Selective Notes and Bibliography

The following abbreviations are used in this section:

RGP—Rube Goldberg Papers in possession of Mrs. Irma Goldberg.

BL—Rube Goldberg Papers at the Bancroft Library, University of California, Berkeley.

Introduction

The opening quote is from a Hammer Galleries catalogue published for a posthumous showing of Rube Goldberg's sculpture, November 23–December 4, 1971.

Rube's cigar theories come from an unpublished story "Stop Smoking That Cigar," c. 1964, RGP. David Sarnoff's quote is in a letter to Rube, October 7, 1959, BL. Anthony Trollope's quote comes from his traveling experiences in America. The other European testimony is Alexis de Tocqueville, *Democracy in America* (2 vols., trans. Francis Bowen; Cambridge, Mass.: Sever and Francis, 1862), Vol 2. See also Peter C. Welsh, "United States Patents 1790 to 1870: New Uses for Old Ideas," Bulletin 241, National Museum of History and Technology.

Chapter 1

Compared to Chicago and Boston, San Francisco has few reliable histories. John P. Young, *San Francisco: A History* (2 vols.; Chicago: J. J. Clarke Publishing Co., 1928), Amelia Ransome Neville, *The Fantastic City* (Boston: Houghton Mifflin Co., 1932), and John S. Hittell, *A History of the City of San Francisco* (San Francisco: H. L. Ban-

croft & Co., 1878) were useful. For local color of the 1880–1910 era, however, newspapers proved most valuable: *Bulletin, Call, Chronicle, Daily News, Evening Post, Examiner,* and *Globe.*

Robert Glass Cleland, *A History of California* (New York: The Macmillan Co., 1923)', and Theodore H. Hittell, *History of California* (San Francisco: N. J. Stone & Co., 1898), give the general outline of the history of California. And Walton Bean's *Boss Ruef's San Francisco* (London: Cambridge University Press, 1952) relates the course of Abe Ruef's political life.

Max Goldberg is still a legend in San Francisco, particularly with the senior generation. Rube's schoolboy friend George Wagner remembered Max with special vividness (interview in May, 1971). Many of Max's personal papers and photographs remain in the possession of Walter Goldberg, Rube's younger brother.

To capture Rube's inspiration for comic art there is no substitute for leafing through the comic magazines of the 1880–1910 era: *Puck, Judge, Life,* and others. Their history is noted in Frank Luther Mott's *History of American Magazines* (5 vols.; Cambridge, Mass.: Harvard University Press, 1938–1968), Vols. 3 and 4, but scholars have generally failed to value comic periodicals as important historic documents. For secondary accounts of the quality of humor at the beginning of the twentieth century see: H. W. Boynton, "American Humor," *Atlantic,* September 1902; C. Chesterton, "Salt of America," *Living Age,* October 27, 1917; Bernard De Voto, "Lineage of Eustace Tilley," *Saturday*

Review of Literature, September 25, 1937; Max Eastman, "Humor and America," *Scribner's*, July 1936; William D. Howells, "Our National Humorists," *Harper's Magazine*, February 1917; Burgess Johnson, "New Humor," *Critic*, April–June 1902; W. D. Nesbit, "The Humor of To-day," *Independent*, May 27, 1902. Constance M. Rourke's *American Humor: A Study of the National Character* is hailed as a classic by many, but I found it of little use in analyzing the unique qualities of humor in the twentieth century.

Chapter 2

Although there is no formal history of art instruction in America, William Morris Hunt's importance as a teacher is noted in Oliver Larkin, *Art and Life in America* (New York: Rinehart & Co., 1949), and Edgar P. Richardson, *Painting in America* (New York: Thomas Y. Crowell Co., 1965). The humor of campus magazines is sampled in Dan Carlinsky, ed., *A Century of College Humor* (New York: Random House, 1971).

The newspaper life of San Francisco is captured in fact by Frank Luther Mott, *American Journalism* (New York: The Macmillan Co., 1947), and in spirit by W. A. Swanberg, *Citizen Hearst* (New York: Charles Scribner's Sons, 1961). There are numerous published reminiscences which add a personal touch, the most useful for this study being Fremont Older, *My Own Story* (New York: The Macmillan Co., 1926).

Rube's quote ". . . nothing is as funny as real life" comes from notes he scribbled for a speech in 1940, RGP.

The note to Max from Oneida is dated July 1902, RGP.

Chapter 3

Pop McCarey's Fight Pavilion is described vividly in Chapter 3 of Frank Capra, *The Name Above the Title* (New York: The Macmillan Co., 1971). The story of Goldfield, Nevada, was told many times by Rube and it is corroborated by Harry J. Coleman, *Give Us a Little Smile, Baby* (New York: E. P. Dutton & Co., 1943).

Gordon Thomas and Max Morgan Witts, *The San Francisco Earthquake* (New York: Stein & Day Publishers, 1971) is a blow-by-blow social account of the disaster of 1906. Other sources included Frederick Funston, *Memories of Two Wars* (London: Constable and Co., 1912), Frank Aitken and Edward Hilton, *A History of the Earthquake and Fire* (San Francisco: E. Hilton Co., 1960), and William Bronson, *The Earth Shook, The Sky Burned* (New York: Doubleday & Co., 1959).

Chapter 4

Foolish Question blurb is from an *Evening Mail* poster, RGP. There is no reliable history of entertainment promotion or image making, but Frank Presbrey, *History and Development of Advertising* (Garden City, N.Y.: Doubleday & Co., 1929) is helpful.

The Dictionary of Americanisms (Chicago: University of Chicago Press, 1951), edited by Mitford M. Mathews, is the source for the usage and meaning of "guy."

Chapter 5

Although Rube's philosophy of humor was strictly his own, he unknowingly echoed many of the observations of Henri Bergson, *Laughter* (New York: The Macmillan Co., 1911). See also Walter Kerr, *Tragedy and Comedy* (New York: Simon & Schuster, 1967). The Goldberg letter of February 5, 1923, is in the possession of Mr. Edgar Gleeson. Gleeson's quote is from an interview in May 1971.

For an older mirror image of Rube's experiences in Europe see Mark Twain, *The Innocents Abroad* (2 vols.; New York: Harper & Brothers, 1869). For Rube's own impressions, see the New York *Evening Mail*, June–August 1913 and June–August 1914. The Frank Stanton "Toast" is a handwritten note, RGP.

Chapter 6

Stockbridge's story is in "McNitt-Goldberg Meeting Made Syndicate History," *American Press*, May 1931. An early

account of Rube's success is L. G. Blochman, "Father Was Wrong," *California Alumni Fortnightly*, March 21, 1921. See also the *New York Times Magazine* January 30, 1916.

Rube's 1921 contract with Virgil McNitt is in BL.

News syndicates are discussed in Frank Luther Mott, *American Journalism* (New York: The Macmillan Co., 1947), and in Edwin Emery, *The Press and America* (Englewood Cliffs, N. J.: Prentice-Hall, 1962).

The rise to fame and wealth of other major cartoonists is noted in Stephen Becker, *Comic Art in America* (New York: Simon & Schuster, 1959), and in several contemporary periodicals—for example, "Masters of Those Pens That Instruct and Amuse," *Gas Logic*, January 1916.

While Paul Rotha, *The Film Till Now* (London: Spring Books, 1967), and Richard Griffith and Arthur Mayer, *The Movies* (New York: Simon & Schuster, 1957), are standard accounts of motion-picture history, the early days of animated film are shrouded in mystery waiting for an energetic historian. Even more desperate is the case of the newsreels. Only one reliable history exists, Raymond Fielding, *The American Newsreel: 1911–1967* (Norman, Oklahoma: University of Oklahoma Press, 1972), a shocking void which demands immediate attention.

A reliable account of Rube's attempt at an animated newsreel is "How Goldberg's Cartoons Joined the Movies," *Motion Picture Mail,* April 22, 1916. The blurbs come from McNitt's advertising literature, RGP.

The day of Rube's wedding the *Evening Mail* printed a small brochure in newspaper format headlined "Beauty Mated with Genius," RGP.

Chapter 7

Although numerous accounts of the work of Charles Chaplin exist, his own *Autobiography* (New York: Simon & Schuster, 1964) is still the most useful. For an analysis of Chaplin's humor, see Frank Capra, *The Name Above the Title* (New York: The Macmillan Co., 1971), pp. 42 and 62.

As for Will Rogers, there are many books, as well, but his life and his humor are handled most perceptively in Walter Blair, *Horse Sense in American Humor* (Chicago: University of Chicago Press, 1942).

The meeting between the Goldbergs and Isadora Duncan is described in John Wheeler, "Selling Other Men's Brains," *Saturday Evening Post,* March 10, 1928. The New Year's Eve parties are mentioned in Ruth Gordon, *Myself Among Others* (New York: Atheneum Publishers, 1971).

Chapters 8 and 9

Hugh Fullerton's observations on cartoonists appeared in *Collier's,* November 8, 1924.

A brief but perceptive sketch of Jimmy Walker and New York politics appears in Chapter 2 of Arthur Mann, *La Guardia Comes to Power 1933* (Chicago: University of Chicago Press, 1969).

Chapter 10

There is no satisfactory treatment of popular attitudes toward the growth of mechanization. Undoubtedly the cartoons from the second half of the nineteenth century to the present day are a primary source. Only the masterworks of Siegfried Giedion, *Mechanization Takes Command* (New York: W. W. Norton & Co., 1969), and John Kouenhouwen, *The Arts in Modern American Civilization* (New York: W. W. Norton & Co., 1948), save the field from oblivion. See also Victor C. Ferkiss, *Technological Man: The Myth and the Reality* (New York: George Braziller, 1969).

Helpful books dealing with inventors and their works include: John W. Oliver, *History of American Technology* (New York: Ronald Press Co., 1956), and Abbot P. Usher, *A History of Mechanical Inventions* (New York: McGraw-Hill Book Co., 1929).

The history of broadcasting is chronicled in Eric Barnouw's *A History of Broadcasting in the United States* (3 vols.; New York: Oxford University Press, 1966–1970). The story of Henry Ford and the Model T is in Allan

Nevins, *Ford* (3 vols; New York: Charles Scribner's Sons, 1954–1962), and Alfred P. Sloan's own account of the rise of Chevrolet is in his autobiography, *My Years with General Motors* (Garden City, N.Y.: Doubleday & Co., 1964). The term "ladder of consumption" was coined by Daniel J. Boorstin, "Self-Liquidating Ideals," paper read to the Committee on Science and Astronautics, 91st Congress, 2nd Session, January 28, 1970.

Chapter 11

A useful source on the relationship between mechanization and the environmental woes is F. Fraser Darling and John P. Milton, eds., *Future Environments of North America* (Garden City, N.Y.: Natural History Press, 1966).

The quote from the Packard factory is in a letter from John Hurt to Rube Goldberg, November 26, 1944, BL.

Rube's inventions have been discussed many times. Two brief but useful accounts are Don Romero, "Wizard of Wacky Inventions," *Mechanix Illustrated*, September 1946, and Henry Okun, *Rube Goldberg: Memorial Exhibition* (Berkeley, Calif.: The Bancroft Library, 1971).

For an extended account of the relationship between Goldberg's inventions and Sigmund Freud's theories, see Peter C. Marzio, "Art Technology, and Satire: The Legacy of Rube Goldberg," *Leonardo*, Fall 1972.

Chapter 12

The changes in American humor during the 1920s and 1930s are discussed briefly in Corey Ford, *The Time for Laughter* (Boston: Little, Brown & Co., 1967). Useful overviews of the 1920s cartoon styles are Rollin Kirby, *Highlights, A Cartoon History of the Nineteen Twenties* (New York: Payson, 1931), and Gilbert Seldes, "Some Sour Commentators," *New Republic*, June 10, 1925. Al Capp's comments come from the *Smithsonian Magazine*, November 1970. See also the analysis of a slightly later era by James

Thurber, "The Saving Grace," *Atlantic Monthly*, November 1959.

A History of the Comic Strip (New York: Crown Publishers, 1968) by Pierre Couperie *et al.* with an introduction by Milton Caniff is the first effort at a complete history of the cartoon strip. Román Gubern's *El Lenguaje de los Comics* (Barcelona, Spain, 1972) investigates the origin and evolution of various comic strip conventions.

Doc Wright facts are from RGP, *Editor & Publisher*, January 20, 1934, and the New York *Journal* (1934). *Lala Palooza* information is from *Time*, November 9, 1936, as well as RGP. Portraits in the *American Golfer*, October 1930, and *Pictorial Review*, January 1936, also provide information about Rube during the 1930s.

Chapters 13 and 14

The Ungentlemanly Art: A History of American Political Cartoons (New York: The Macmillan Co., 1969) by Stephen Hess and Milton Kaplan is a model for all historians of the visual record. The bibliography is a thorough accounting of the editorial cartoon literature.

Grantland Rice's comments come from "Lesson 19," *Famous Artists' Cartoon Course* (Westport, Connecticut). E. H. Gombrich's analysis of *Peace Today* is in "The Cartoonist's Armory," *South Atlantic Quarterly*, Spring 1963.

Roy Howard quote is from a letter to Rube November 11, 1950, BL. Warren King material is from "New York Daily News Editorial Cartoonist," *Cartoonist Profiles*, February 1971.

Walter Blair's "Laughter in Wartime America," *College English*, April 1945, is useful for placing Rube's editorial works in a general context. See also "Mr. Goldberg at Mr. Morgan's," *Time*, December 7, 1942. Lowell Thomas quote is from radio script at BL. Quote beginning "Life is kind of futile . . ." is from Herbert Hoover Presidential Library, Oral History Interview, October 3, 1968.

Chapter 15

Since language is always changing, dictionaries and glossaries disagree on the status or even the meaning of specific words. A learned bibliographic analysis of the field, as related to the American language, is in Daniel J. Boorstin, *The Americans: The National Experience* (New York: Random House, 1965), pp. 477–480. Standard sources on the status of slang, including "comic words," are: H. L. Mencken, *The American Language* (New York: Alfred A. Knopf, 1957), Mitford M. Mathews, ed., *A Dictionary of Americanisms* (Chicago: University of Chicago Press, 1951), James Maitland, *The American Slang Dictionary* (Chicago: privately printed, 1891), Harold Wentworth and Stuart Berg Flexner, *Dictionary of American Slang* (New York: Thomas Y. Crowell Co., 1960), and William A. Craigie, *A Dictionary of American English* (4 vols.; Chicago: University of Chicago Press, 1938).

Jimmy Durante quote is from a letter (n.d.) at BL.

Chapter 16

Facts regarding the origins of the National Cartoonists Society were supplied by Russell Patterson in a letter dated April 10, 1972. The same account is given in Stephen Becker, *Comic Art in America* (New York: Simon & Schuster, 1959). See also "Biography," *Current Biography*, September 1948. Bernard Baruch's quotes are from a letter at BL.

For a report on Rube during the 1950s see "Rube's No Boob," *Pageant*, January 1951, and "Captive Humorist at Seventy-Six," *Newsweek*, November 16, 1959.

Chapter 17

Rube's radio and television schedules were gathered from the New York *Sun* entertainment pages (January 1943–December 1949), and *TV Guide* (November 27–December 3, 1948). The *Reader's Digest* quote is from an article by John Chapman, "My Most Unforgettable Character," June 1965.

Invitations, letters, and cartoons related to Rube's eightieth birthday party are well indexed at BL.

Life, October 1965, headed the list of magazines to report on Rube's new career in sculpture. See also *Long Island Commercial Review*, August 17, 1964; Carolyn F. Ruffin, "People Are Peculiar . . . ," *Christian Science Monitor*, May 11, 1967; "Rube Goldberg Turns to Cartooning in Clay," *Friends*, January 1965; "Latch on to Tomorrow," *Famous Artists Magazine*, Vol. 18, No. 3, 1970; "Rube (A) to Rube (B)," *Newsweek*, May 4, 1964; "To Make Them Laugh," *Time*, May 1, 1964; and "He Sculptures His Satire," *Harvest Years*, October 1969.

Walter Blair, "Is American Humor Dead?" *Chicago Tribune*, November 14, 1971, Section 1A, gives a learned account of the doomsayers of laughter.

For a personal eulogy from one of Rube's contemporaries see Harry Hershfield's article in *Silurian News*, March 29, 1971.

Illustration Credits

BANCROFT LIBRARY, UNIVERSITY OF CALIFORNIA AT BERKELEY: Original drawings. Figs. 2, 5, 8, 12, 13, 24, 28, 32, 38, 40, 42–44, 49, 54–56, 59–61, 67–72, 75, 78, 82–88, 92, 95, 96, 98, 99, 101, 102, 108, 109, 135, 136, 144, 151, 152.

ROBERT DUNN: Fig. 179.

MRS. IRMA GOLDBERG: Original drawings and newspaper clippings. Figs. 3, 4, 6, 11, 17, 19–23, 26, 27, 30, 31, 33–37, 39, 43, 45–48, 50–52, 57, 58, 62–66, 73, 74, 77, 79, 80, 88–91, 93, 94, 97, 100, 103, 104, 109–122, 124–127, 129–134, 137–143, 180–182, 184–188.

JOHNNY HART: Fig. 190. By permission of John Hart and © 1973 Field Enterprises, Inc.

KARL HUBENTHAL: Fig. 189. By permission of Karl Hubenthal and the Los Angeles *Herald-Examiner*.

LIBRARY OF CONGRESS: Photos are from microfilm and original newspapers. Figs. 13–16, 18, 53, 81, 105, 106, 123, 145, 147, 149, 153–163, 167, 168, 183.

SMITHSONIAN INSTITUTION: Original newspapers and original drawings. Figs. 1, 7, 9, 10, 25, 76, 128, 146, 170, 171, 177, 178.

Index

73 74 75 76 77 10 9 8 7 6 5 4 3 2 1